WYETH AT KUERNERS

Houghton Mifflin Company, Boston, Massachusetts · 1976

WYETH
AT
KUERNERS

Printed in the United States of America

H 10 9 8 7 6 5 4 3 2 1

Library of Congress Cataloging in Publication Data
Wyeth, Andrew, 1917-
 Wyeth at Kuerners.

 1. Wyeth, Andrew, 1917- 2. Kuerner, Karl,
1898- —Portraits, etc. 3. Kuerner, Anna—Portraits,
etc. 4. Farm life in art. I. Wyeth, Betsy James,
1921- II. Title.
ND237.W93W93 759.13 76-6171
ISBN 0-395-21990-6

TABLE OF CONTENTS

PREFACE

ANDREW WYETH's earliest painting of the Kuerner farm is an oil dated 1932. His most recent was painted last winter. Forty-four years is a long time to keep going back to the same place to find creative inspiration, and I became curious to see if there just might be a strong thread of continuity, a hidden meaning, that would perhaps run through this forty-four-year involvement. That curiosity was what started me on this book. I began by first sorting through drawers of drawings and watercolors which had been discarded, pulling out everything which Andrew Wyeth had done of the Kuerners and their farm. The pile of unframed work, of all sizes, grew. Many were quick, on-the-spot notations often blurred by falling snow. Some were mud-spattered. Others were left unfinished or had been removed with such haste from a drawing pad or a block of watercolor paper that they were torn. One drawing, for the tempera *Karl,* had the tiny footprints of one of our sons marching right across it. They probably belonged to Nicholas, for Jamie would have been too young to walk barefooted on the drawing-littered floor of his father's studio in 1947, when his father was working on *Karl.* Jamie left his mark on one, however. He drew a knight's head on a prestudy for *Brown Swiss.* Dogs, and most frequently the artist himself,

walk all over drawings—for when a tempera is in process on the studio easel all prestudies for it are tacked to the walls or lie scattered about on the floor for quick reference.

The amount of work I found in those drawers confused me. So I came to the decision to have it all photographed—at least everything would be the same size. The Brandywine River Museum in Chadds Ford, Pennsylvania, loaned me their photographic equipment and their photographer. The seemingly hopeless task began. I added photographs of paintings that had been sold and long since left the artist's possession. When everything was completed the count totaled four hundred fifty-nine works of art done at Kuerners. The scholarly approach would have been to arrange everything in chronological order—beginning with that first oil of Karl Kuerner's barn right on up and through to the last picture. It didn't work. In the first place it bored my husband to be pinned down to dates. He kept reshuffling my neatly arranged stack of photographs, yanking out this one and that one, muttering to himself, "Why didn't I go on with that idea?" or "That would have been much better that way, not the way I did it."

He was the one who finally encouraged me to arrange the book

in my own order and so I hope you will forgive me for throwing all scholarship to the four winds, for disregarding dates, seasons and the chronological sequence of pictures done as prestudies for temperas and drybrush watercolors. The first painting reproduced was done in 1961, whereas a drawing completed in 1944 appears toward the end of the book. You will see a watering trough on the side of Kuerners Hill in early spring; move to the next page and see it after a snowstorm. Winter predominates, however, because those are the months that Andrew Wyeth lives in Chadds Ford. He spends the summer months in Maine.

Not all four hundred and fifty-nine works of art are reproduced because the artist has deep misgivings about "letting out," as he calls it, "my messy self." Rarely has he allowed his working self to be seen. We had several editing, or rather eliminating sessions where I pleaded to keep a drawing or a watercolor in, while he insisted it be removed. He won eighty-three times. Three hundred nineteen of the three hundred seventy-six pictures in this book have never been reproduced before. It seemed to me the moment had arrived for someone other than the artist to be the judge and to be allowed to catch a glimpse of Andrew Wyeth at work. In the end the book turned out to be a walk, starting on the top of Kuerners Hill and leaving, after exploring every corner of the farm, with the Hill disappearing in the distance as a snow-capped rise – a walk that took Andrew Wyeth forty-four years to complete. May this experience at Kuerners increase your understanding of one man's creative involvement with one place and may you see a little deeper beneath the surface and sense the meanings that lie hidden there.

BETSY JAMES WYETH

Chadds Ford, Pennsylvania

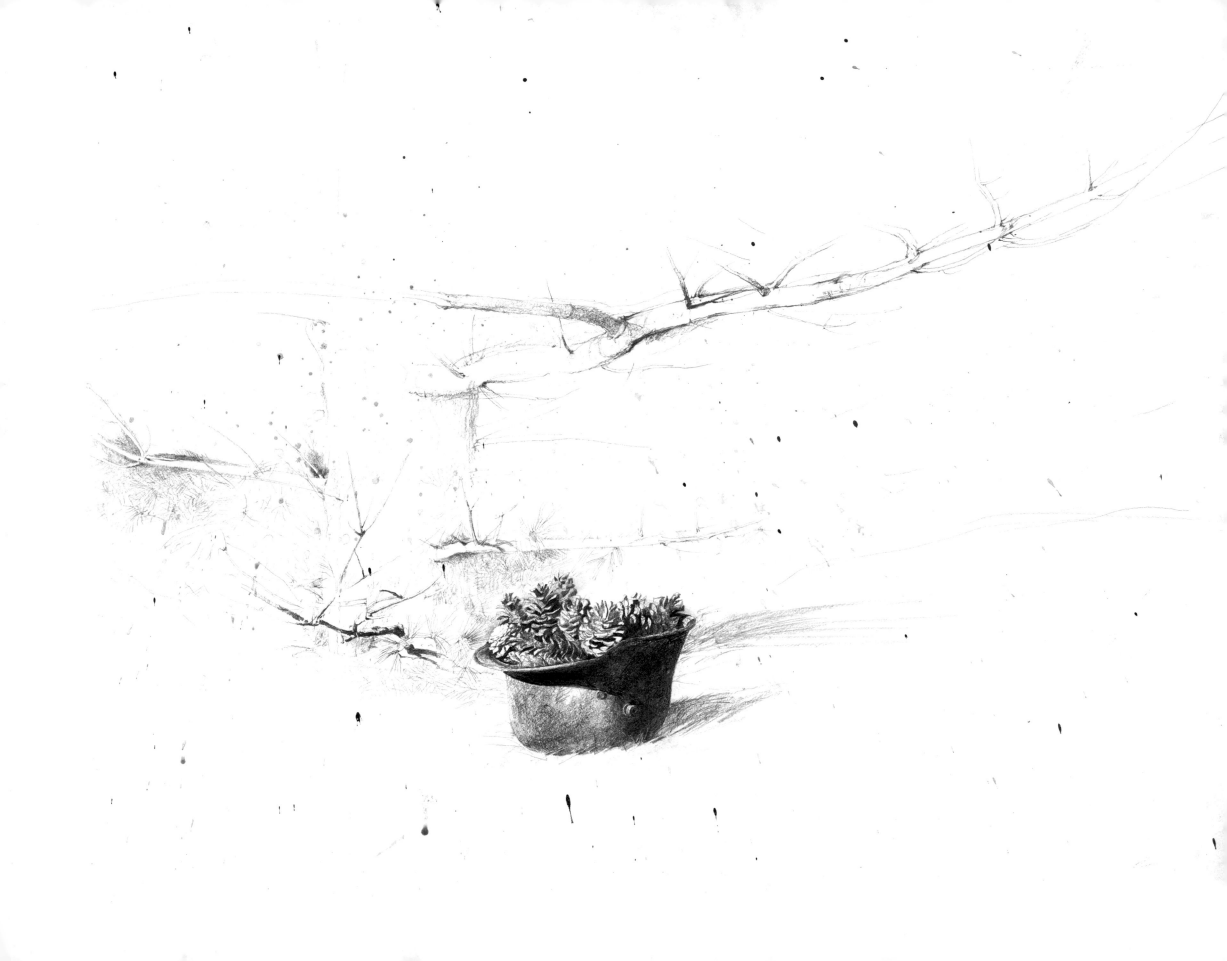

WYETH AT KUERNERS

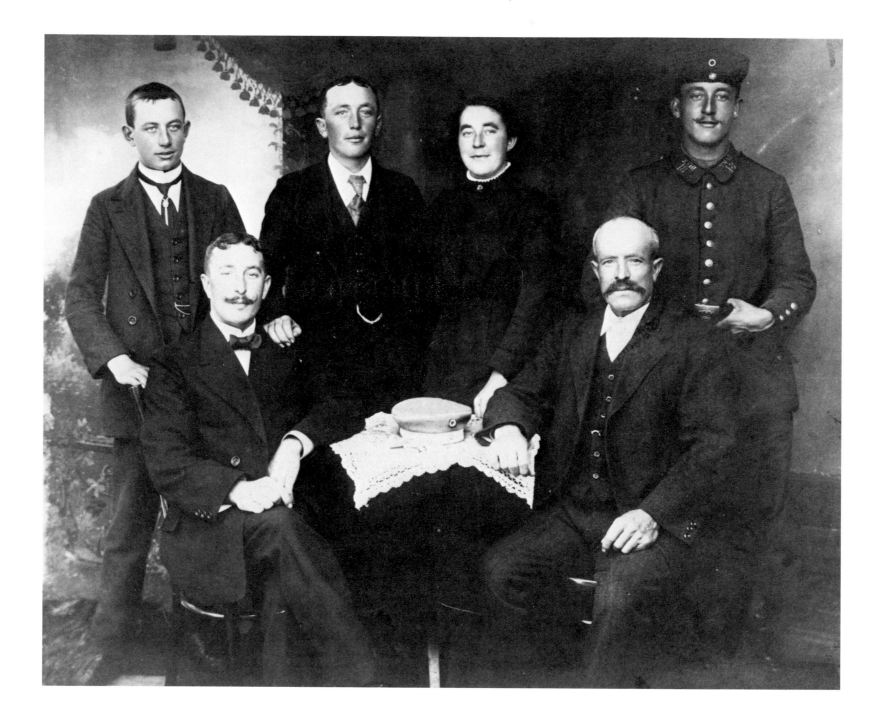

Kuerners

I HAVE OFTEN WONDERED if Karl Kuerner misses the mountain country surrounding the village of Neuffen, in the state of Württemberg, where he was born on the seventeenth of April, 1898, and where he herded sheep as a young man before and after the First World War. All that remains of Karl's life in Germany is a soft accent and four photographs. The first photo is a typical studio shot that shows Karl's father and eldest brother seated at a small table. Karl stands between his youngest brother and his only sister. Two brothers had already enlisted in the German army. One, seen in uniform, was home on furlough, but the other was absent at the front. Karl posed in uniform for the second photo shortly after he was drafted. He is very proud of the third photograph. Rows of German soldiers stand at rigid attention – every helmeted head turned to the right. The officers are saluting the Crown Prince. Karl remembers vividly how he moved between the rows, reviewing the troops. When the Crown Prince reached Karl, who stood in the fourth row, third man in, he pinned the Iron Cross on Karl's uniform. The last and final photograph is quite different. The war is over and lost. Karl, in his shepherd's cape, holds a newborn lamb in his arms. His young helper, Albert Vogels, stands beside him.

A month before Andrew Wyeth was born in the corner upstairs bedroom of his parents' home at Chadds Ford, July 12, 1917, Karl Kuerner was wounded severely in the arm during a heavy machine gun battle on the German front. By fall he had recovered and returned to fight as machine-gunner number two in the battle at Verdun. After Germany's defeat he went back home, hoping to continue his old life as a sheepherder in the area of the Black Forest. It was there that he met a young lady named Anna Faulhaber. She often visited him on the mountain slopes where he tended his flock of sheep. They fell in love and on March 19, 1922, their first child, Louise, was born – but within a year they realized their future in Germany was hopeless.

On August 25, 1923, Karl sailed for America, leaving his infant daughter and Anna with her parents in the small village of Gölldorf. After working for two years in the slaughterhouses of Philadelphia he had managed to save enough money to send for Anna and his daughter. Karl Kuerner still feels that if Anna had never left Germany she would not be the withdrawn person she is today. After her arrival in Philadelphia on October 5, 1925, she seemed depressed and desperately homesick for the village she had known all her life.

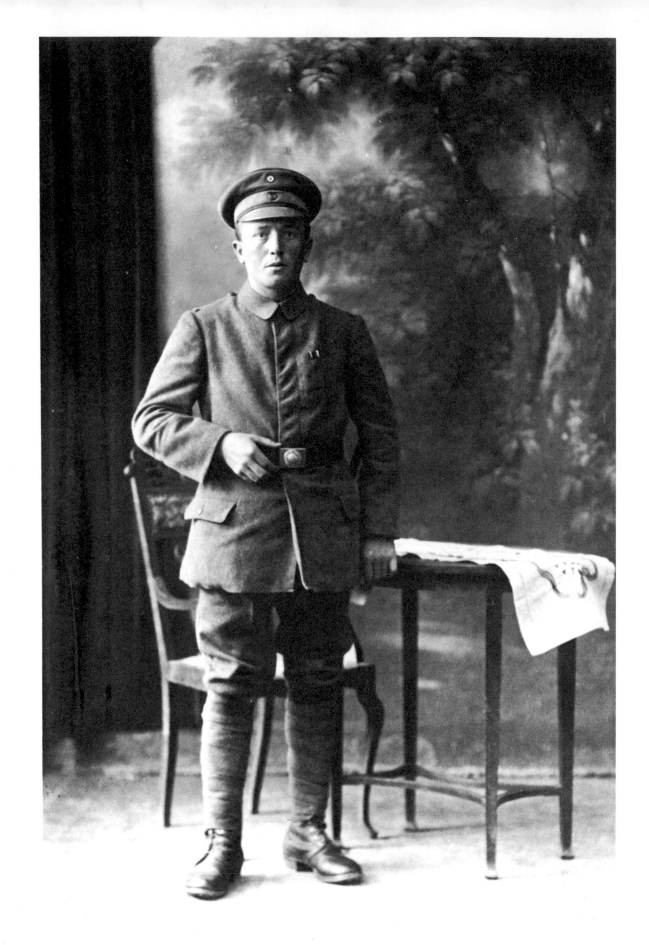

4

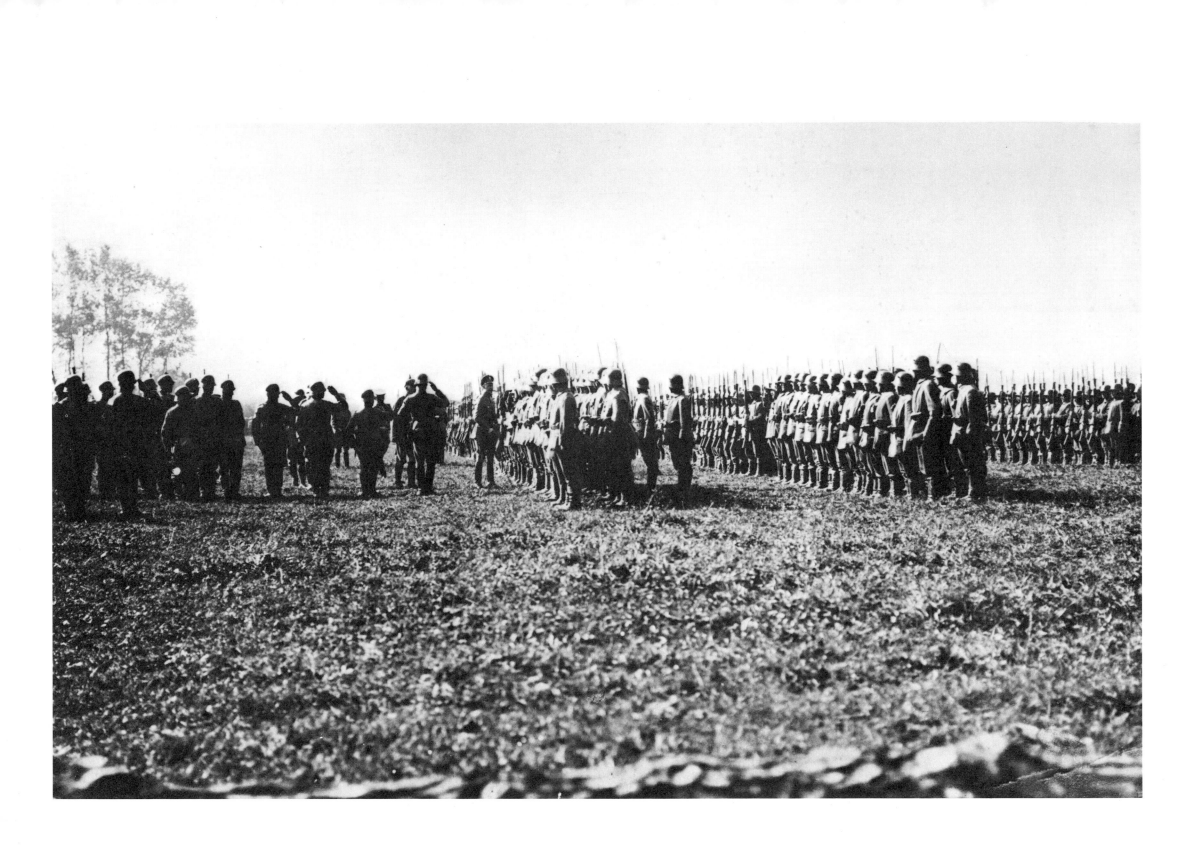

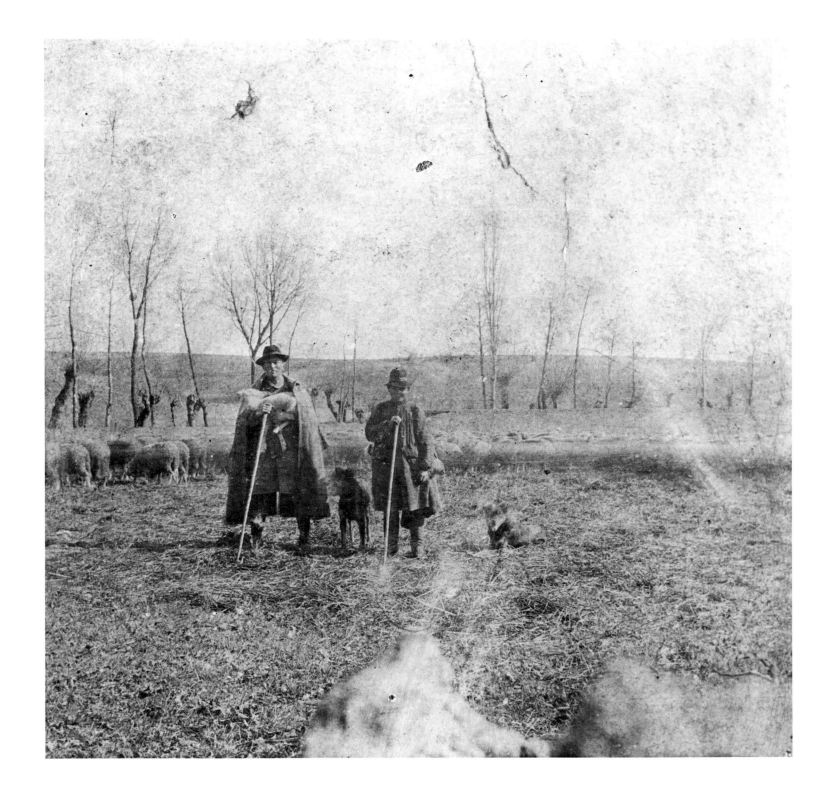

6

The noisy city and strange language confused her. She began to show the first signs of her later withdrawal from reality but improved after Karl was able to rent a large farm in the rolling hills of the Brandywine River Valley. Anna worked long hours helping her husband with the farm work and raising their growing family of four daughters and one son. After fourteen years of frugal living and hard work Karl had saved enough money to buy the farm, but by then Anna had lost all touch with reality for long periods of time. She had no friends and became an elusive, darting figure to Karl's German friends when they visited the farm on Sundays.

The Kuerner farm is about a mile's walk from Andrew Wyeth's studio in Chadds Ford. Suburbia has changed this walk considerably in the last few years. Until the late 1950's the artist could cross cornfields and pastures and walk through a woods undisturbed. Nowadays he has to choose his path with caution to avoid meeting someone on the way—the land has been sold, large tracts subdivided, houses built, the brook in the woods dammed to create a pond and "no trespassing" signs warn him off. Even Karl Kuerner has sold a few acres here and there; but Kuerners Hill remains unchanged, for Karl and his only son, Karl Jr., still farm the land.

Kuerners Hill

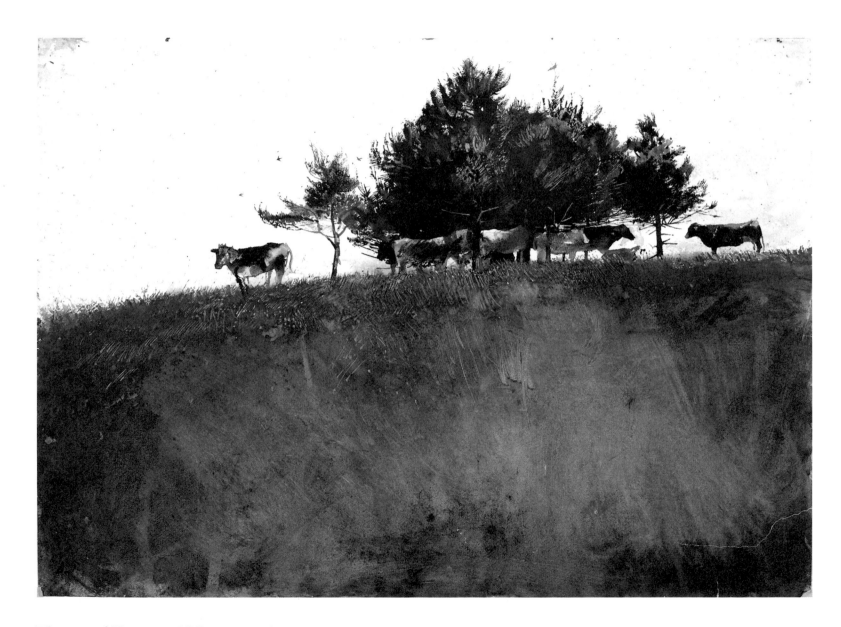

The top of Kuerners Hill was windswept and barren until Karl planted
a stand of pines a few years ago. Here cattle gather for shade.

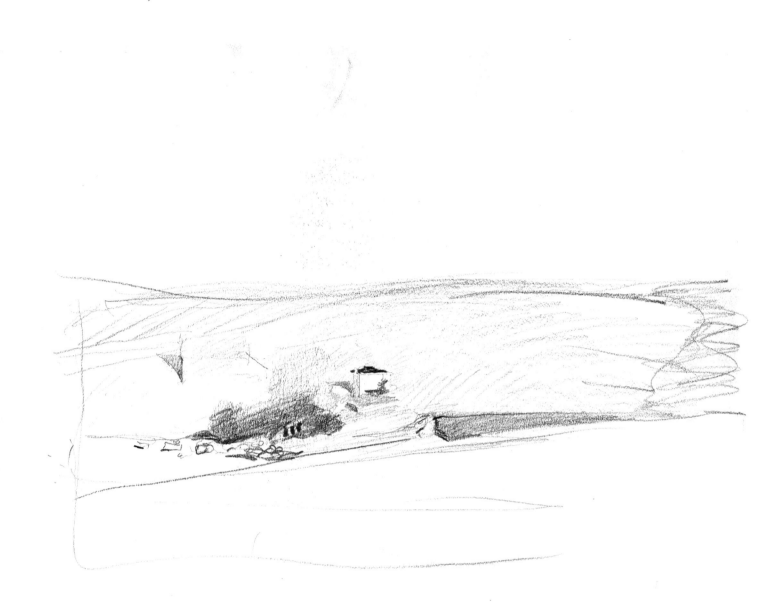

Far below, the farm buildings look like German toys under a Christmas tree.

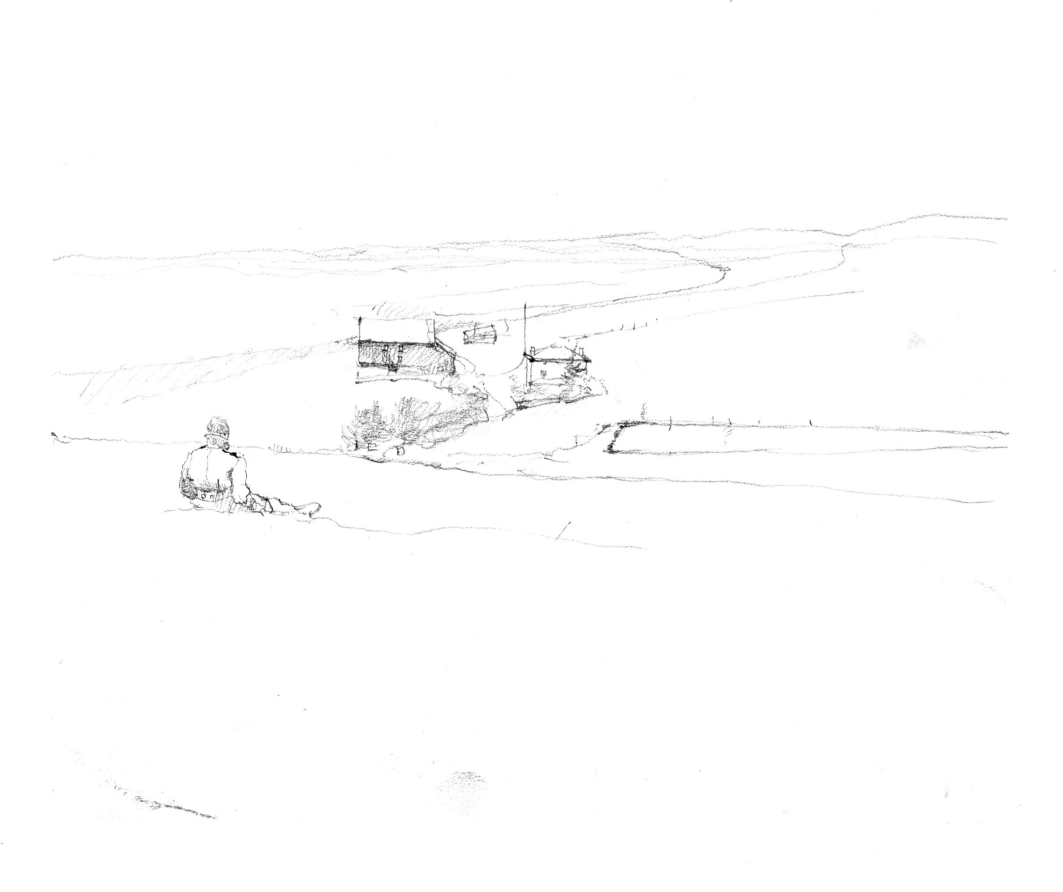

11

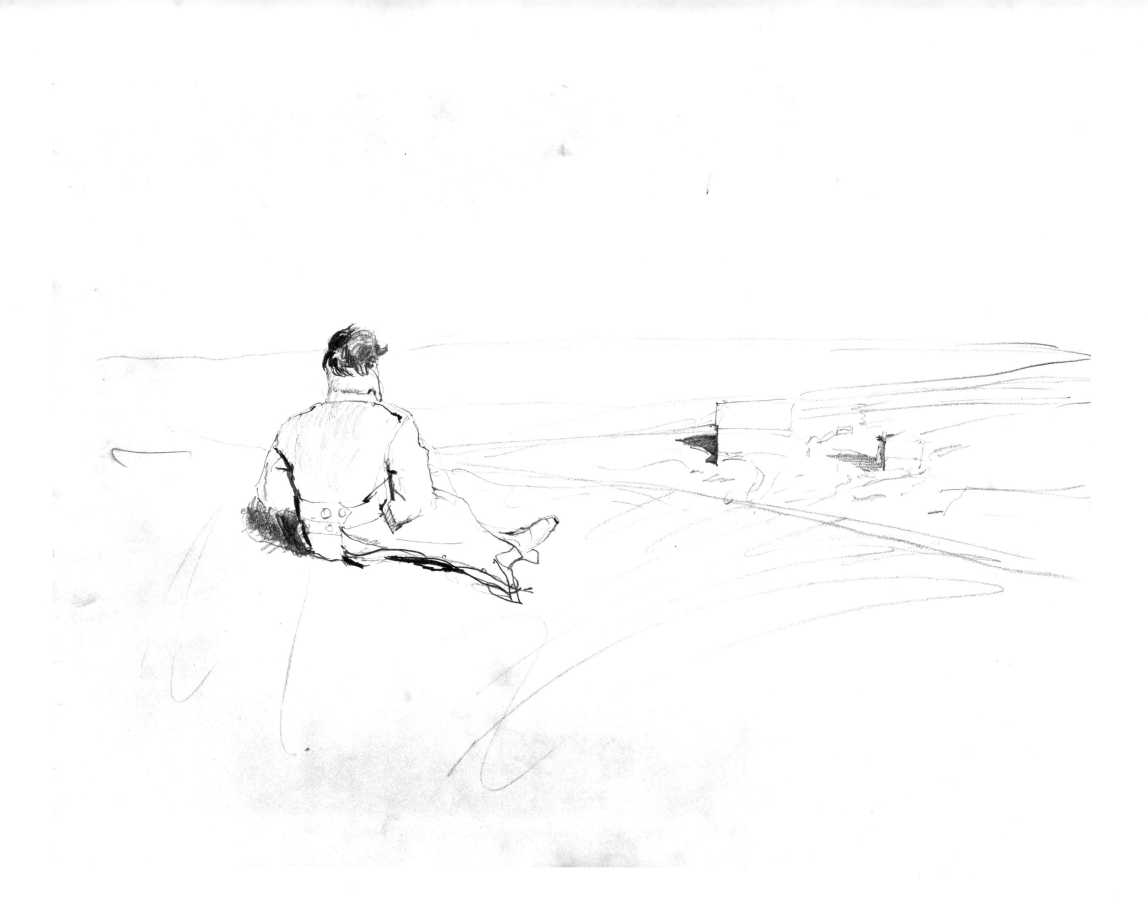

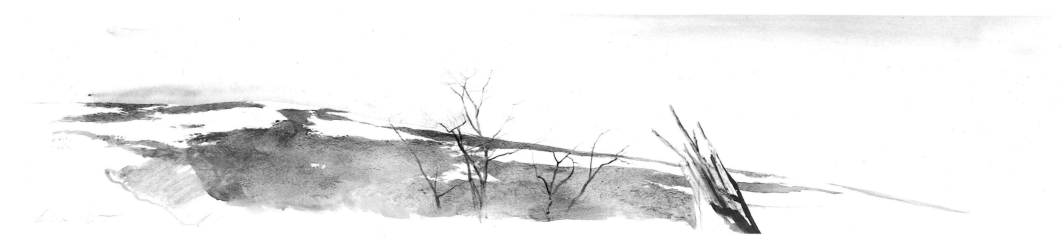

Where a long ridge of land ends and slopes down to the valley the artist calls Kuerners Hill.

A fence line separates Karl Kuerner's property from his neighbor's.

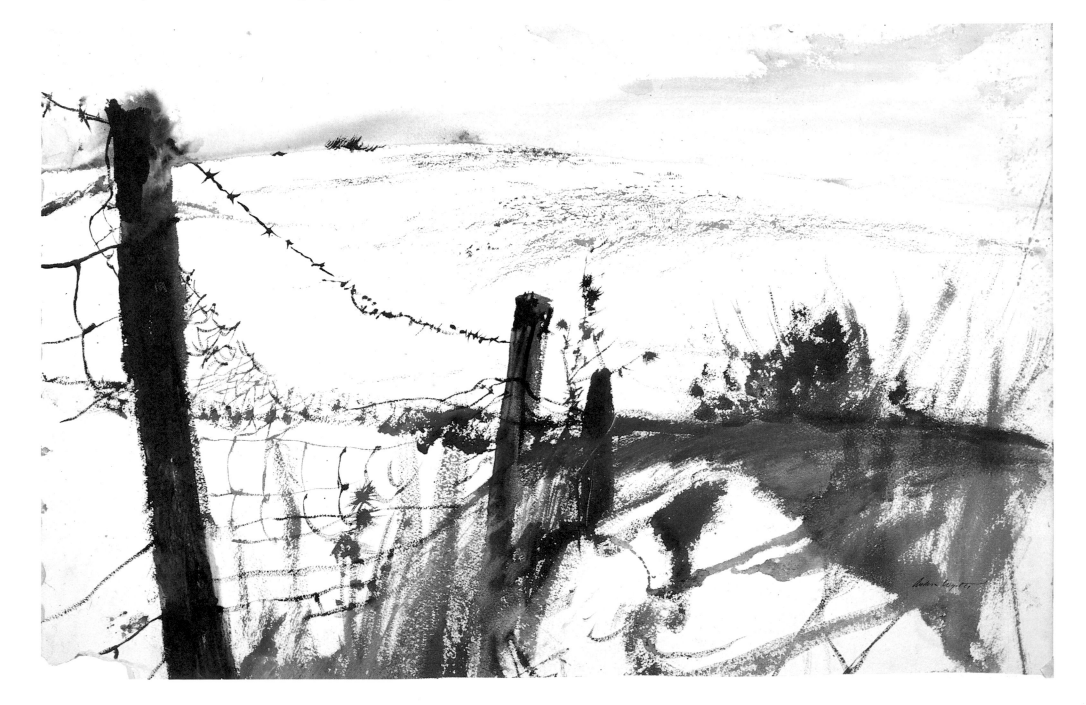

Halfway down the Hill lie the unmelted remains of snowdrifts. The next spring Wyeth was working on a moonlight landscape and wondered if a moon would improve the picture. A large sheet of white paper lay face down on his studio table. He cut a full moon out of the upper lefthand corner of this watercolor without checking to see if the paper had anything on the other side.

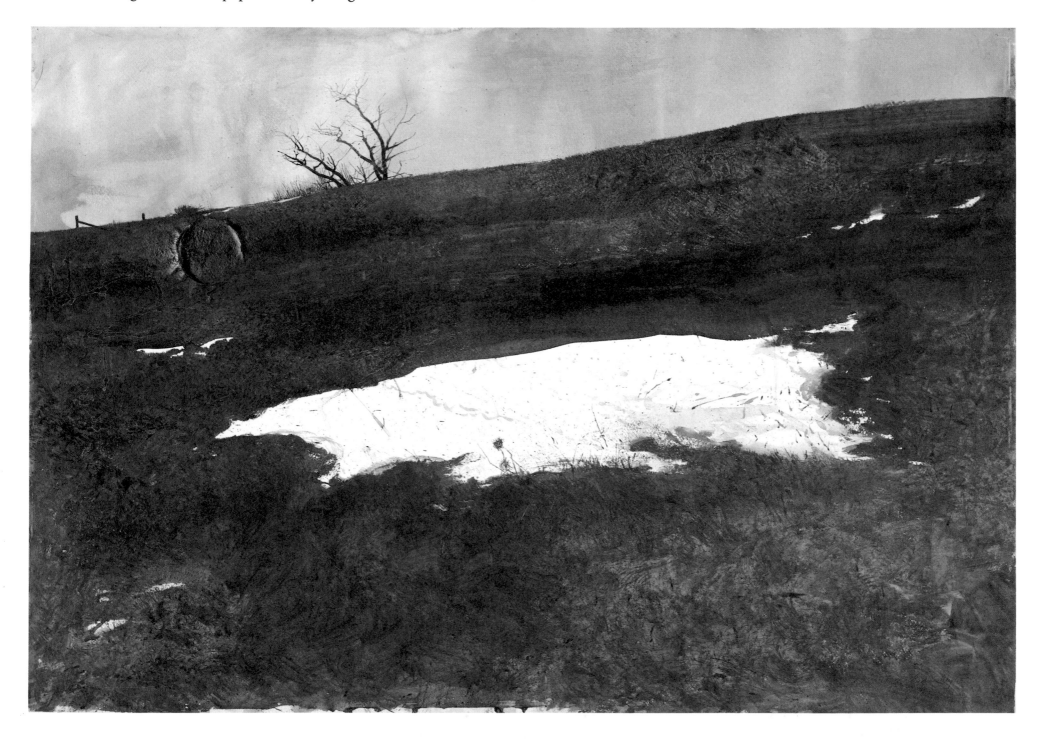

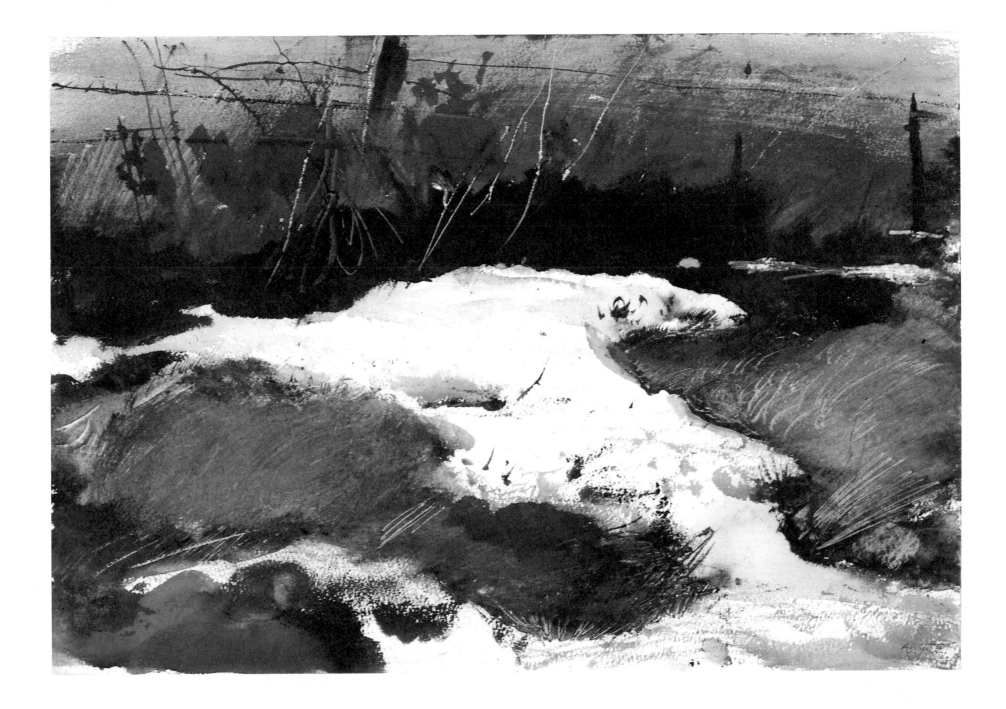

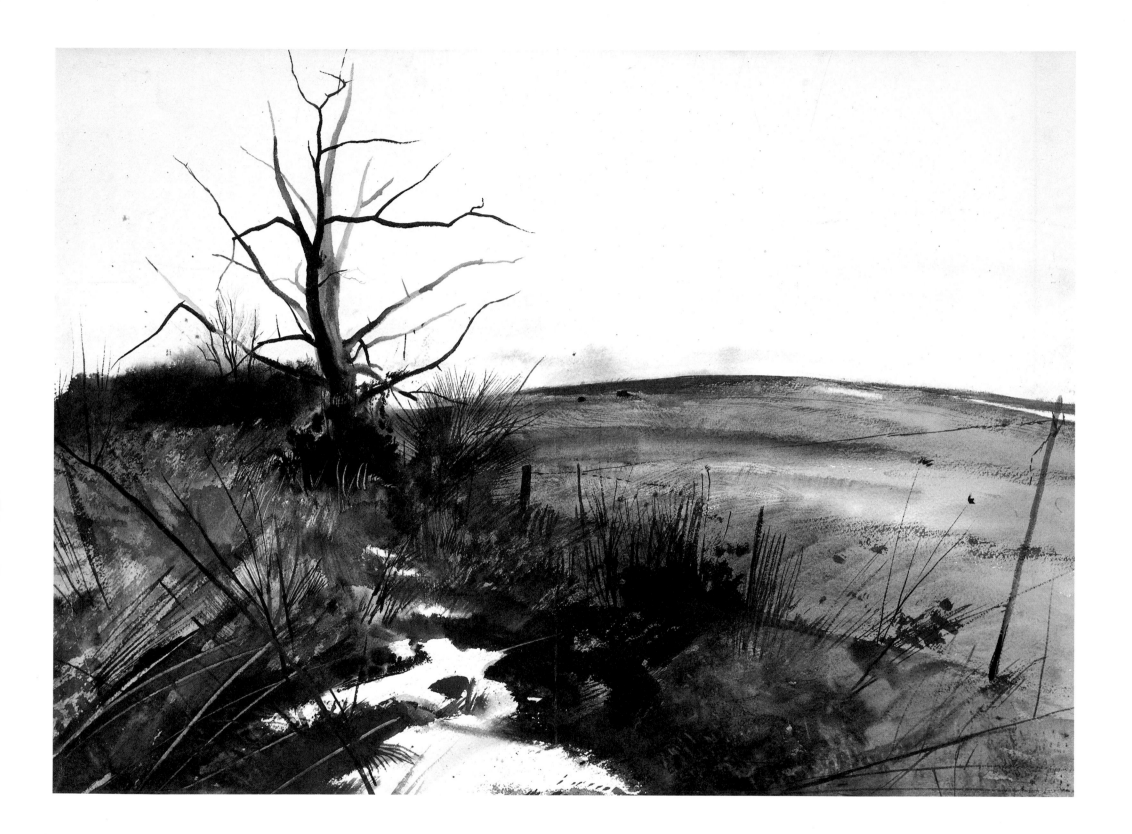

18

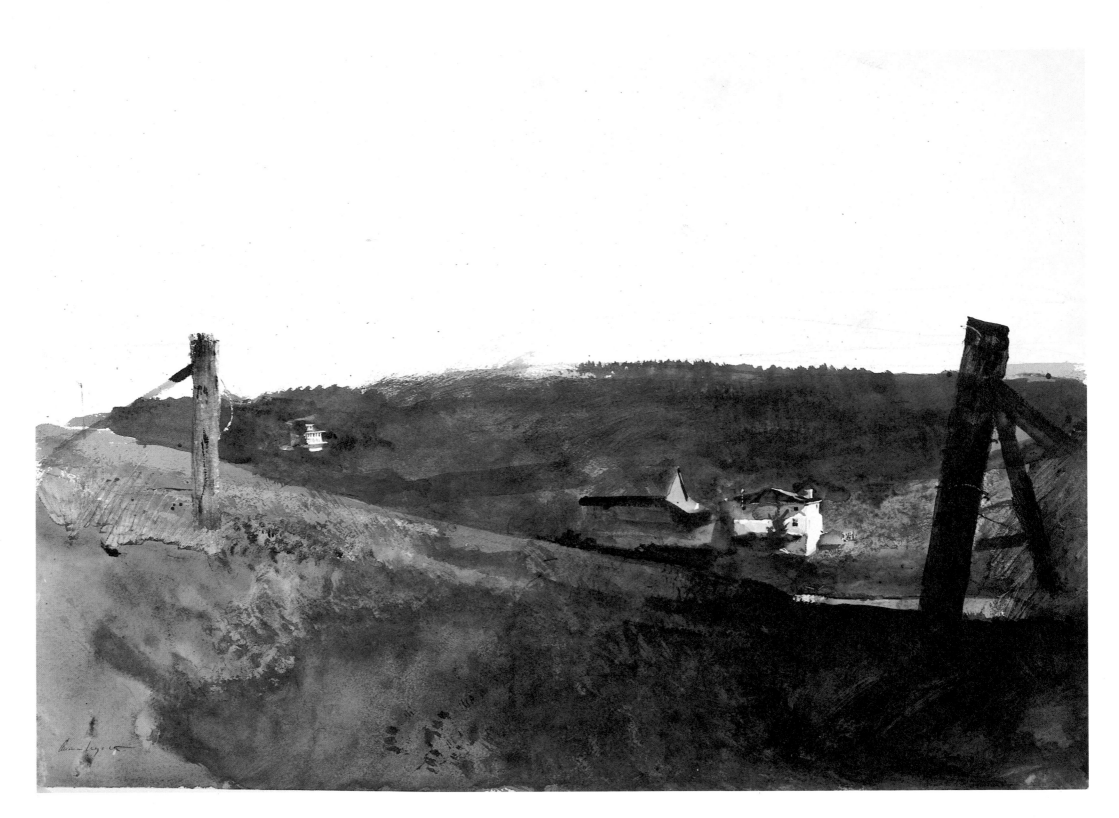

Through the opening in the fence are the Kuerner farm and to the left "Lafayette Hall"
where Howard Pyle lived with his family for the six summers he taught his famous art school
at Chadds Ford from 1898 through 1903.

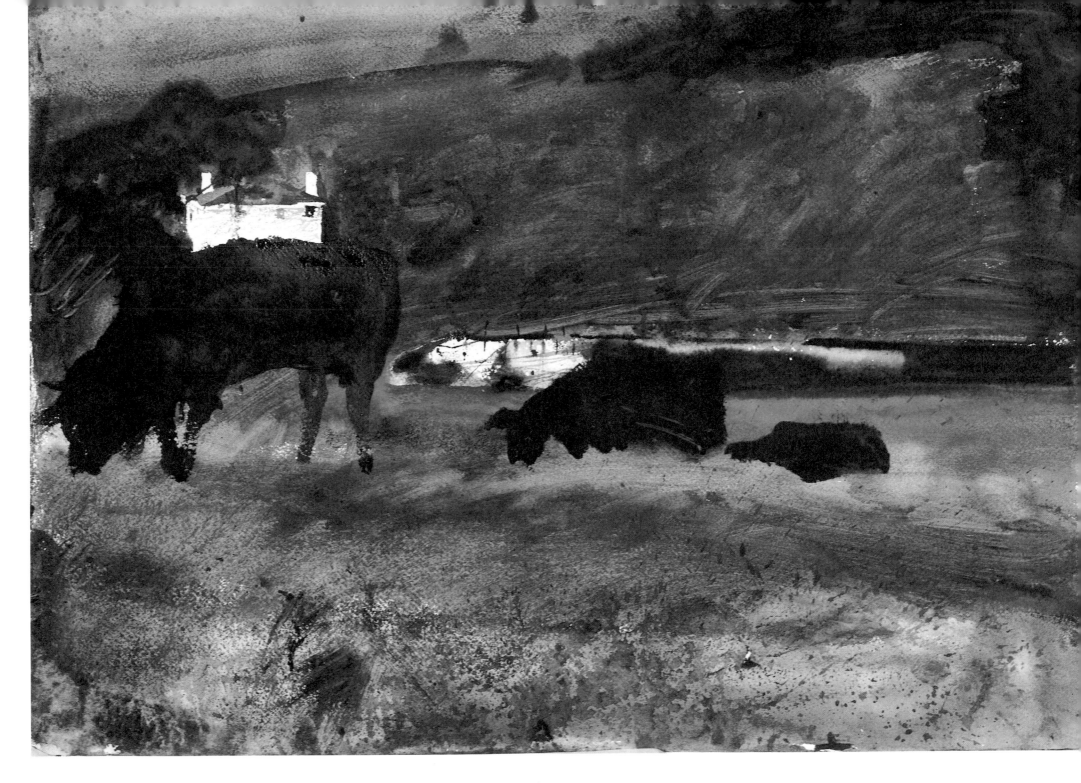

Cattle graze on the hillside pasture. Across the road is the farm pond Karl Kuerner
made by damming the small stream that flows in front of the house.

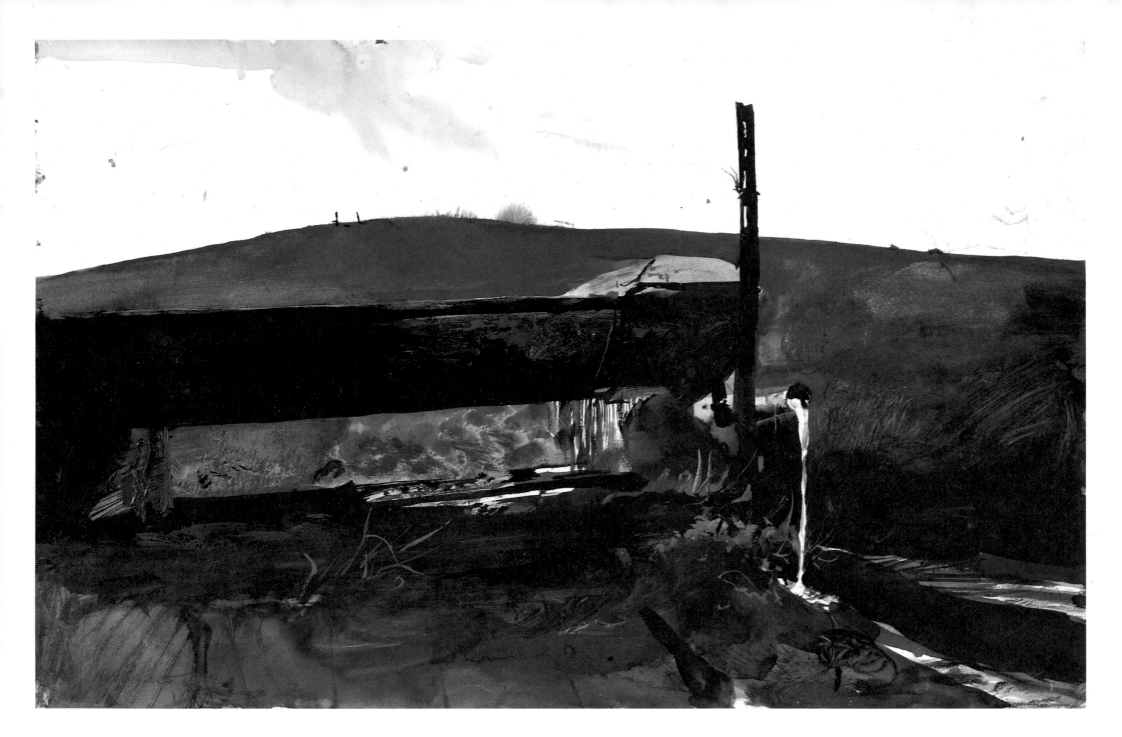

Kuerners Hill, barren of trees, rises above a cattle watering trough.
The spring water runs continually from the overflow pipe.

The same watering trough locked in ice, but still the spring water flows. Winter winds have blown the snow off the top of Kuerners Hill.

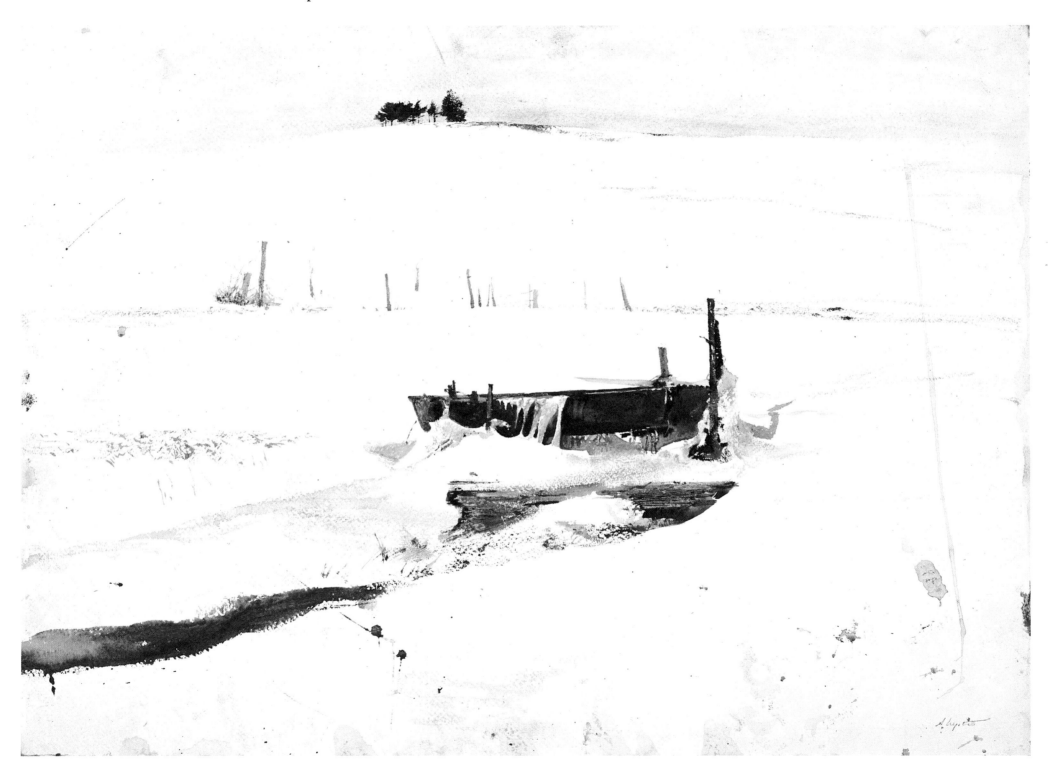

At the Entrance to Kuerners

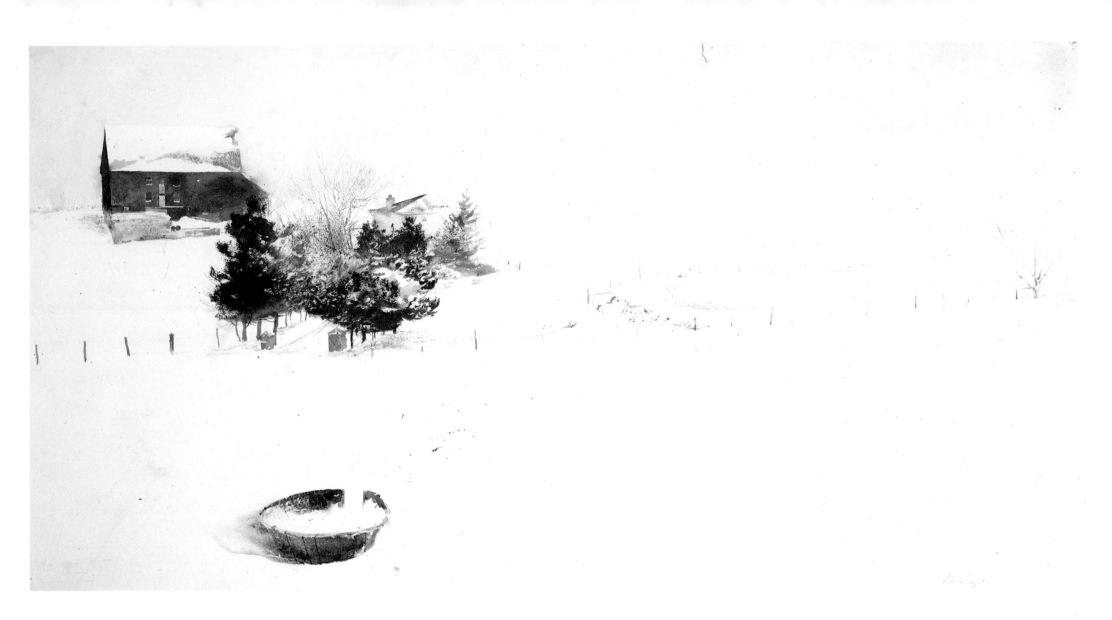

A half-barrel, used for holding a salt lick, is full of fine snow.

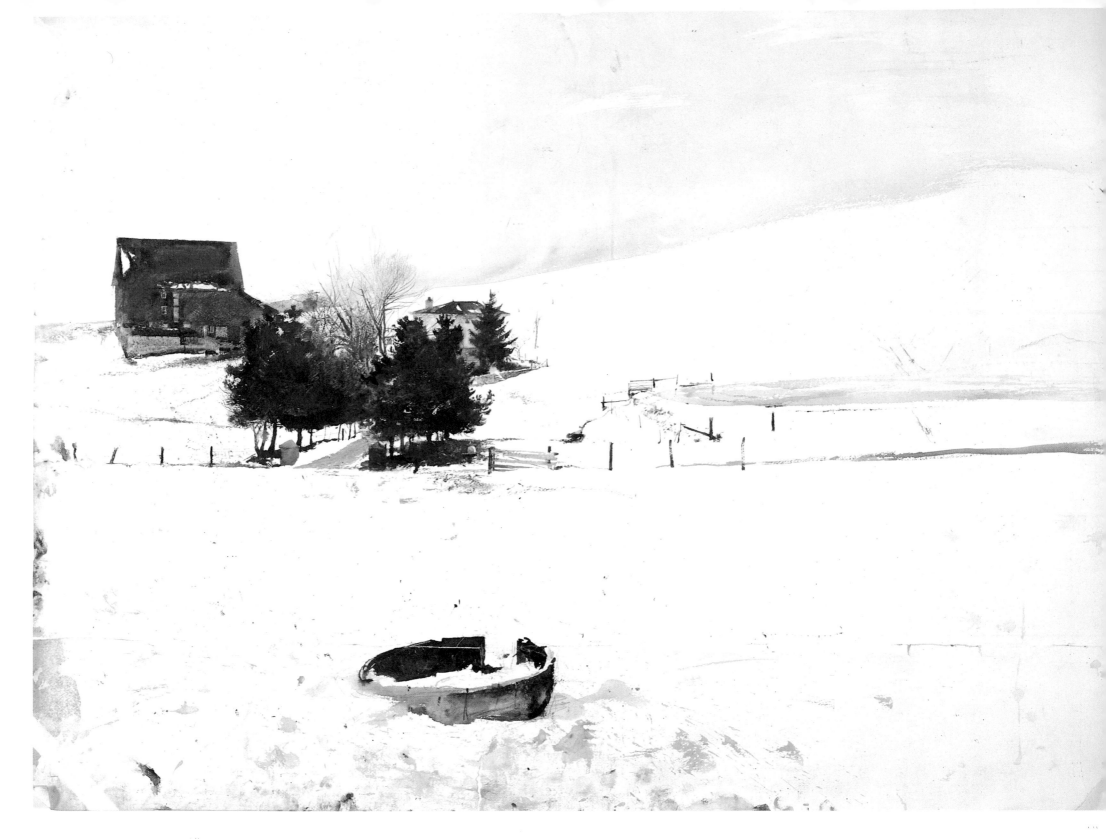

The day after the storm.

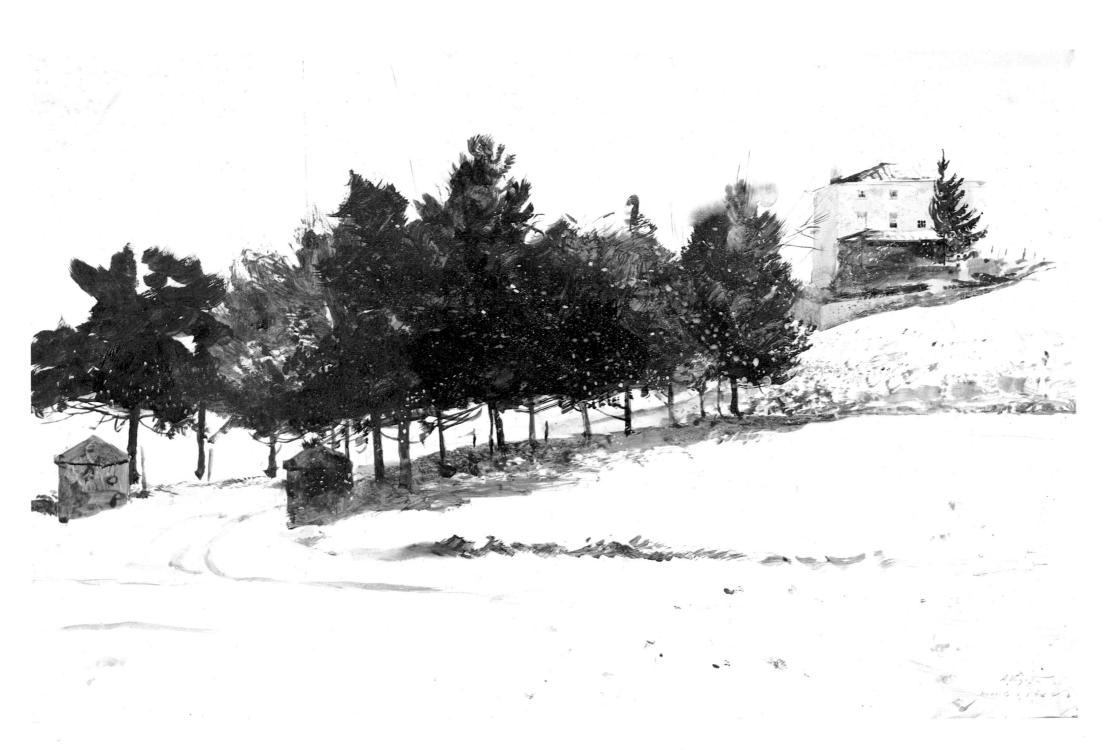

A public road divides the Kuerner property at the foot of the Hill. Across this road are the stone entrance posts on either side of the driveway. When snow falls Karl and his son leave on tractors to plow their customers out. After a blizzard they have been known to plow from dawn until well after dark.

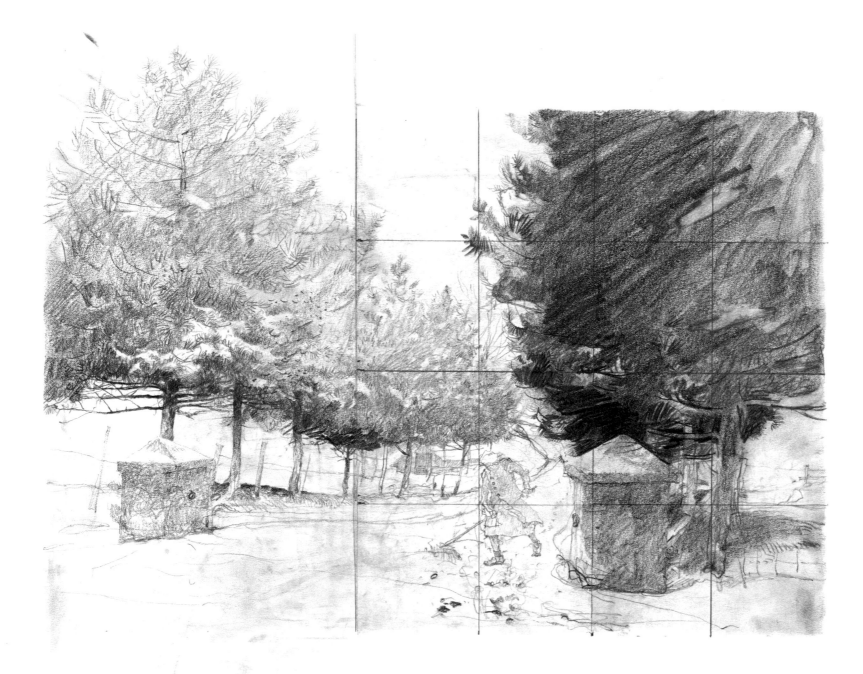

On rare occasions Andrew Wyeth will grid or score a drawing so that he can accurately transfer the composition to a tempera panel. Not only was this drawing scored but two sections were cut away from the original drawing. He never completed the tempera and one section of the drawing has been lost.

Just inside the entrance is the figure of Karl's wife, Anna Kuerner,
sweeping snow off the driveway with a heavy barn broom.
This shy, elusive woman never stops working from dawn until nightfall.

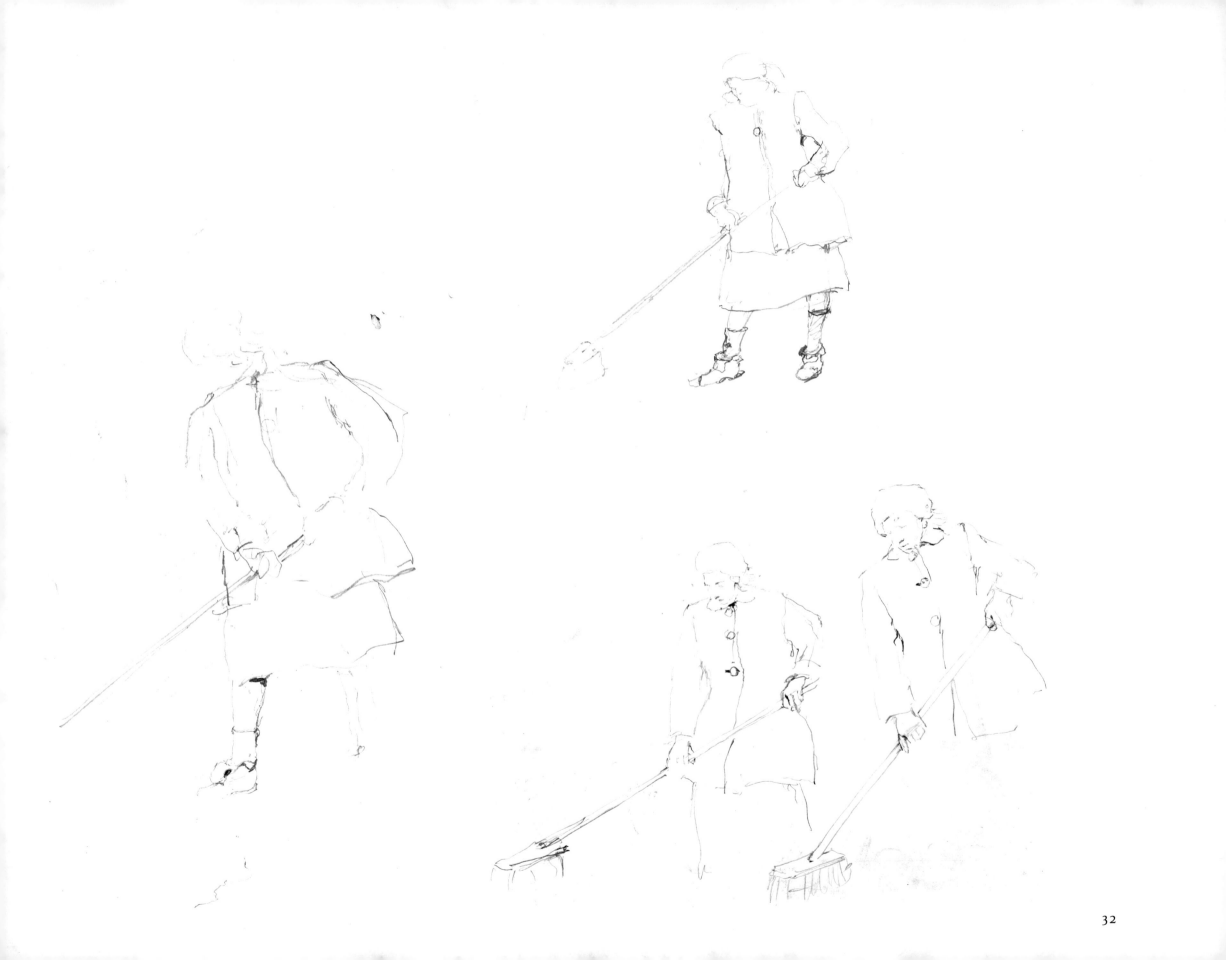

32

33

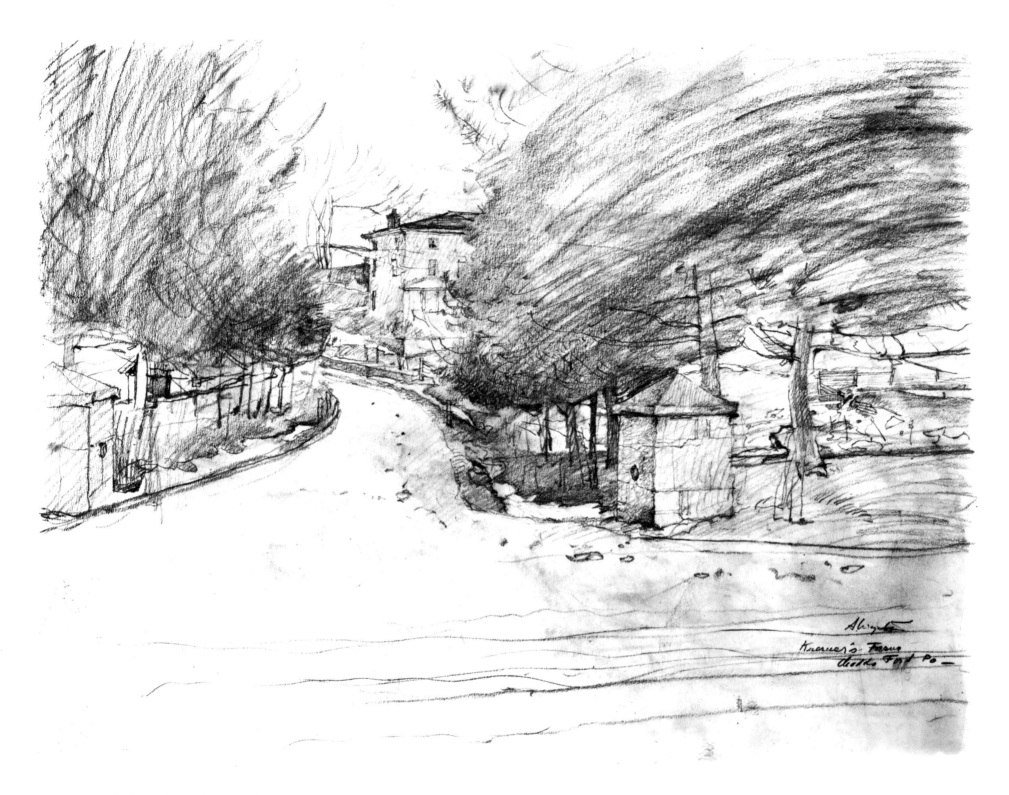

Cattle have been herded from the Hill pasture across the road.
On their way to the barn they have littered the driveway with their dung.

During World War II German prisoners of war worked on the Kuerner farm. Much of their stone masonry remains today – such as the serpentine stone entrance posts. Karl is very fond of this particular pale green stone and hauled the rocks from "Windtryst," a fire-gutted mansion that once stood on the hill-side across the valley. In 1911 the artist's father, N. C. Wyeth, rented rooms in "Wind-tryst", staying there a few months until he could move his wife and two young children into their new home.

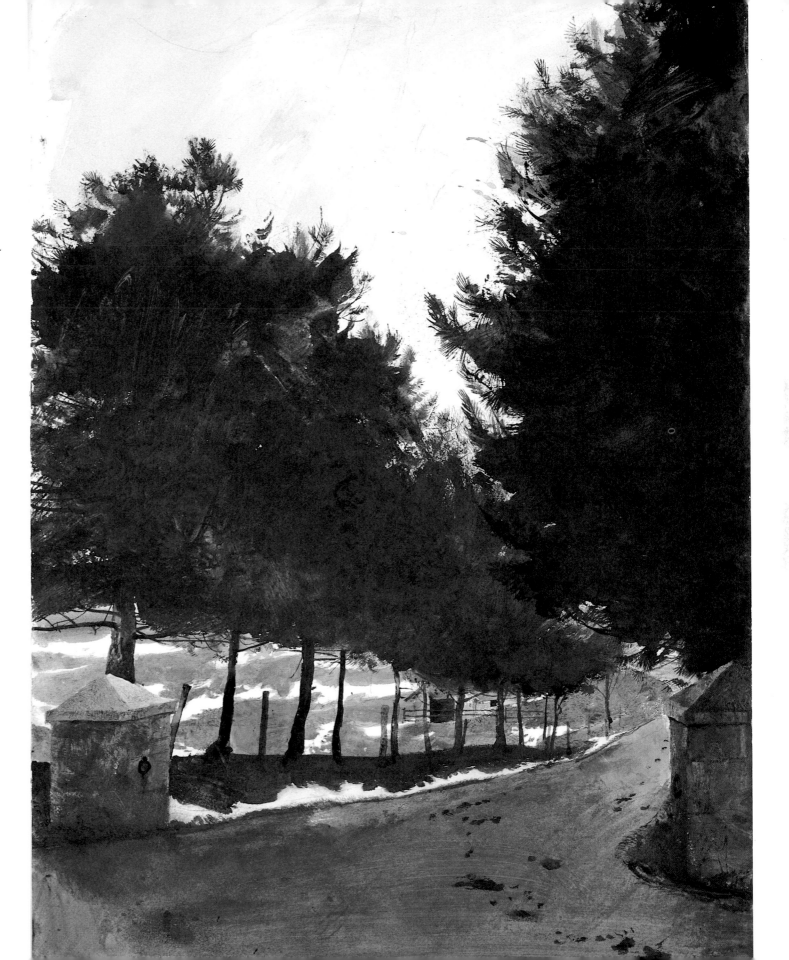

Down the Driveway to the Spillway

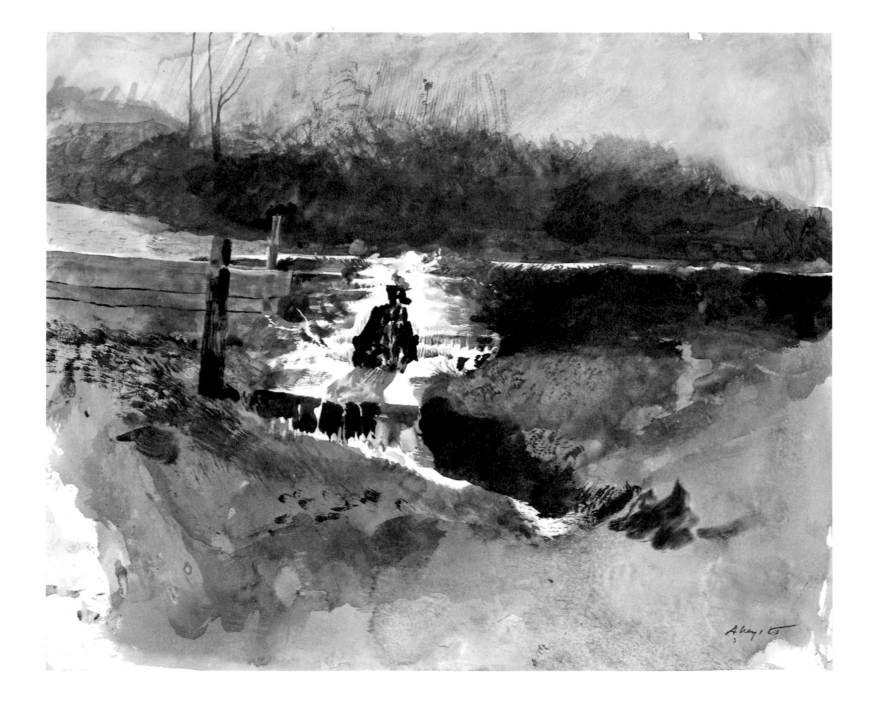

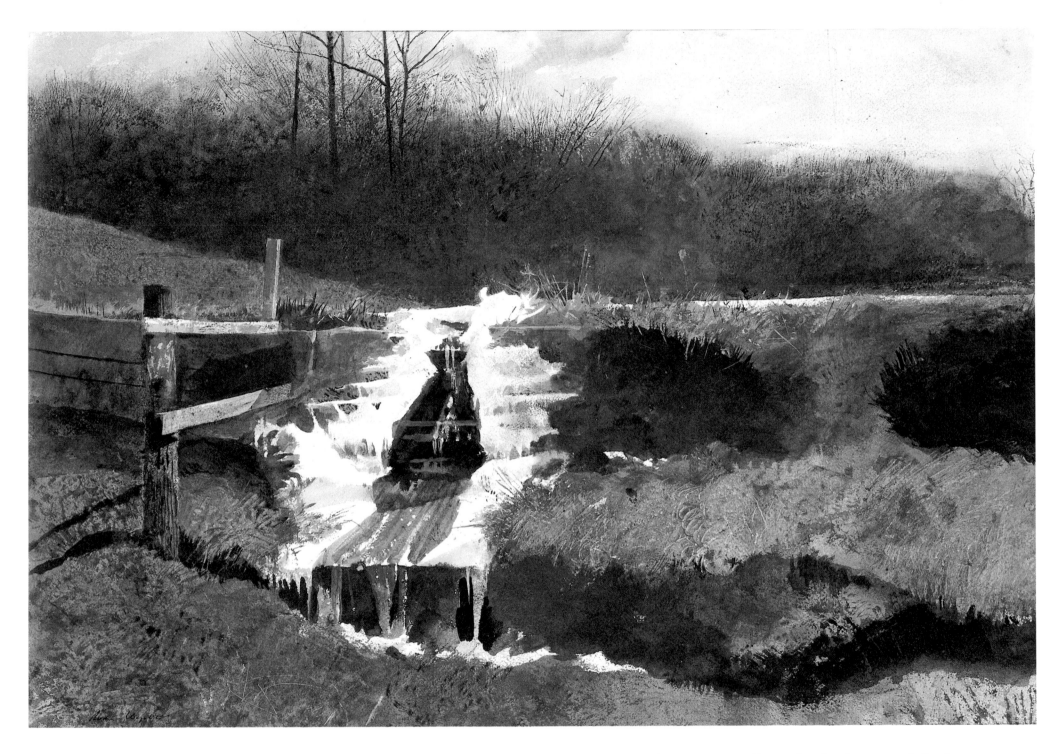

The Kuerners never turn down an offer of abandoned railroad ties. Here they have been used to make a spillway for the farm pond. Ice has collected on the sides, but the pond water still flows down the middle of the stepped railroad ties, rattling across a sheet of corrugated metal before flowing under a stone bridge.

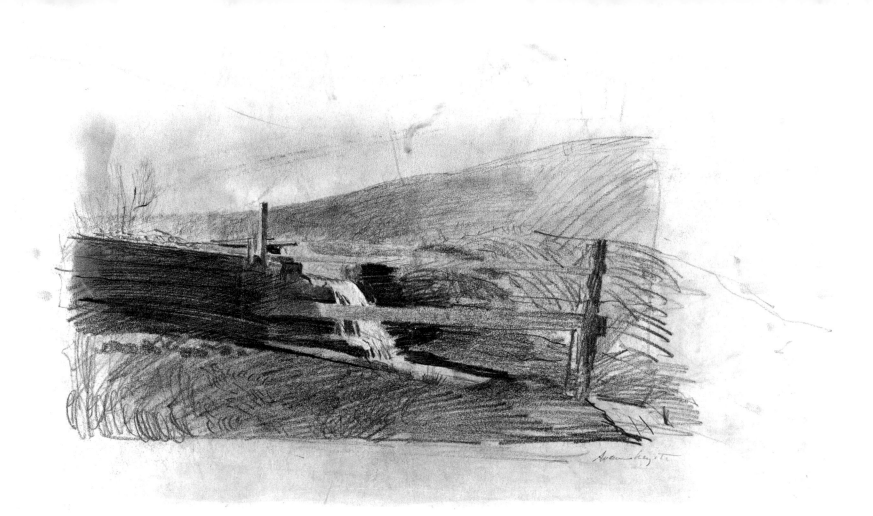

In the far distance is the roof of Karl's small frame tenant house that sits close by the public road.

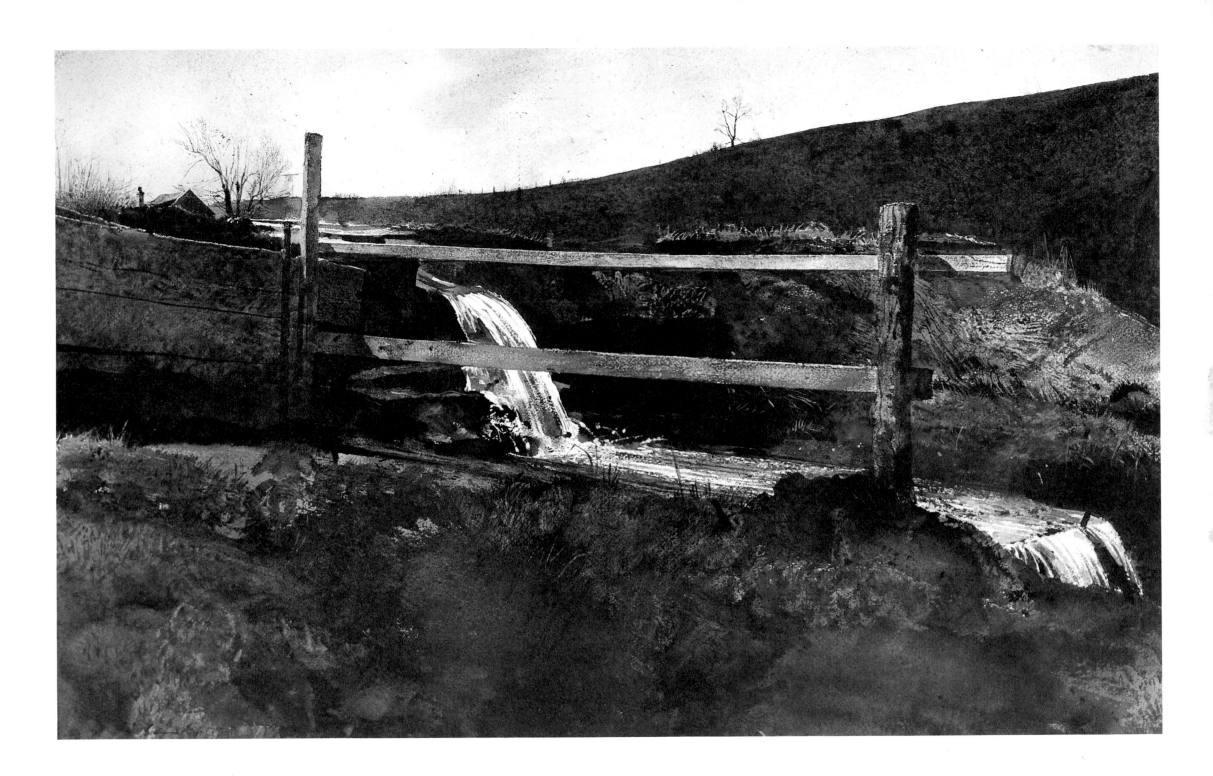

39

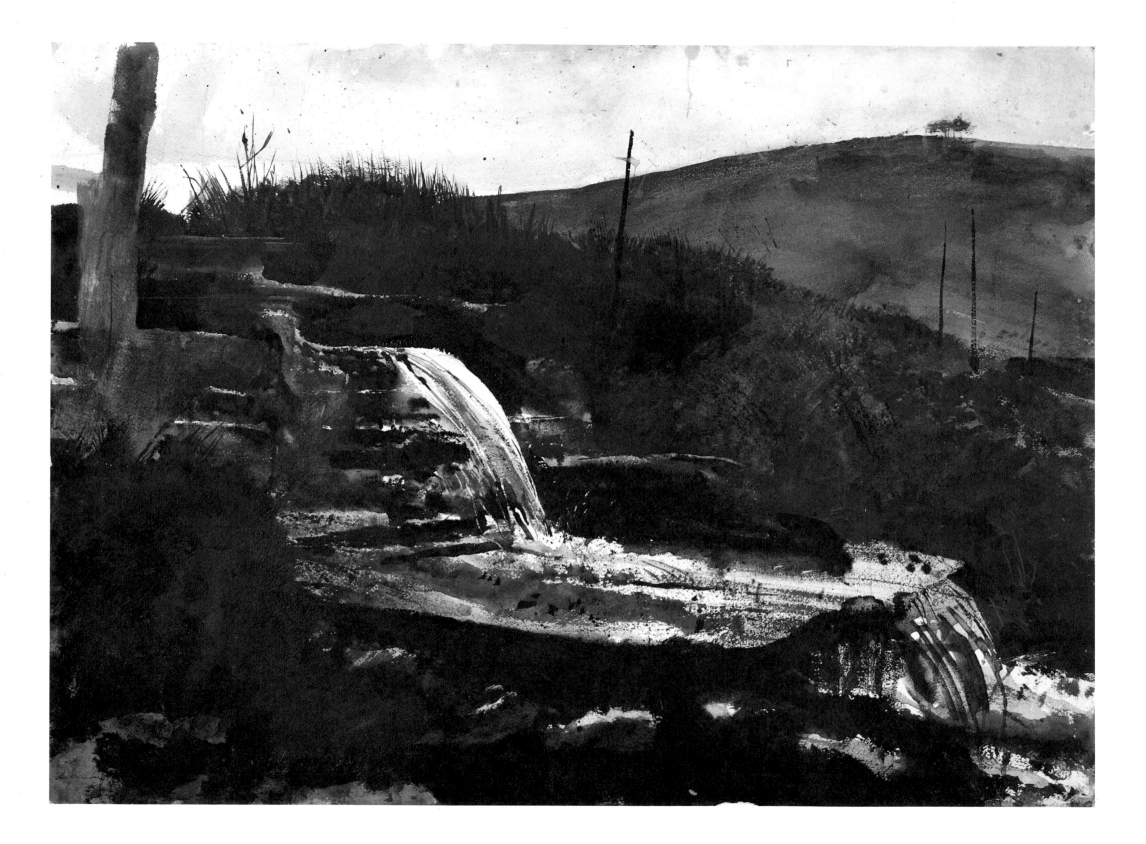

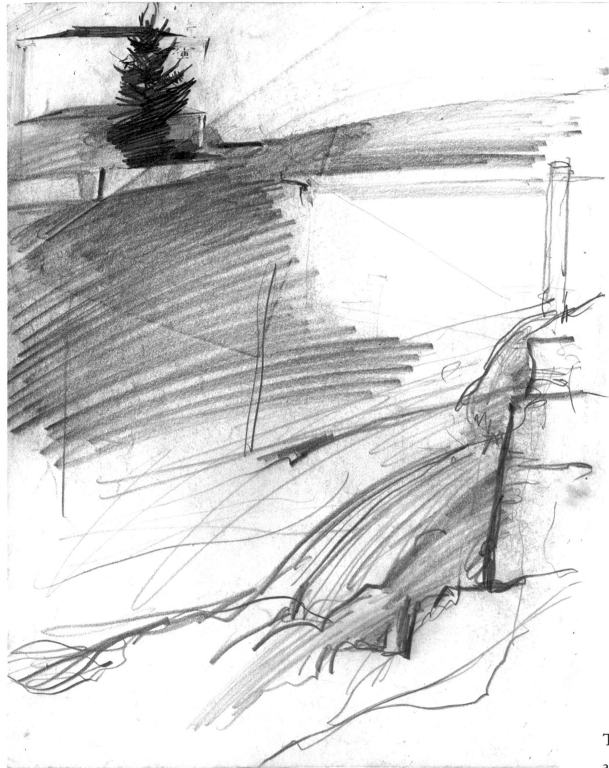

The farmhouse loomed above the waterfalls when the
artist turned to face the opposite direction.

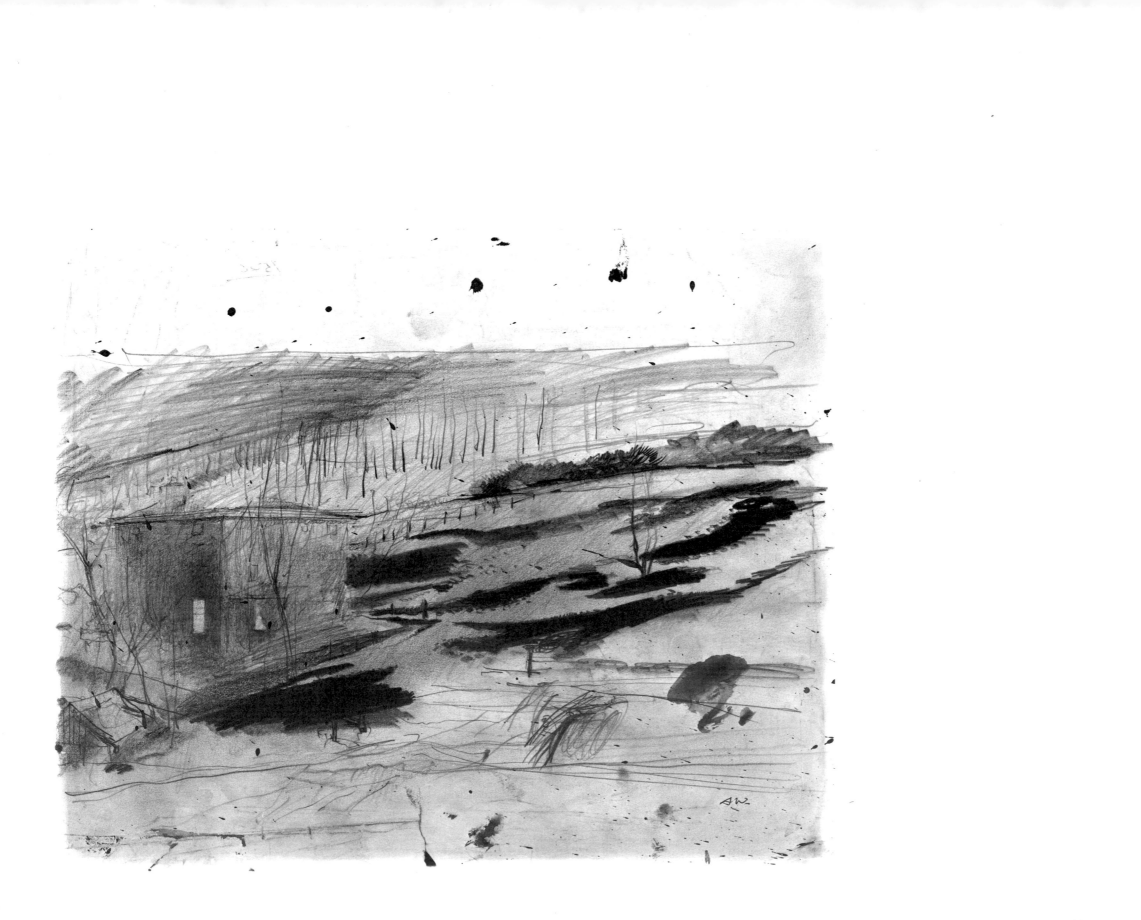

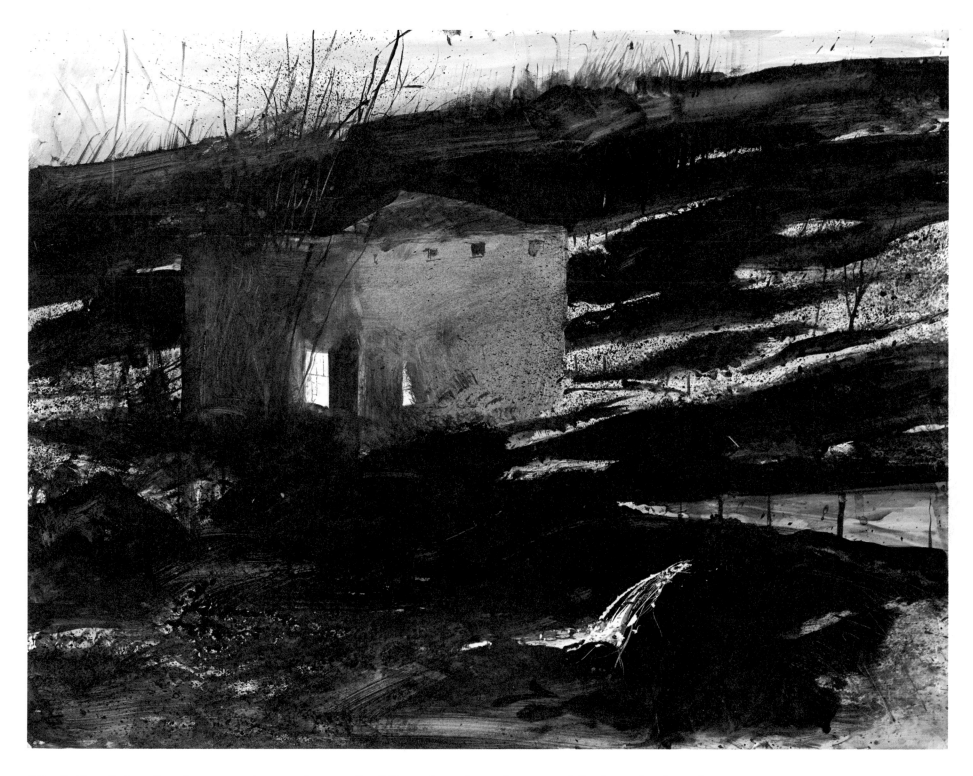

The fading light of a winter evening catches on the falls and patches of snow, while the only sign of life comes from the corner windows in the farmhouse.

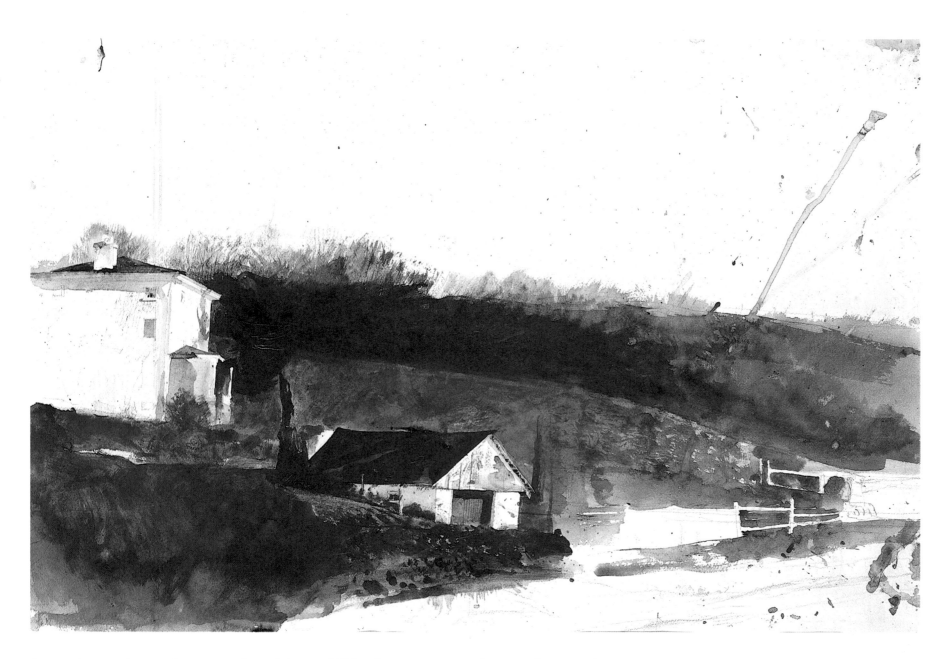

Several times buyers have purchased framed Wyeth paintings without realizing a drawing existed on the reverse side.
The owner of this prestudy for *Evening At Kuerners* discovered it when he had his picture reframed.

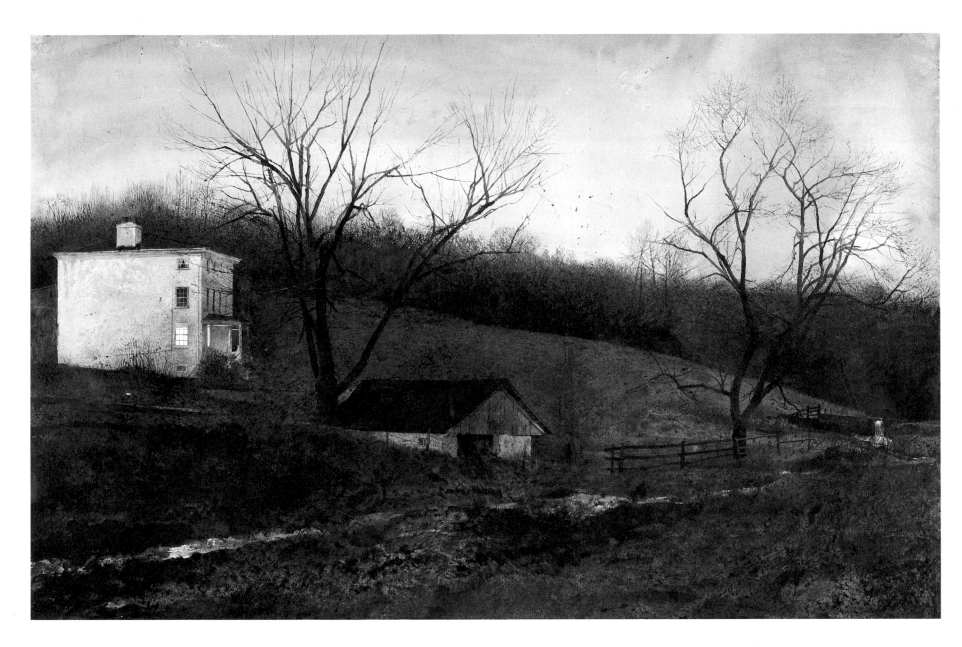

The trees are still bare, but the first greens of spring are beginning to show through on the hillside. The lighted downstairs windows reflect in the stream as evening approaches. The ground is thawing, for cattle have trampled it into mud beside the stream. The nights, however, are still too chilly to leave the springhouse door open.

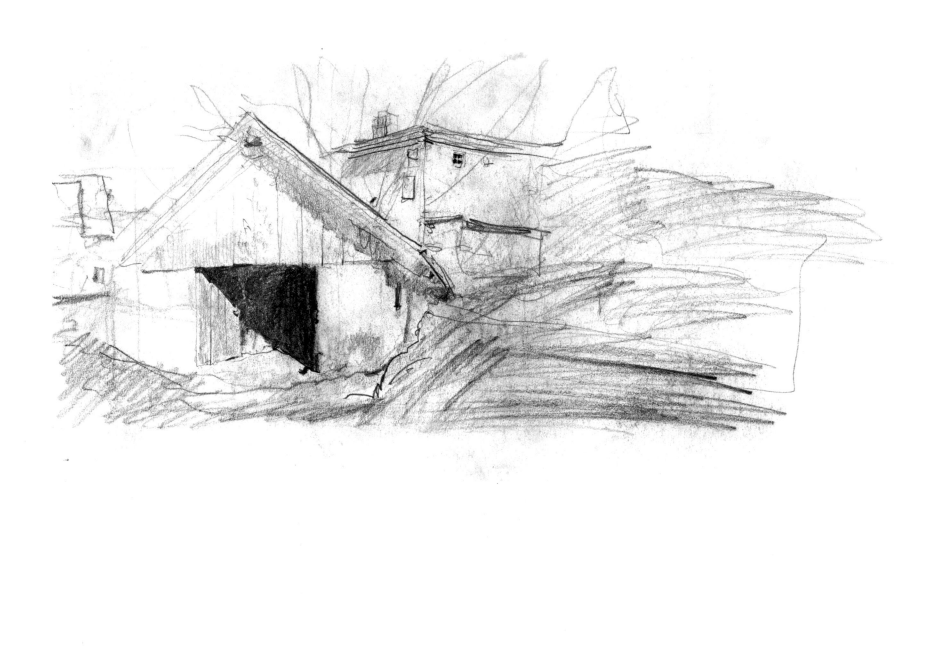

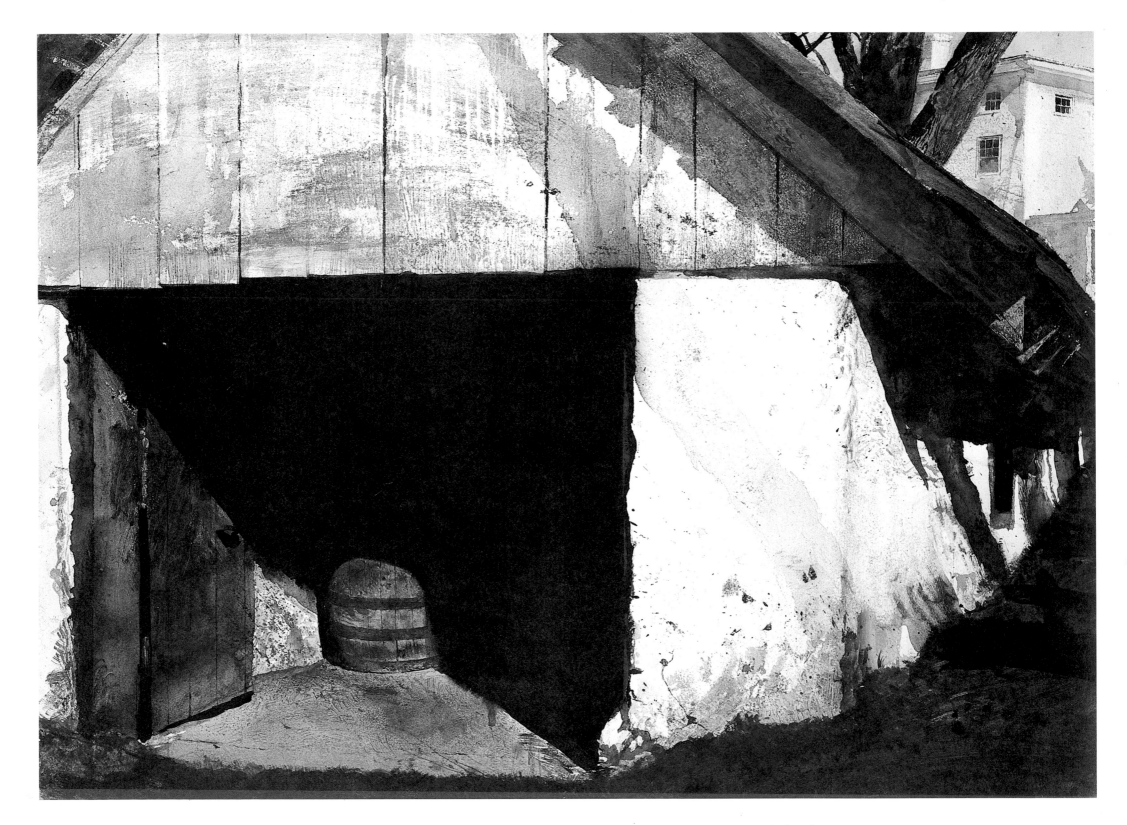

The day is warm enough to open the springhouse door to air it out. Sunlight slants across a big barrel that has been drained dry of its contents, hard cider, through the winter months.

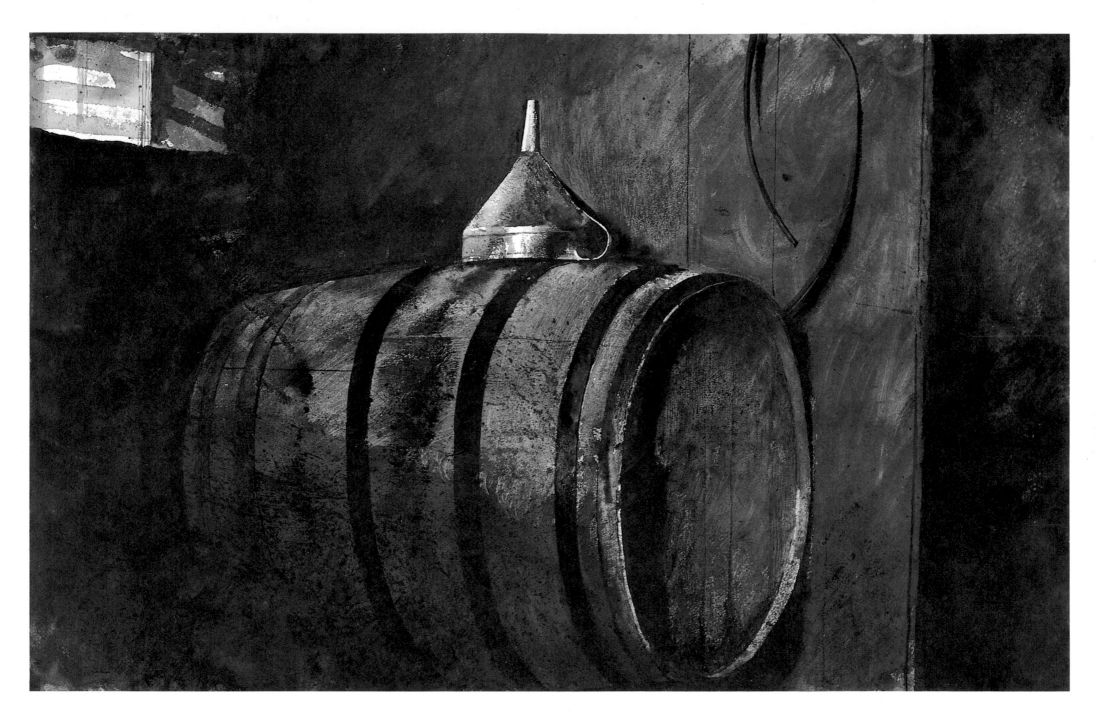

In November the Kuerners descend into certain abandoned apple orchards, quickly gathering up all the wind-falls. Burlap bags full of apples are taken to the cider press where Karl watches to see that only his apples are used. When the sweet cider begins to work, the barrel is sealed and left undisturbed for a month. By Christmas the hard cider is pale gold –like champagne.

The slaughtered head and side of a pig hang from ceiling hooks over three barrels of hard cider.
Early in November Karl brings a barrel of cider to Andrew Wyeth.

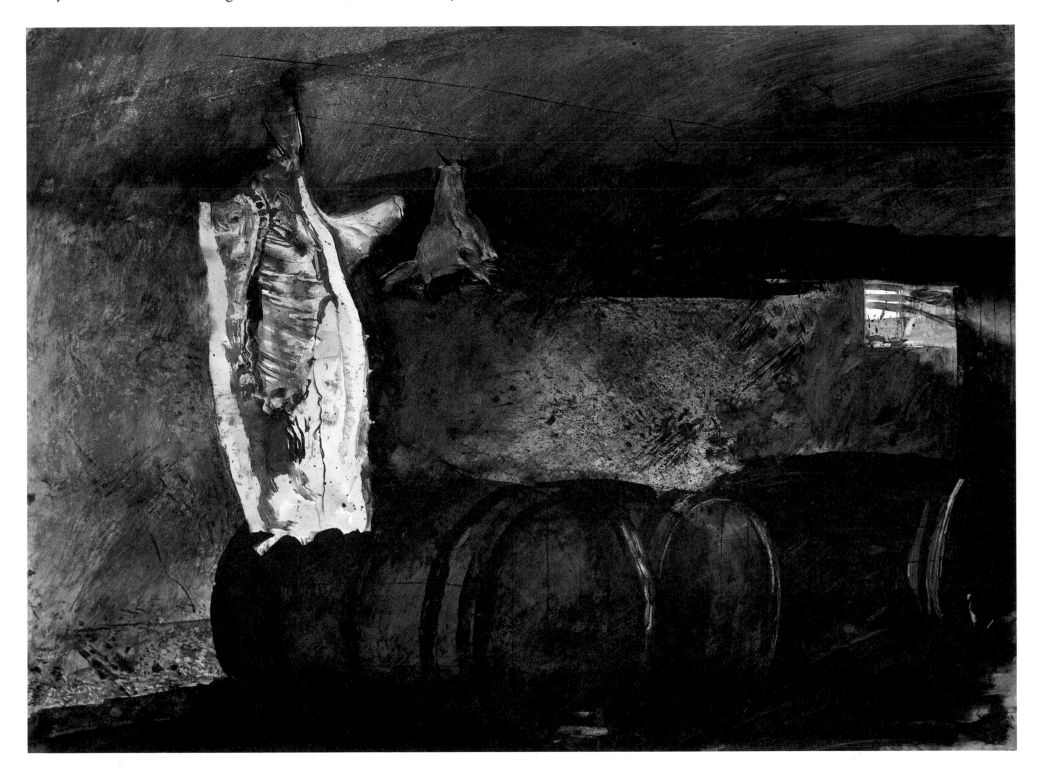

house. The house looked like this in the morning light.

And as I walked up the lane by the house and toward the barn I noticed the rope and chain I used for hanging the pig when Karl and his son butchered it a number of weeks ago I thought of you Bill and how you would have smiled

Andrew Wyeth almost never discusses a tempera while it is in process but often gives a clue about the subject when he writes a letter to a close friend. He was working on *Brown Swiss* when this letter was written.

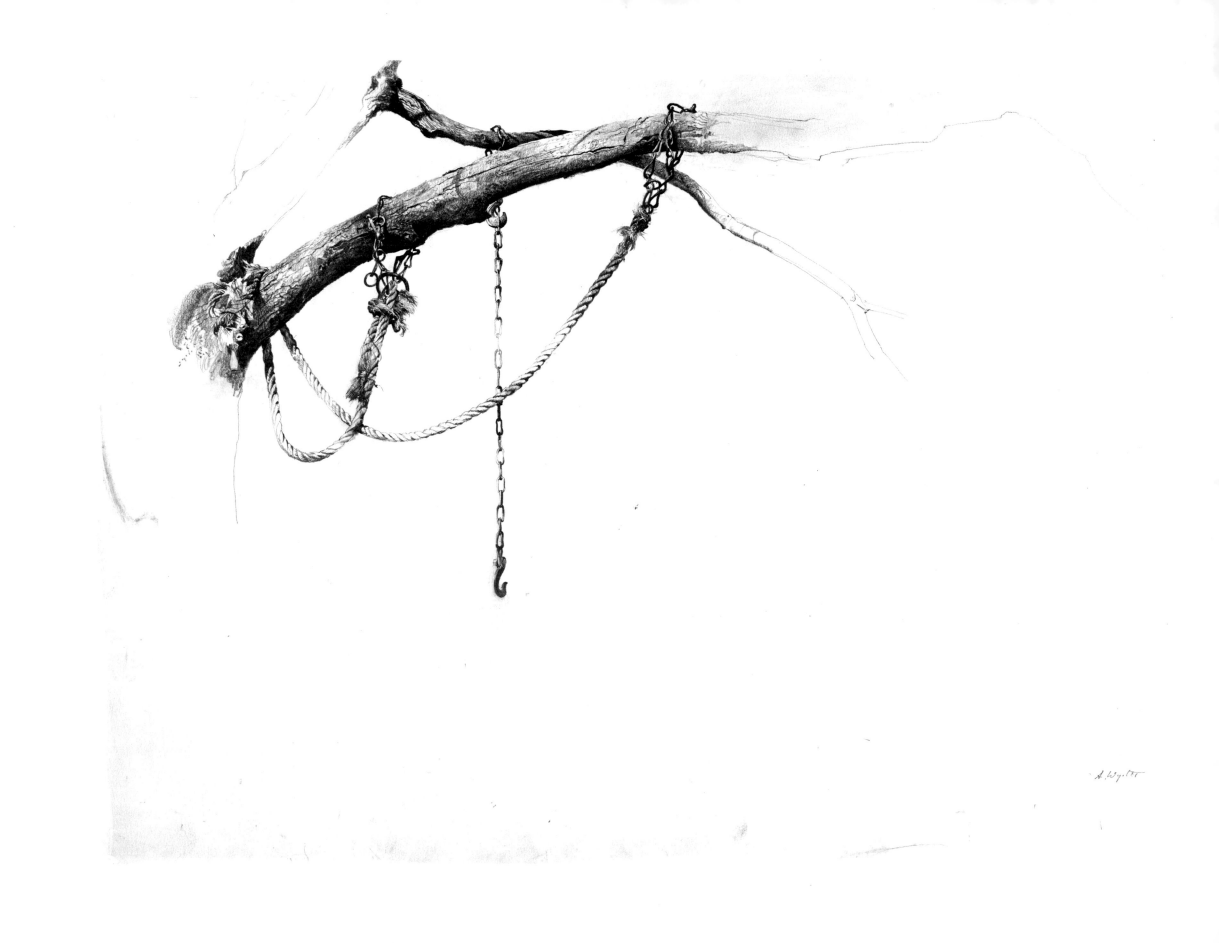

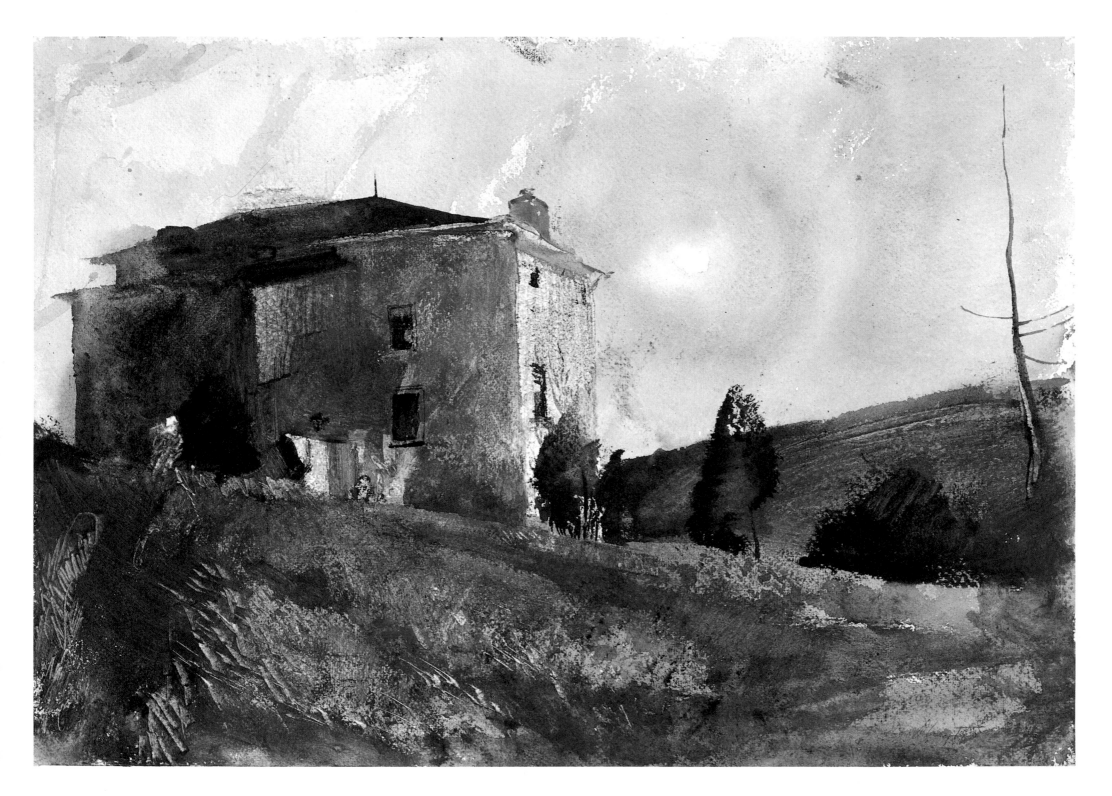

All coming and going takes place between the barn and this back entrance to the farmhouse.

Anna Kuerner moved so quickly her white-kerchiefed figure is almost lost before she entered the house.

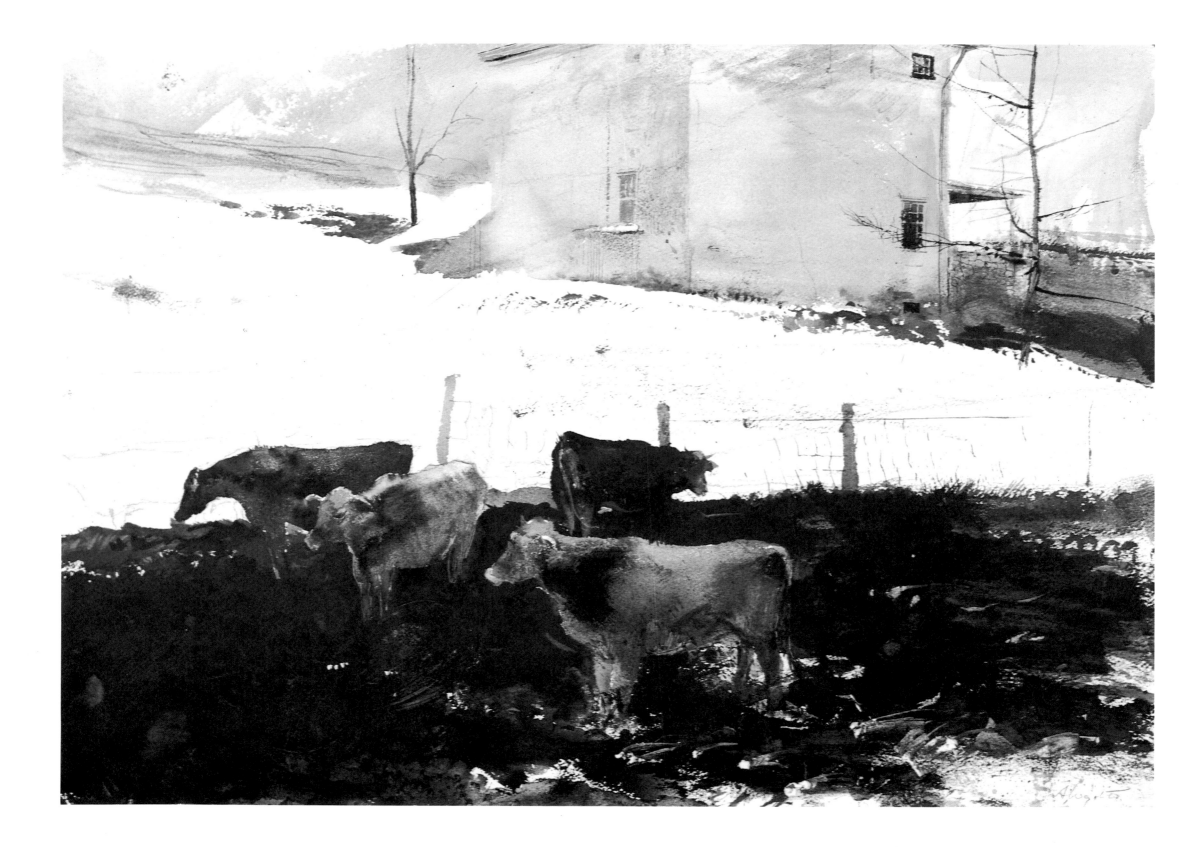

Cattle appear to be herding right up to the house, but a fence
that runs along the driveway keeps them in the barnyard pasture.

Kuerners from the Railroad Embankment

These sweeping views of the farm were done from the high railroad embankment
that forms the northern boundary of the Kuerner property.

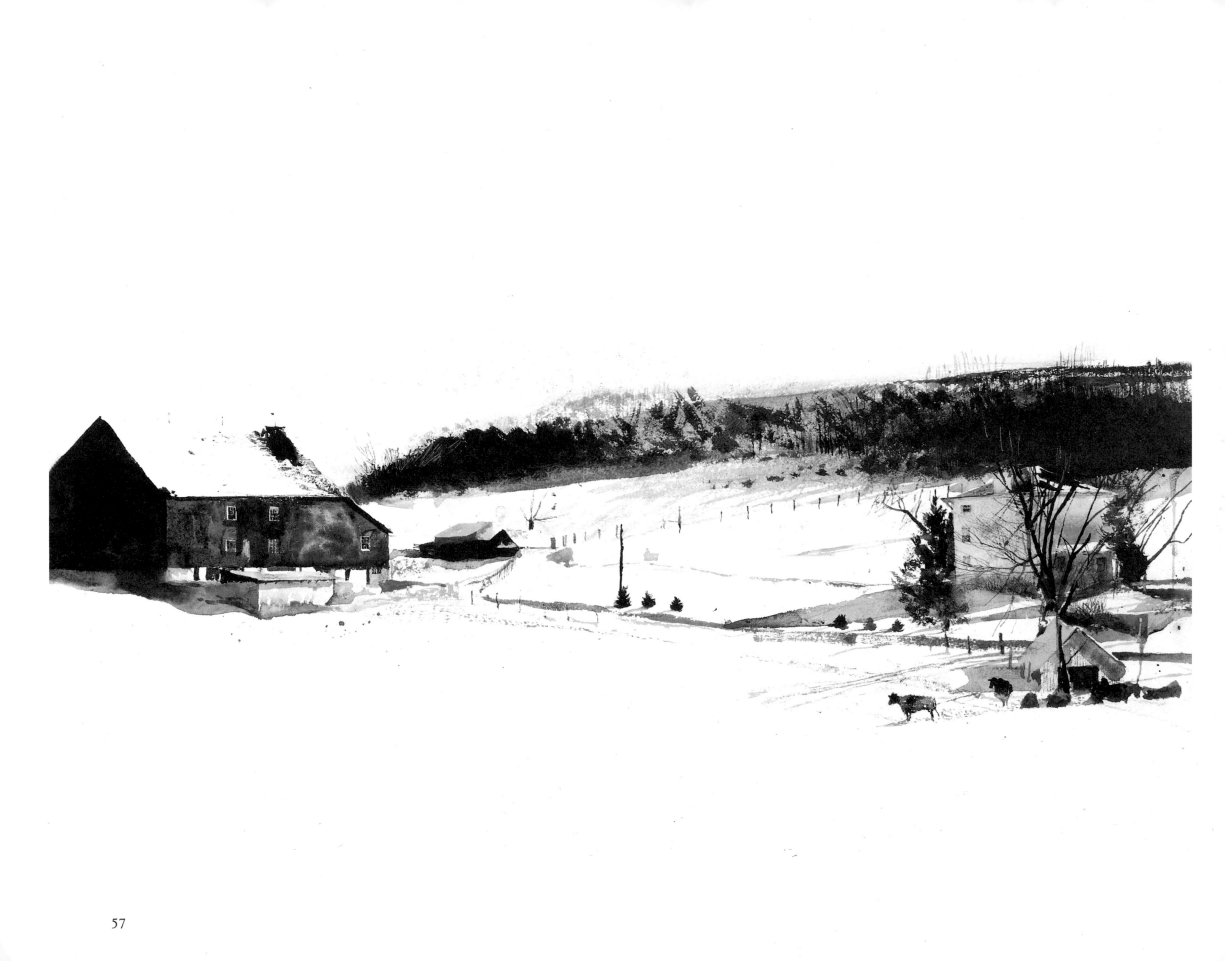

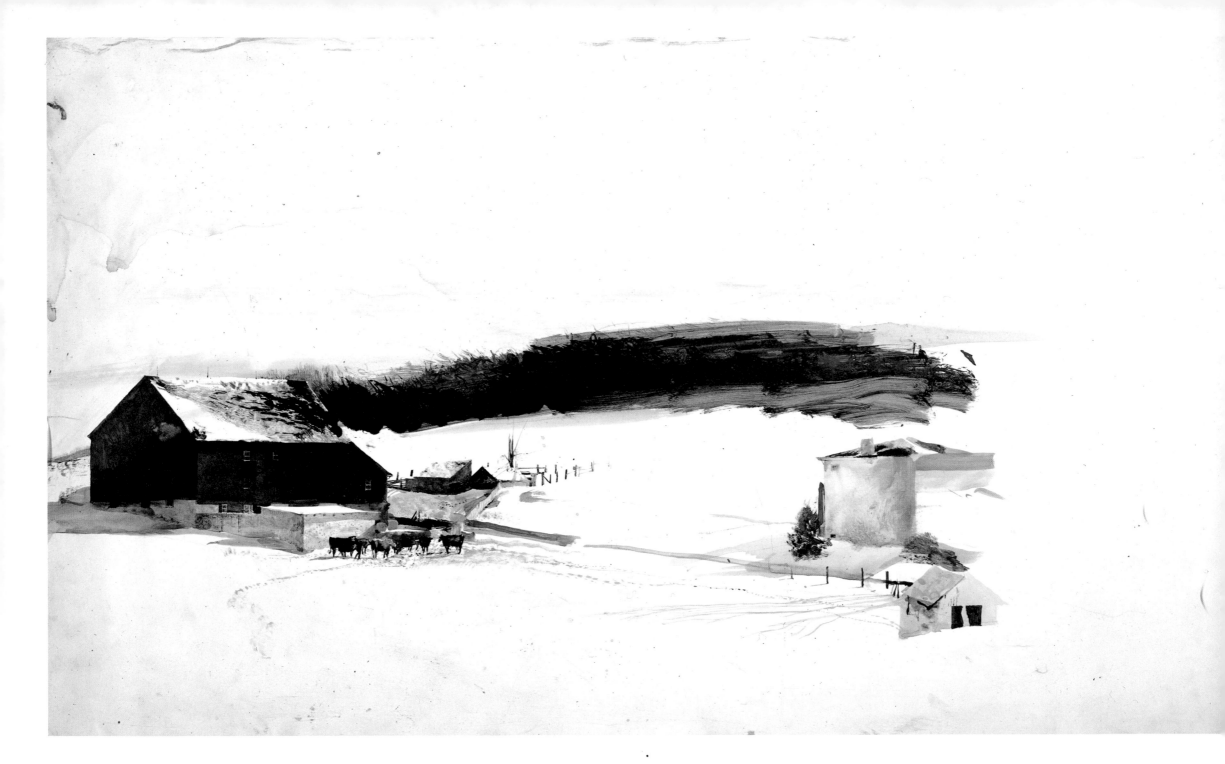

The cattle have moved from the springhouse as the day progresses, finally disappearing
into the barn before the short winter day turns into night.

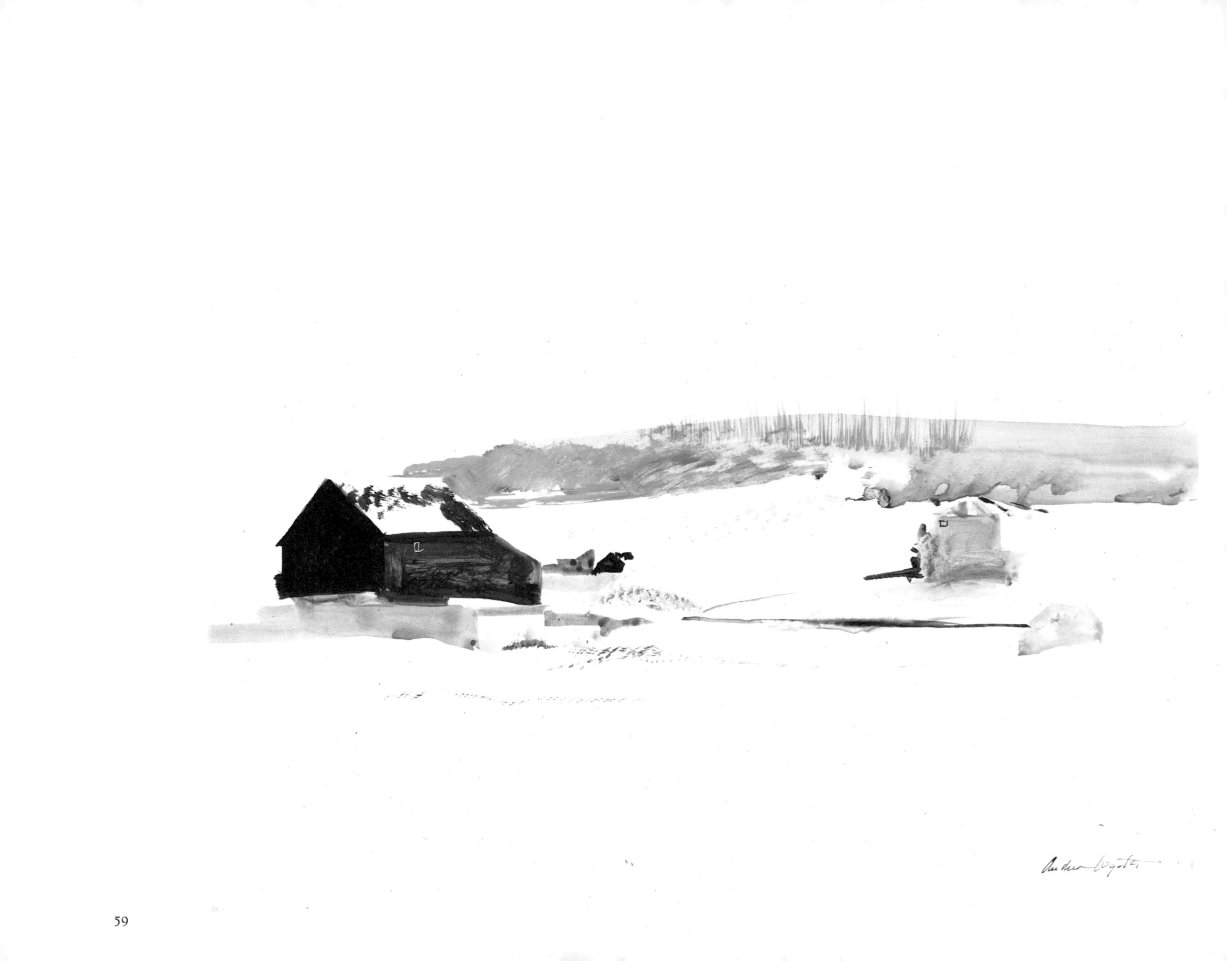

59

The railroad tracks, now abandoned, that make the northern boundary. "Lafayette Hall" rises over the track embankment. The public road that runs in front of Kuerners crosses these tracks a few yards to the left and within sight of the farmhouse. On October 19, 1945, Andrew Wyeth's father and nephew were killed at this railroad crossing by a westbound freight train.

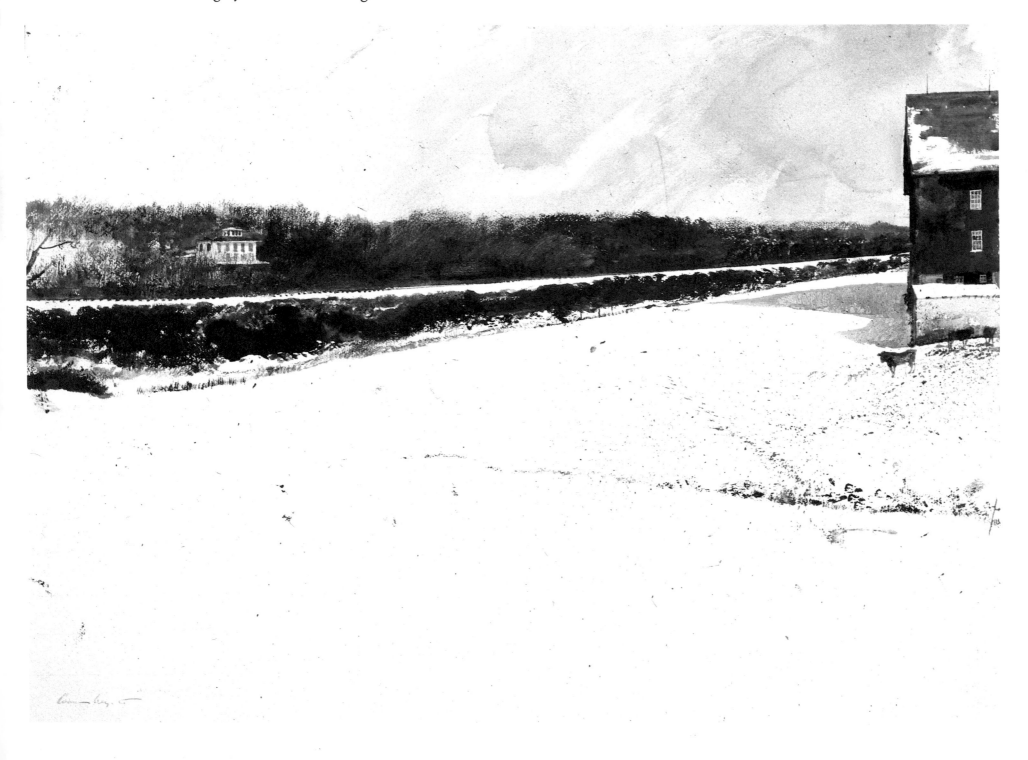

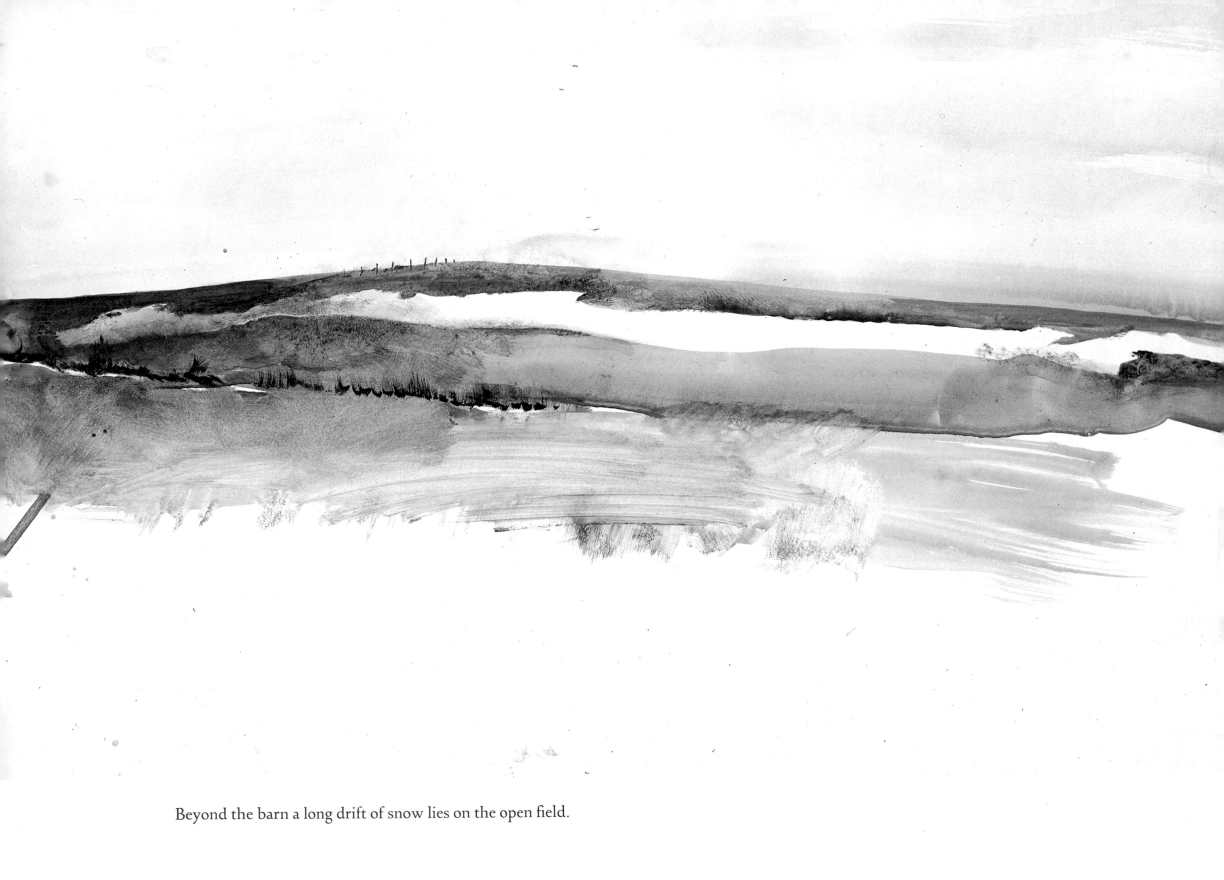

Beyond the barn a long drift of snow lies on the open field.

Approaching the House from the Back

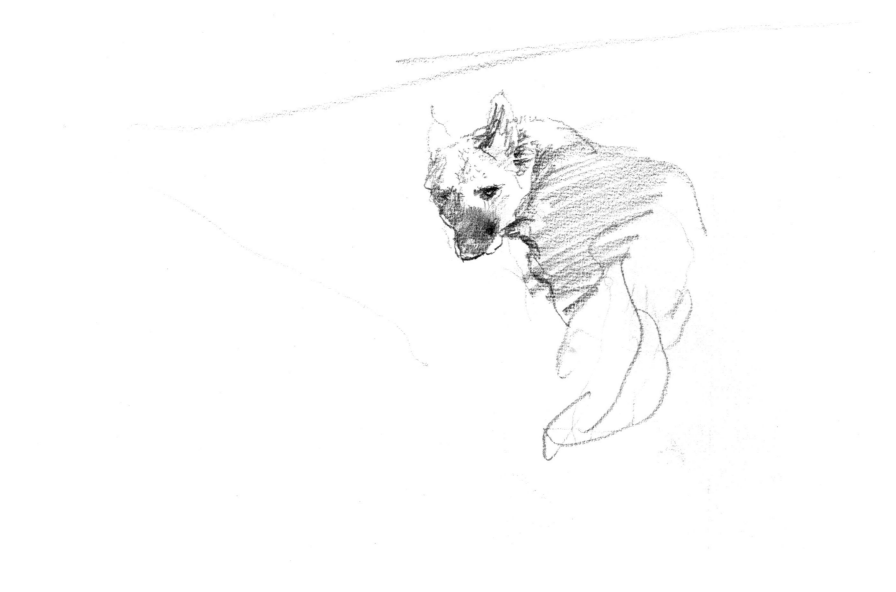

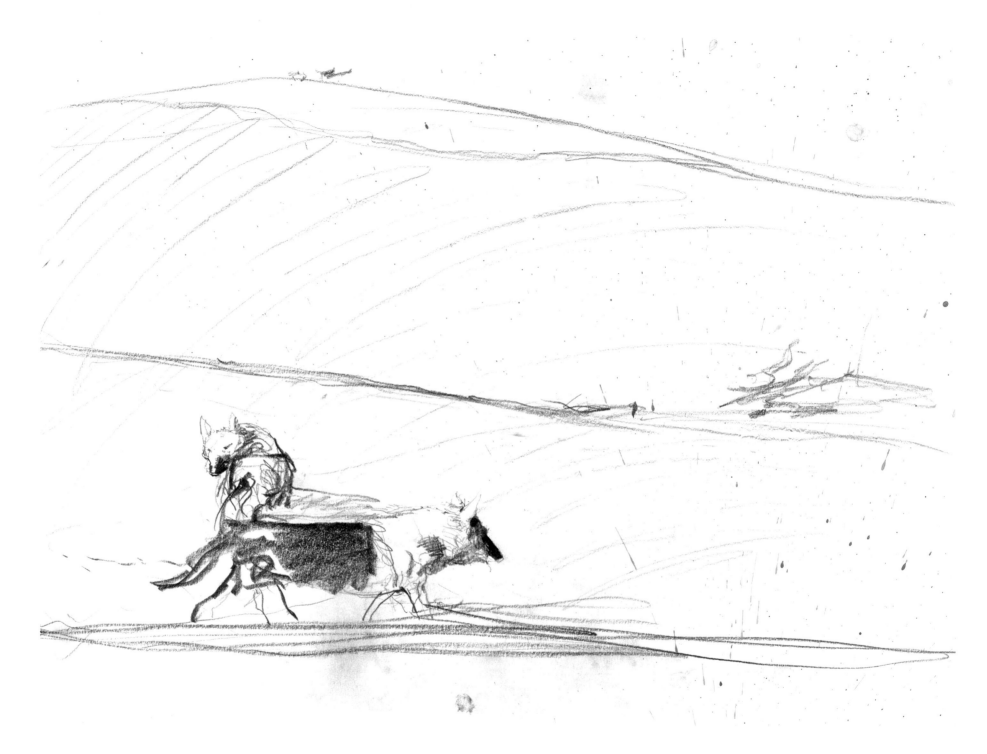

The first sheep dog Karl owned, back in Germany, was named Nel.

Since then every German shepherd has been called Nel.

Late in the day she is unchained for a run across the fields.

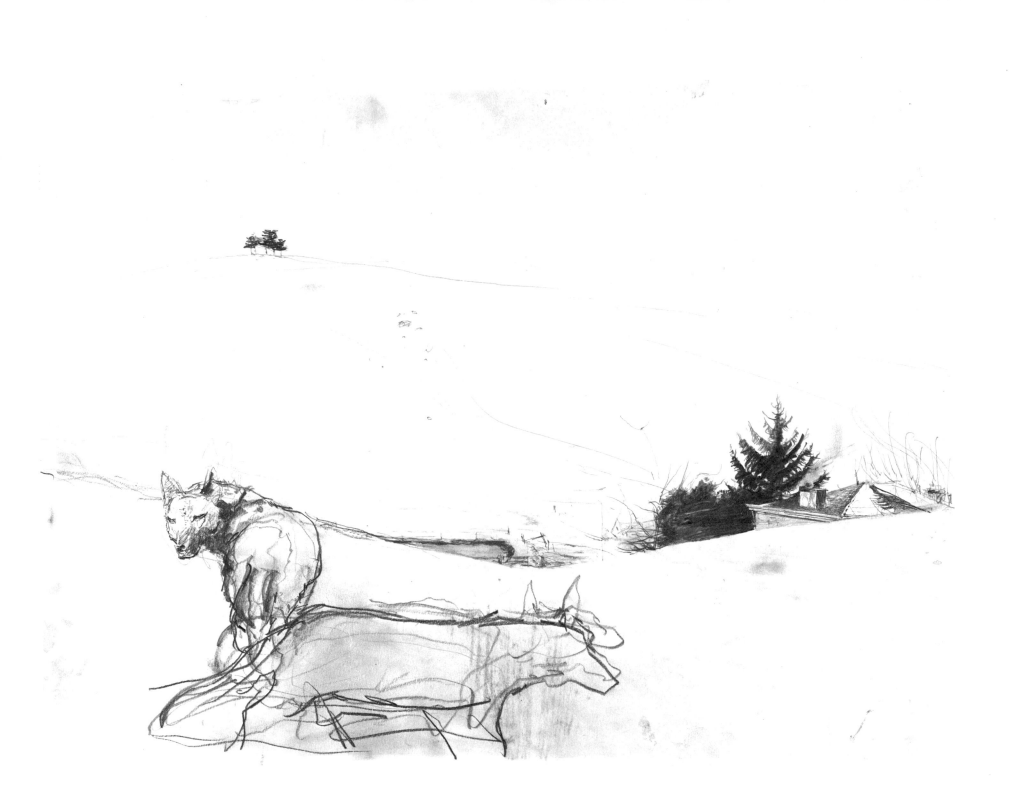

Kuerners Hill comes back into view when the German shepherd
approaches the house from the slopes that rise behind it.

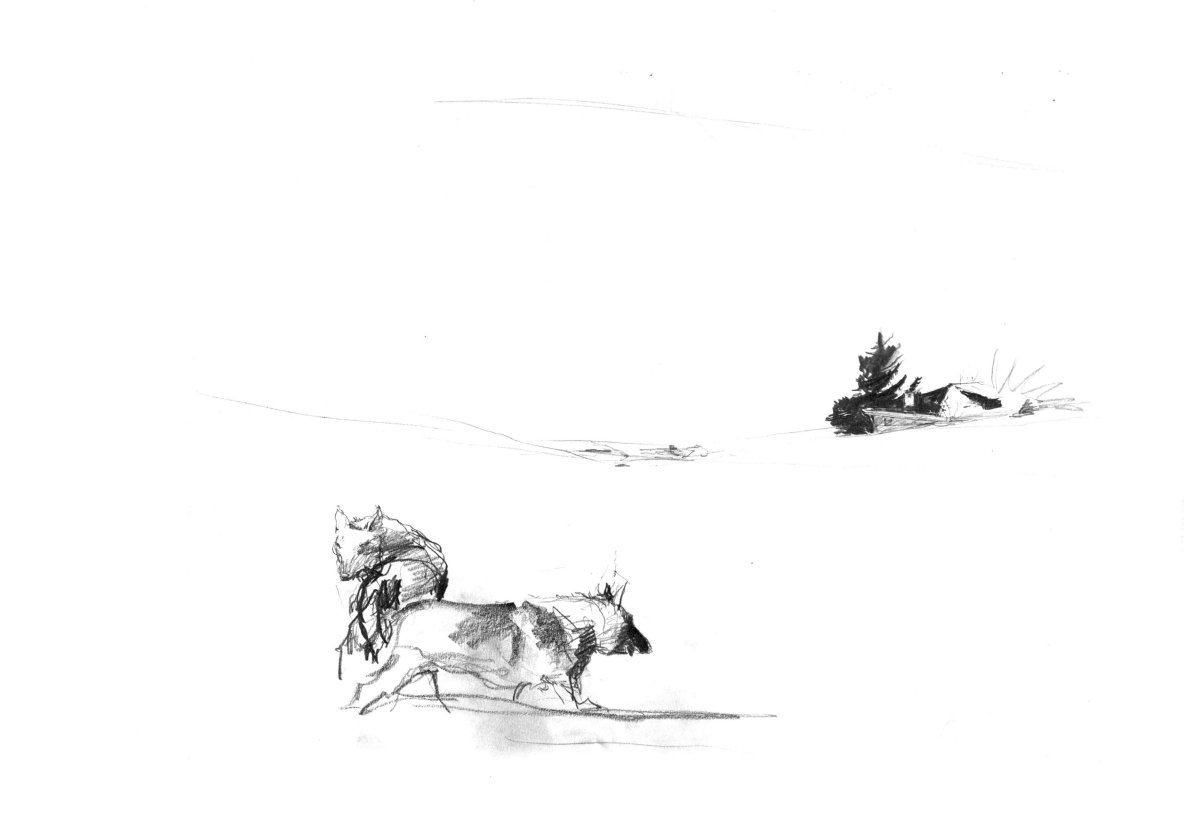

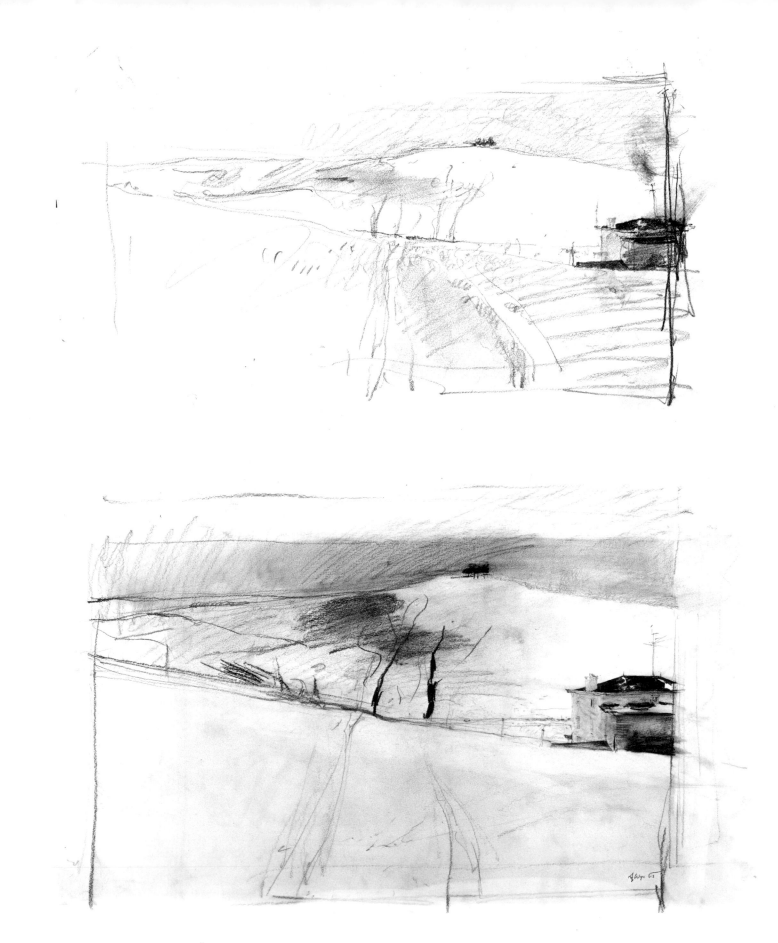

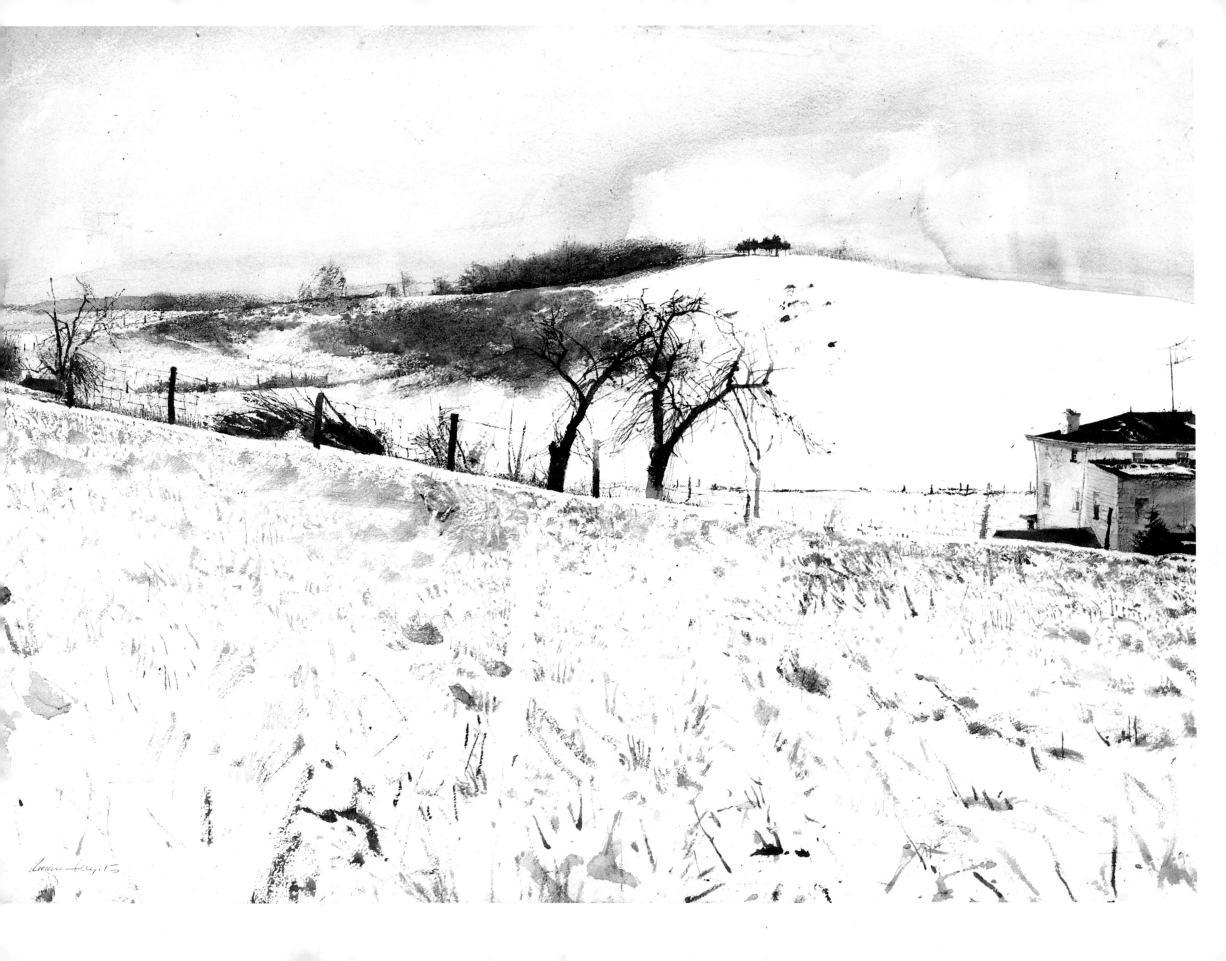

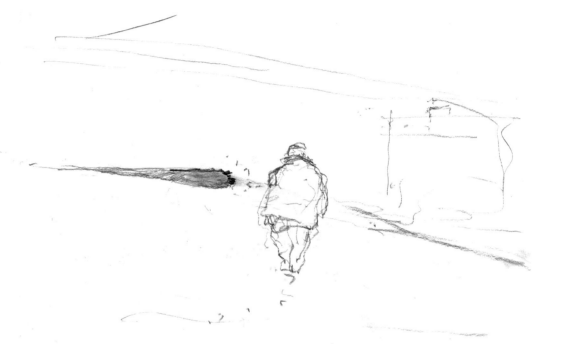

The stocky figure of Karl Kuerner.

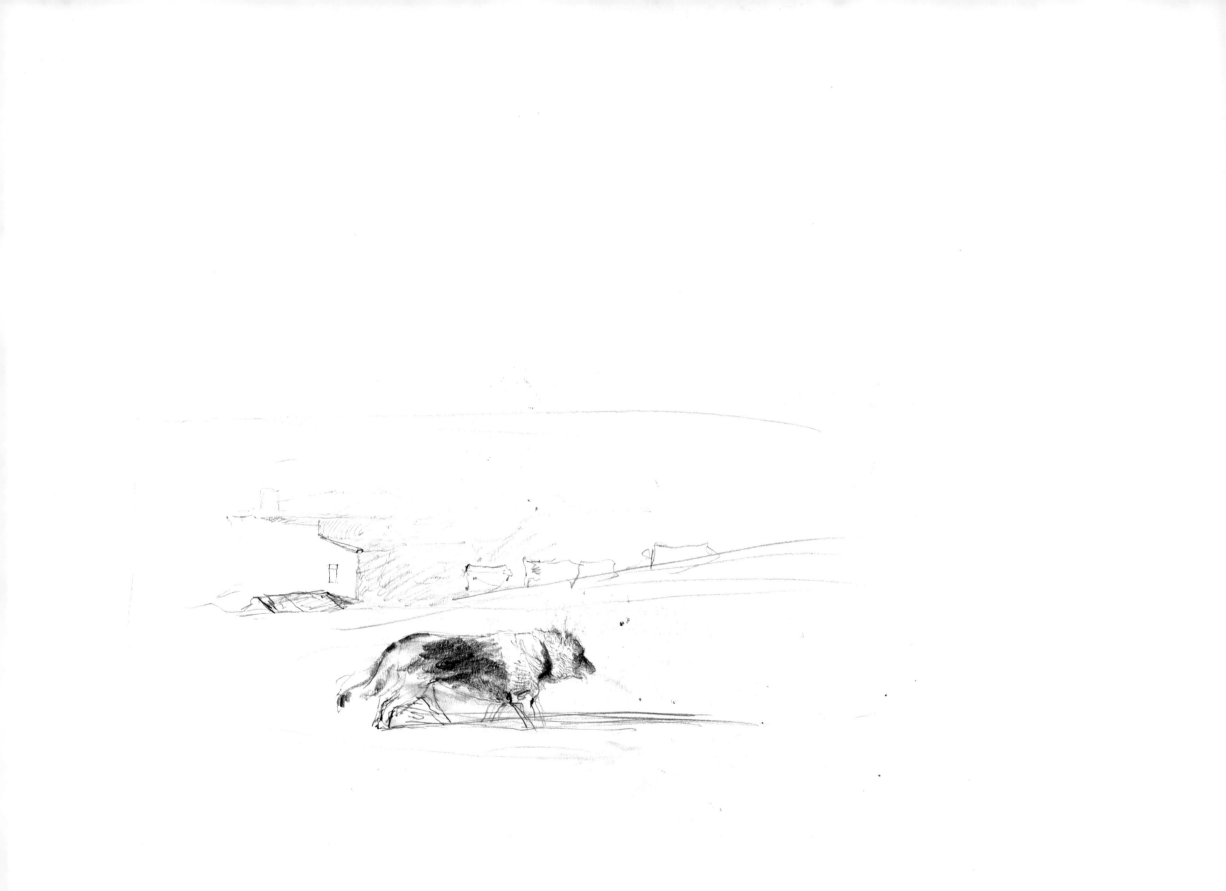

The artist titled this watercolor *The Prowler*.

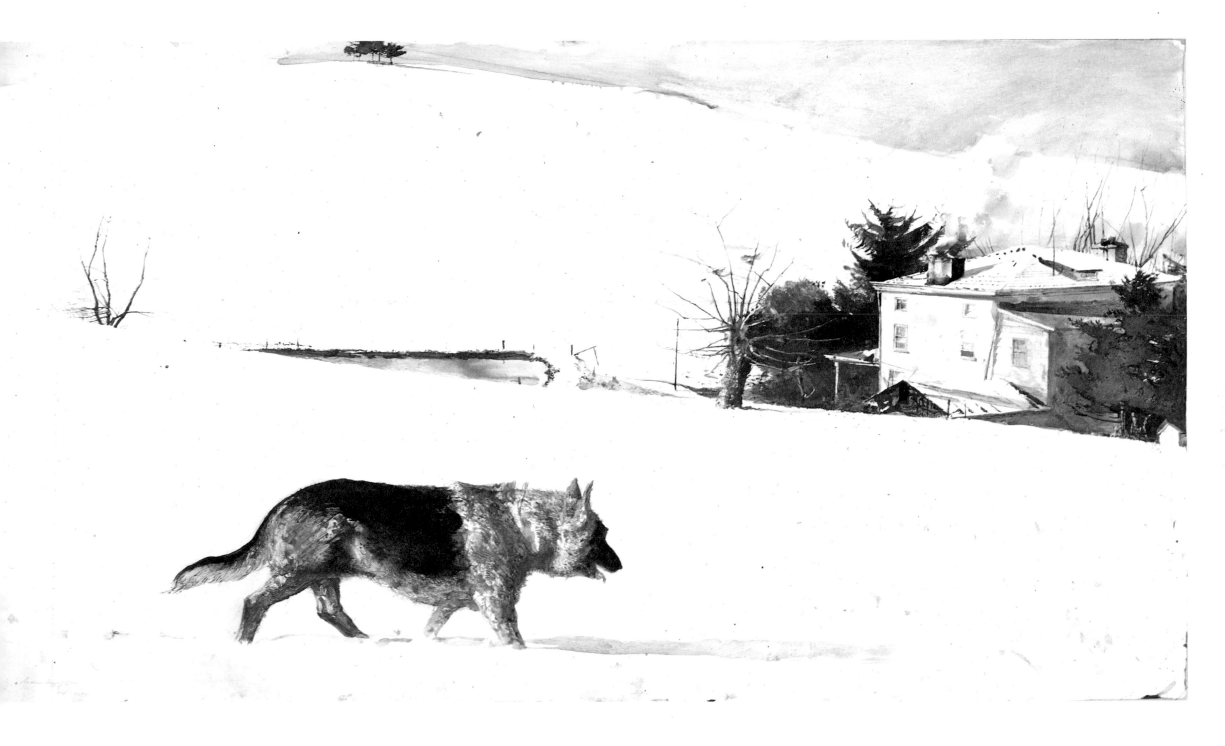

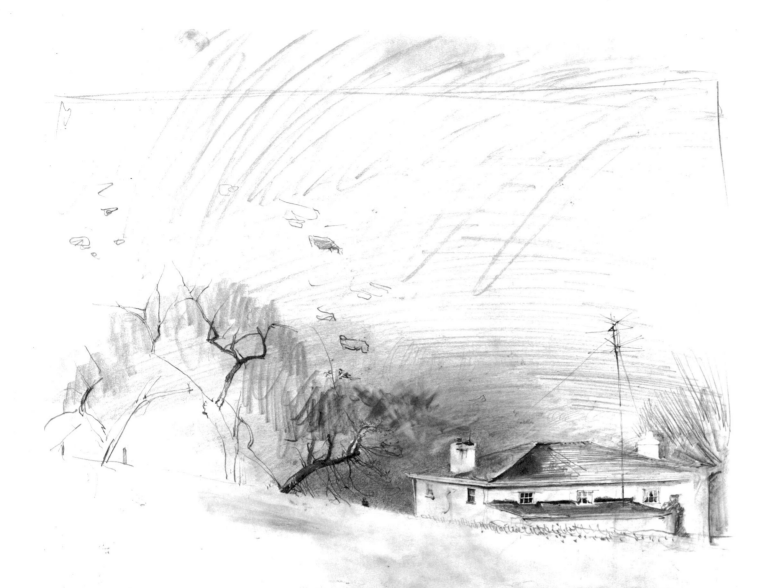

Down Through the Orchard

The farmhouse appears submerged between the orchard hillside
and the Alpine slopes of Kuerners Hill where cattle graze.

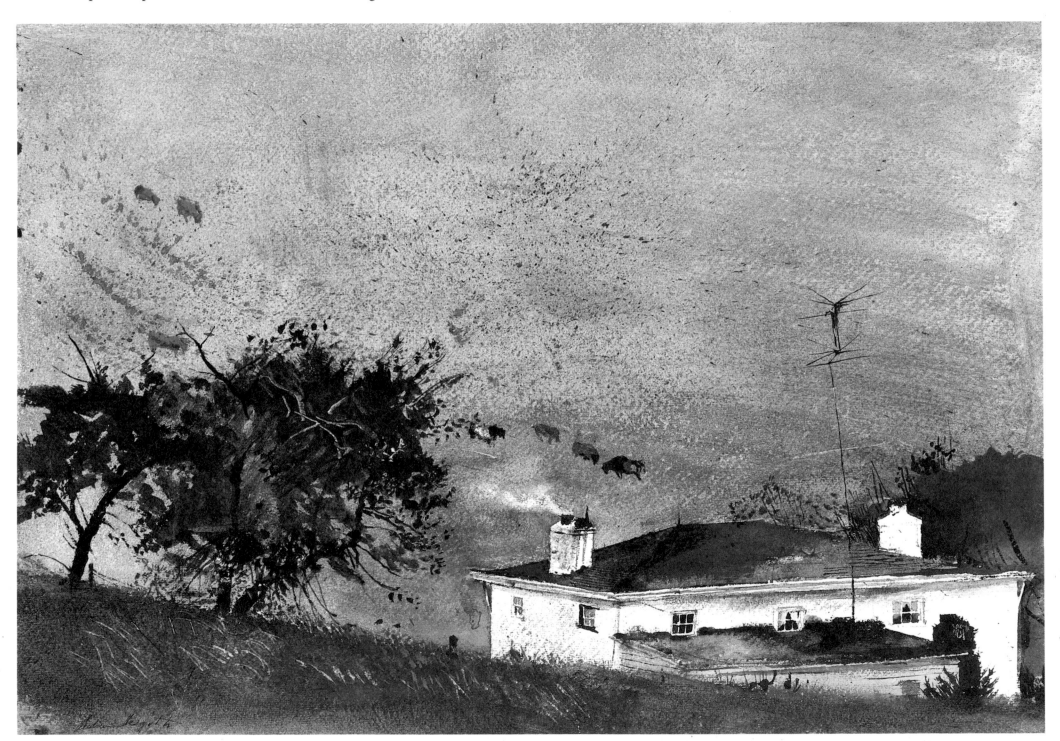

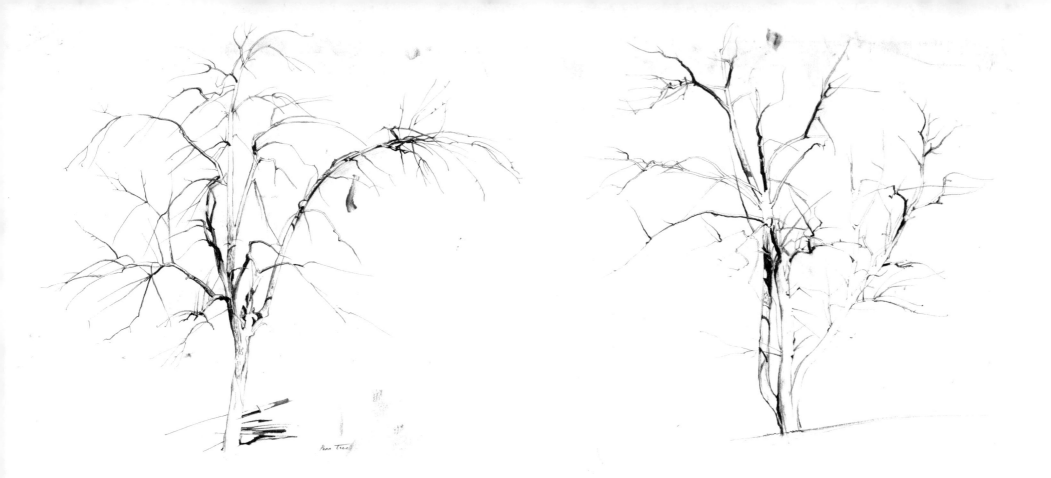

Karl has kept his recipe for hard cider a secret. His son thinks that perhaps
the juice from the pears that grow on these orchard trees is added.

The orchard slopes down to the house where a fence keeps the cattle out of the farm pond.

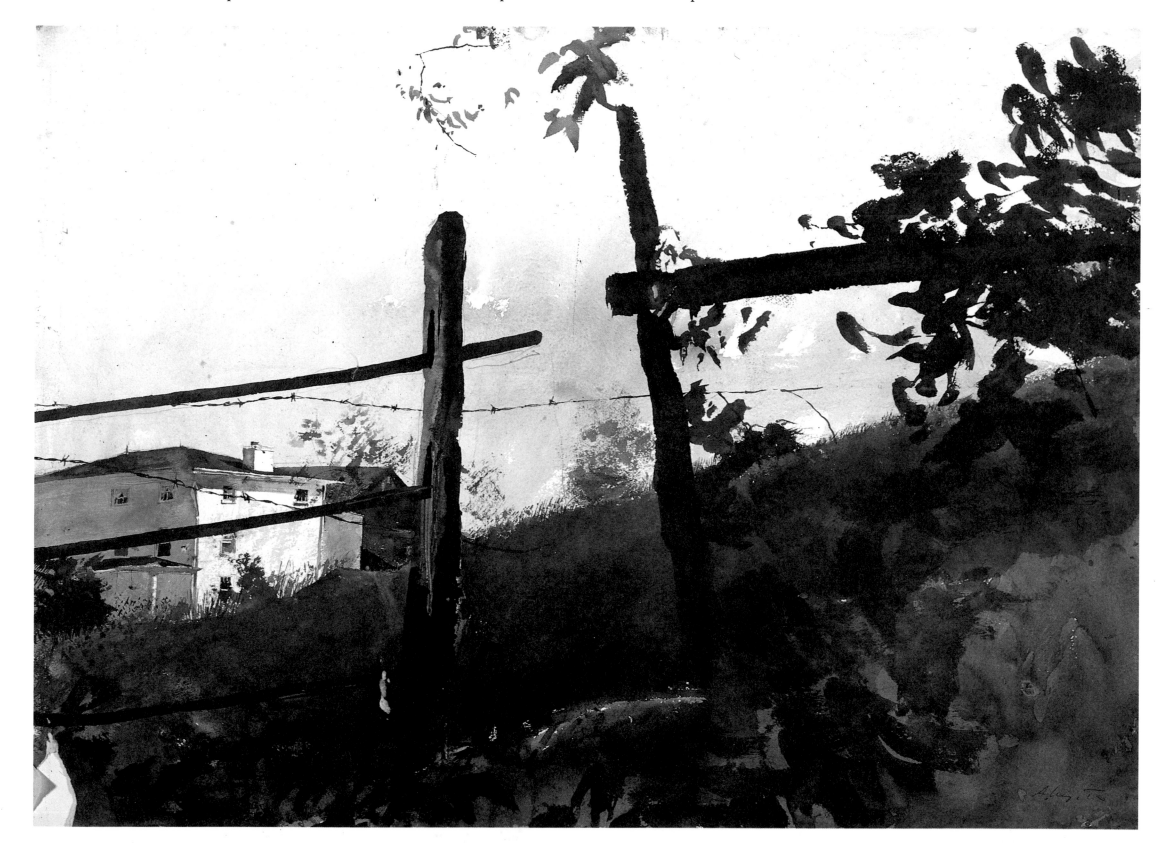

The big gum tree that grew beside the farm pond below the orchard.

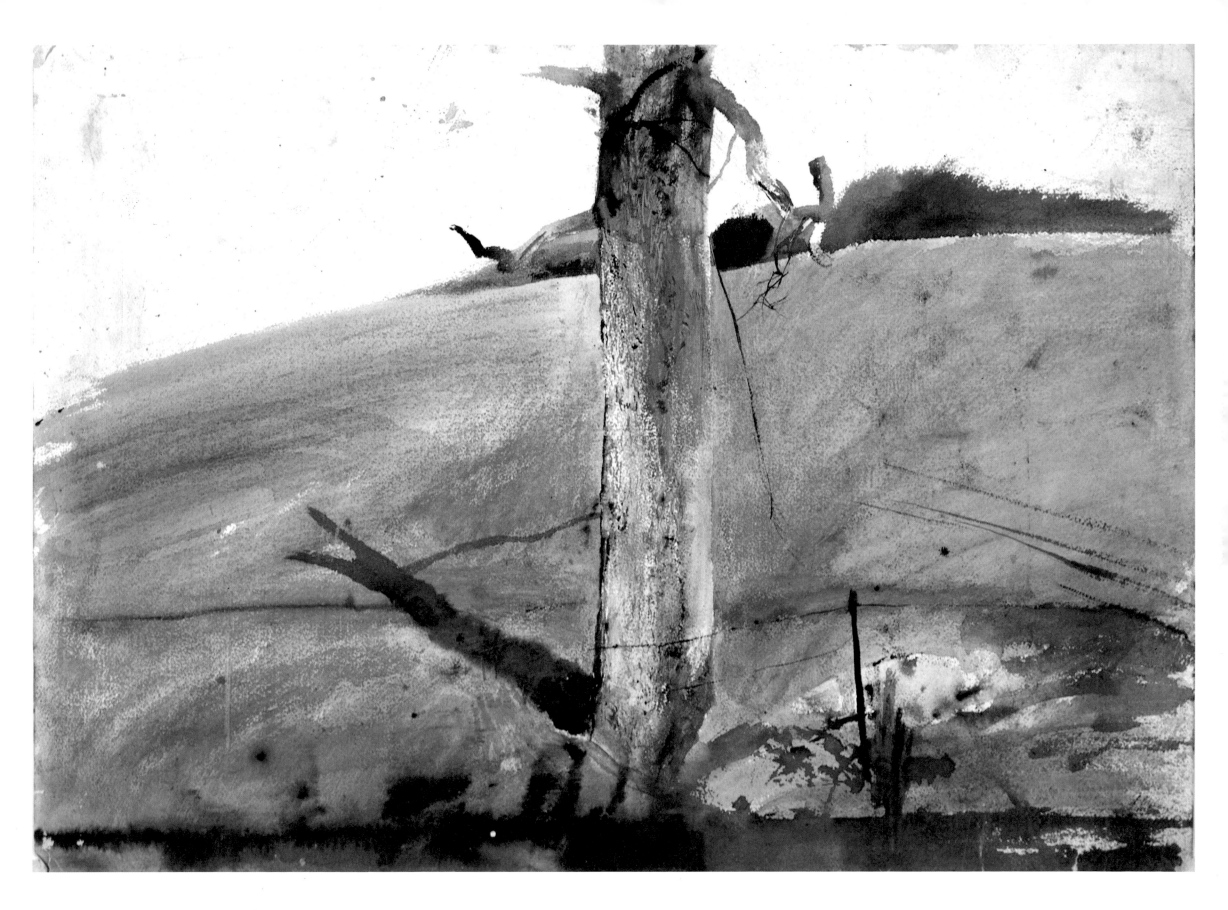

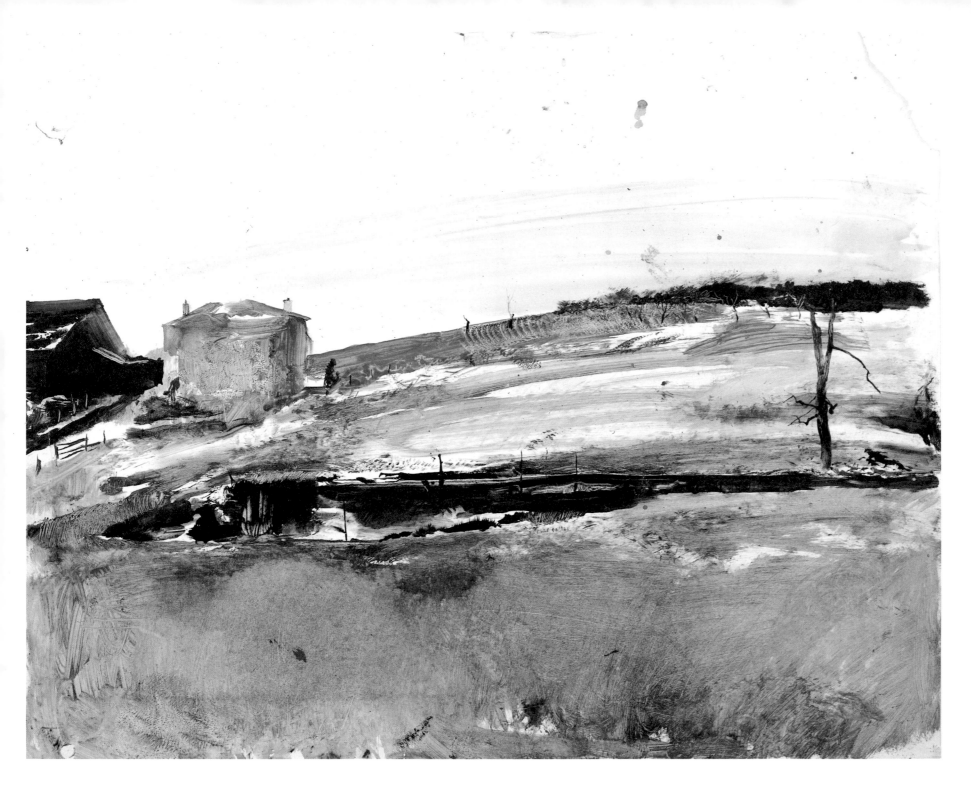

The tall gum tree at the far end of the pond, the orchard above
and the house seemingly connected to the barn.

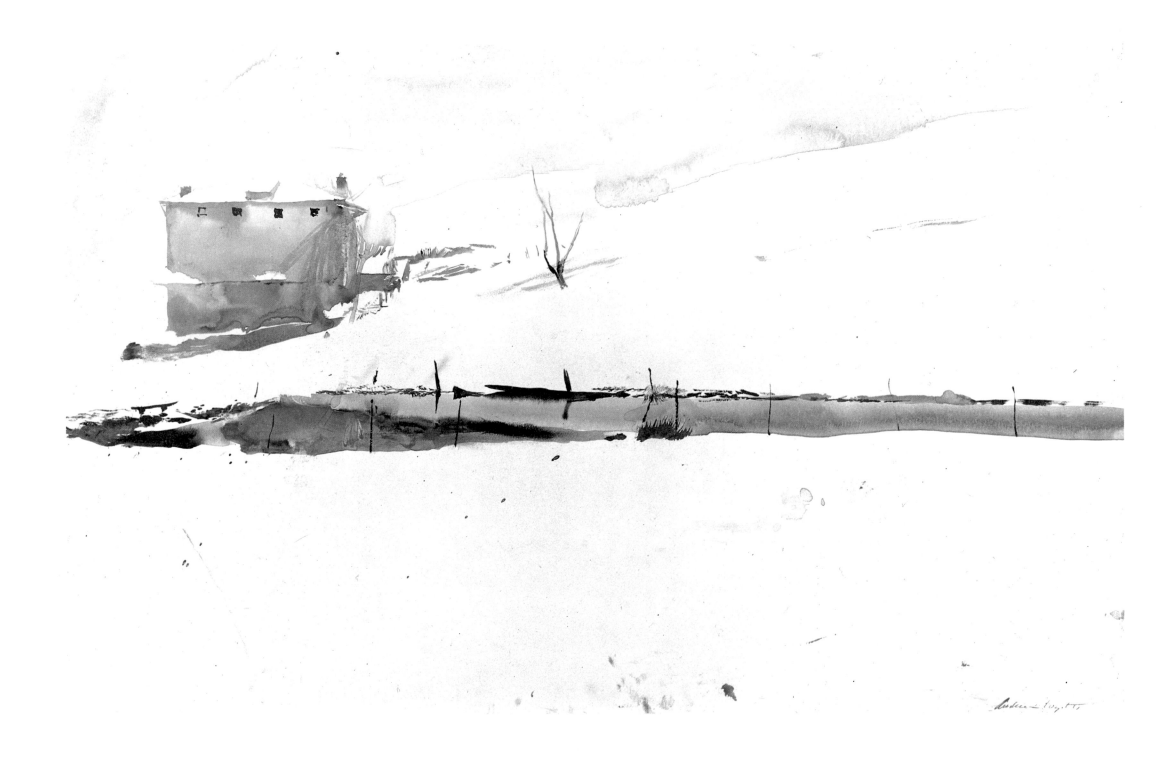

There are few idle hours on the Kuerner farm. The only suggestions of leisure are a bench placed on the dam breast,

a swimming dock

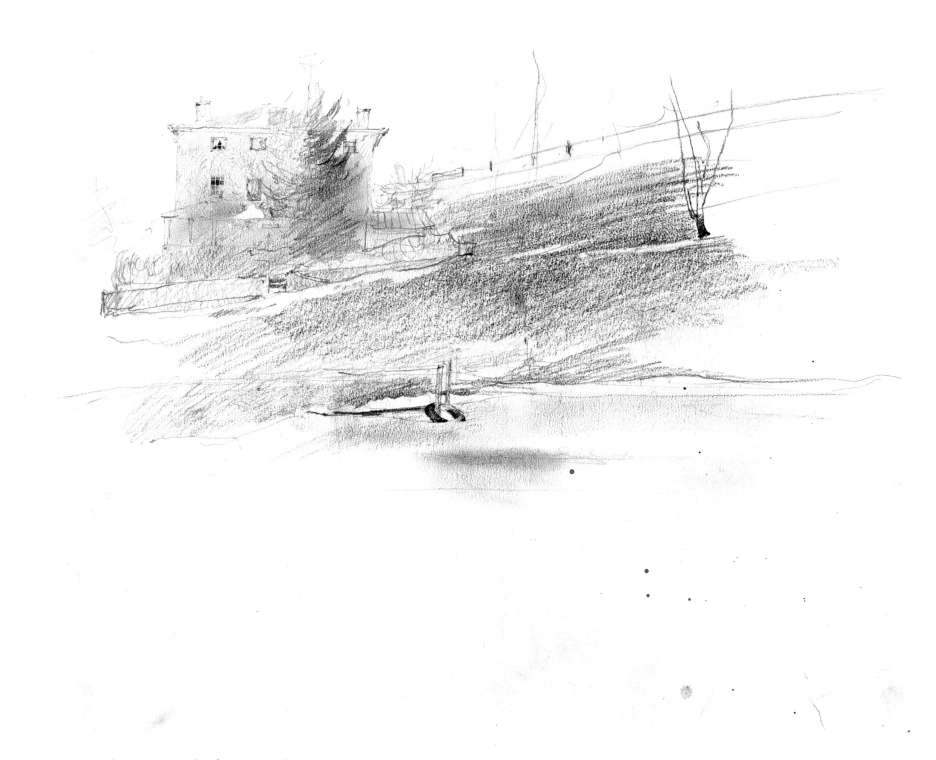

and an inner tube frozen in the ice.

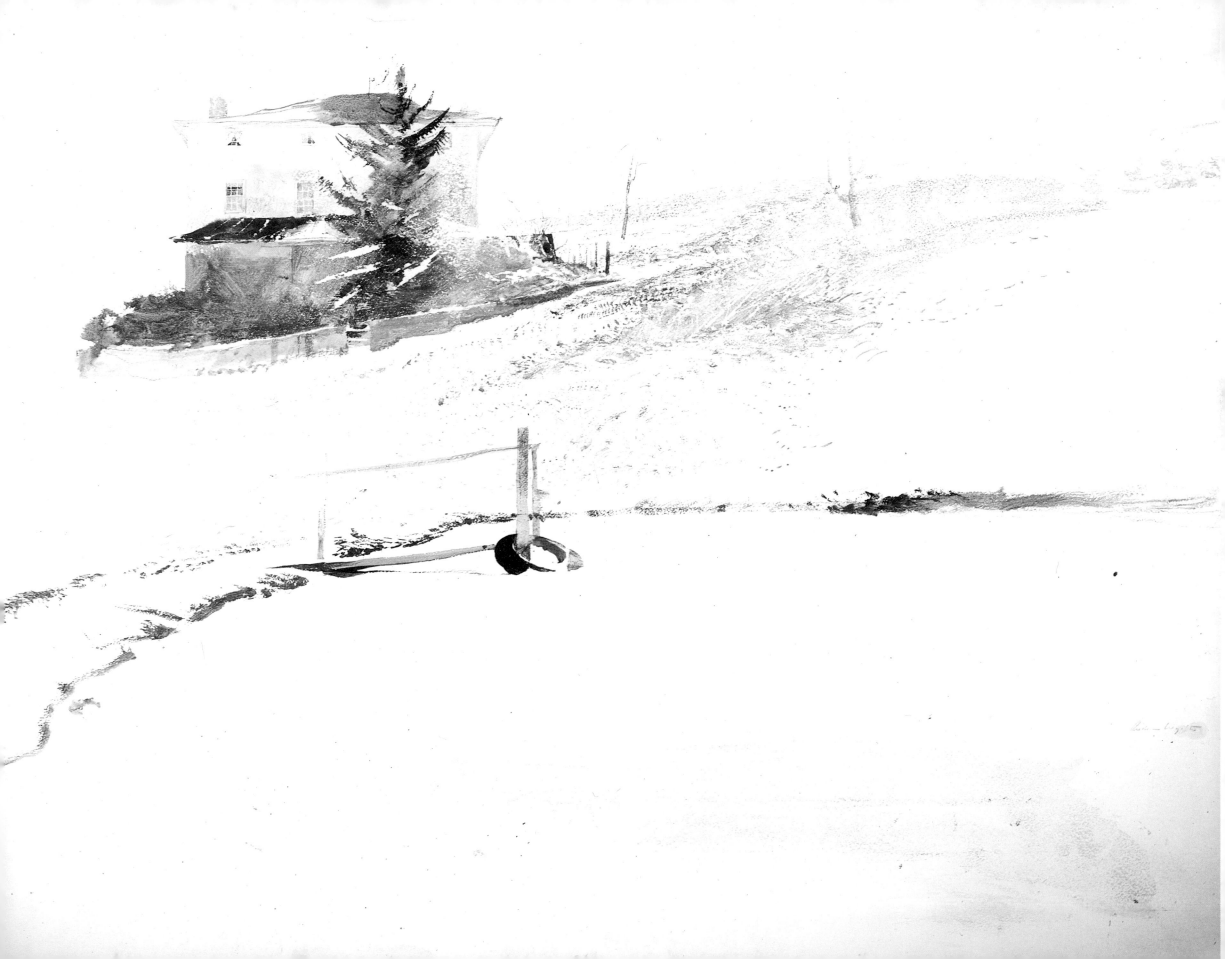

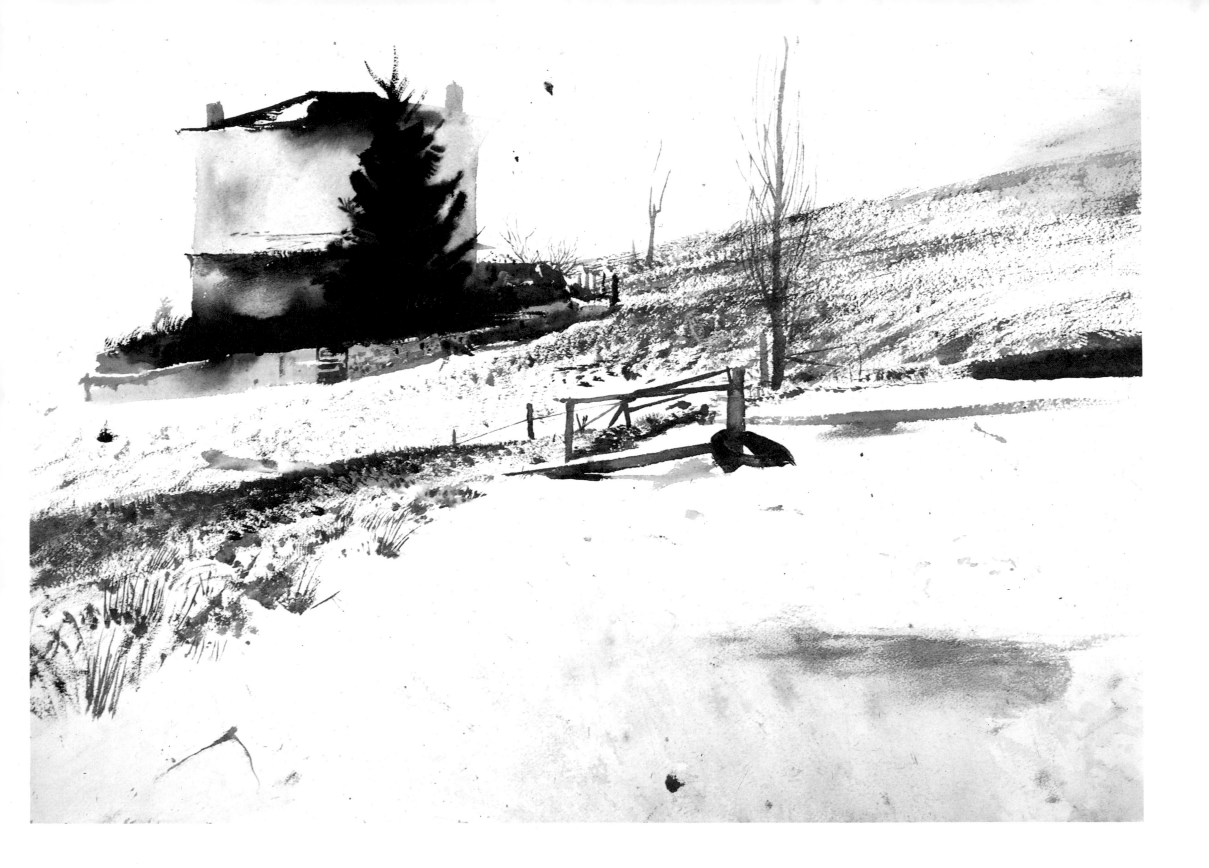

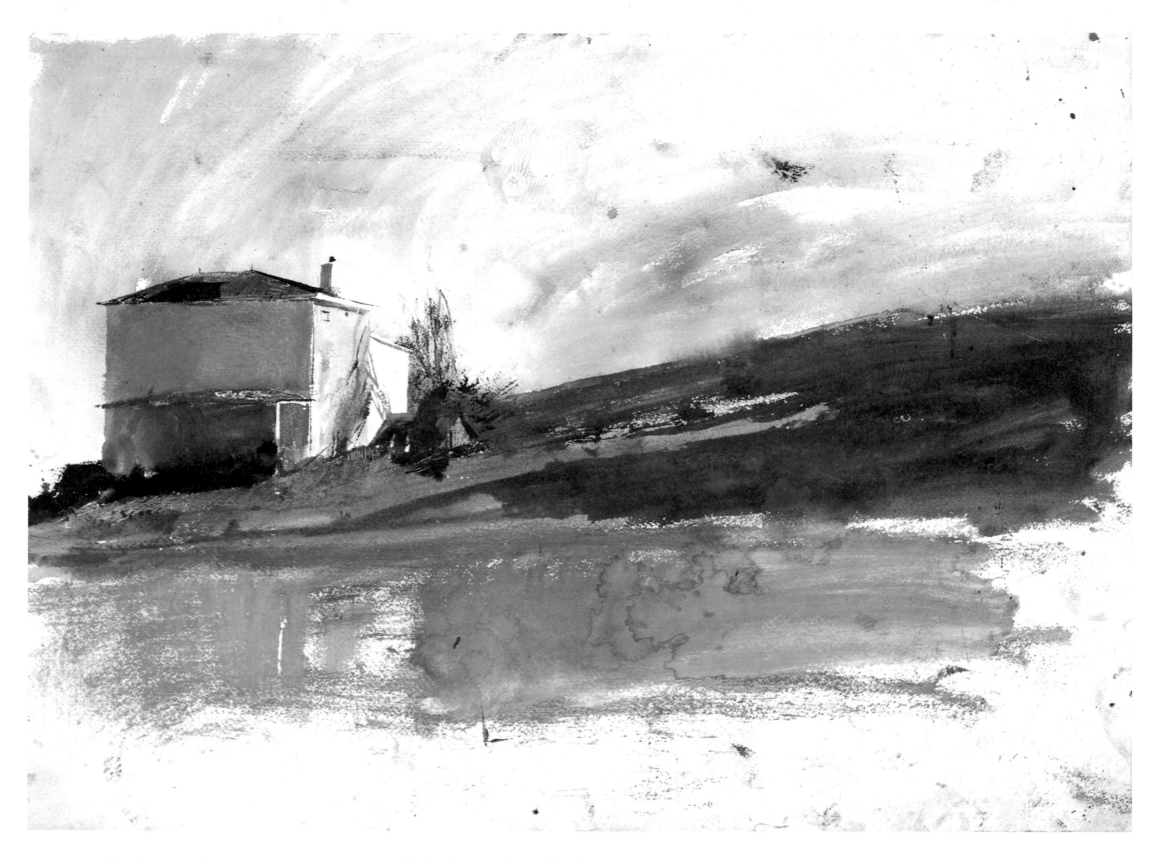

The farm pond becomes more important with the house reflected in the water.

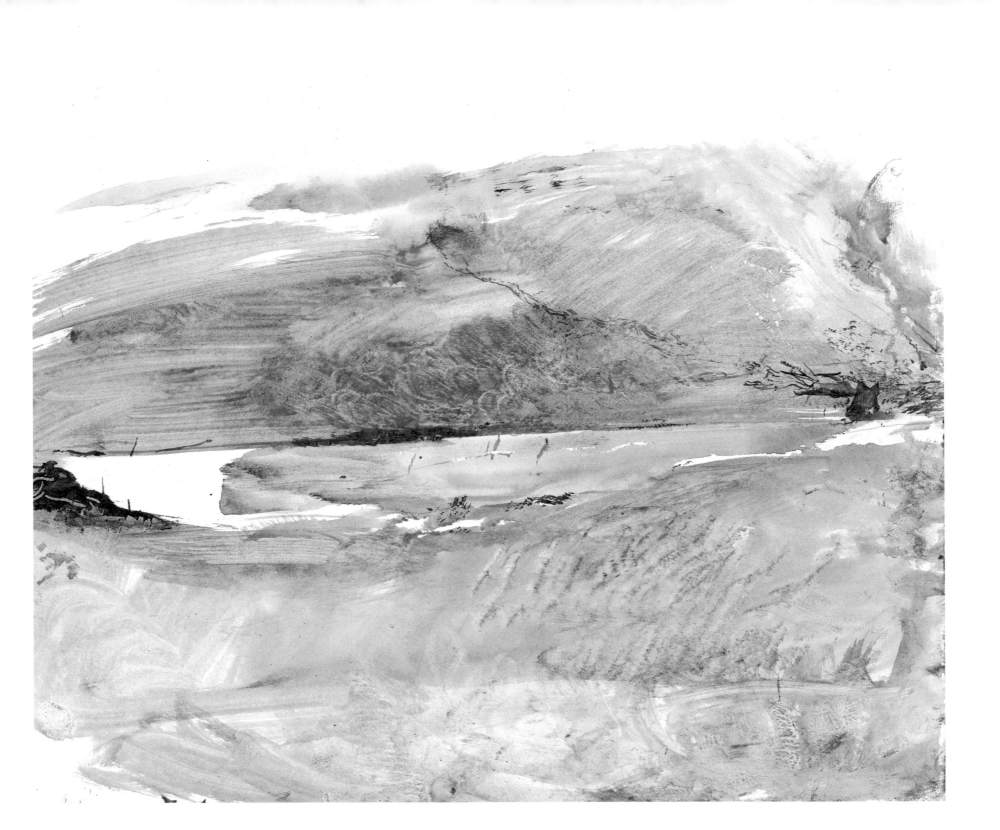

The pale blue sky of winter is reflected –

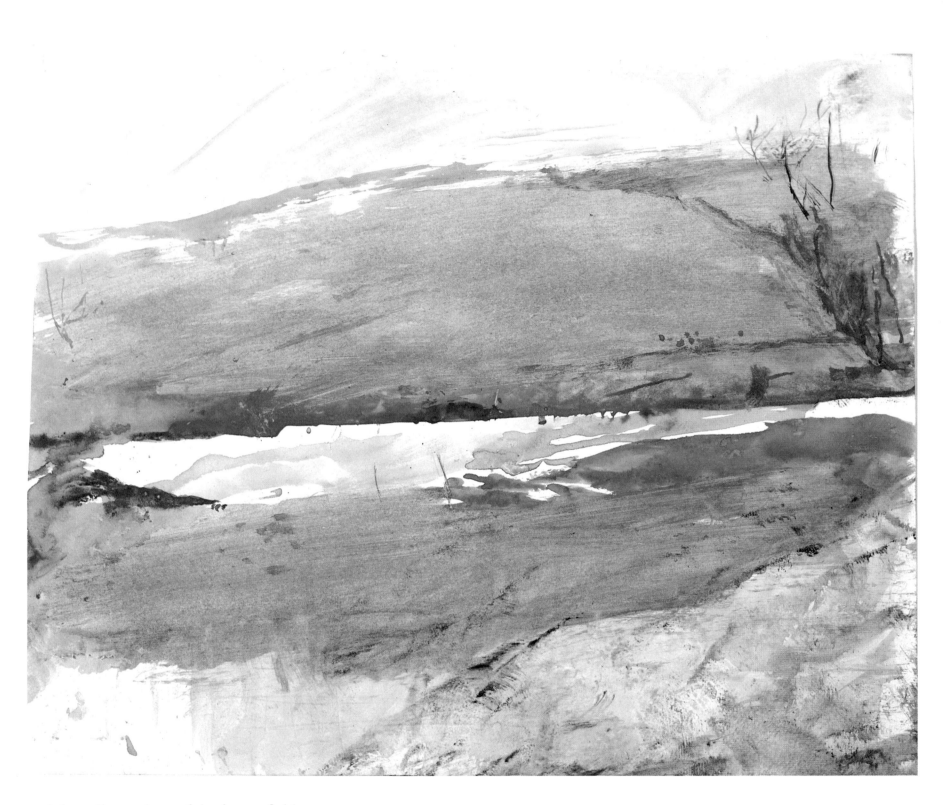

and the yellow ochres of the frozen fields.

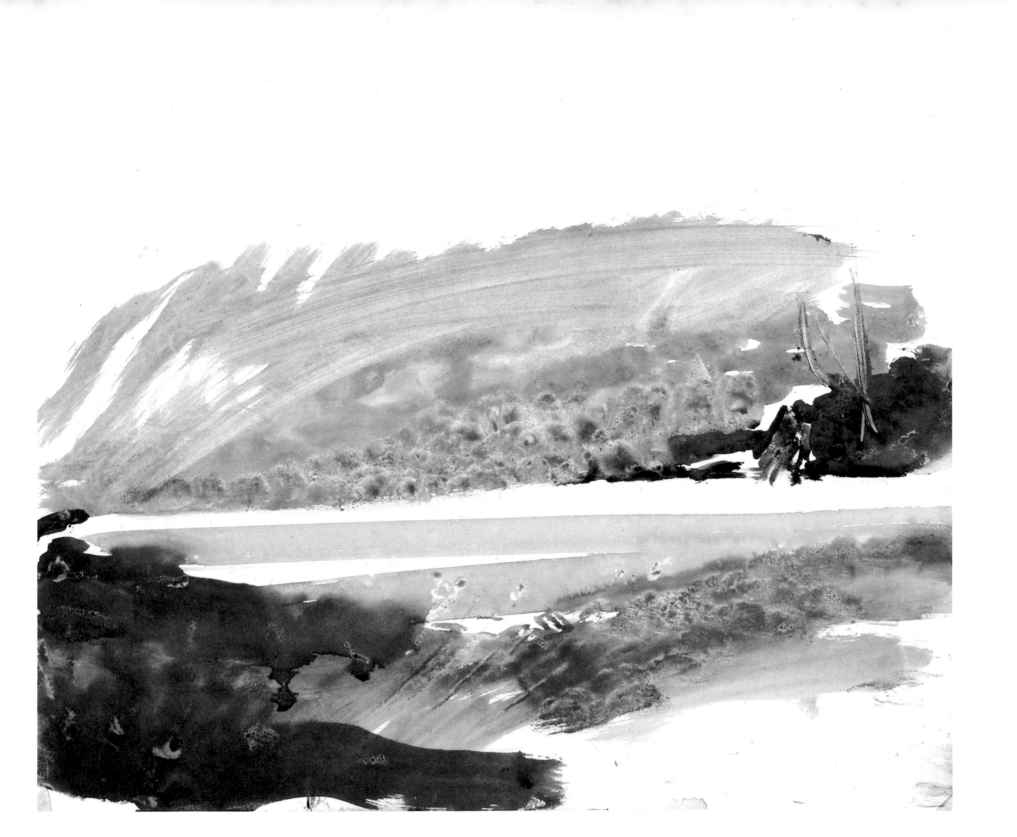

On another day the pond is dull and tawny –

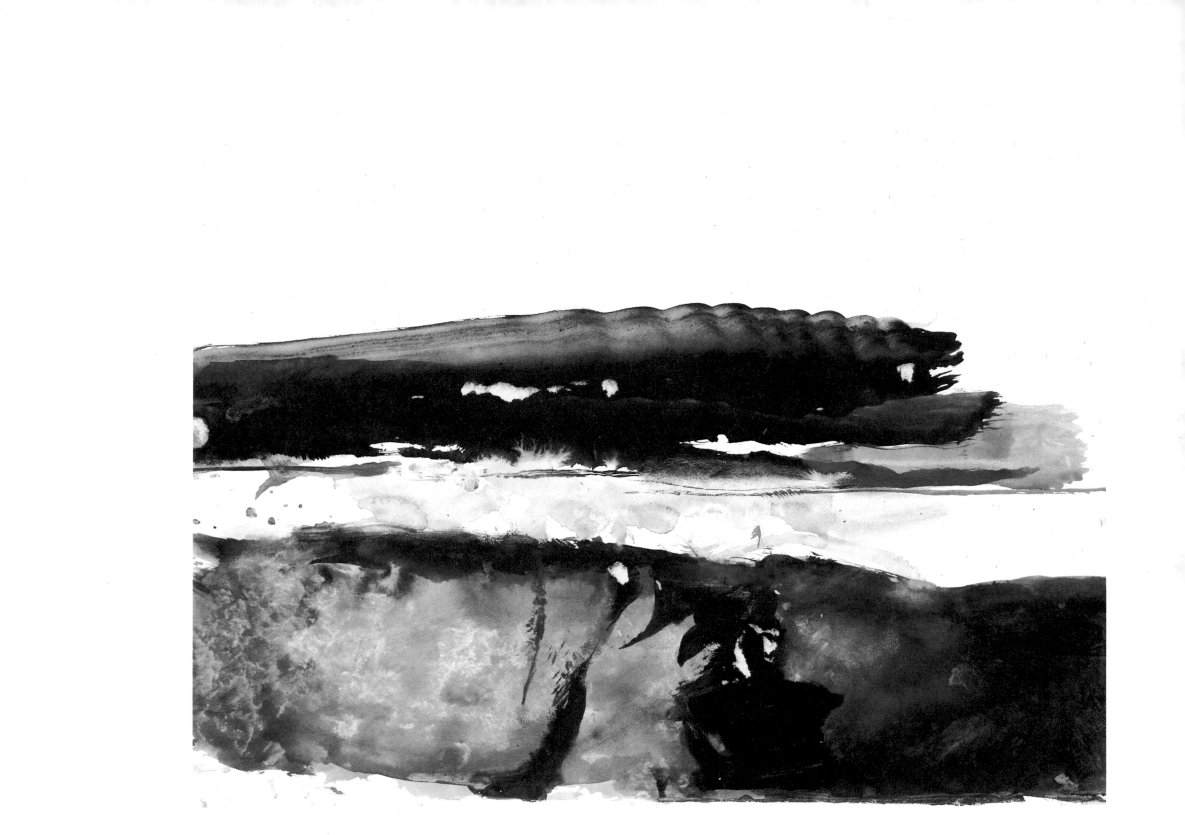

then glows in contrast to the black ground.

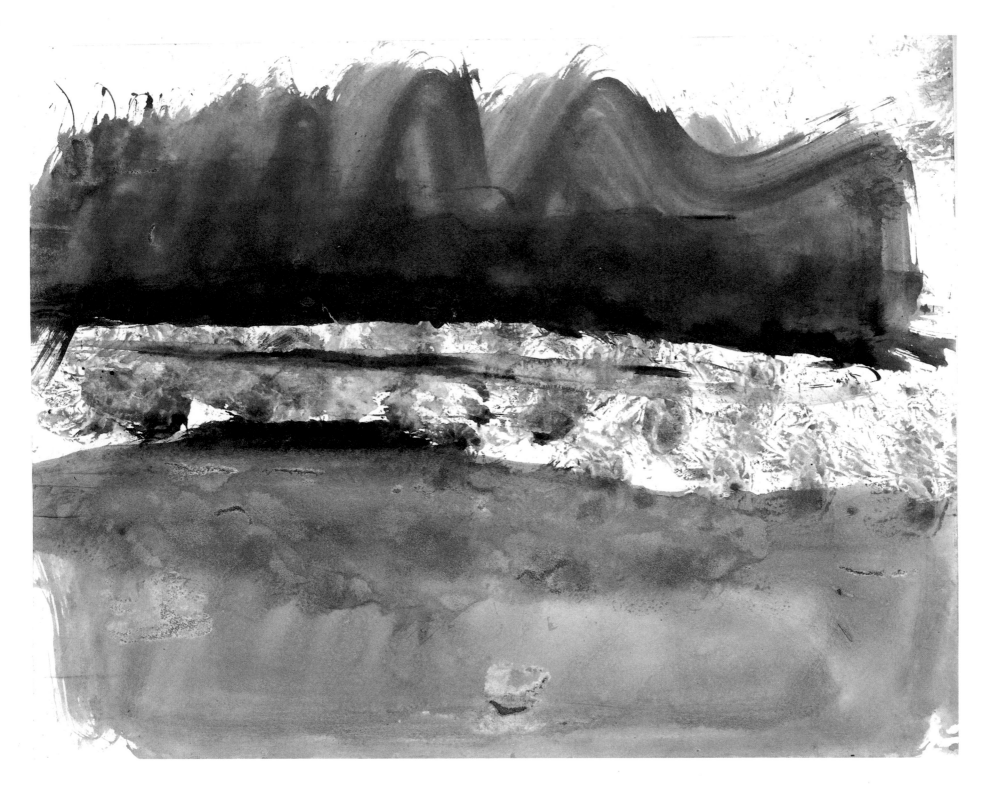

Snow on the hillside above the pond.

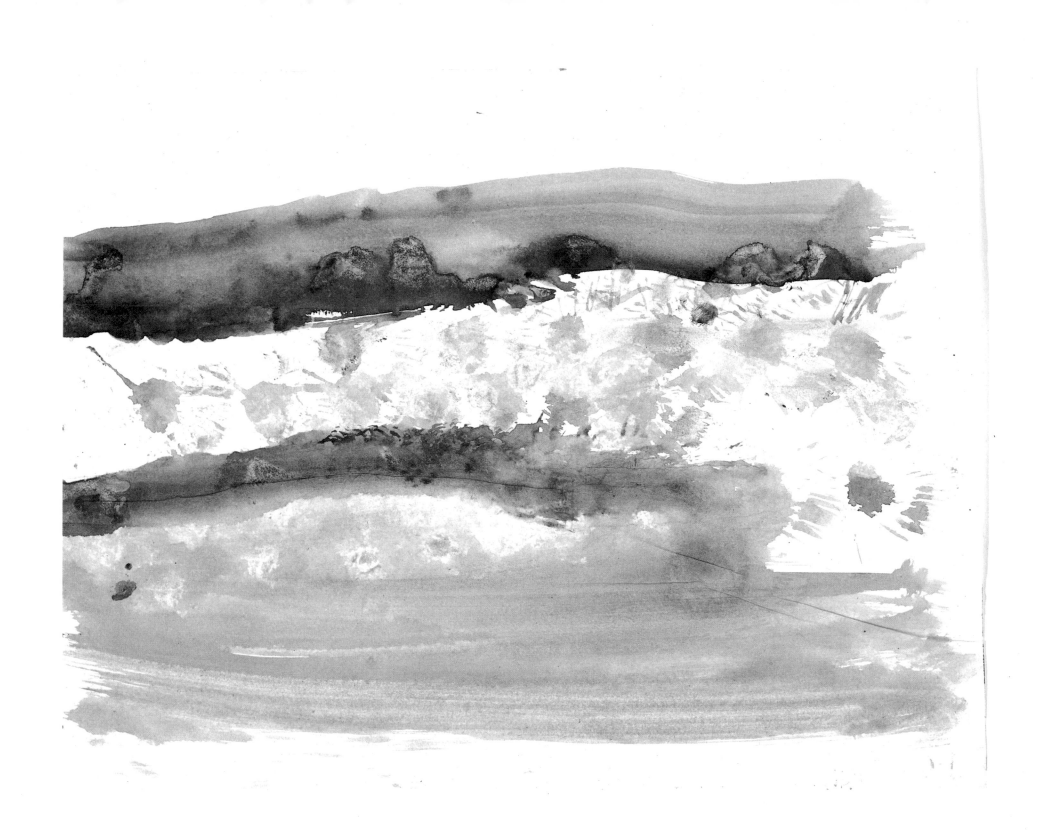

Everything is upside down. A lone Brown Swiss cow –

a small window in the top floor of the house and the kitchen chimney.

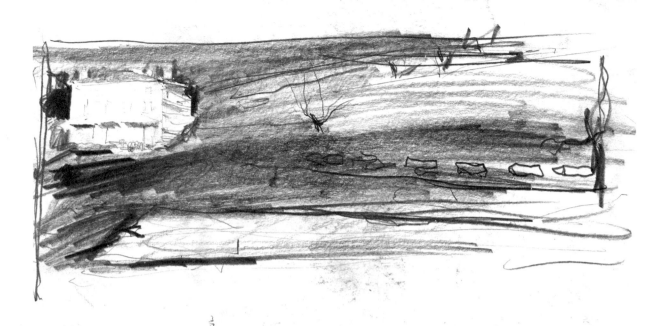

A long line of cattle, like boxcars,
walks single file beside the pond.
Jamie's drawing of a knight's head
appears upside down.

The final composition
of the farmhouse and pond
is abstracted into white shapes
against black.

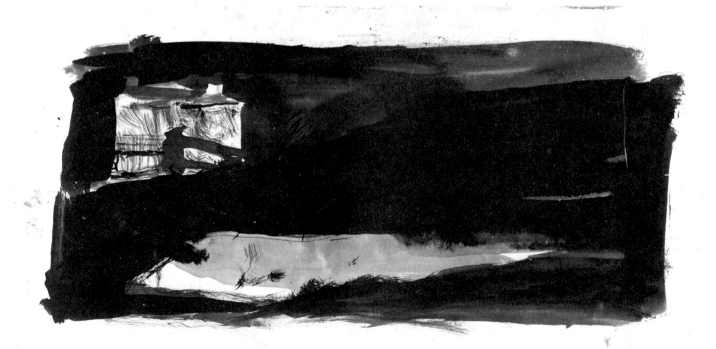

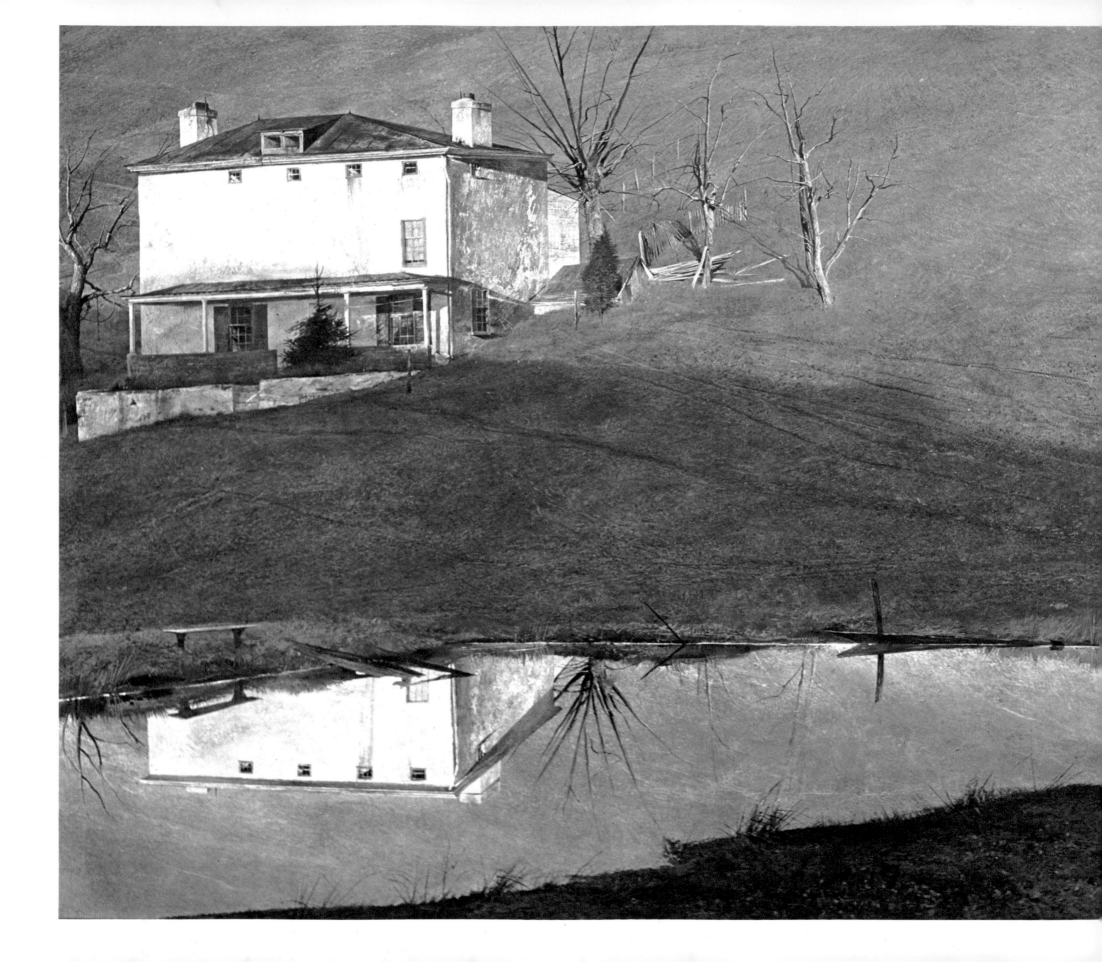

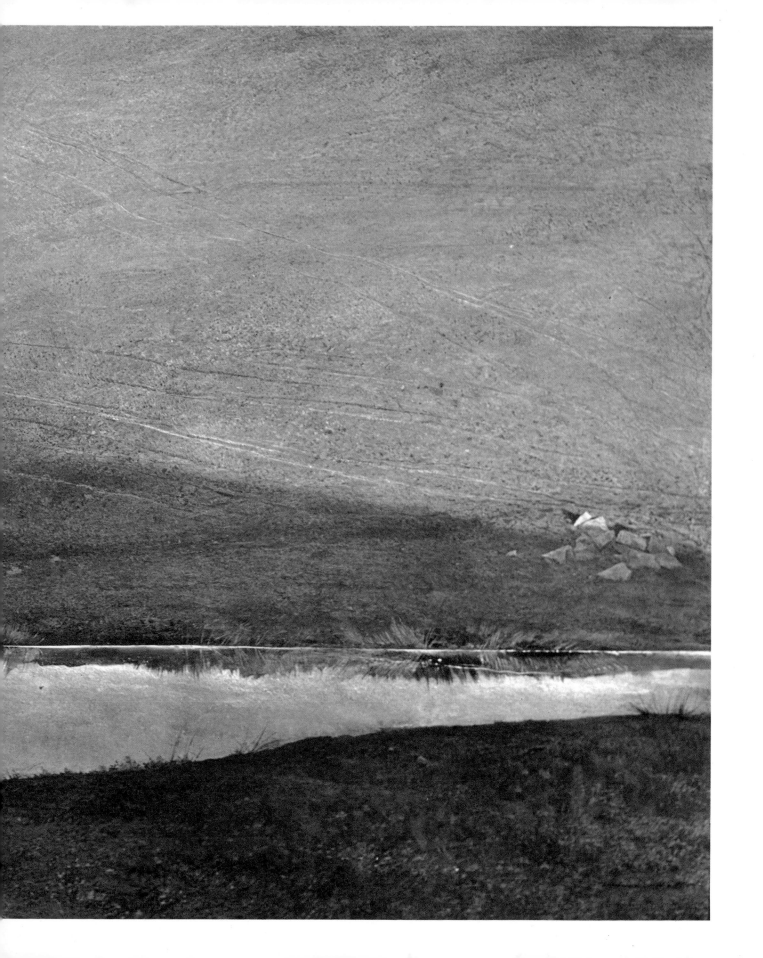

Brown Swiss is painted. The cattle have been replaced with the sweeping tracks made by Karl's tractor – like marks left on a granite surface by receding glaciers. Kuerners Hill casts its shadow on the land as well as the artist's seated figure. A pile of pale green serpentine rocks from "Windtryst" lies scattered on the ground at the far end of the pond in place of the gum tree.

The House from the Orchard Slope

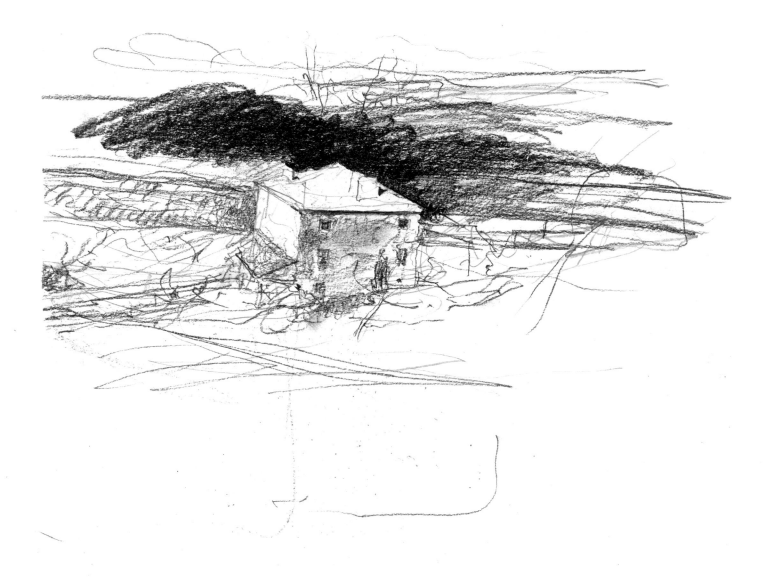

A short walk back up from the pond to the orchard changes the angle
of the house, revealing the southwestern exposure.

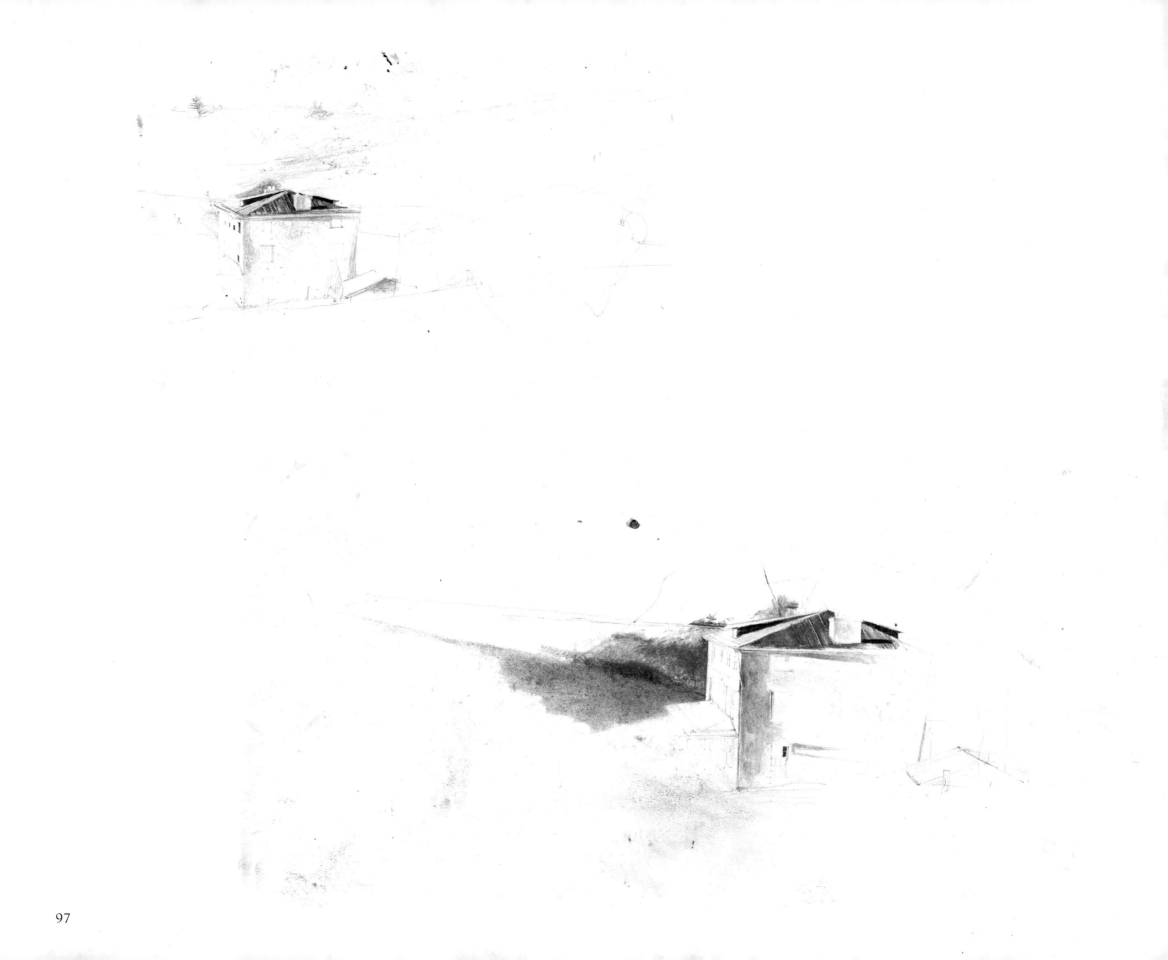

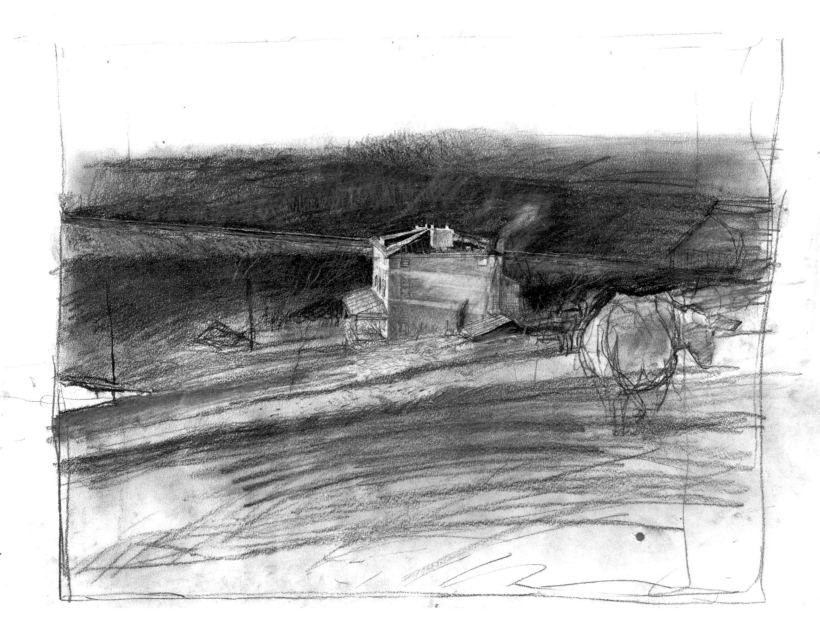

The steel railroad tracks catch the evening light as a lone Brown Swiss cow grazes. Anna Kuerner refuses to use the electric stove in the kitchen, so she must be cooking her supper on the wood-burning stove in the back entry room.

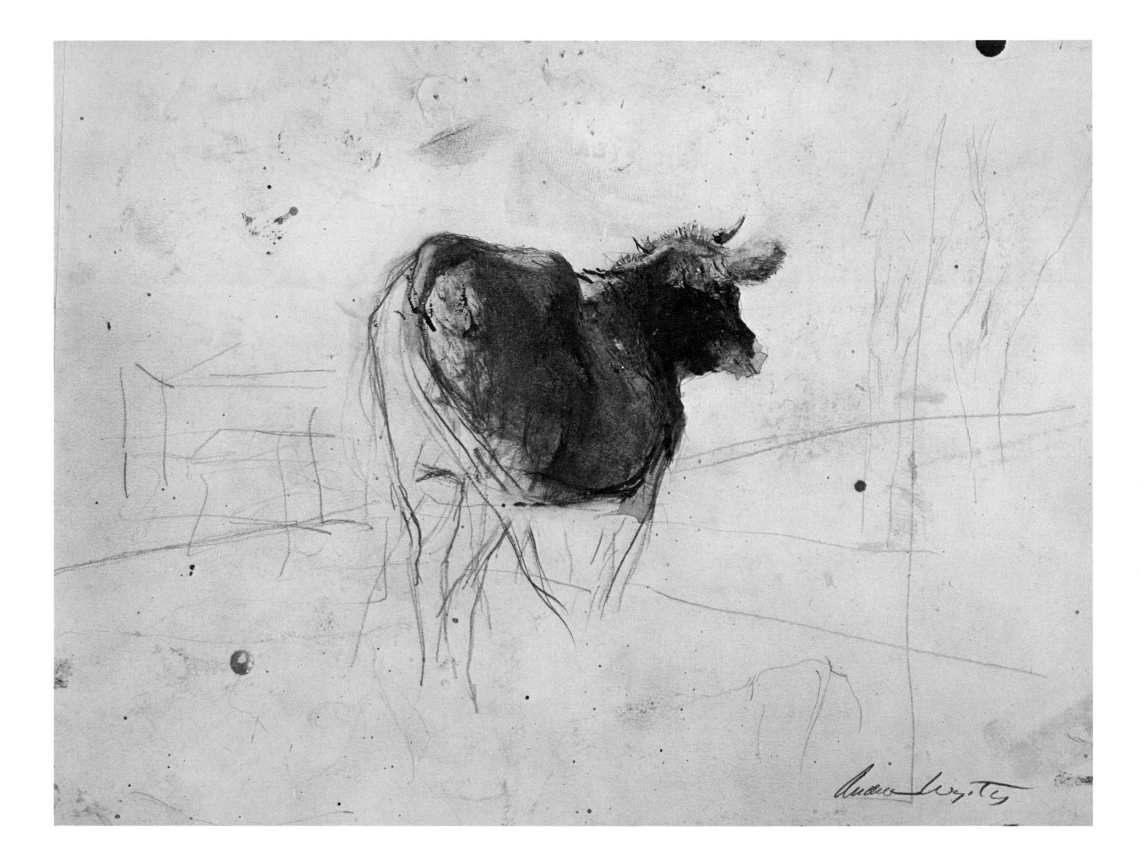

99

A lone light glows from the corner window in the kitchen

and something too indistinct to identify casts long fingerlike shadows on the white wall.

The shadows taking on a shape

become the horns from a big bull moose.

The Kitchen Window

Wyeth moves in closer to the house, concentrating on the kitchen window –
while indicating the moose horns with a few brief pencil lines.

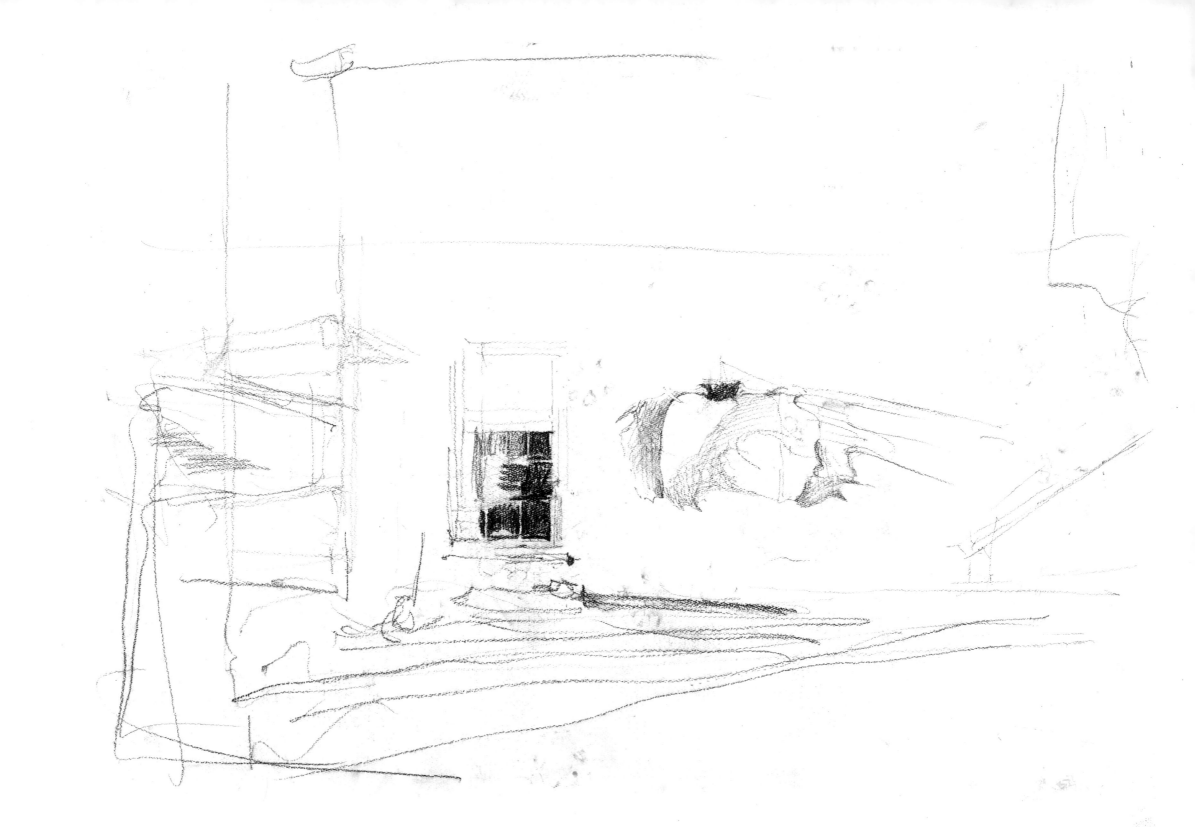

Now the rack of horns becomes a dominant part of the composition.

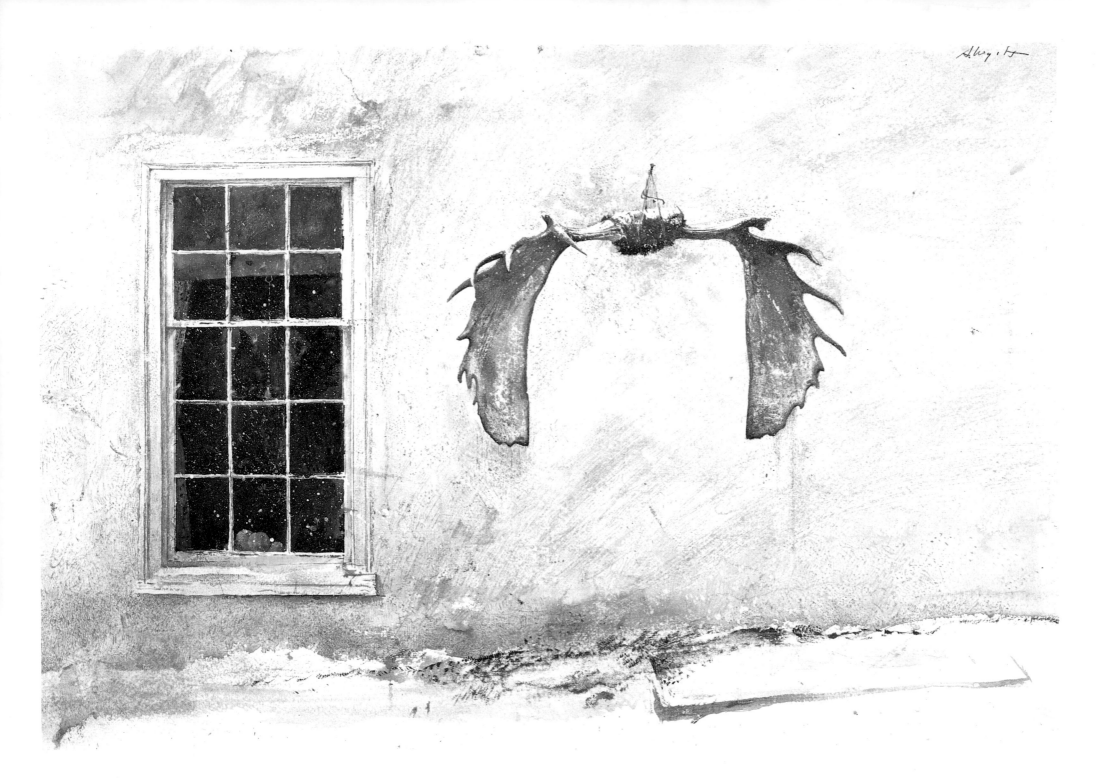

This drybrush, *Moose Horns*, was completed first. The horns seem to hang limply in the falling snow. A basket of oranges sits on the kitchen windowsill. For years Karl had wanted to hunt moose but the pressing duties of the farm and the expense prevented such a luxury. Not until 1963 did circumstances allow him to travel to Newfoundland and bring back this trophy. He proudly displayed it that winter on the outside wall.

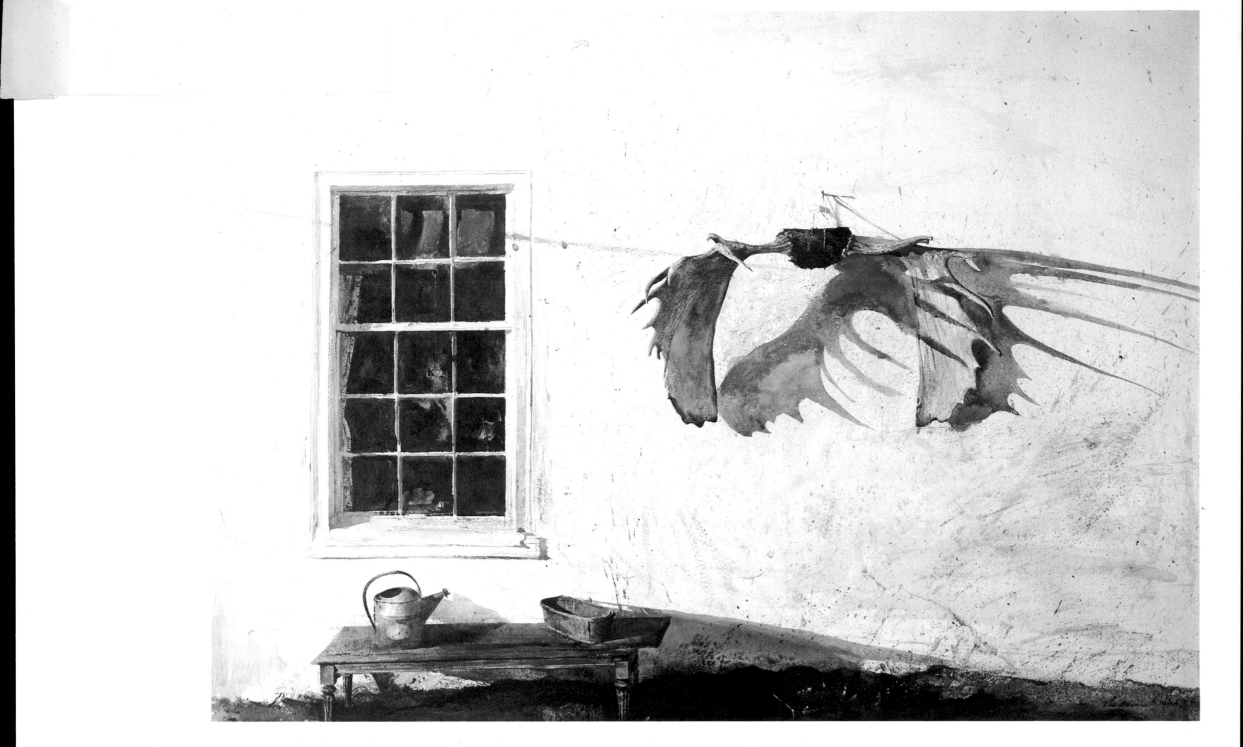

In this final watercolor, titled *The Trophy*, motion has entered the picture along with a watering can and a mushroom basket sitting on a bench. The sweeping shadows cast by the horns even suggest the profile of a moose head. The basket of oranges still sits on the windowsill.

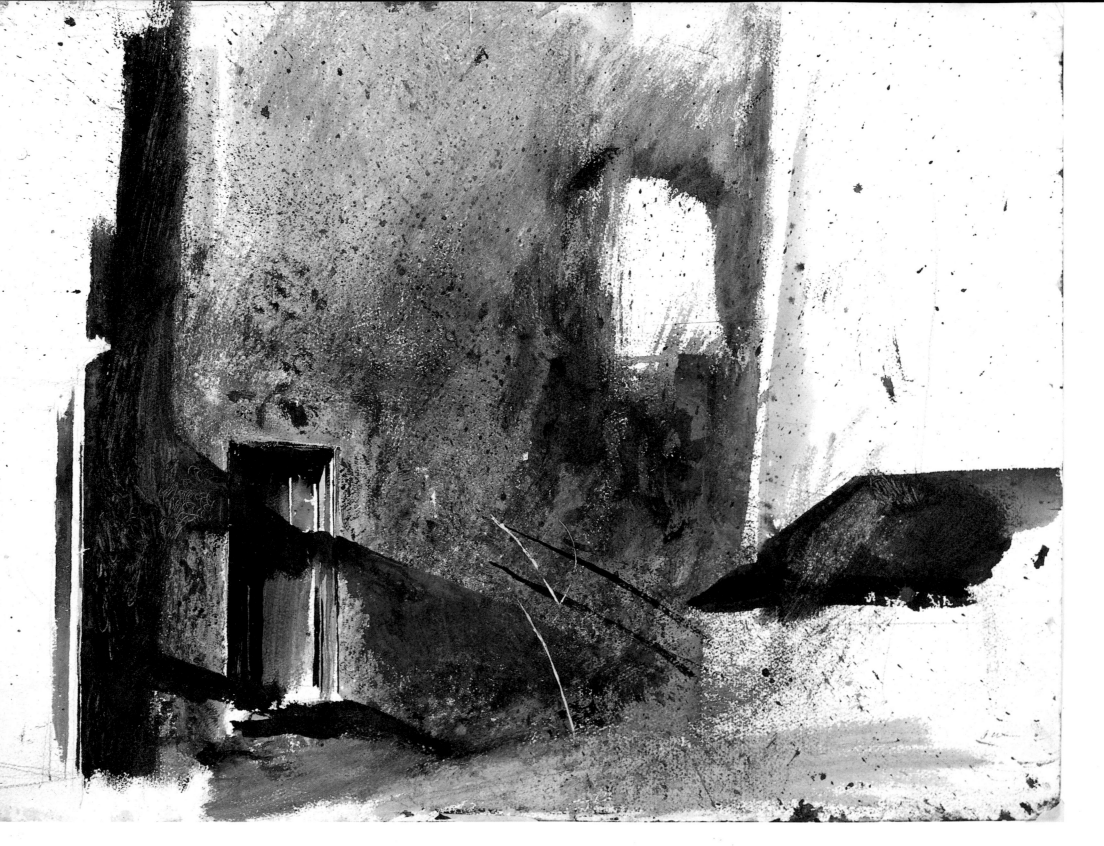

This corner window in the kitchen appears over and over again.
The artist will eliminate window after window, but seldom this one.

Through the window is seen a figure seated at the kitchen table.

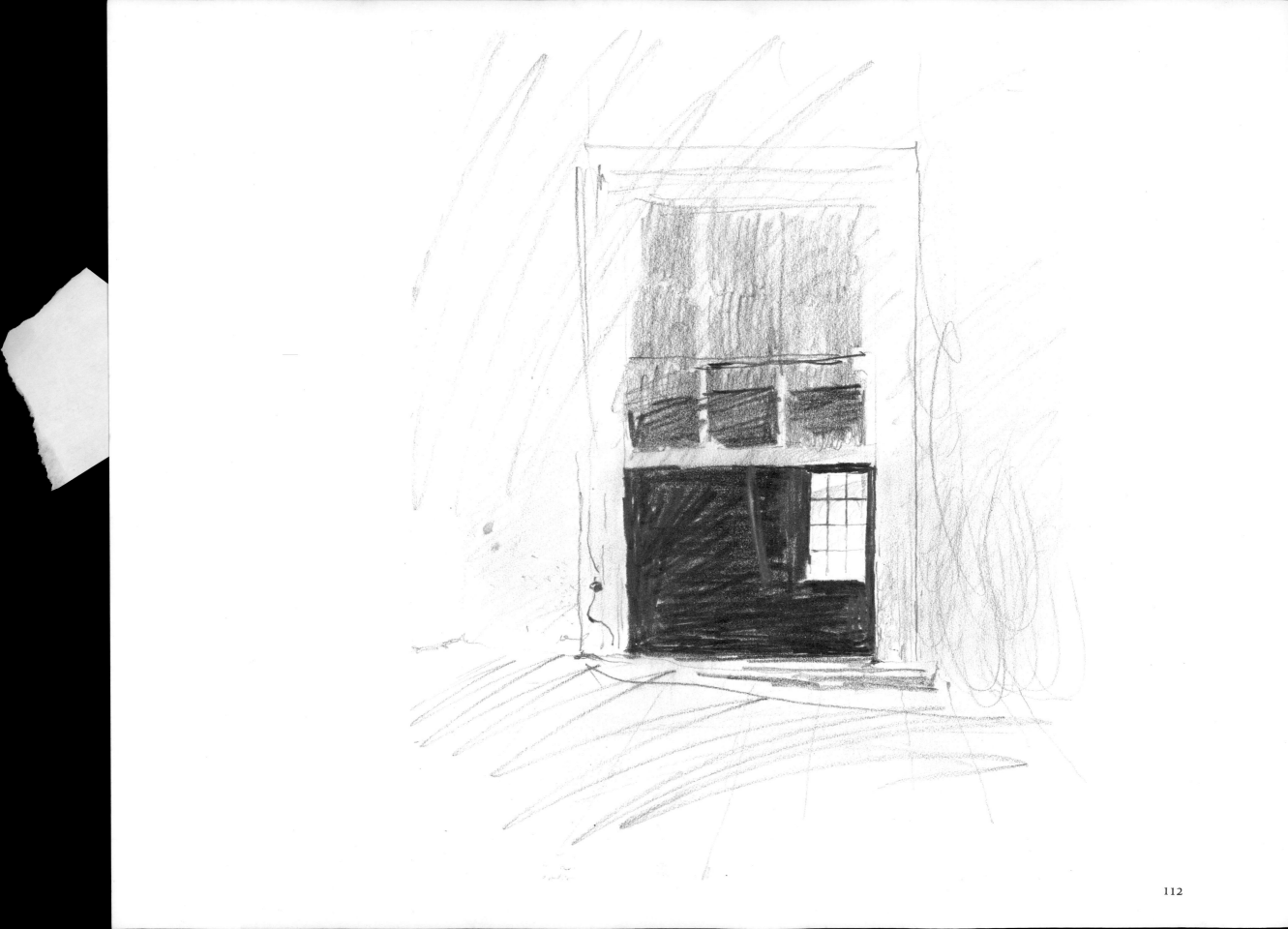

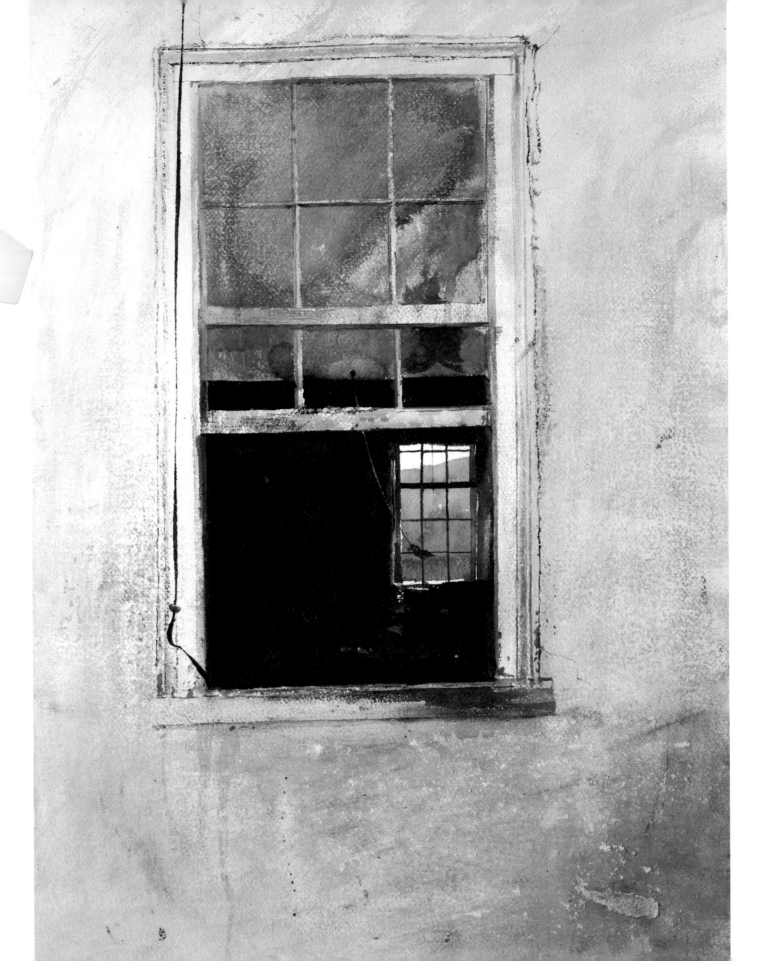

A shade pull blows
in the spring breeze.

113

In the Kitchen

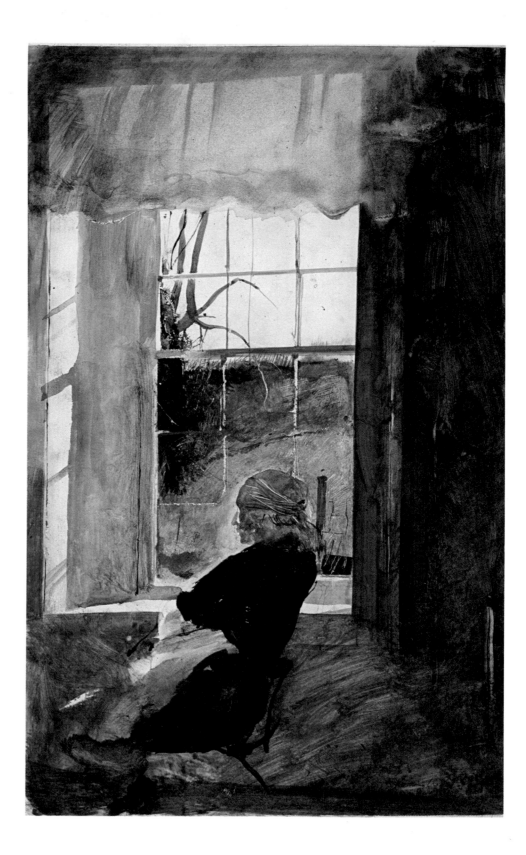

The seated figure becomes Anna Kuerner.

Anna has suffered from acute headaches
all her life and wears a kerchief tied tightly around
her head, believing it helps to relieve the pain.

117

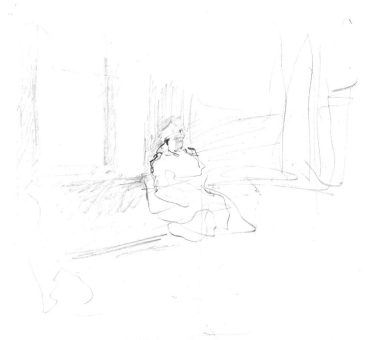

The first slight indications
that something will appear
on the floor at Anna's feet.

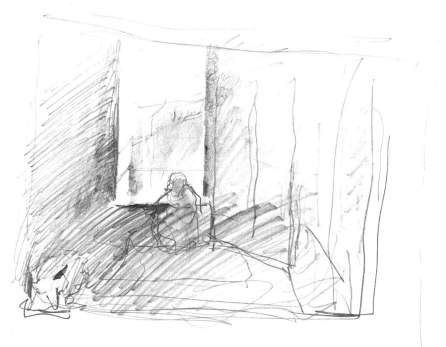

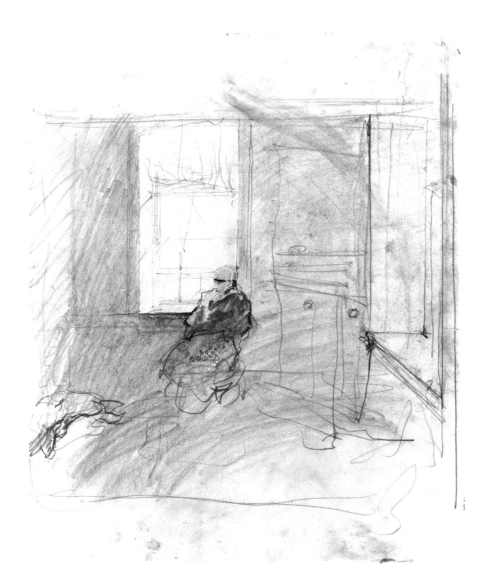

The scrambled lines become a sleeping dog.

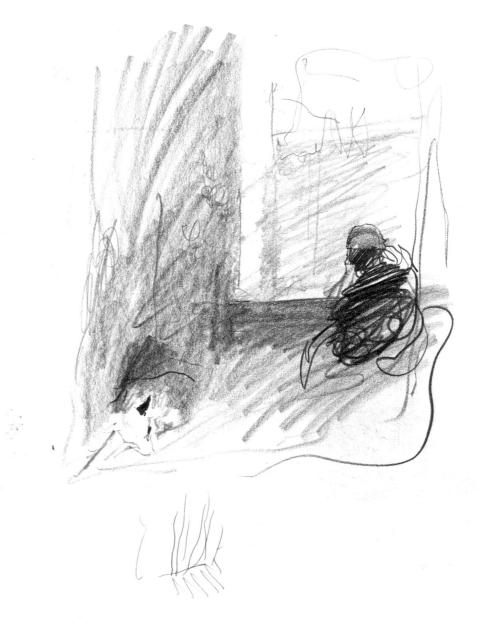

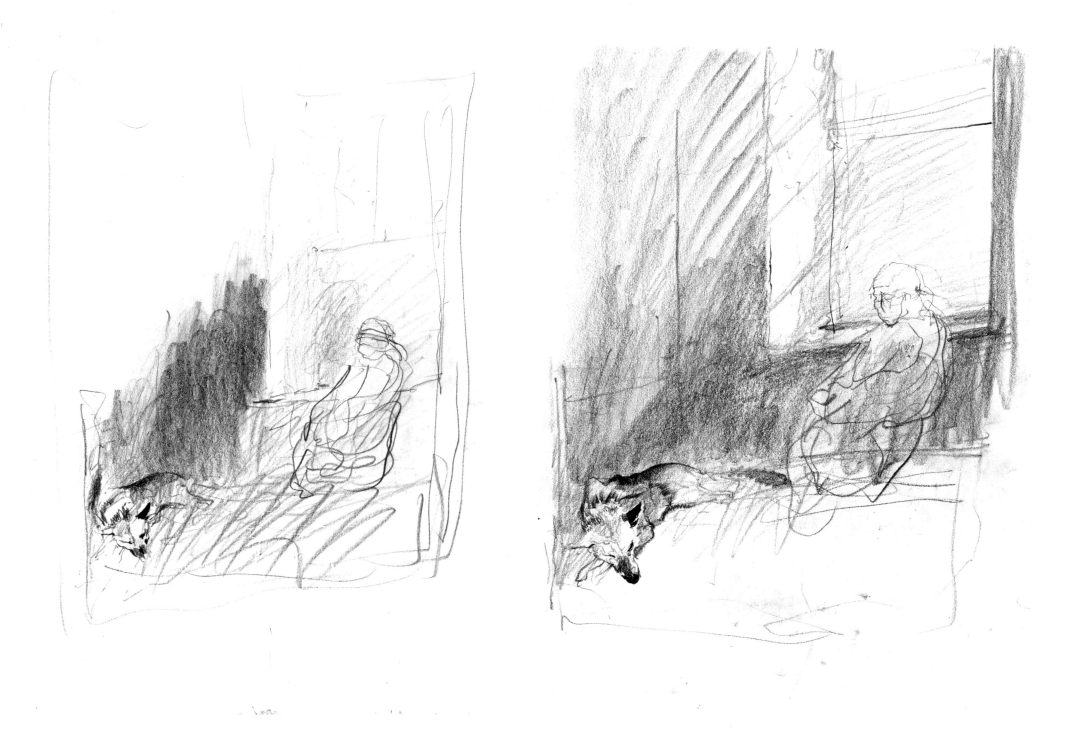

The sleeping dog becomes a German shepherd. Anna's figure is losing importance.

121

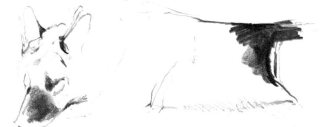
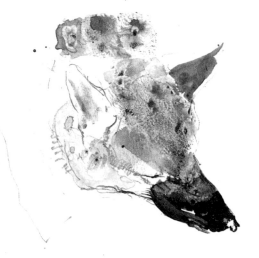

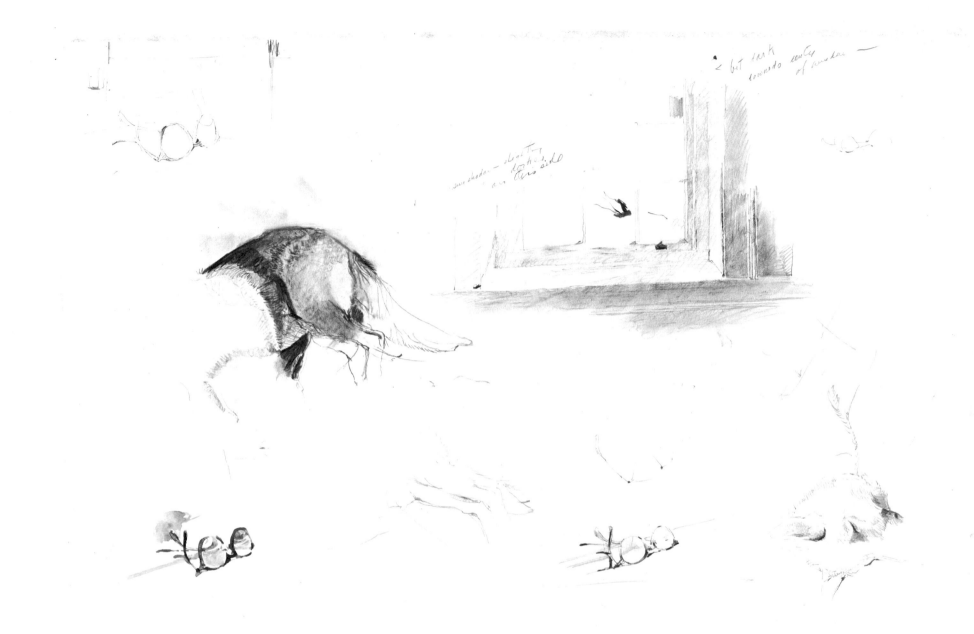

All that is left of Anna are her glasses.

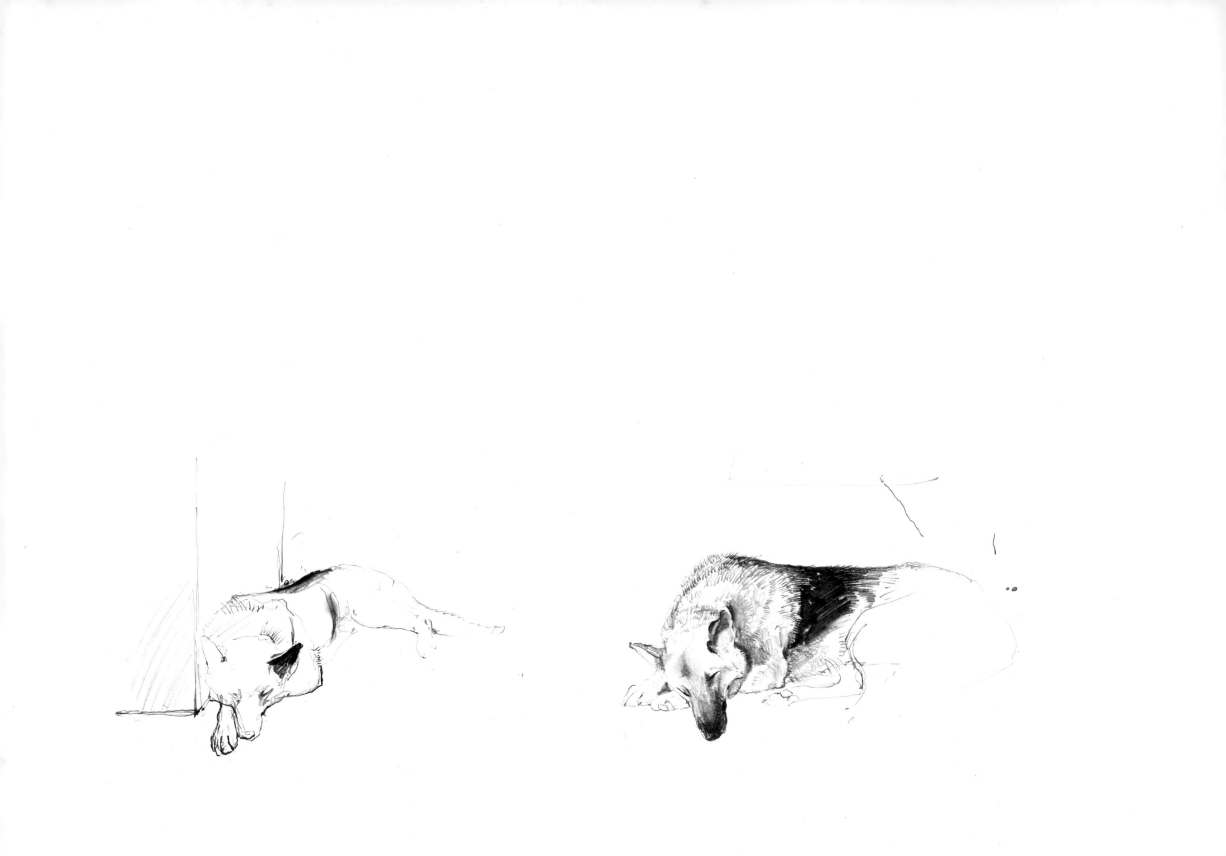

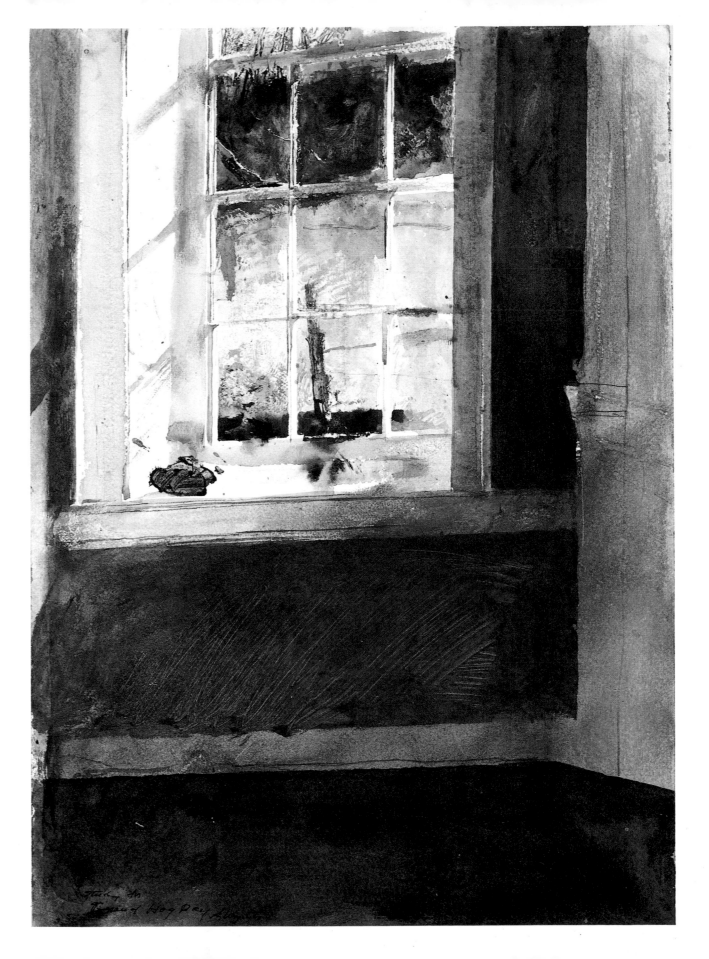

The mid-morning sun has turned the kitchen into a rich gold but both Anna and the dog have disappeared. The one object that never leaves is the window.

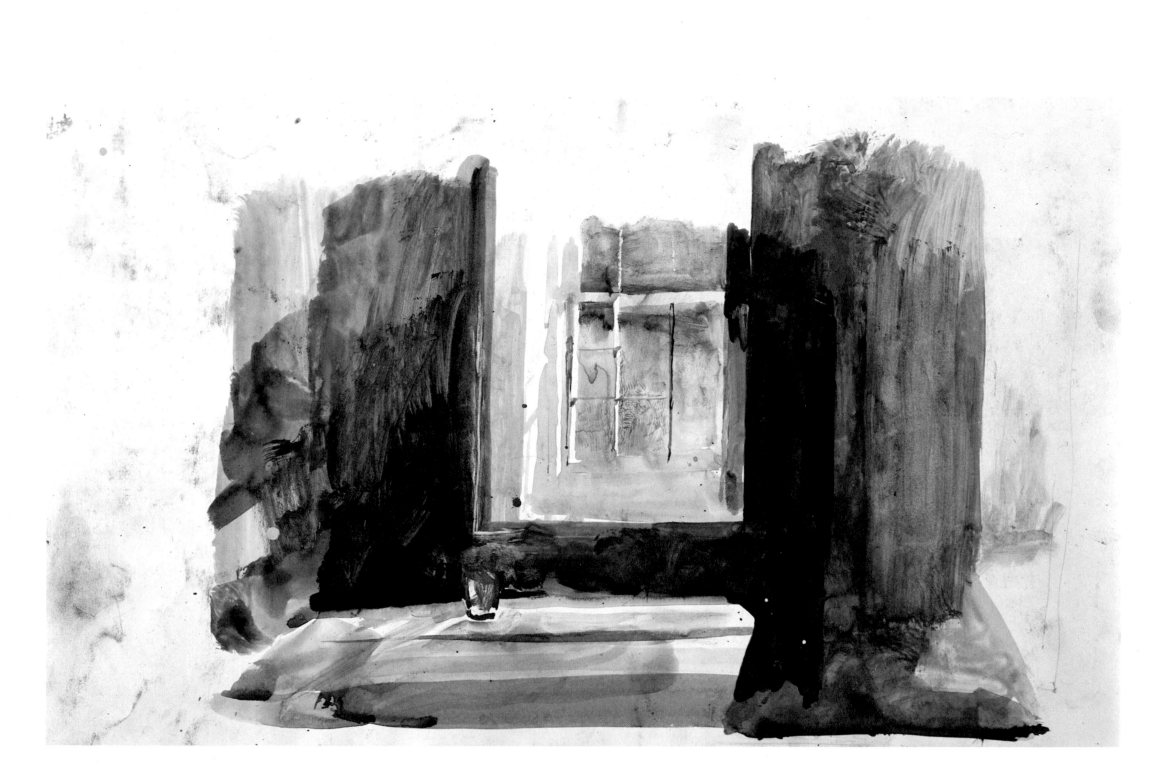

For the first time a table top appears in the composition – with a glass of hard cider.

Now it is set for the noontime meal. Half a loaf
of Anna's homemade bread rests on the cutting board.

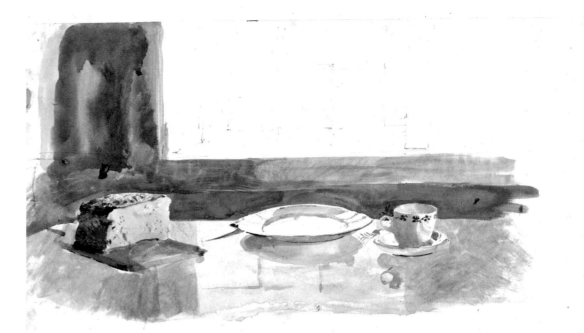

All food is gone but the fork, knife, plate
and flower-trimmed cup remain.

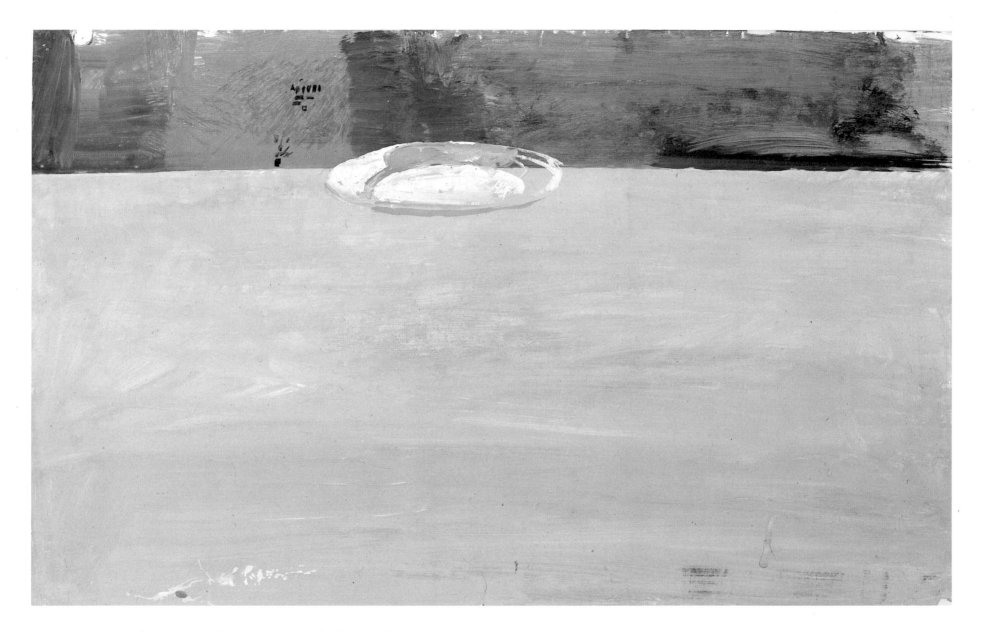

Everything has been cleared away except the lone white plate.

The first indication of wallpaper designs appears on the wall behind.

A casual visitor to the Kuerner farm might overlook the fact that Anna even exists she is so elusive, having withdrawn from reality many years ago. Her touch is seen in very few places on the farm. One of them is the flowered wallpaper in the kitchen.

Anna's high work shoes
sit on the kitchen table.

The German shepherd
comes back into the kitchen
to sleep under the window.

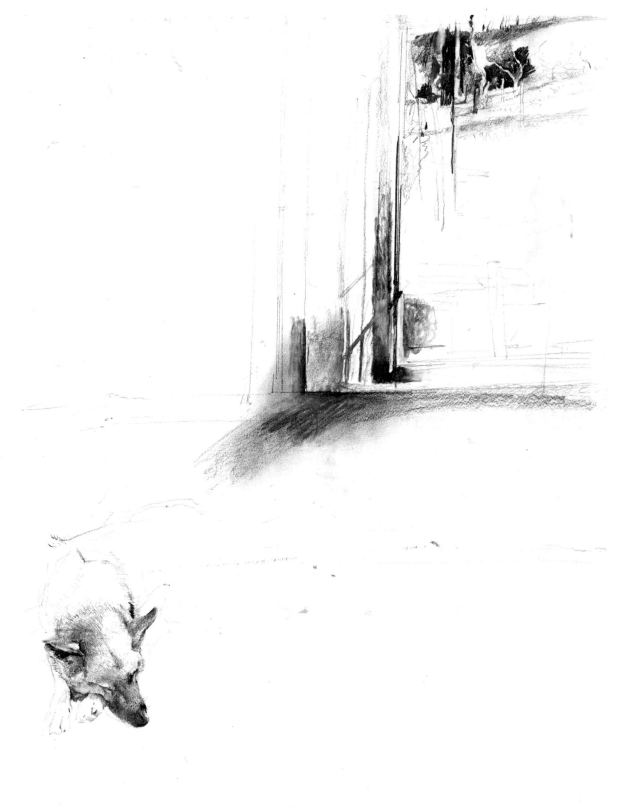

The Gum Tree Log

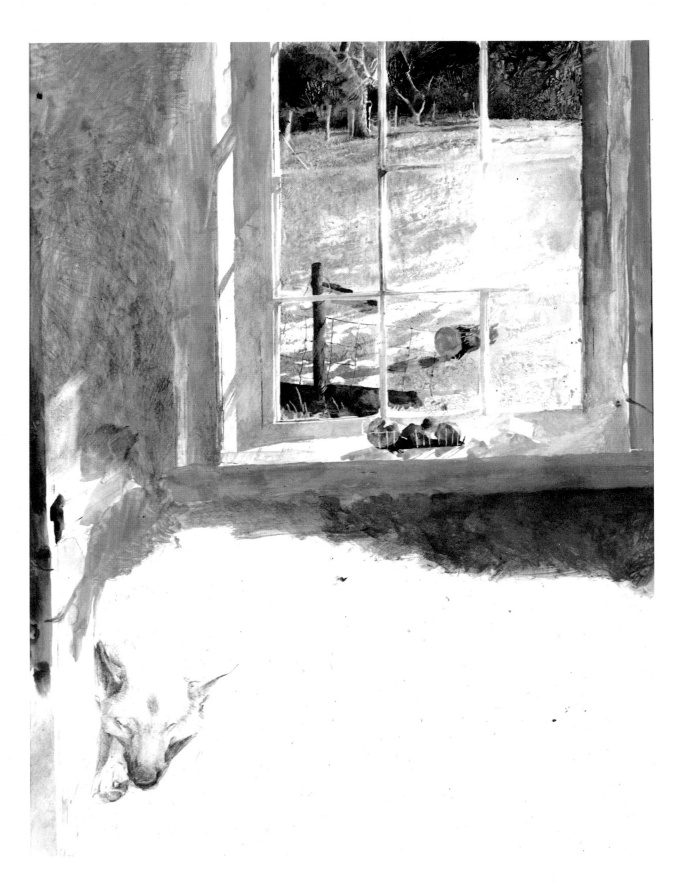

For the first time a seemingly small log
can be seen through the window, while the dog still
sleeps on the floor. A basket of oranges, as in
Moose Horns and *The Trophy,* sits on the deep
windowsill.

The artist knew that seemingly small log, for it was the trunk of the gum tree that grew
by the farm pond. If a tree shows the slightest signs of decay, the Kuerners cut it down.

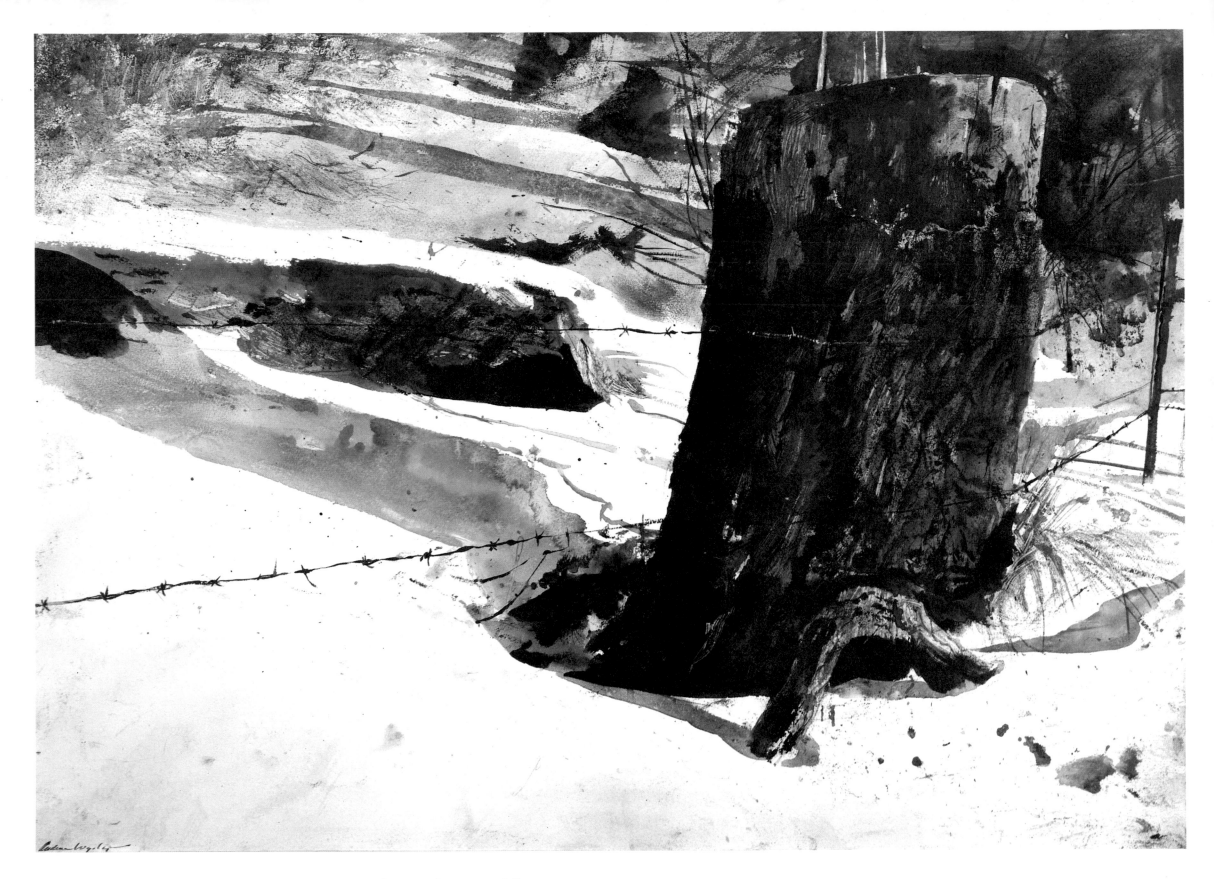

The gum tree stump in winter after the first snowfall.

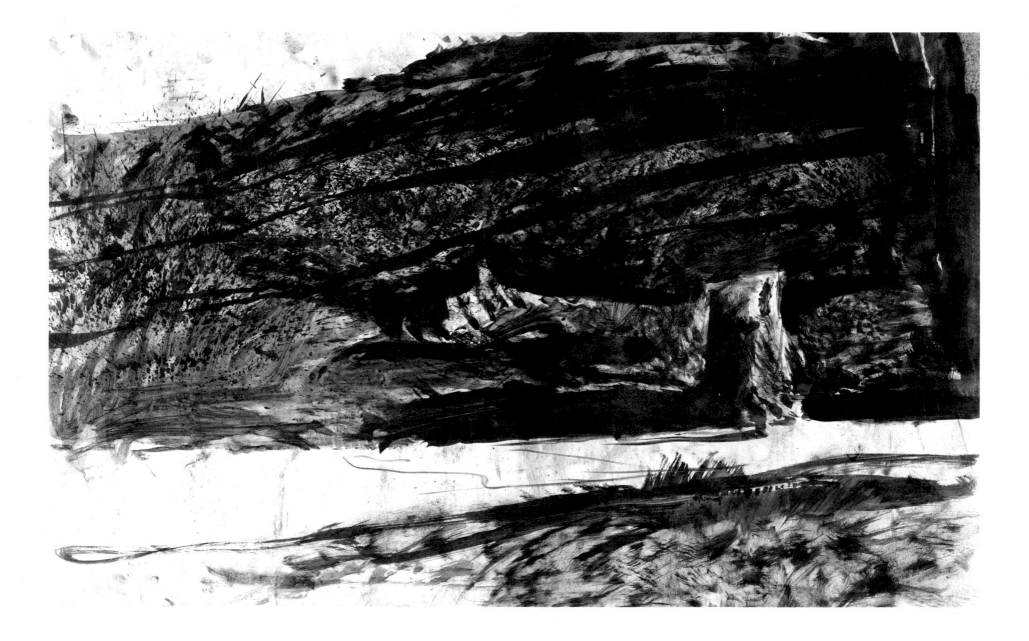

136

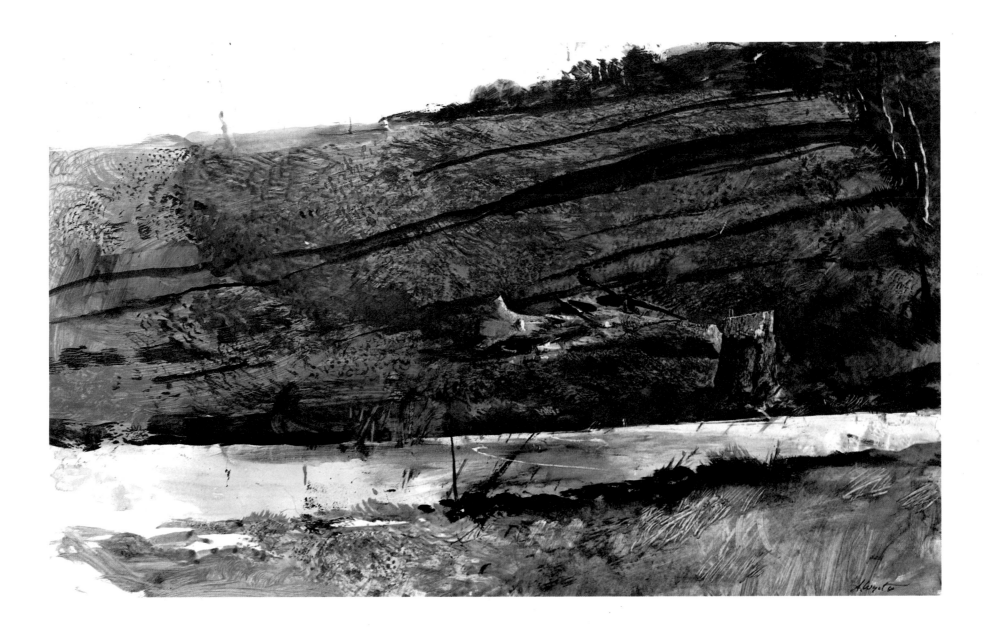

The main branches have been cut off.

Sections of the trunk have been sawed into chunks
and a hauling chain wrapped around the main log
so that it could be dragged by tractor
up from the farm pond to the house.

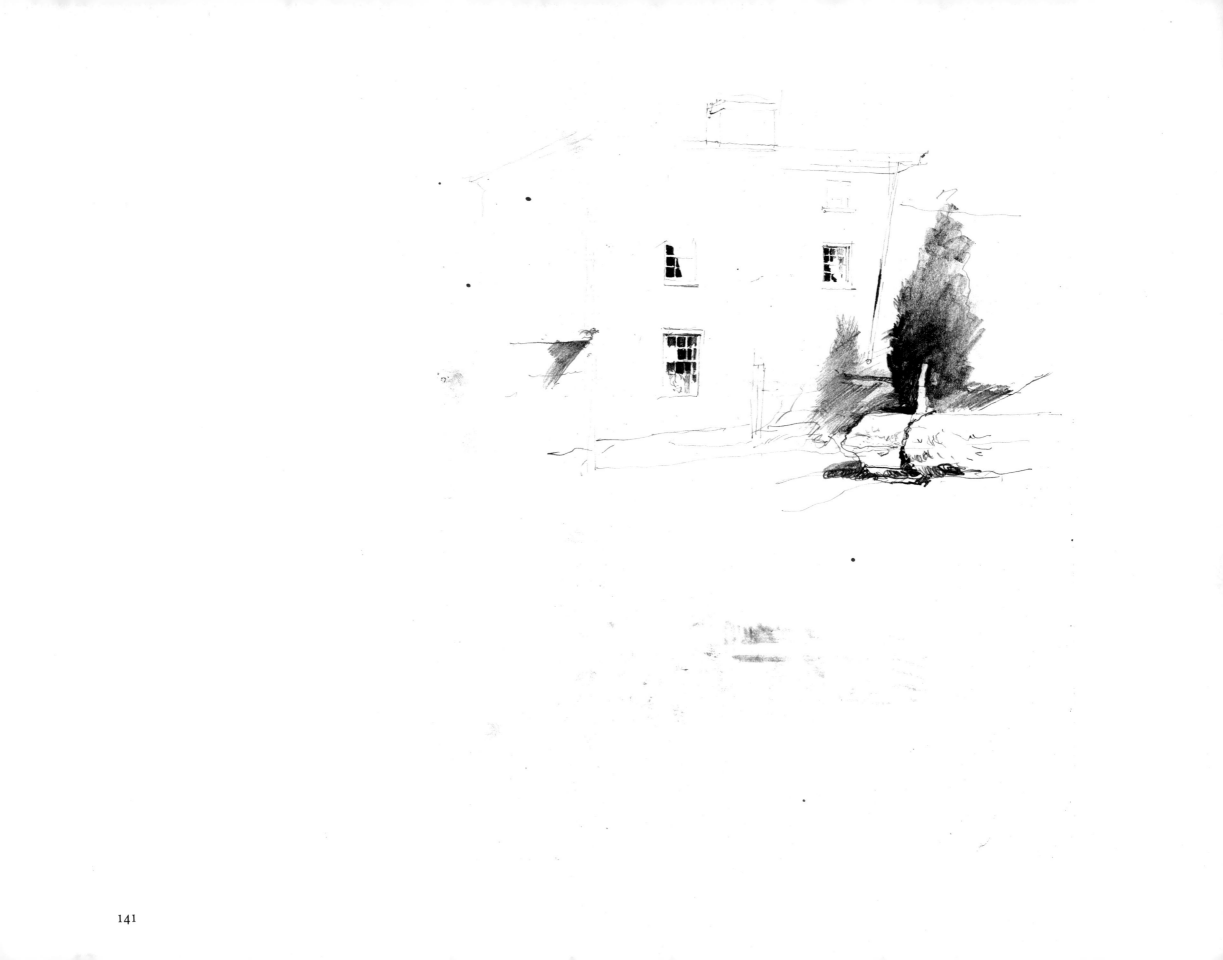

141

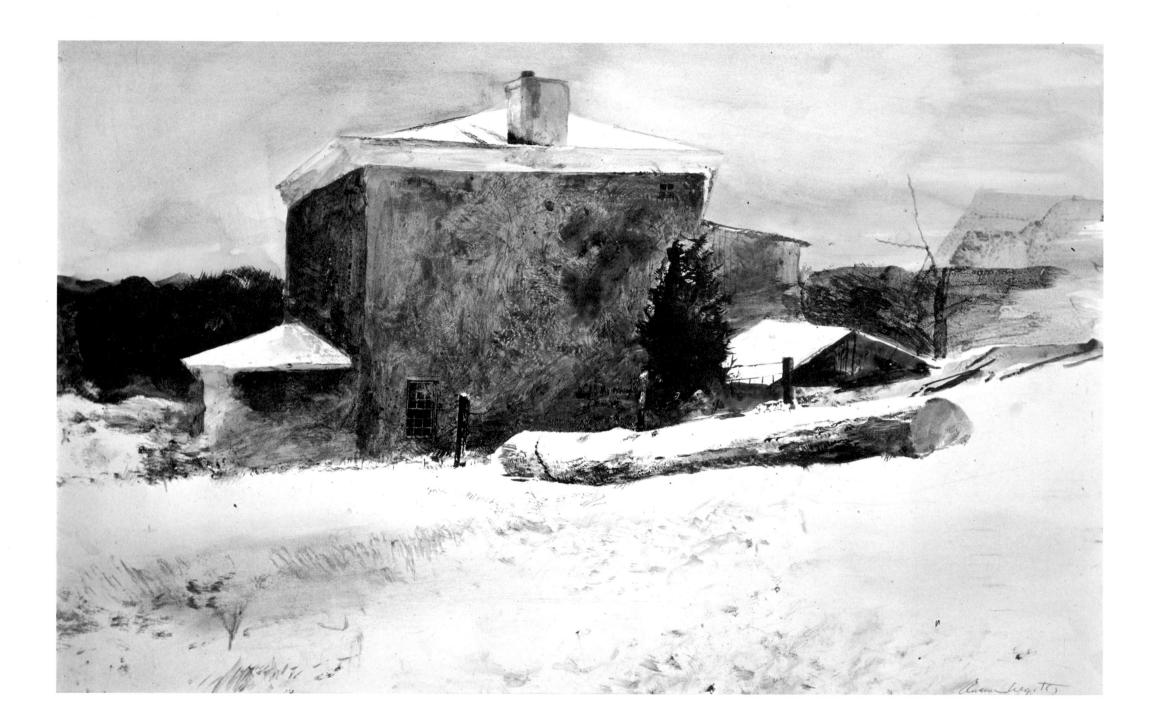

142

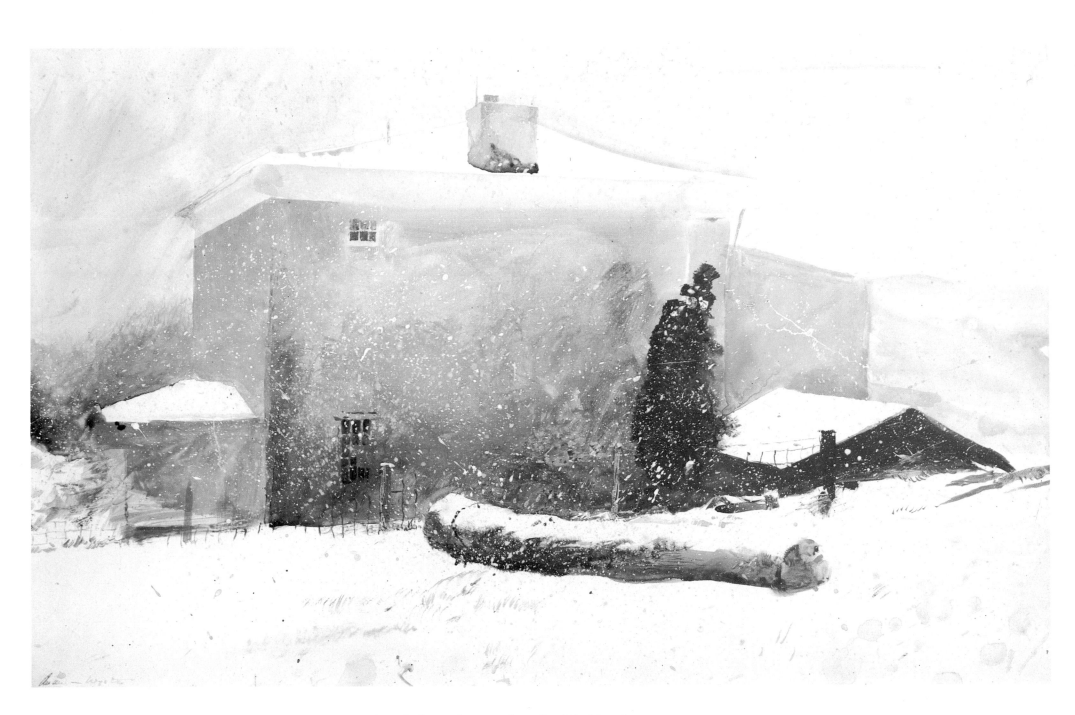

In the two years since *Brown Swiss* was painted the cedar tree has doubled in size.

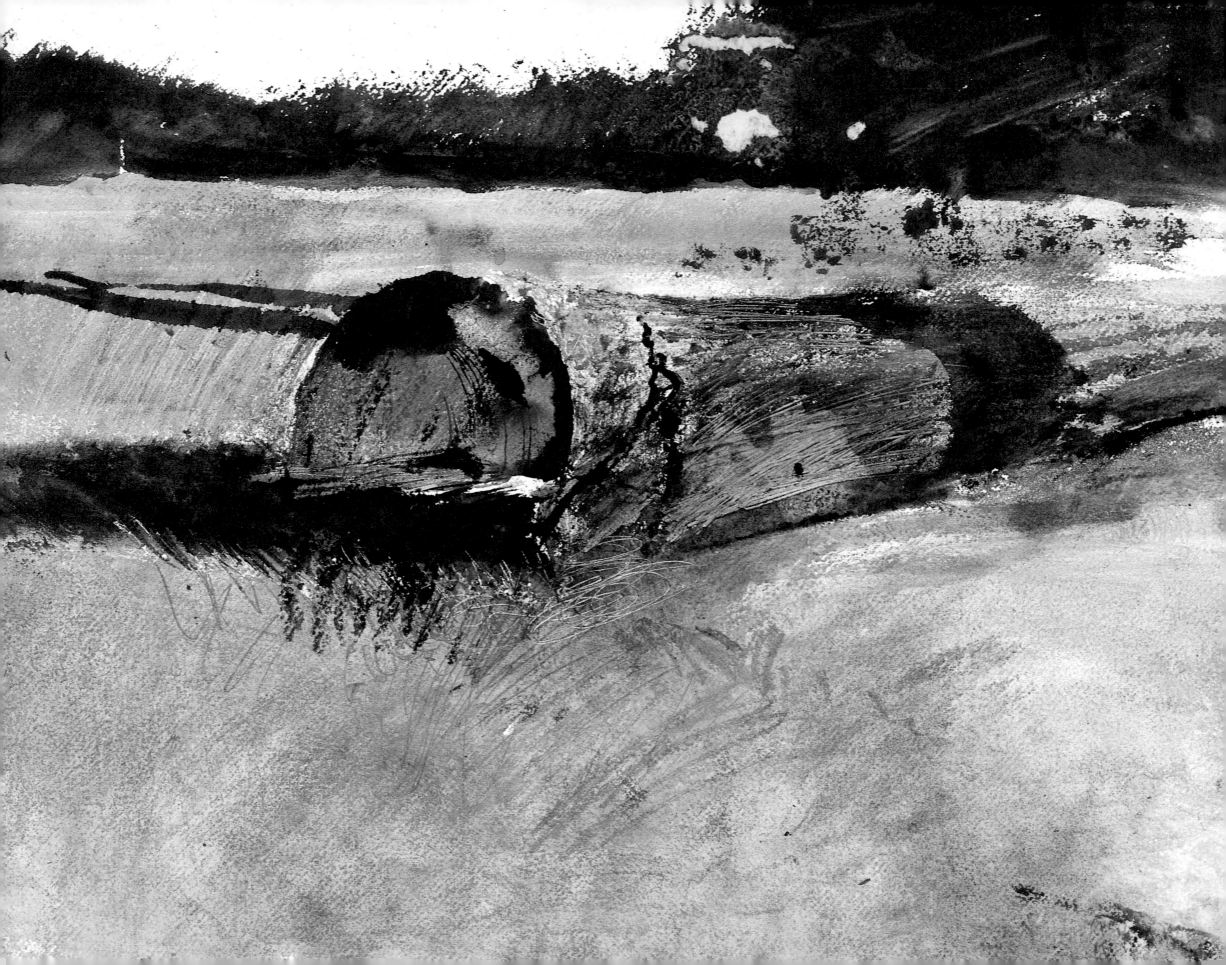

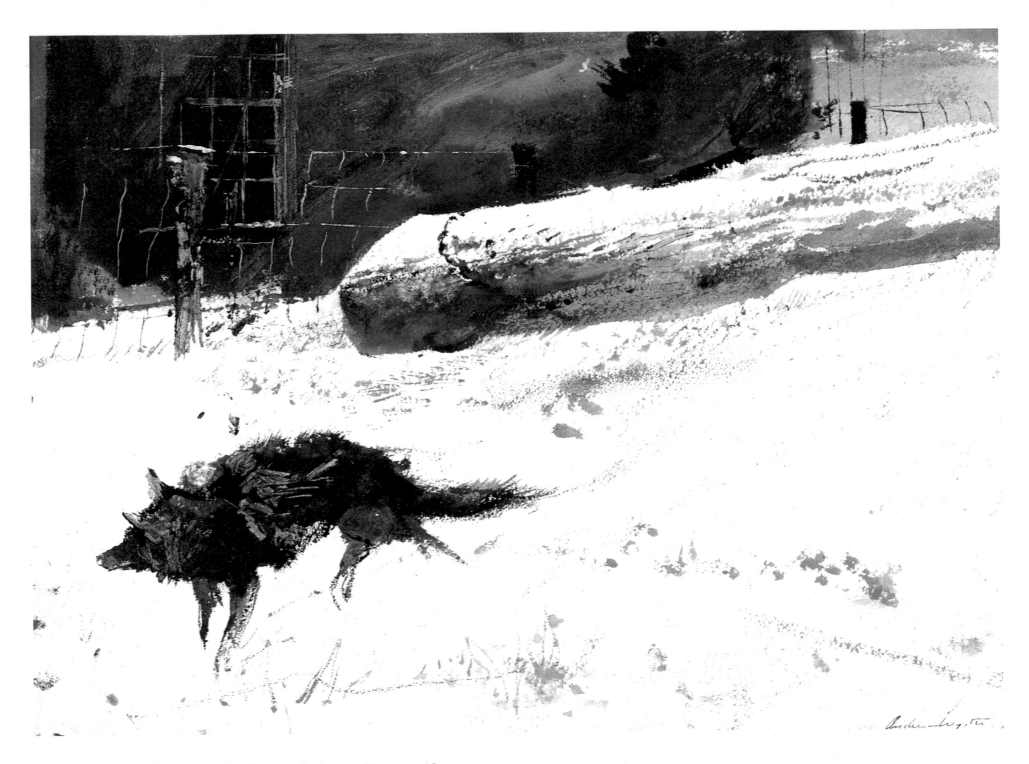

The German shepherd prowls close to the house like a wolf,
then vanishes forever from the picture.

The log and fence post are increasing in size
through the briefly indicated windowpanes.

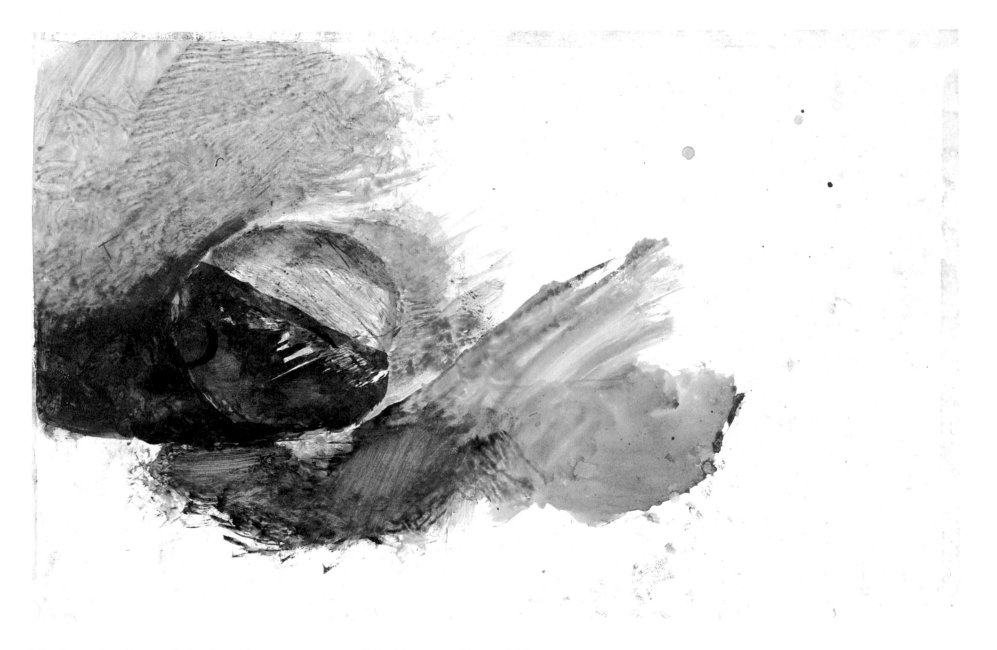

The jagged splinters left when the gum tree was felled become like wolf fangs.

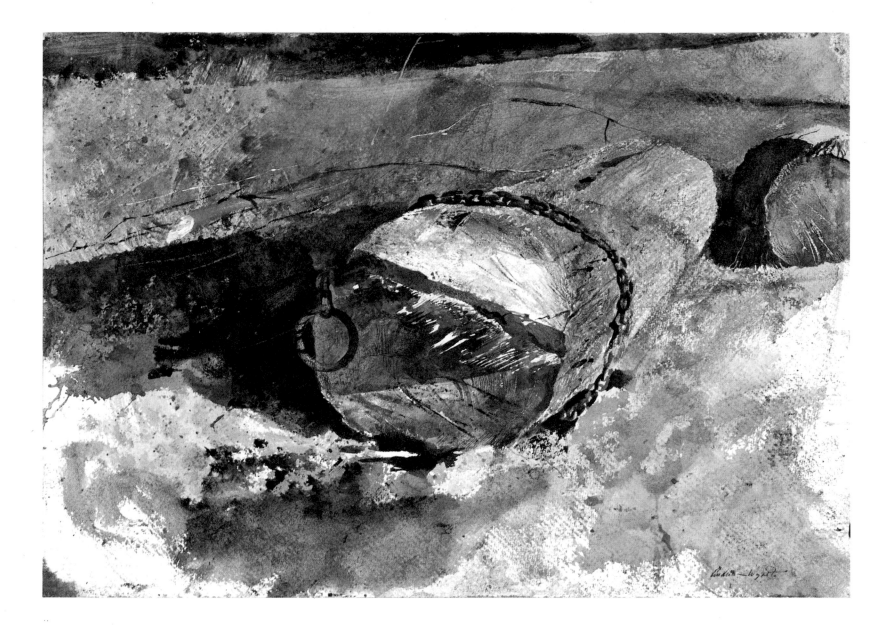

Karl begins to cut the big log into two-foot lengths with his chain saw.

The artist works quickly before the wood is split into firewood, since he never asks anyone to save something he wants to paint. After *Groundhog Day* was completed Karl saw the tempera when he delivered a load of split gum tree firewood to the artist's studio, then hurried home to replace the cracked windowpane he had overlooked in his kitchen window.

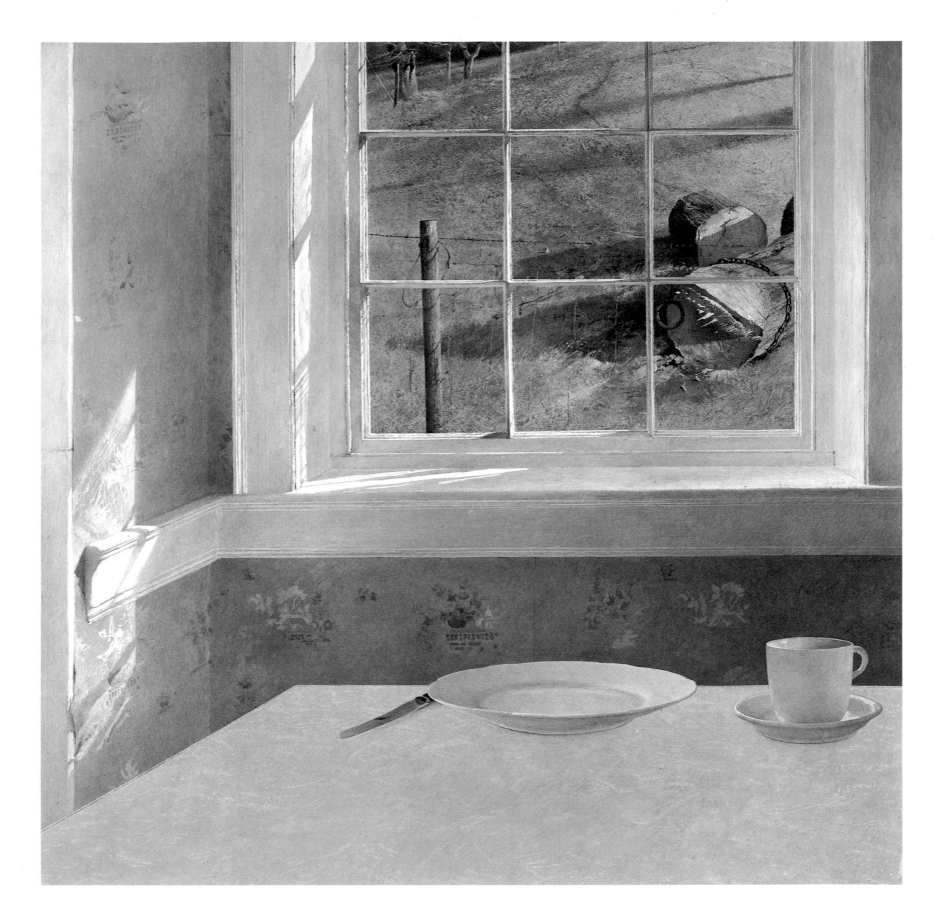

149

Back Outside

Through the *Groundhog Day* window Anna's figure can be seen seated at the kitchen table.

Cows wander across the winter landscape.

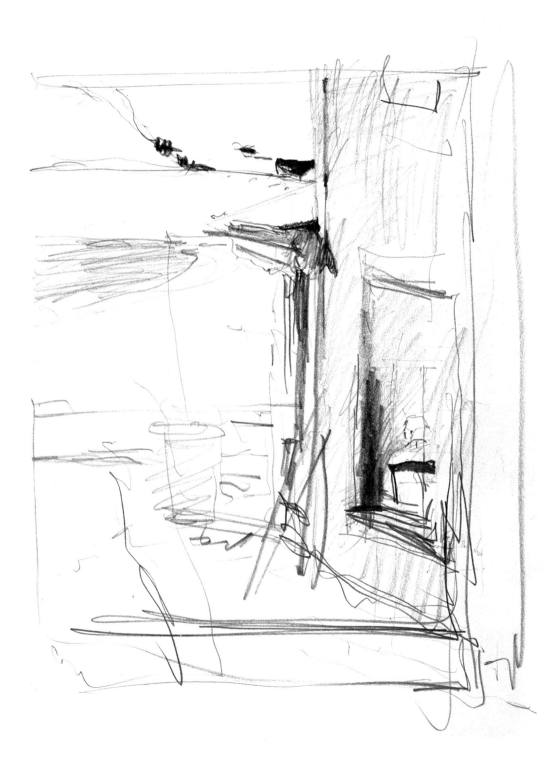
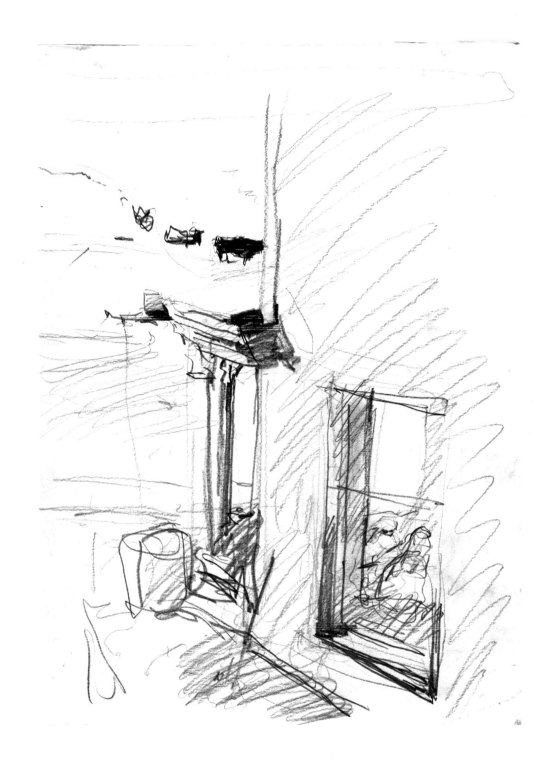

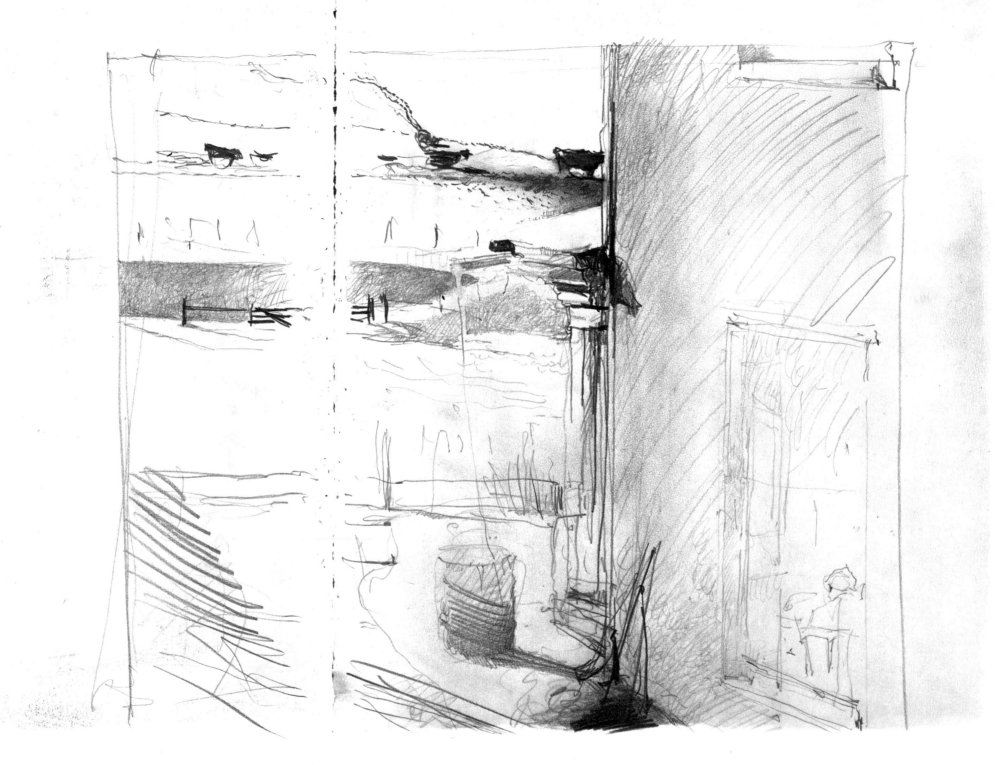

The composition is enlarged to include more of the farm pond.

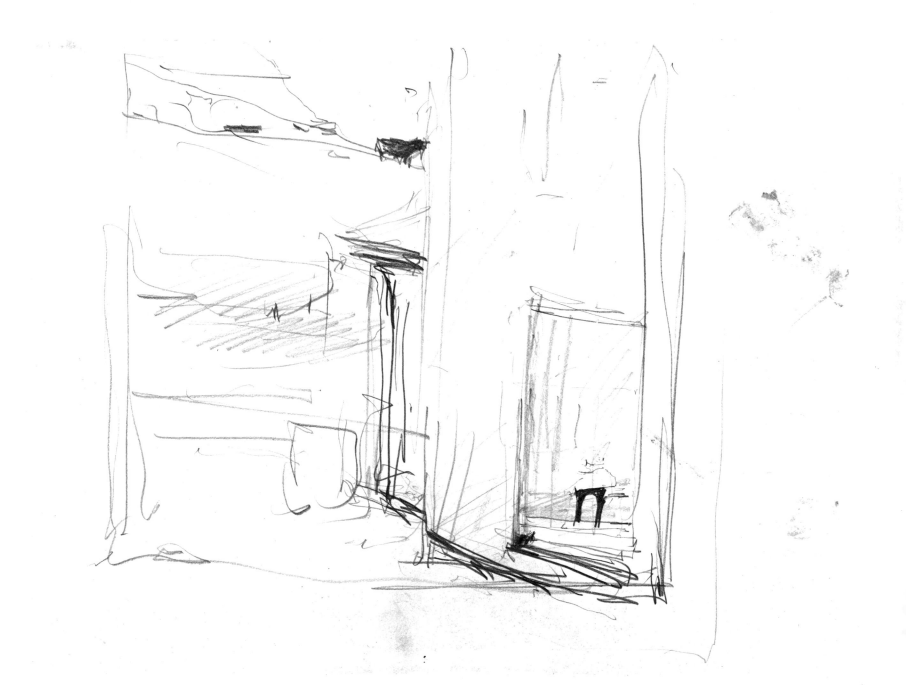

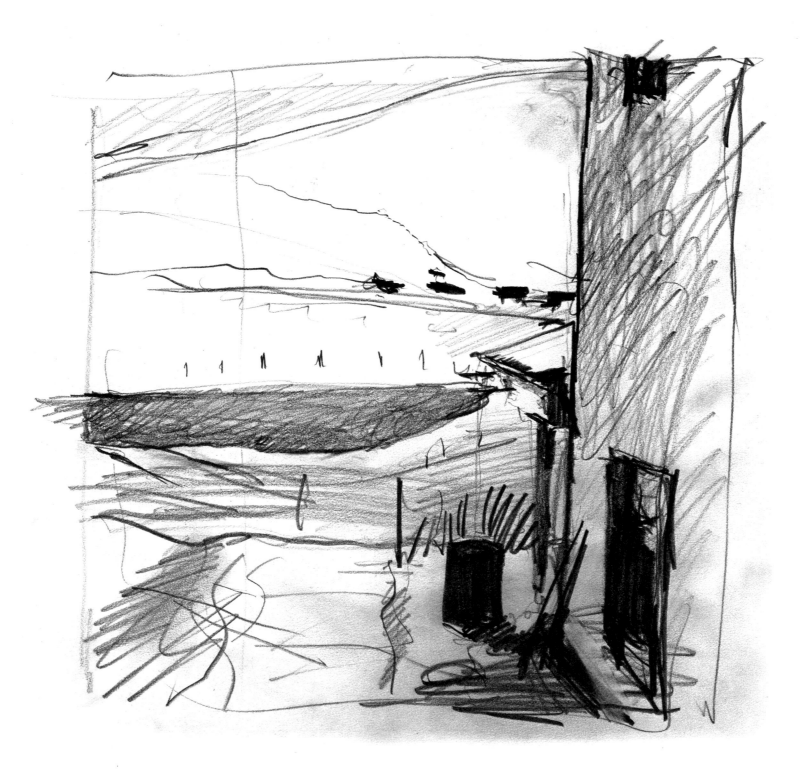

154

Anna's figure and the cows begin to disappear.

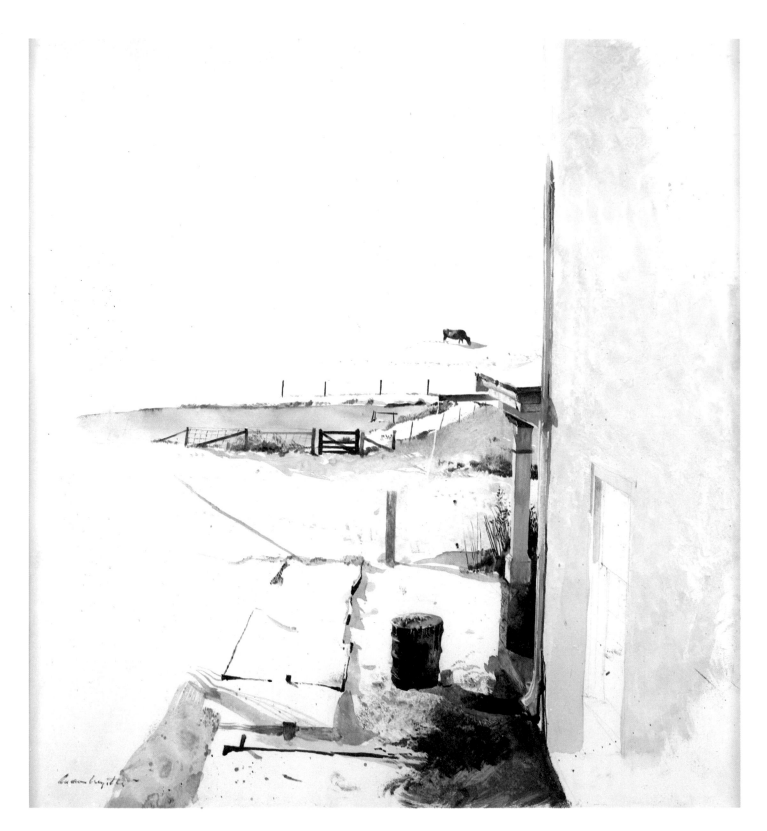

The cold frames for the kitchen garden are filled with snow,
while a lone cow seems to exist in a void of white.

A brief glimpse of spring.
The rich greens become
dark in contrast with
the pond water.

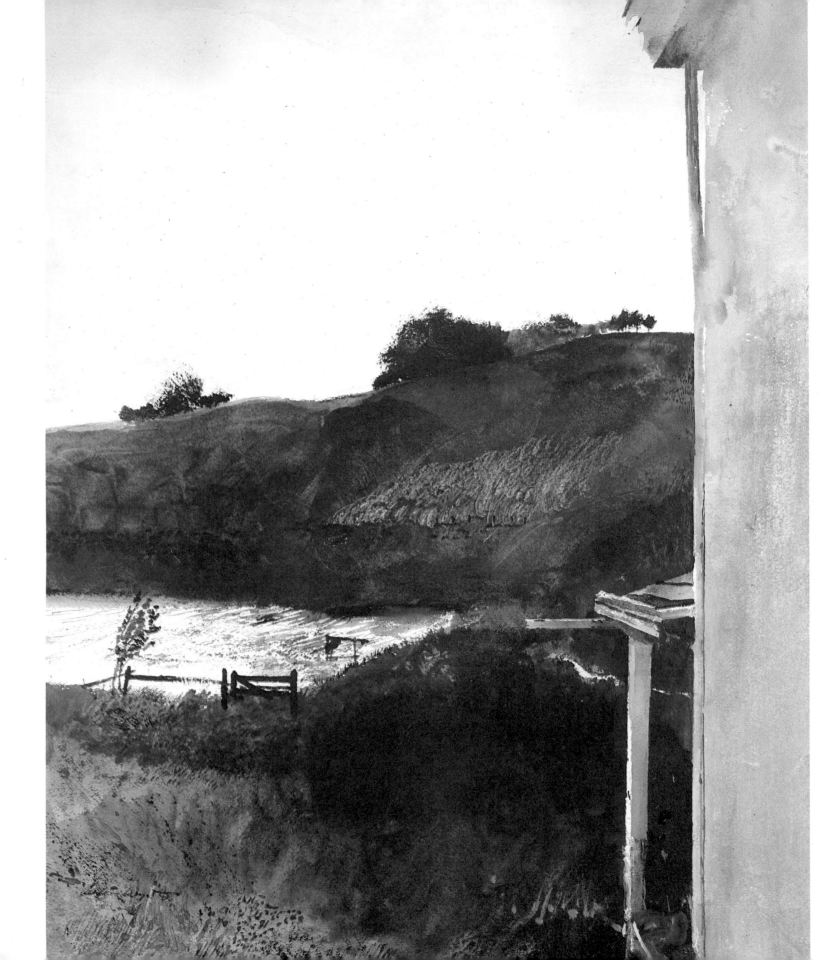

The Kitchen Chimney

Close to the kitchen garden is the bulkhead that leads down into the cellar
where sides of bacon and smoked hams hang from hooks driven into the floor beams above.

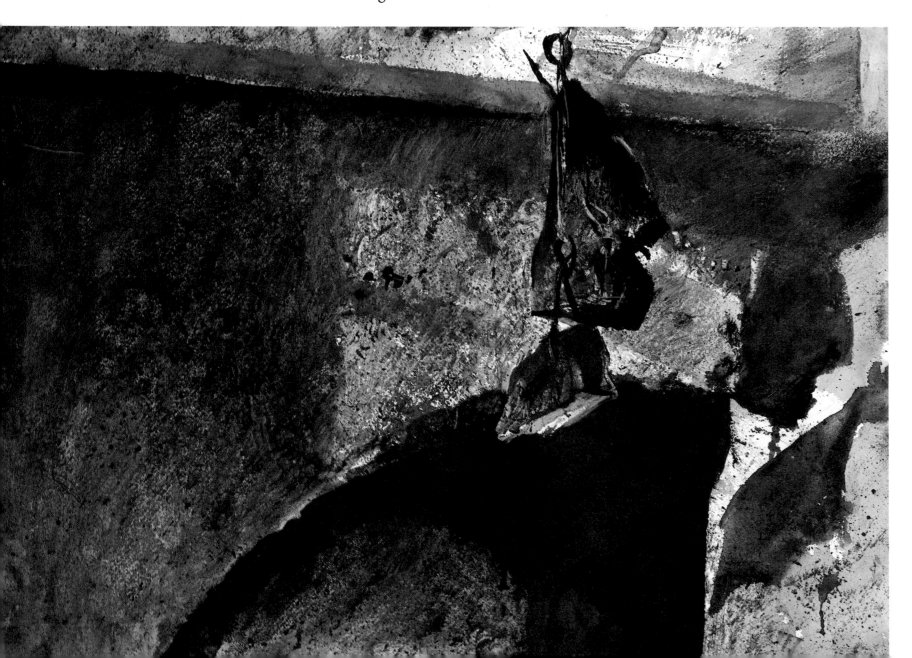

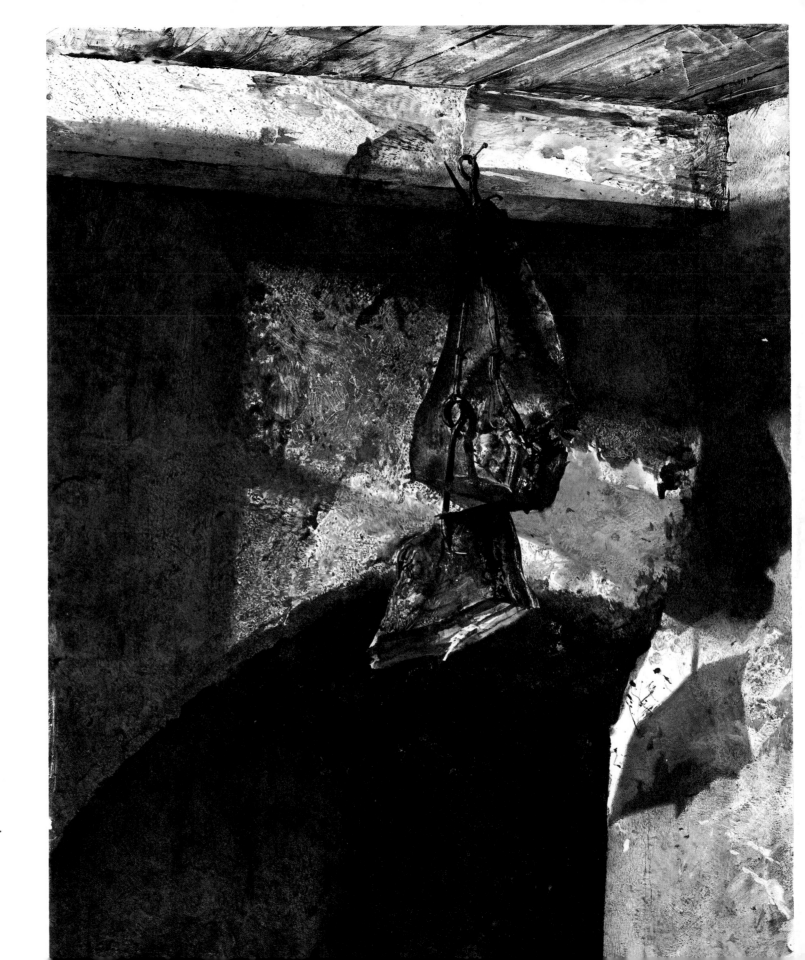

A massive stone arch
supports the hearth
of the large fireplace
in the kitchen overhead.

The fireplace in the kitchen is kept boarded up and used only for smoking pork. Once, while working on a drawing for *Brown Swiss*, the artist was startled to see a figure reflected upside down in the water of the farm pond. He looked up and there, high on the rooftop, was Karl, cleaning out this chimney.

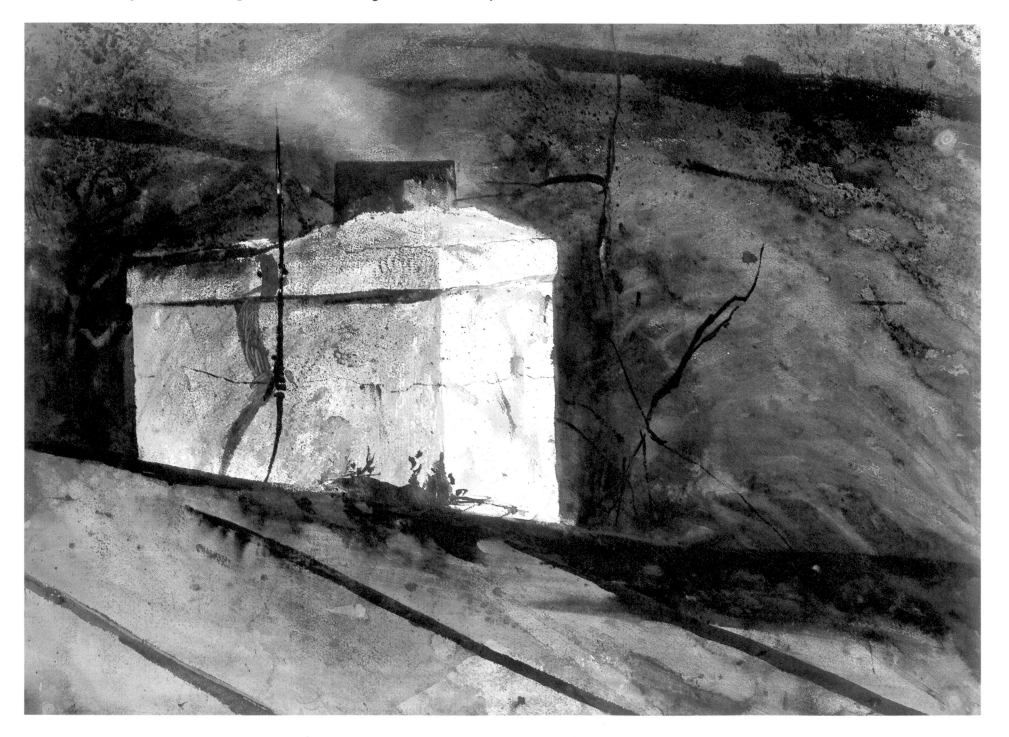

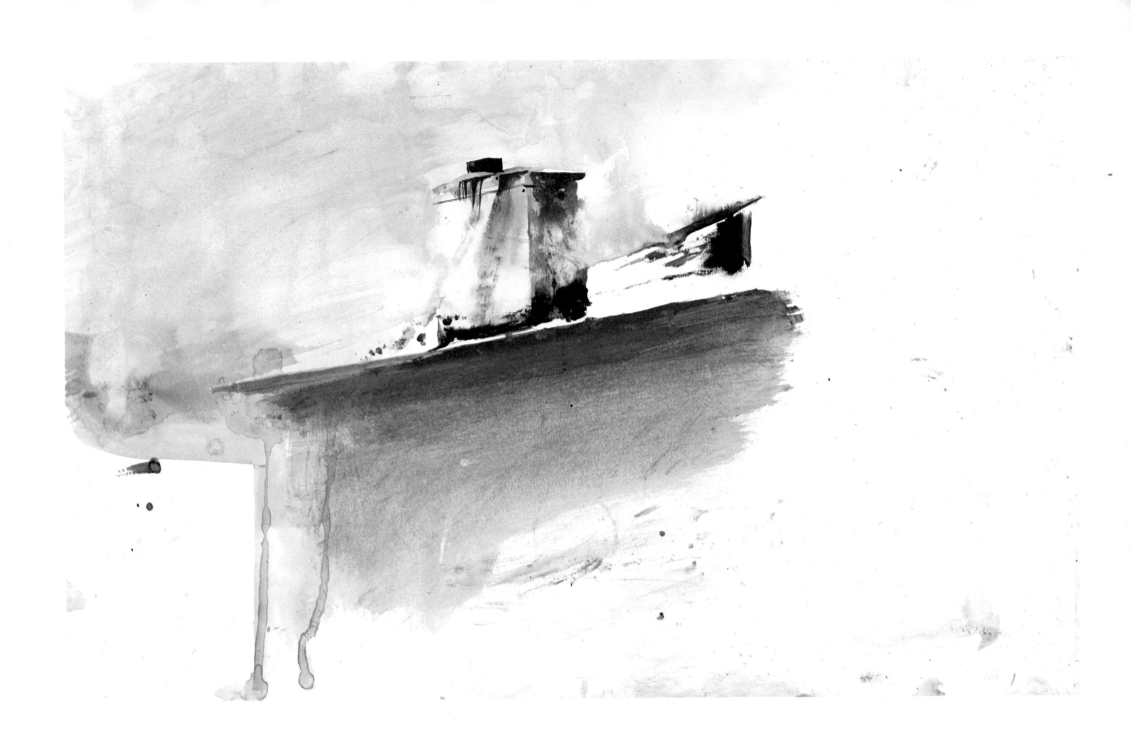

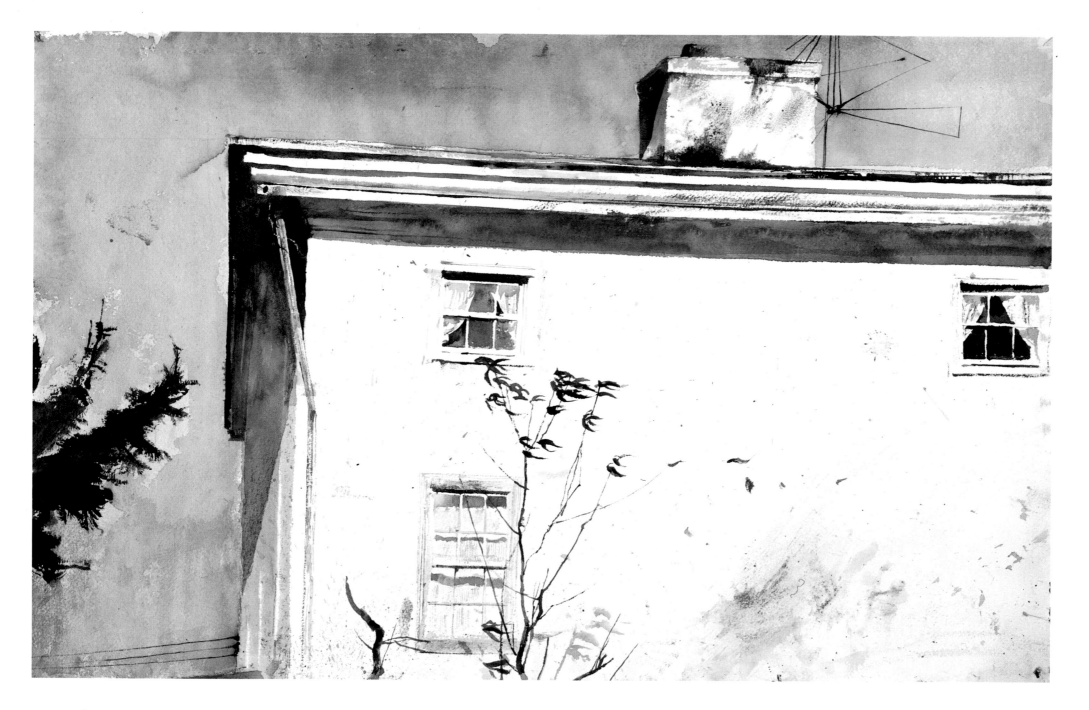

Over and over again the big chimney appears, sometimes with a TV aerial –

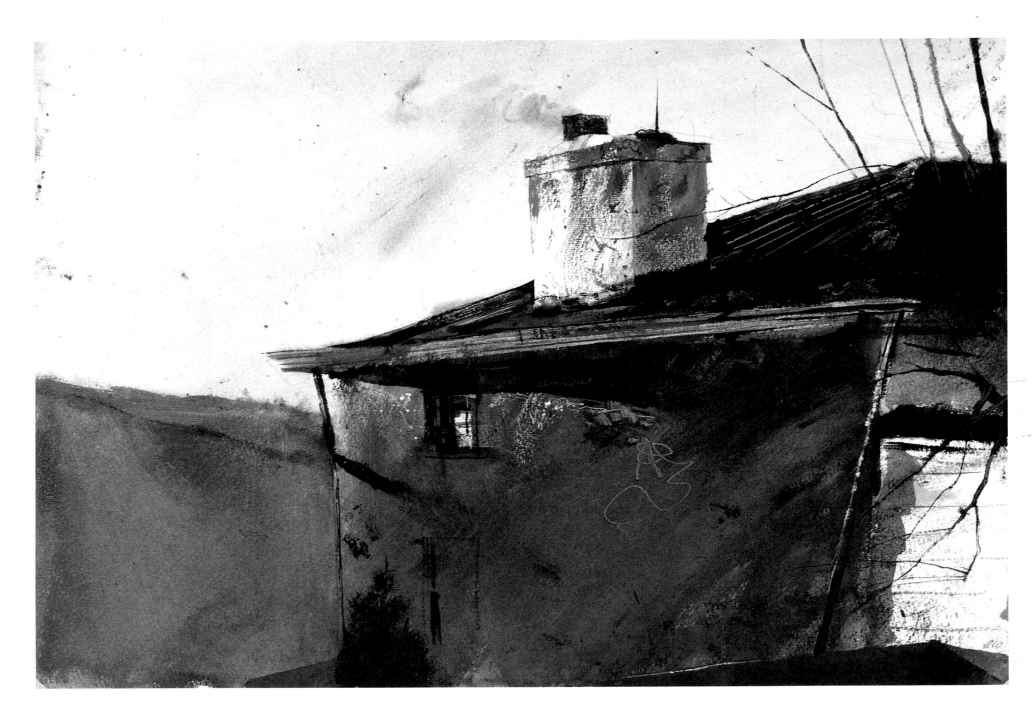

sometimes not.

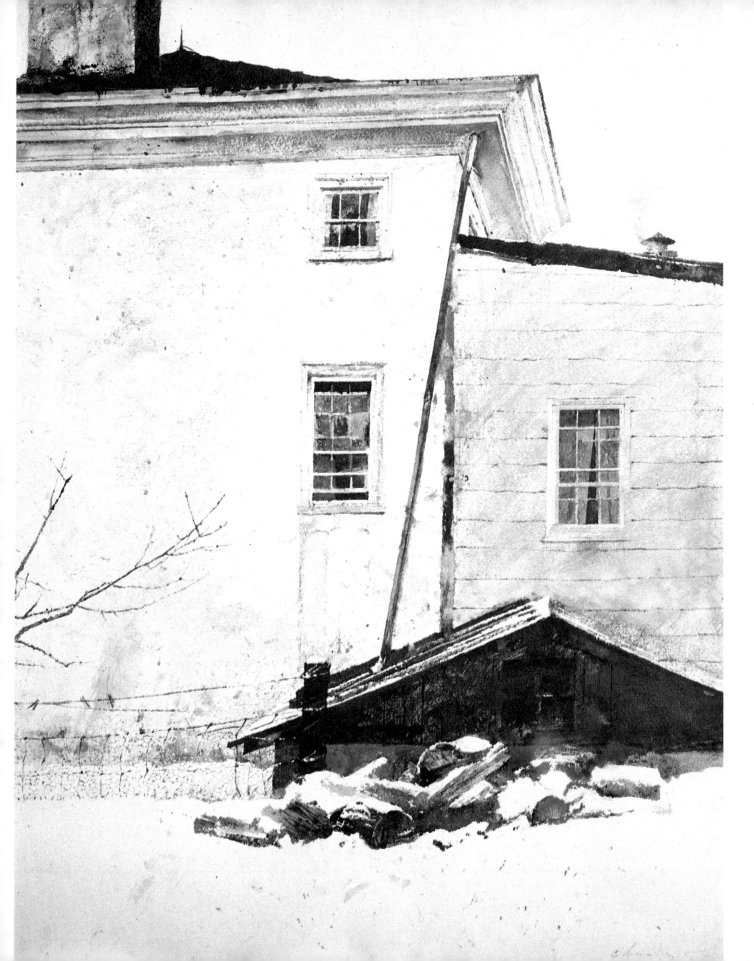

Even on the coldest winter days this second floor window is left slightly open. Anna must be cooking again, for smoke is coming from the chimney of the back entry room.

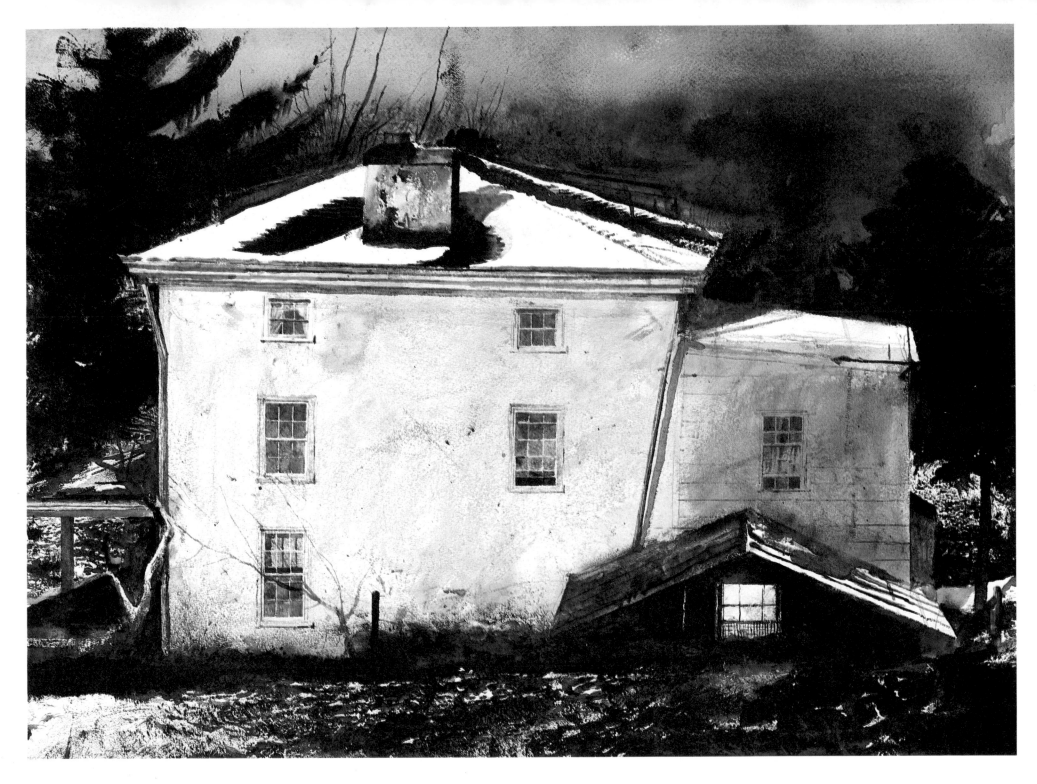

The artist sat quietly on the hillside watching the darkness of a winter evening descend on the house. He was about to leave when suddenly a light appeared in the woodshed window. He waited. His ear picked up the distant sound of chopping. When he stole closer he looked in and found Anna splitting kindling.

Leaving the House

Anna on her way into the woodshed.

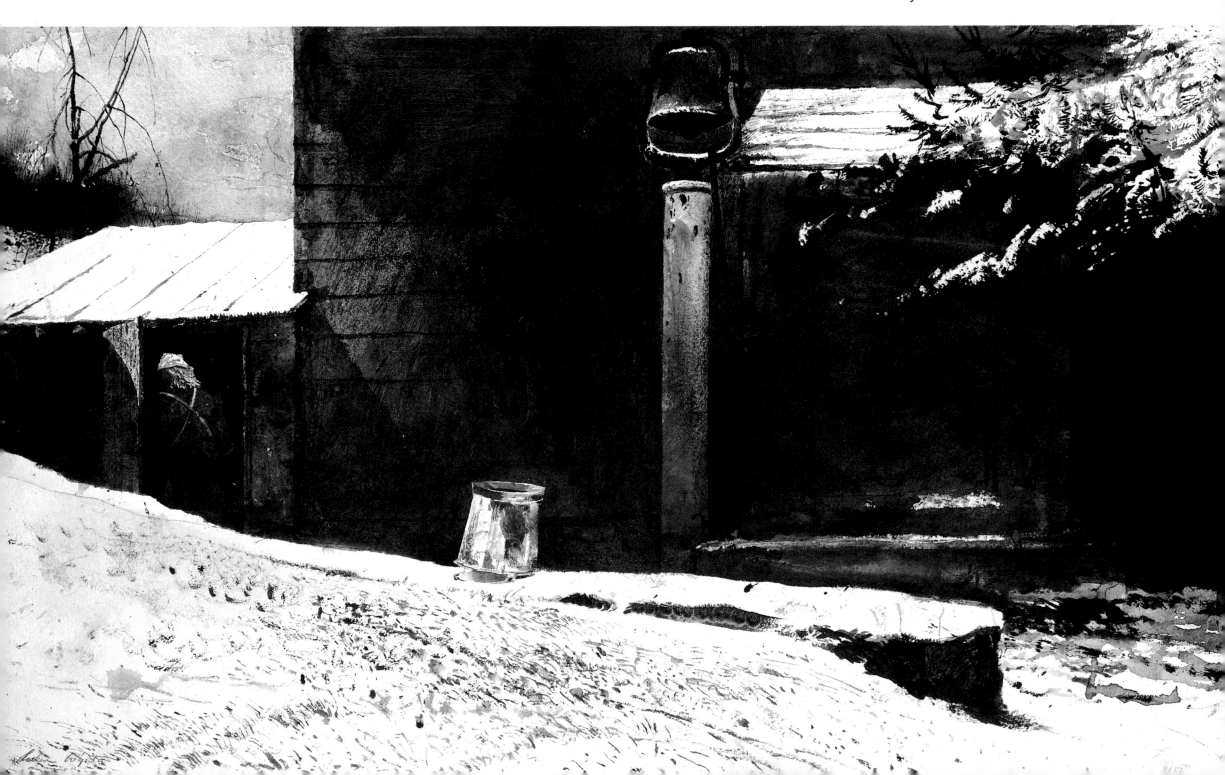

Anna serves the main meal promptly at noon – not five minutes before
or five minutes after. If Karl and his son are working in the fields
Anna rings the farm bell to announce dinner.

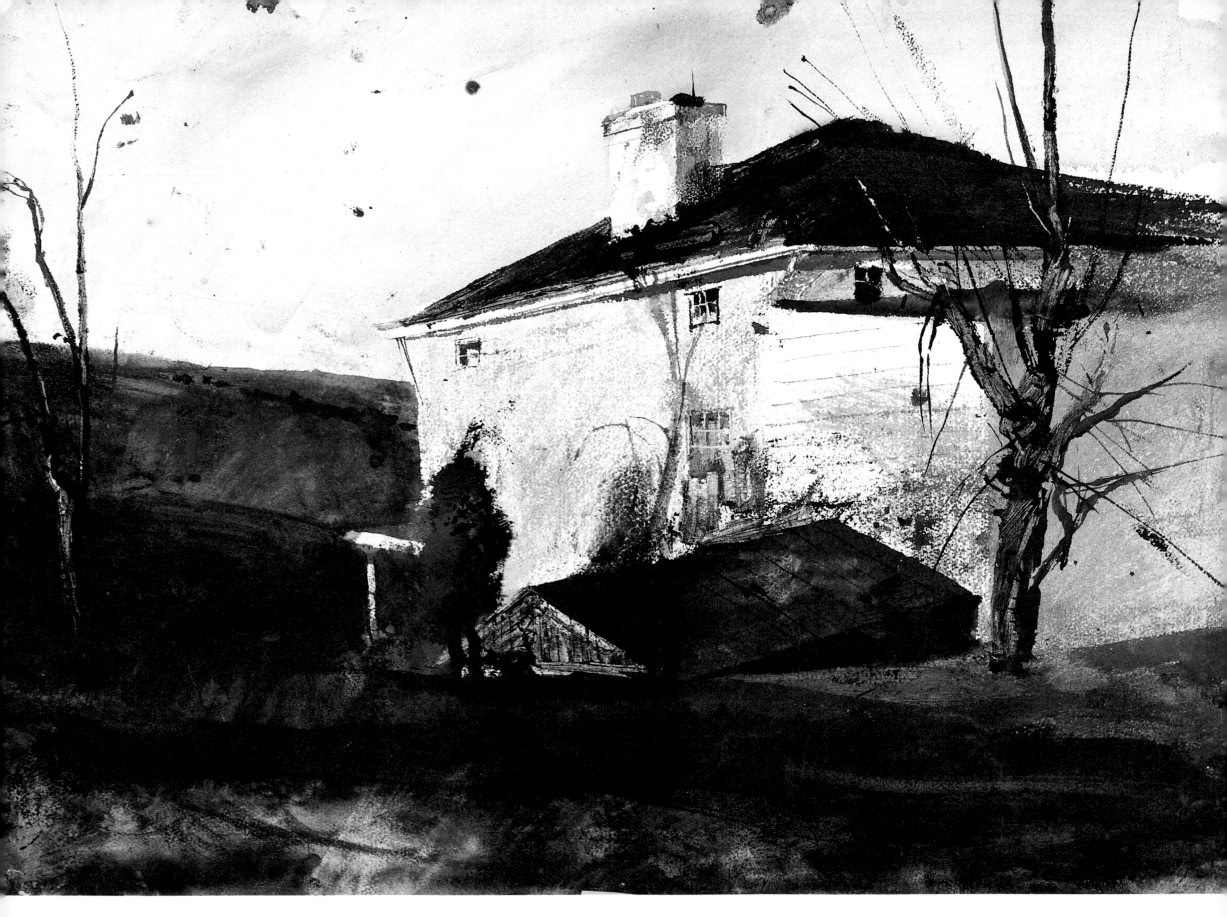

As we leave the house the moose horn trophy still hangs
on the side wall, partly hidden by the woodshed roof.

When Andrew Wyeth sees something he wants to remember he will grab any drawing pad within reach. This time Anna Kuerner was shaking a dust mop out the second story window. Both of these drawings of the mop were done on pages in a pad that already contained the seated figure of Willard Snowden, who posed for the artist many times during the few years he lived in the Chadds Ford studio.

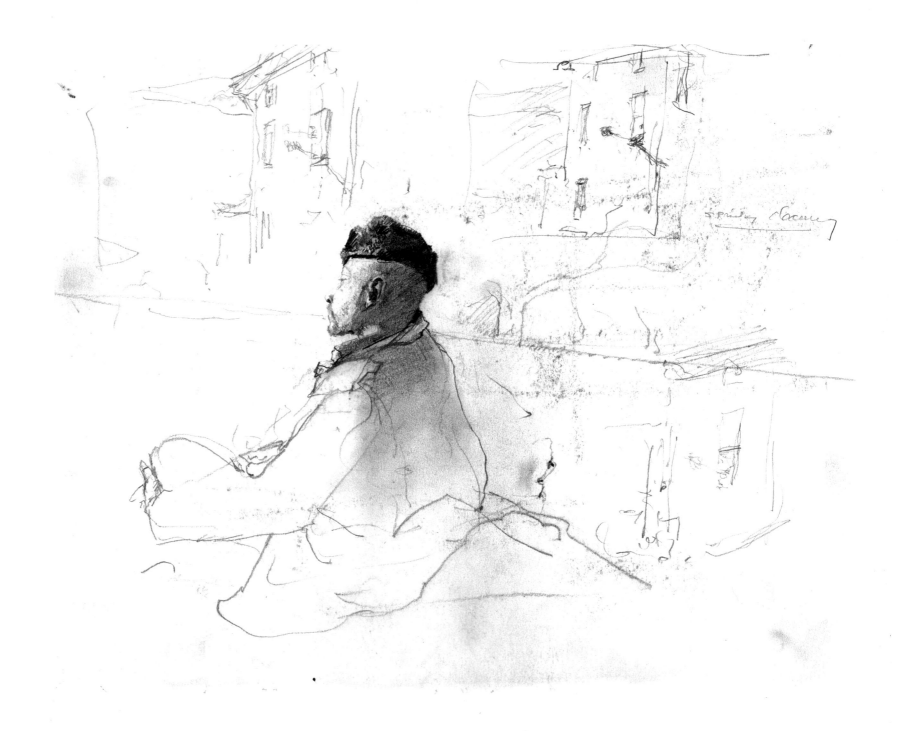

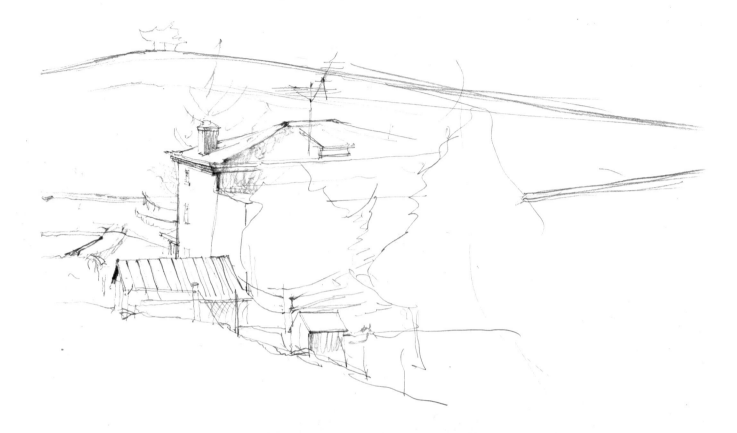

All the trees except one that appeared
near the woodshed entrance in *Brown Swiss*
have been cut down — even the cedar.

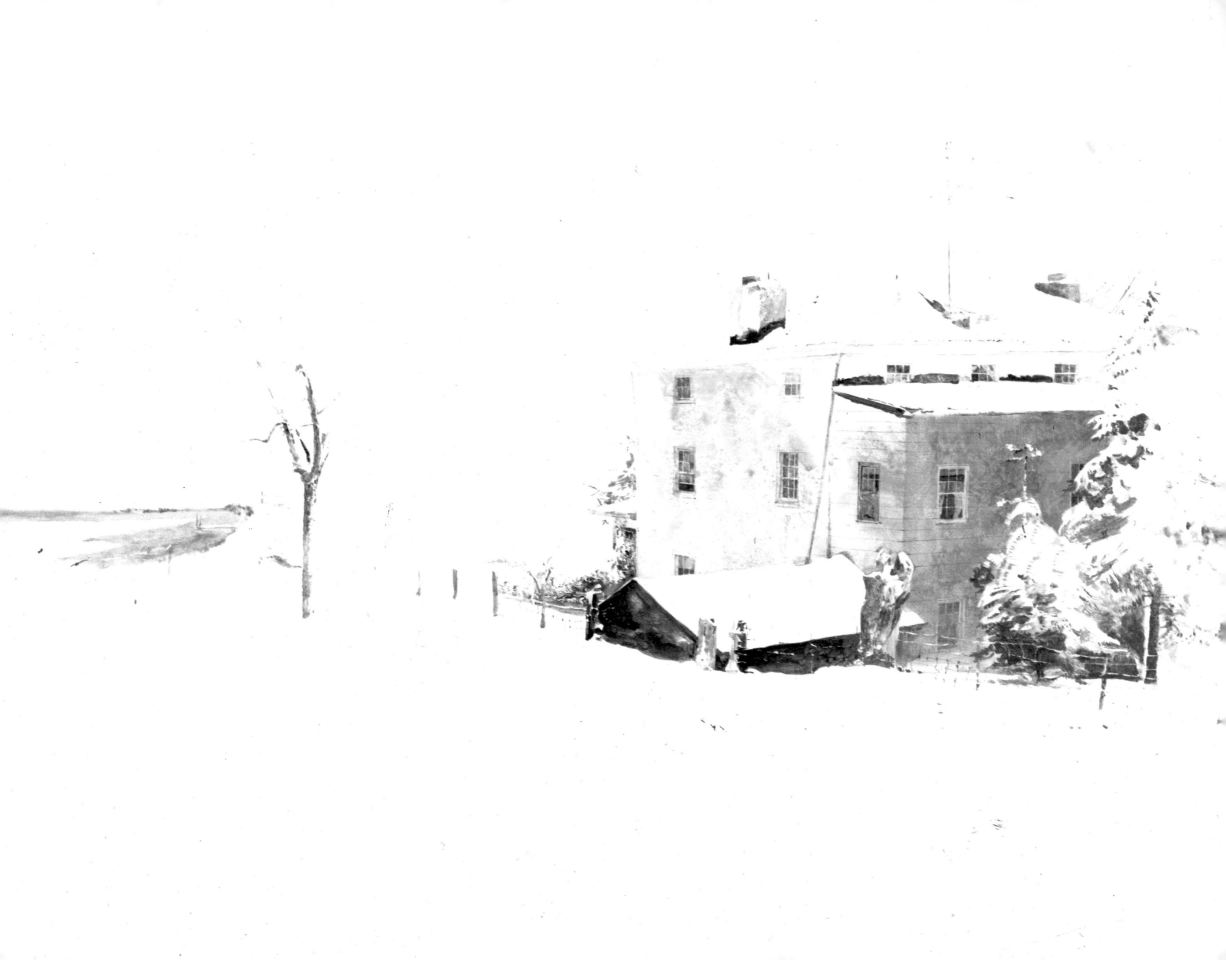

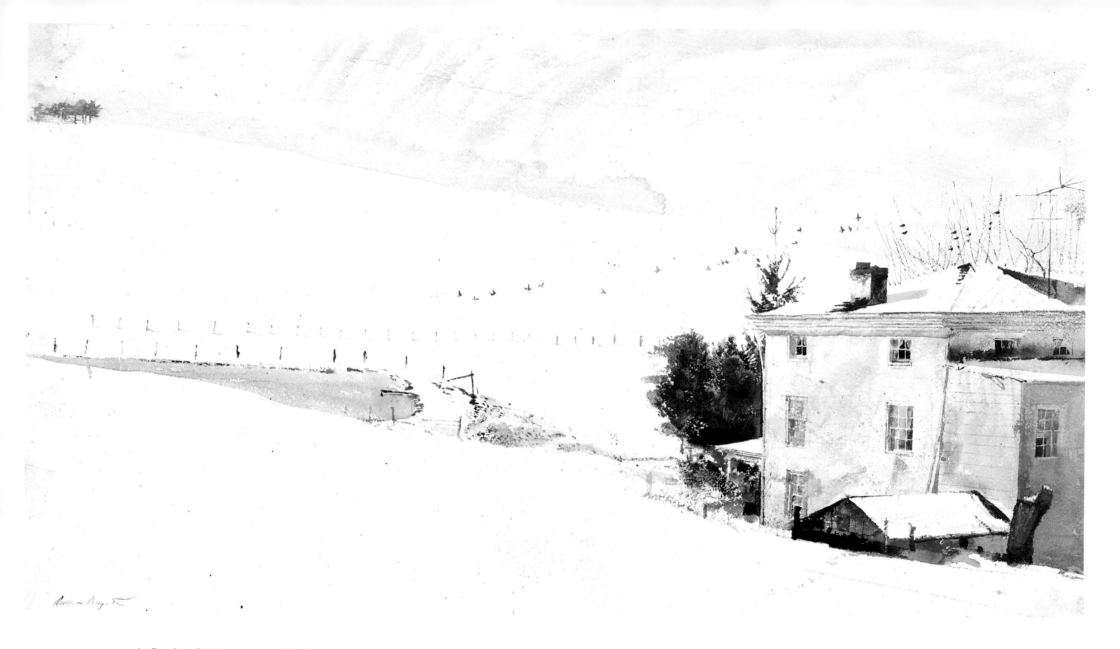

A flock of pigeons on their way to the barn.

A lone light coming from the kitchen window
as evening descends.

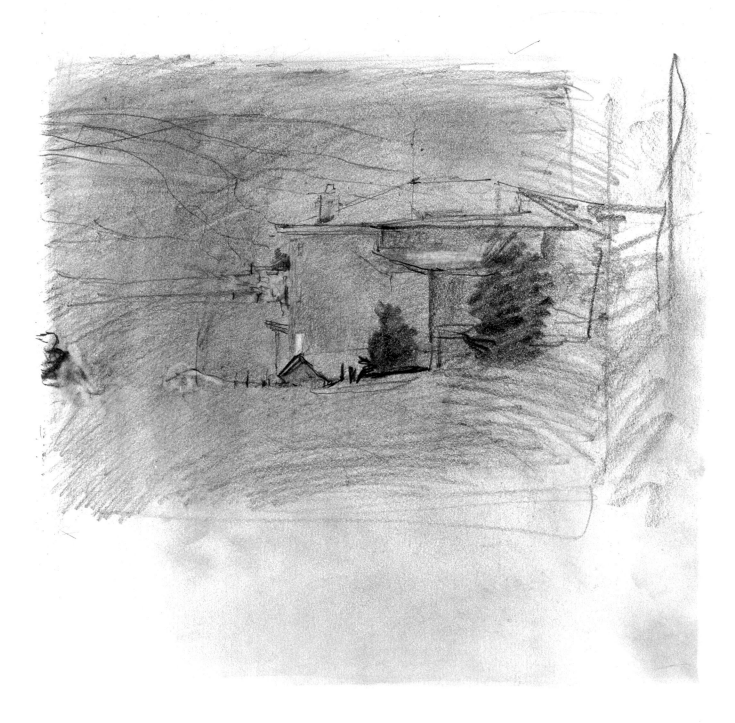

176

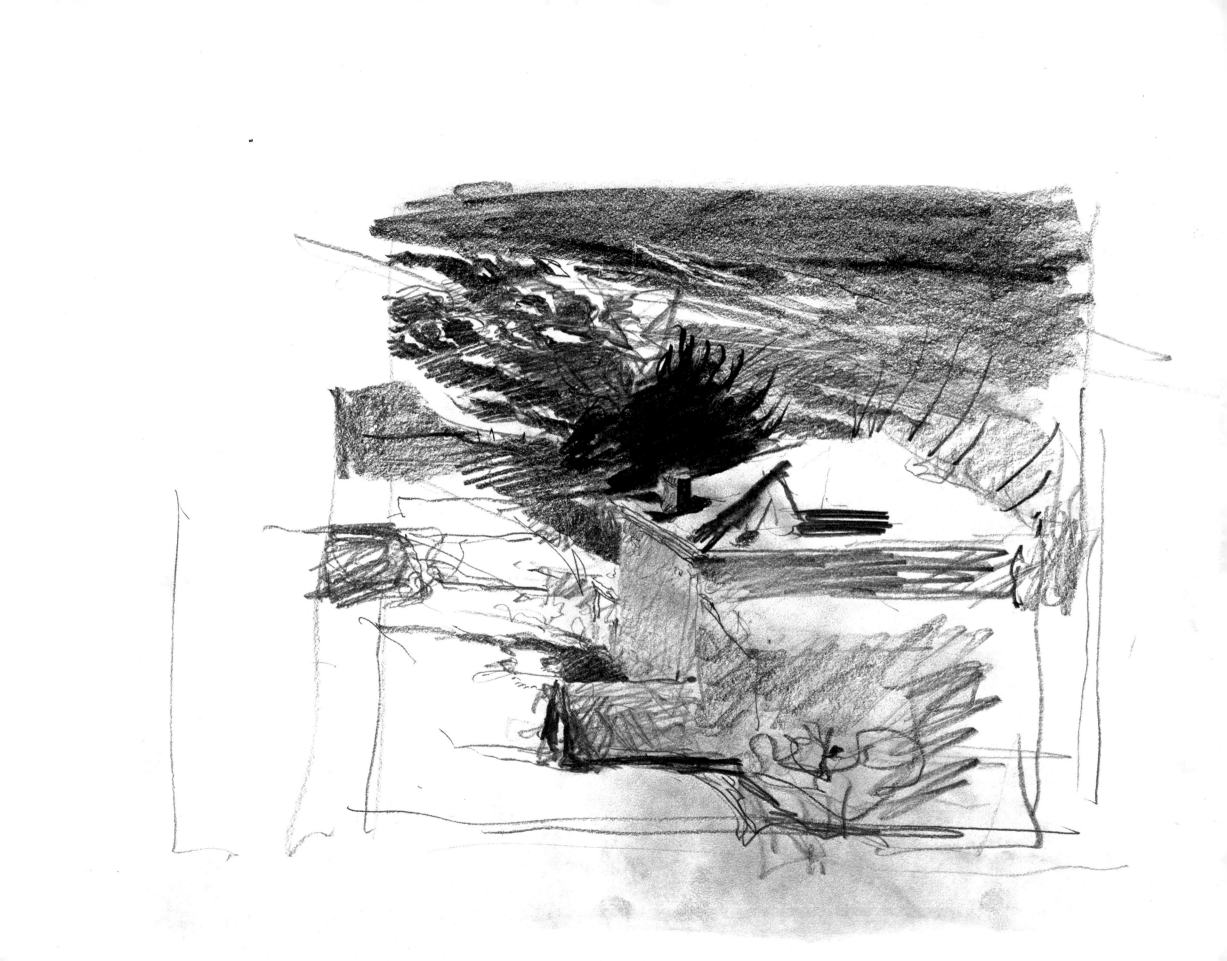

Moonlight casts its spell over the winter landscape.

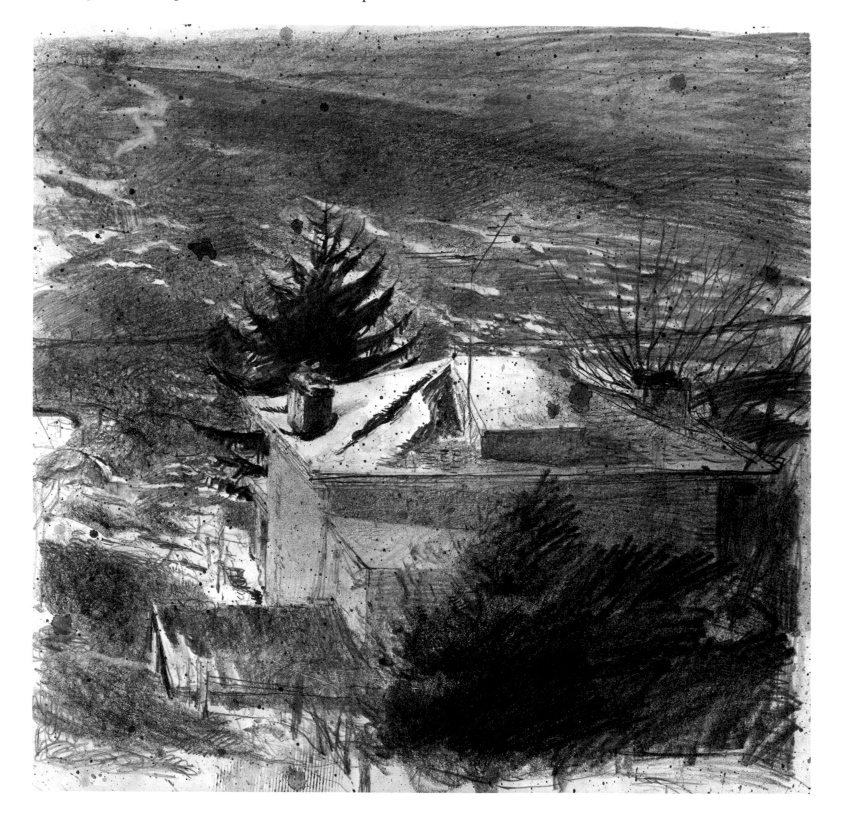

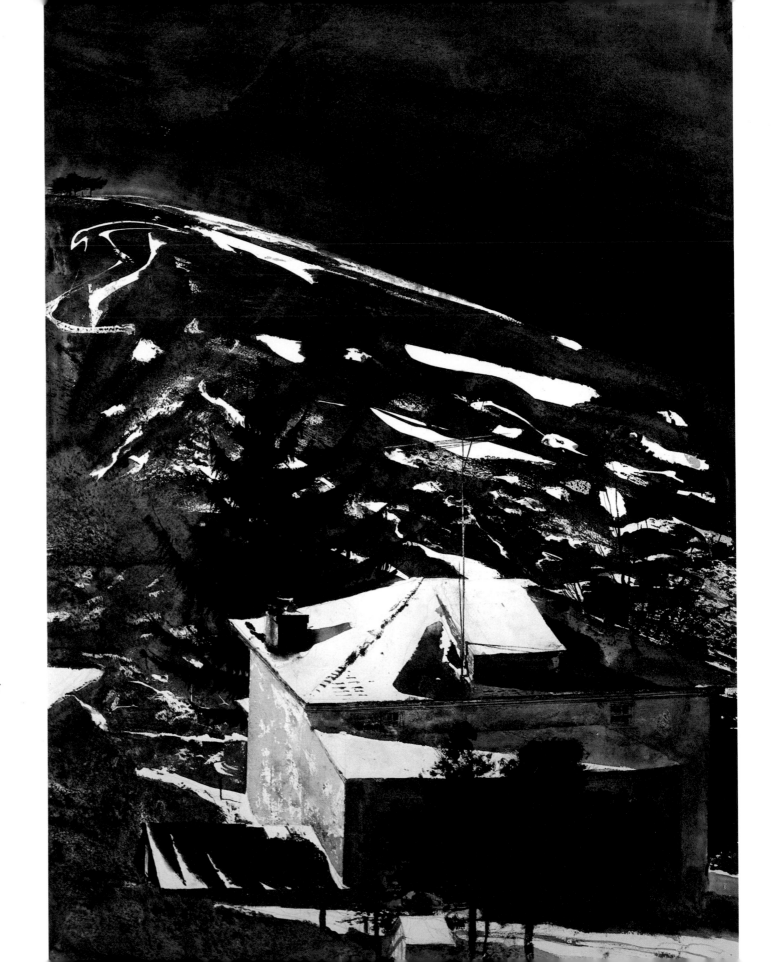

During the Second World War
Andrew Wyeth dreamed
that short-wave messages
were sent to Germany
from this house.

The gate has been opened, allowing the cattle to graze
in the orchard and down around the farm pond.

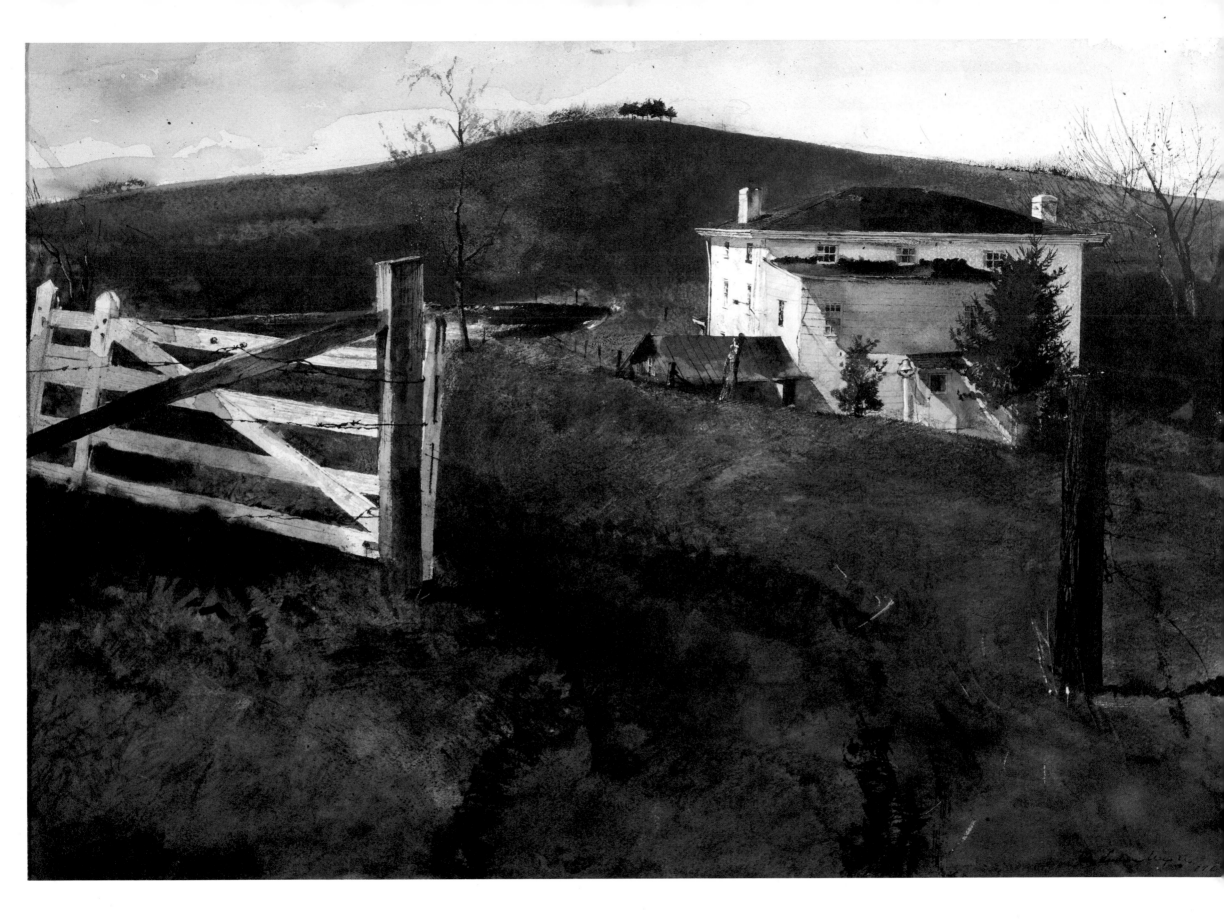

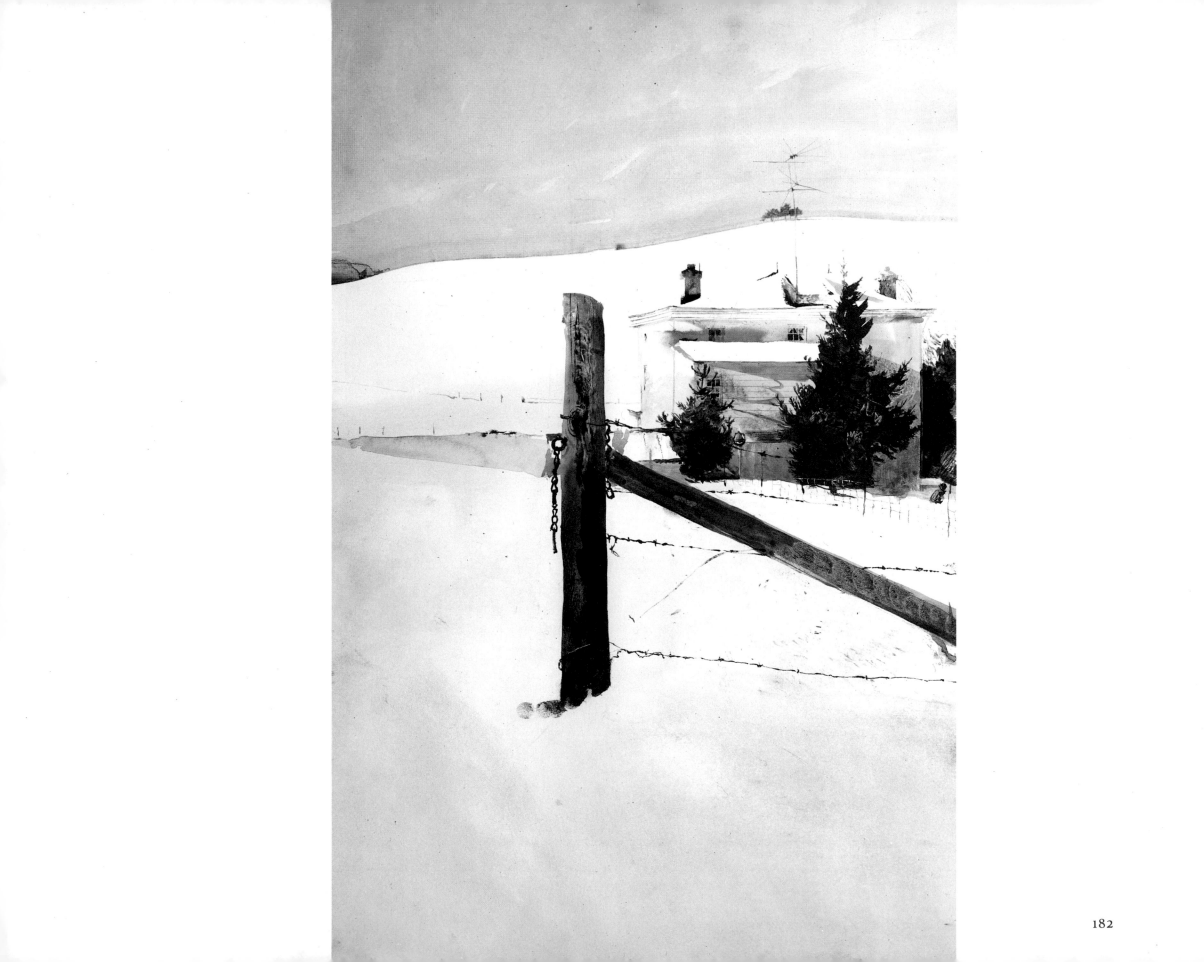

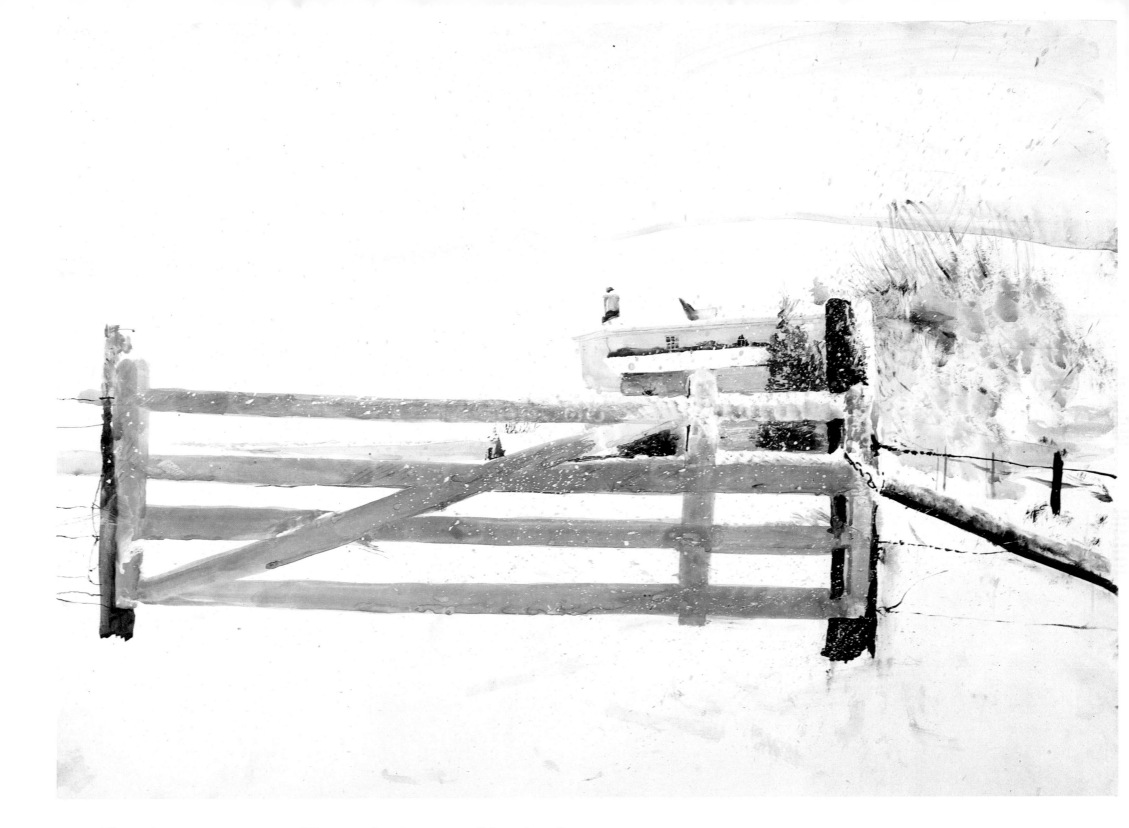

The artist roams every part of Kuerners but is very careful to close the gate.

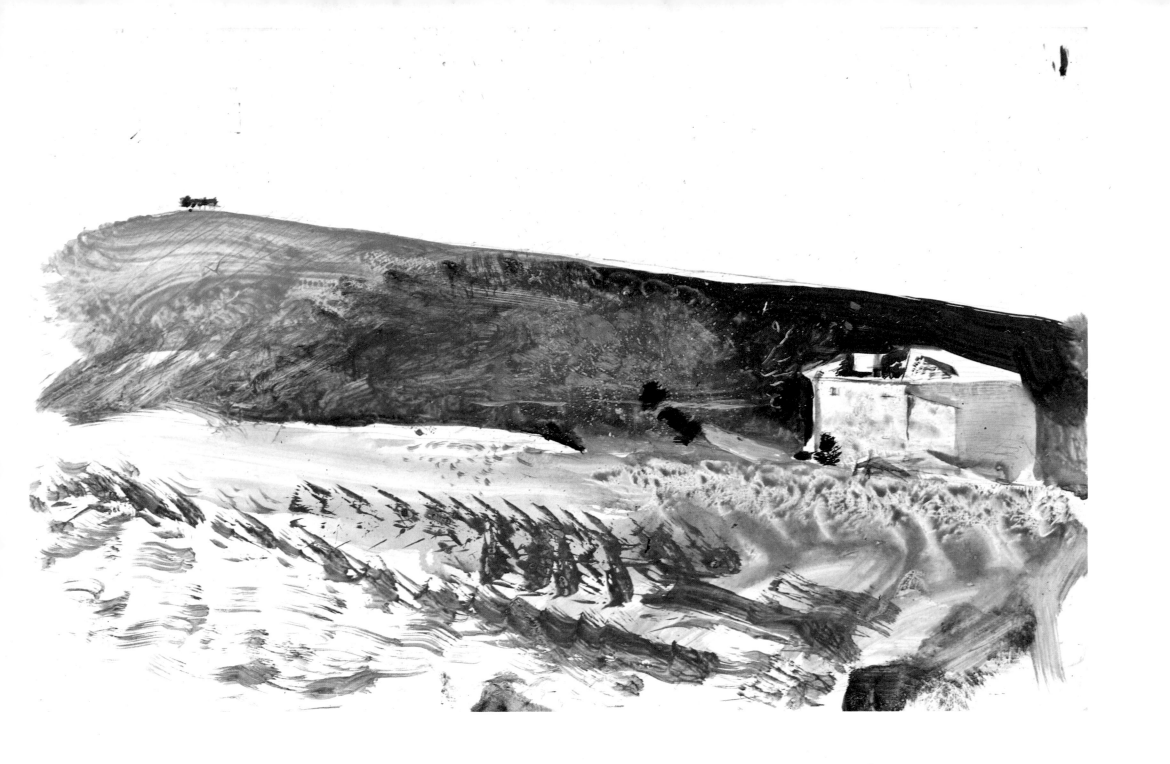

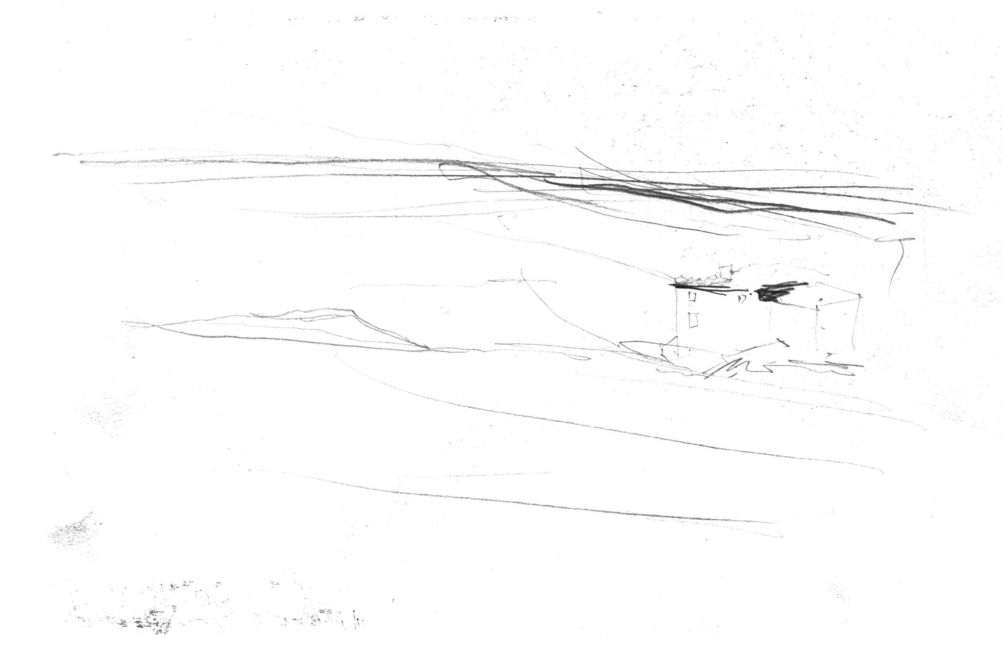

High in the hills that rise over the orchard,
the house seems to become a lonely outpost
in the sweeping landscape.

At the Shooting Range

The open country in back and above with the melting snow pouring down the hills like white lava.

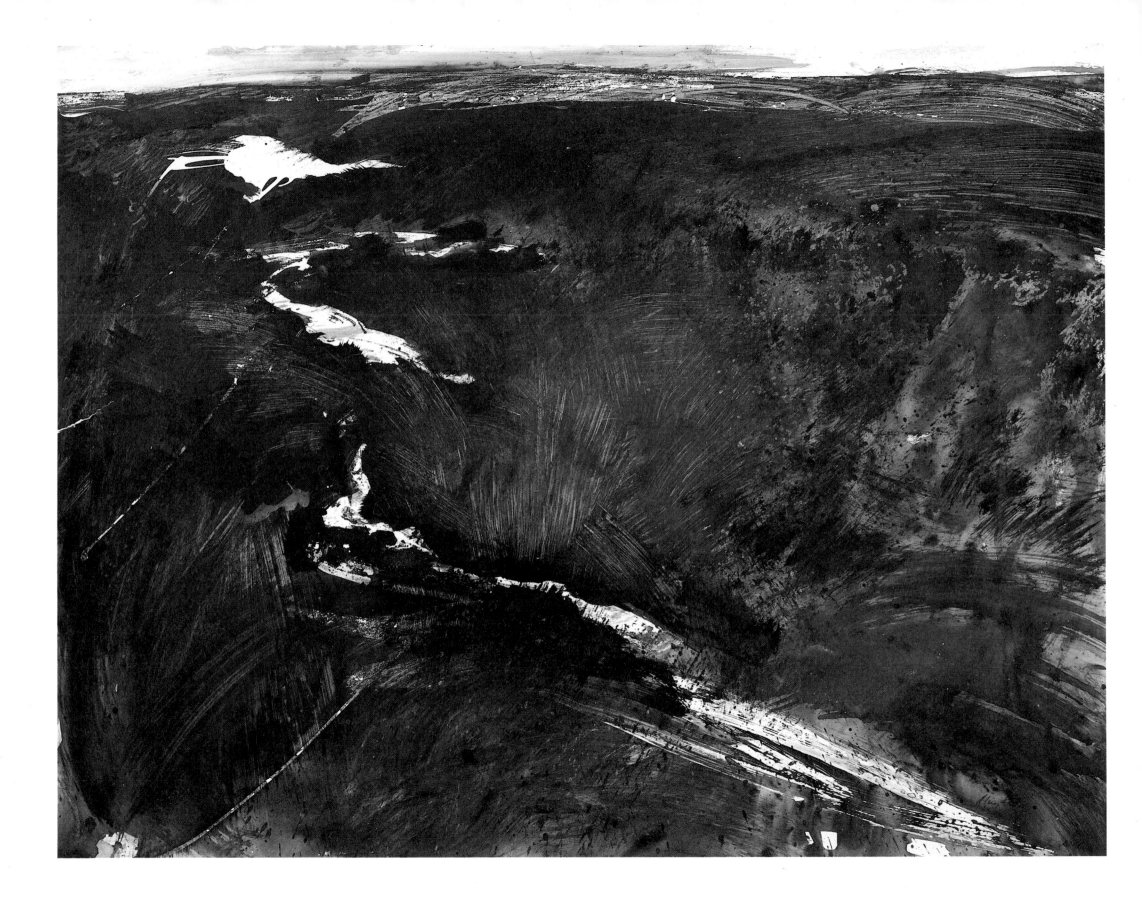

Wyeth found this buck deer head in the snow way beyond the barn, where the rolling fields are cleared except in an area the Kuerners call The Big Pines. This is close to the shooting range where Karl and his son target-practice with high powered rifles on Sundays.

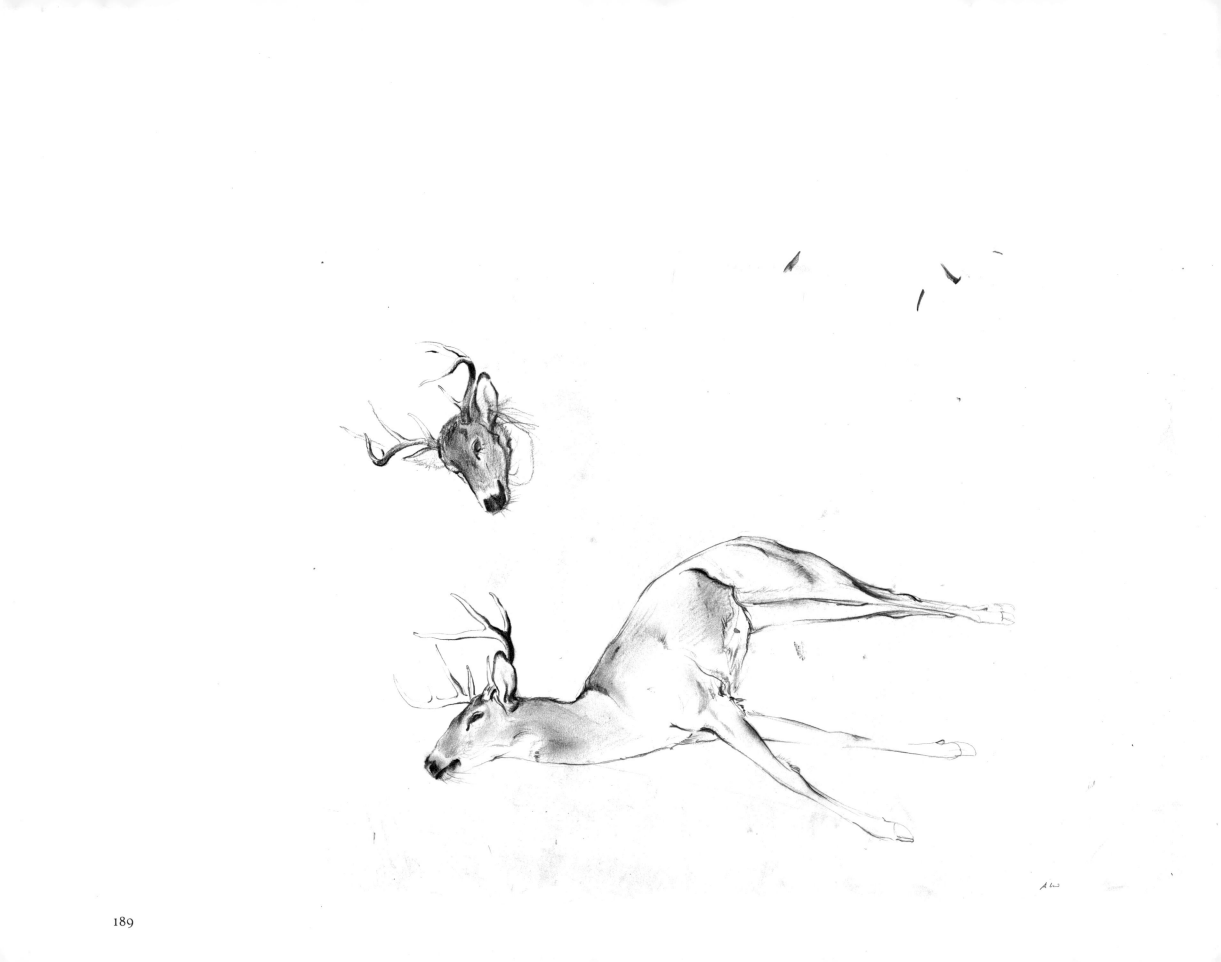

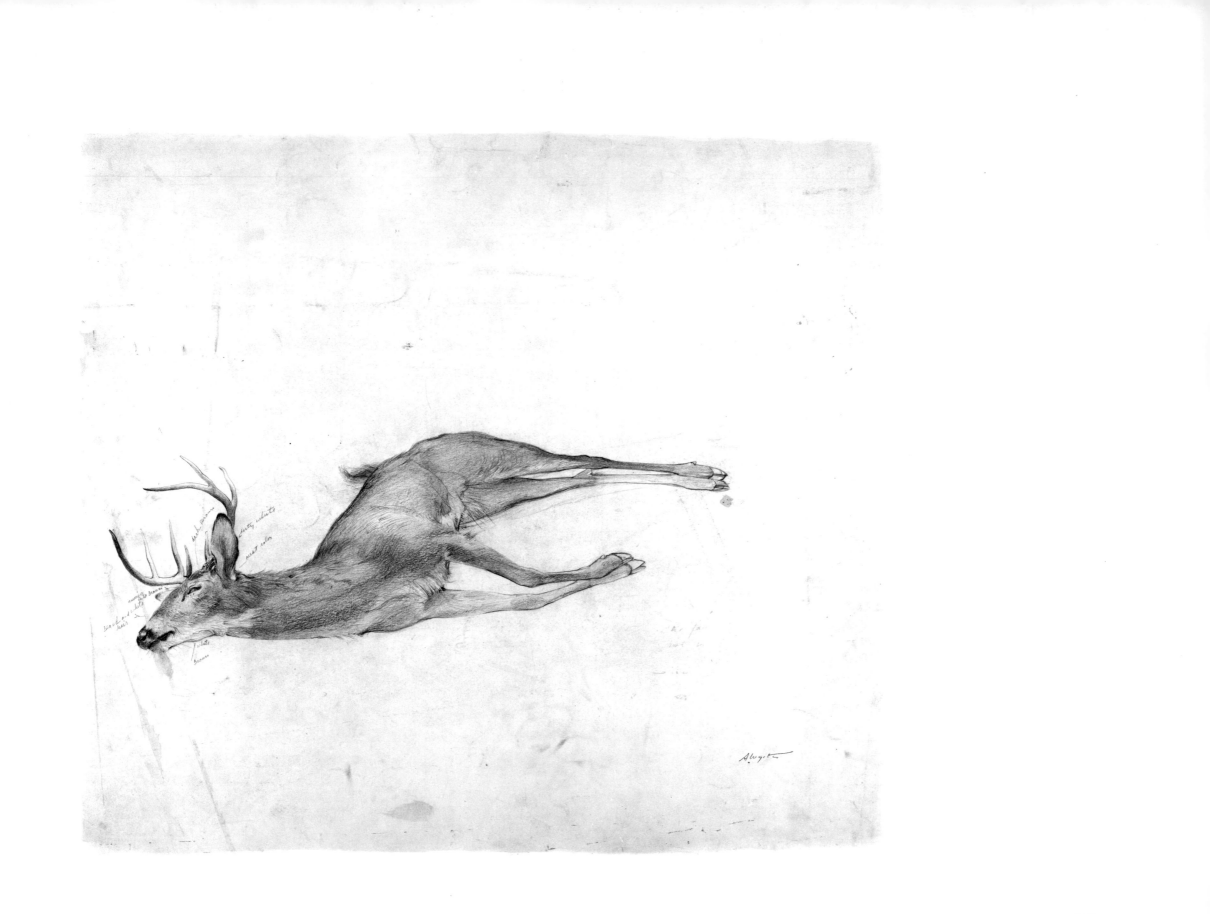

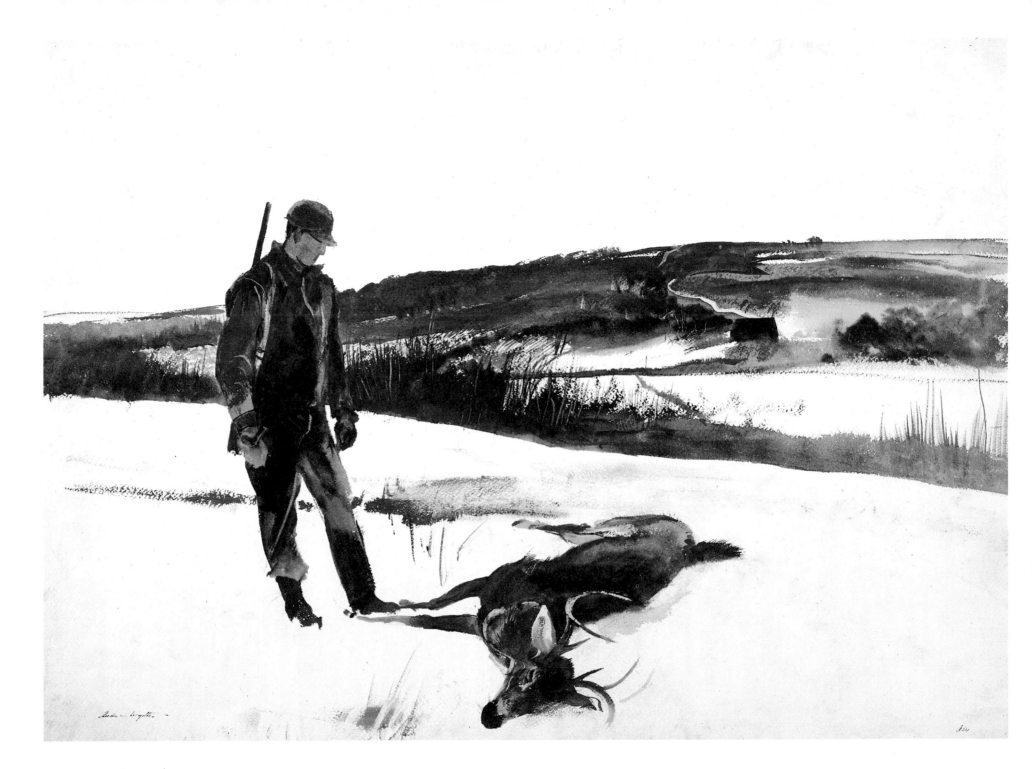

Young Karl, rifle slung over his shoulder, stands looking down onto the deer he has just shot.
The barn across the valley belonged to the "Lafayette Hall" property and has been torn down.

191

A long, open shed faces the back fields. It is used
for storing cordwood and farm machinery.

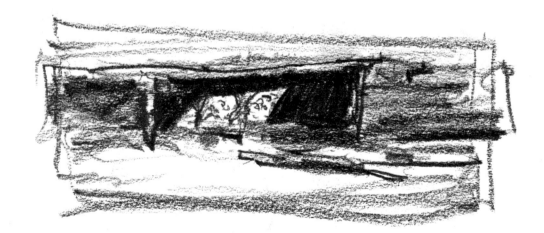

The Outbuildings

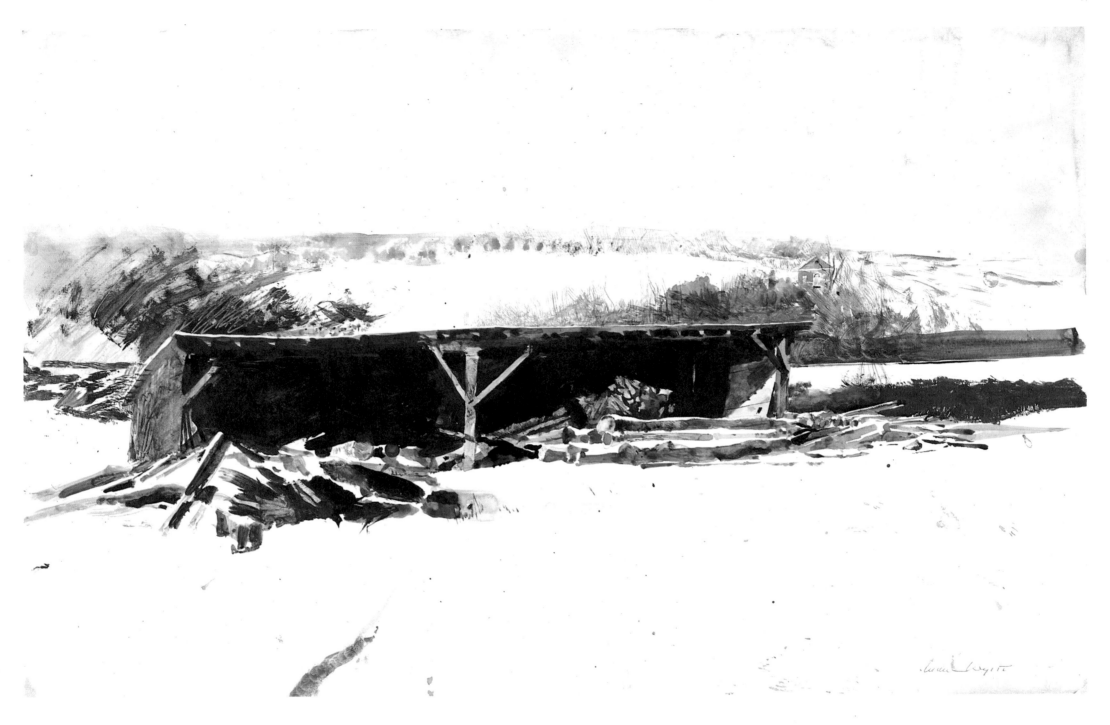

The Brandywine Baptist Church sits on the side of the distant hill across the valley.

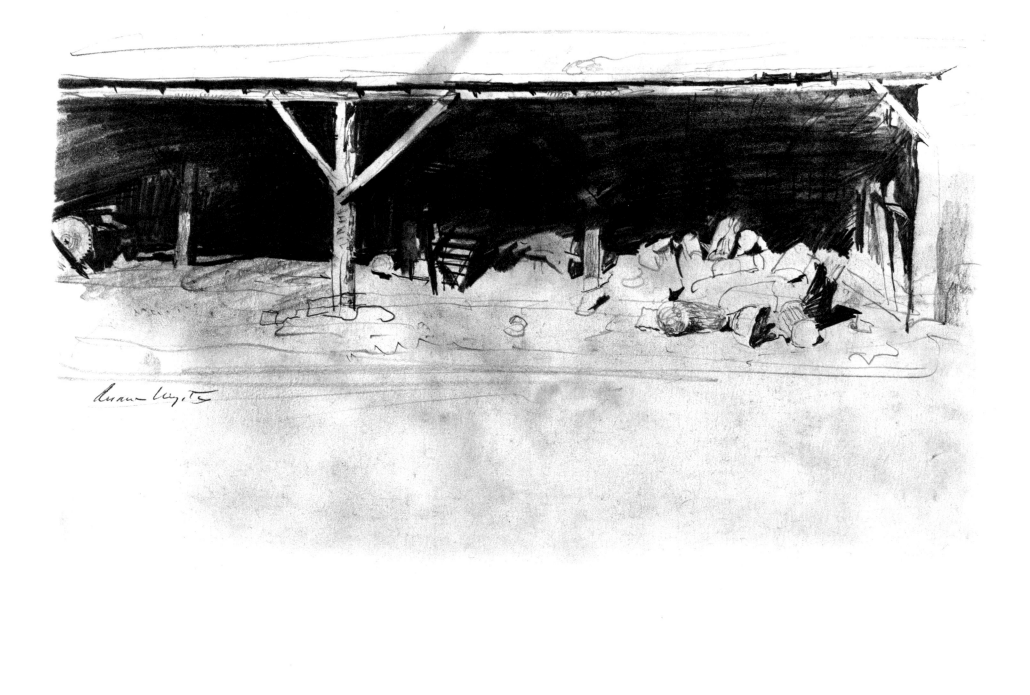

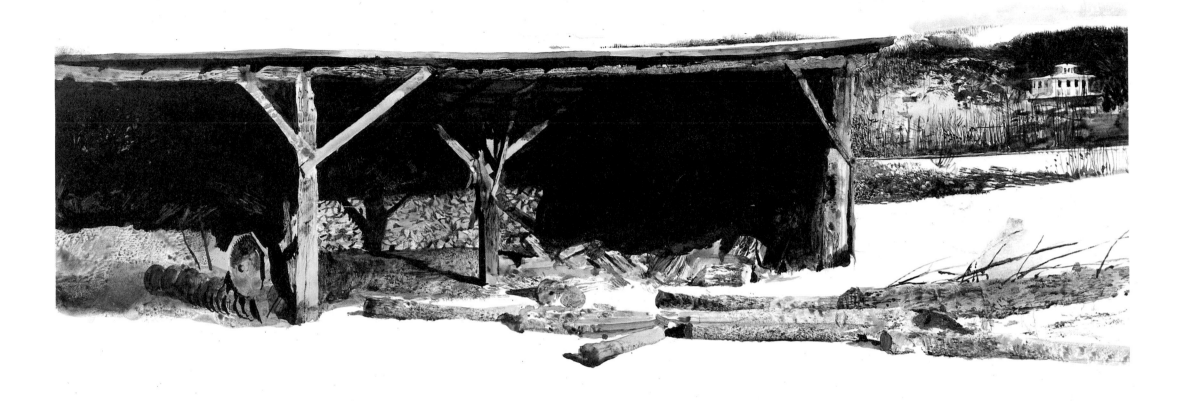

Over the railroad embankment is "Lafayette Hall," looking like an oversized pilothouse on a riverboat.

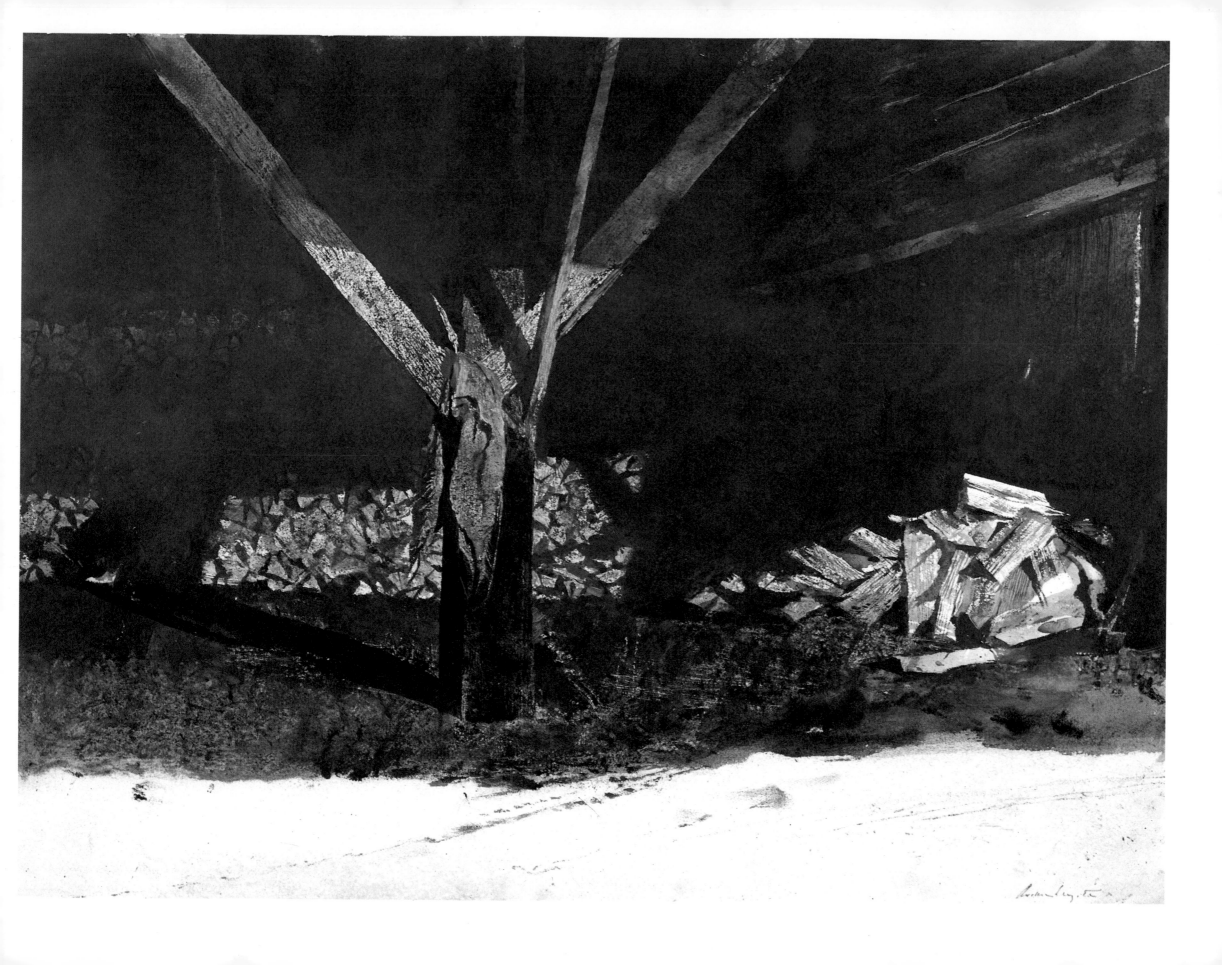

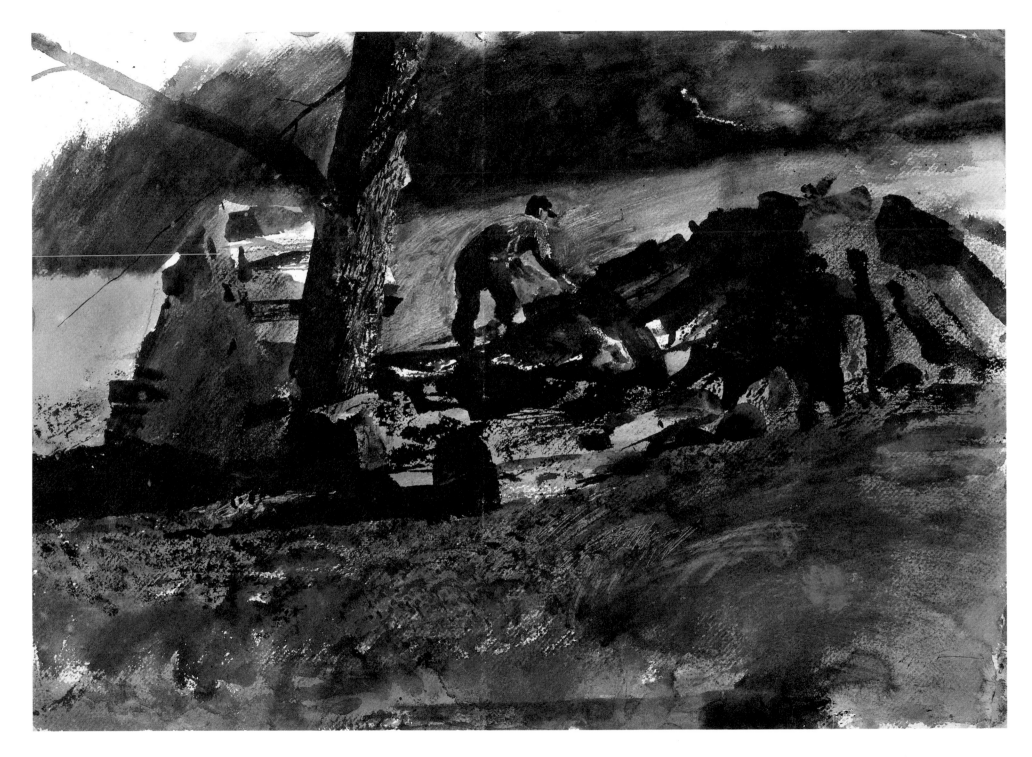

Young Karl stacking cordwood that he had split.

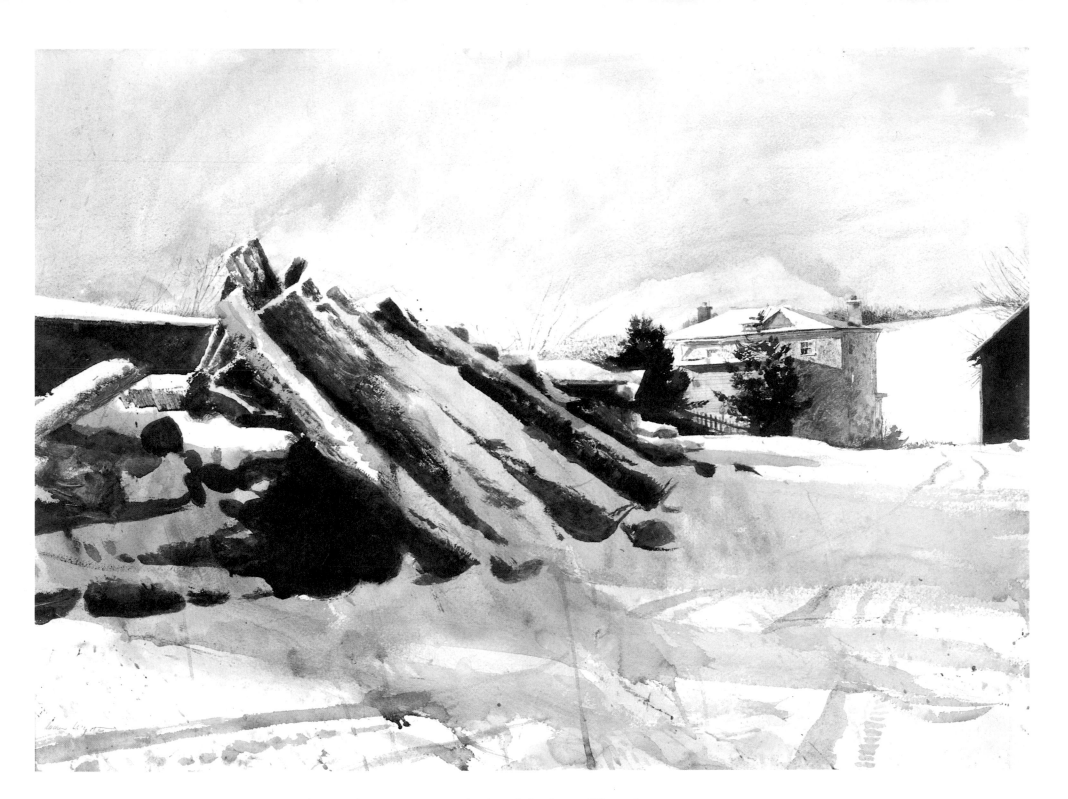

A cart road runs between the back of the long open shed and the barn. These logs piled against the back wall of the shed will be used to replace fence posts.

The next outbuilding beyond the open shed is Anna's chicken coop.

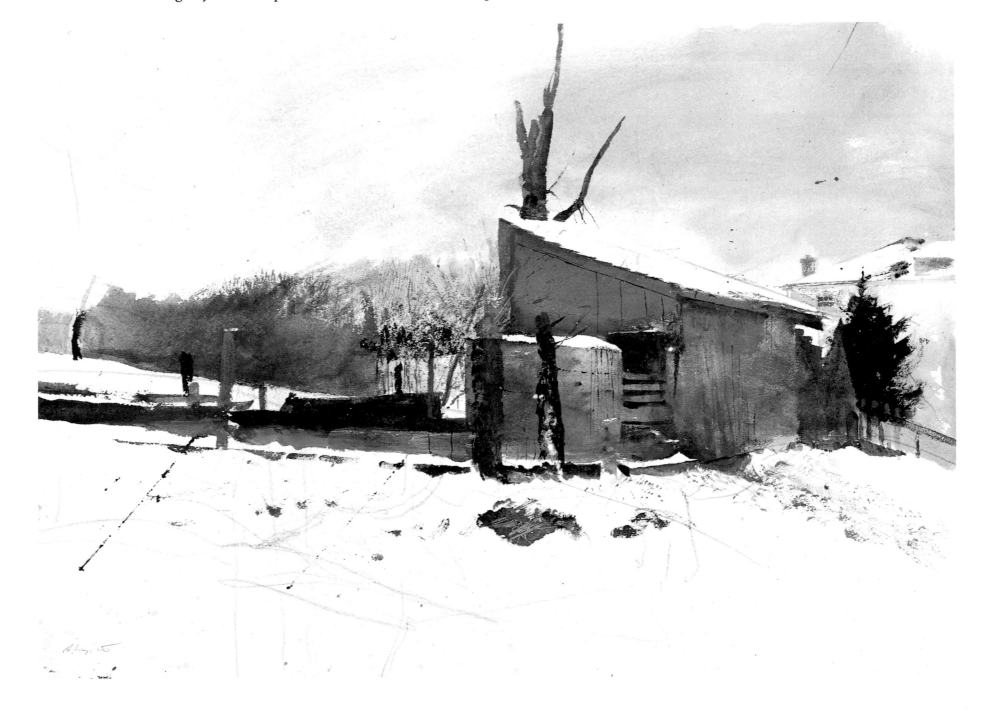

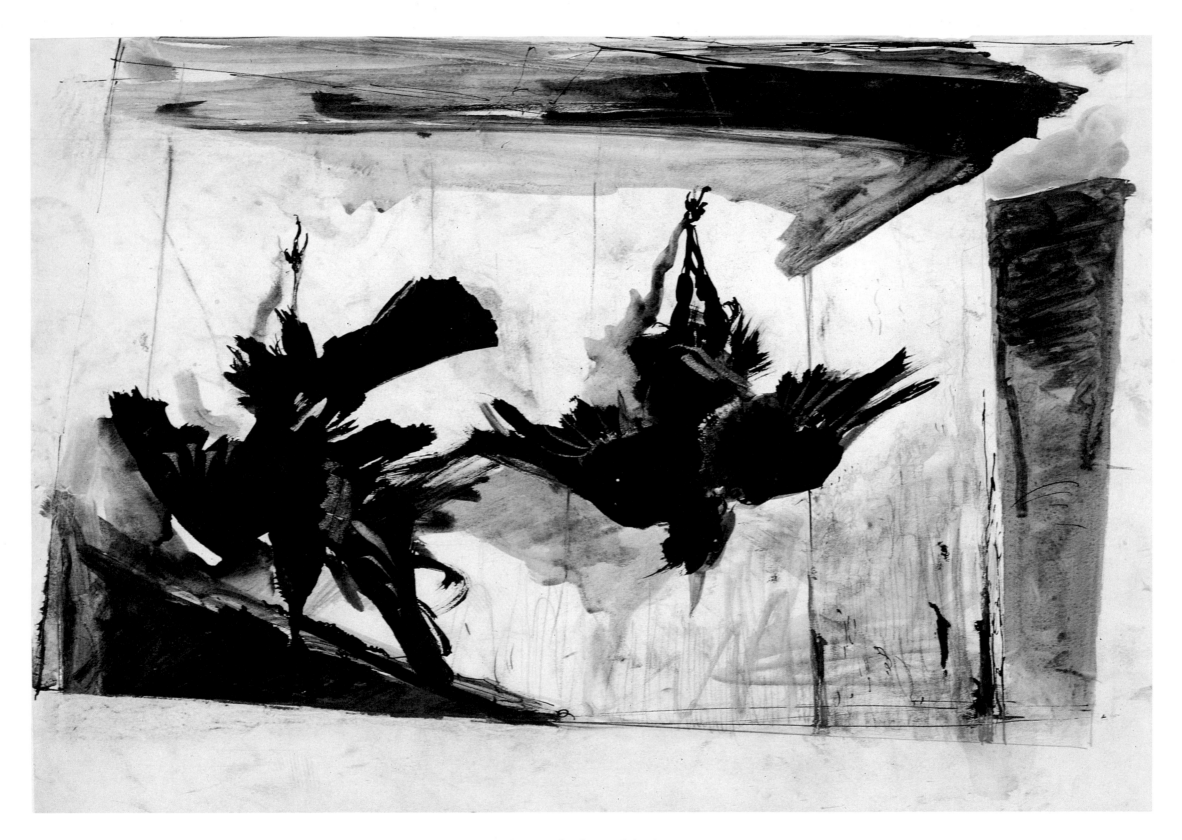

Two dead crows have been nailed to the wall of a small, whitewashed woodshed.

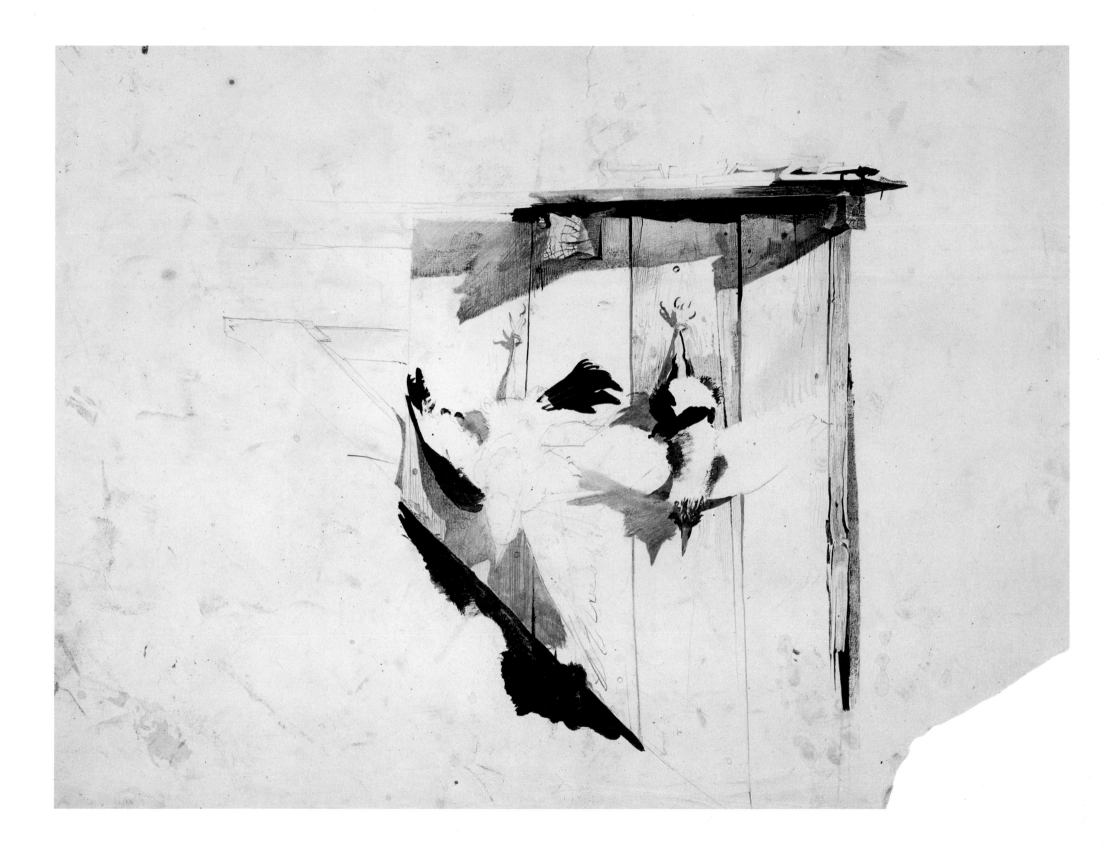

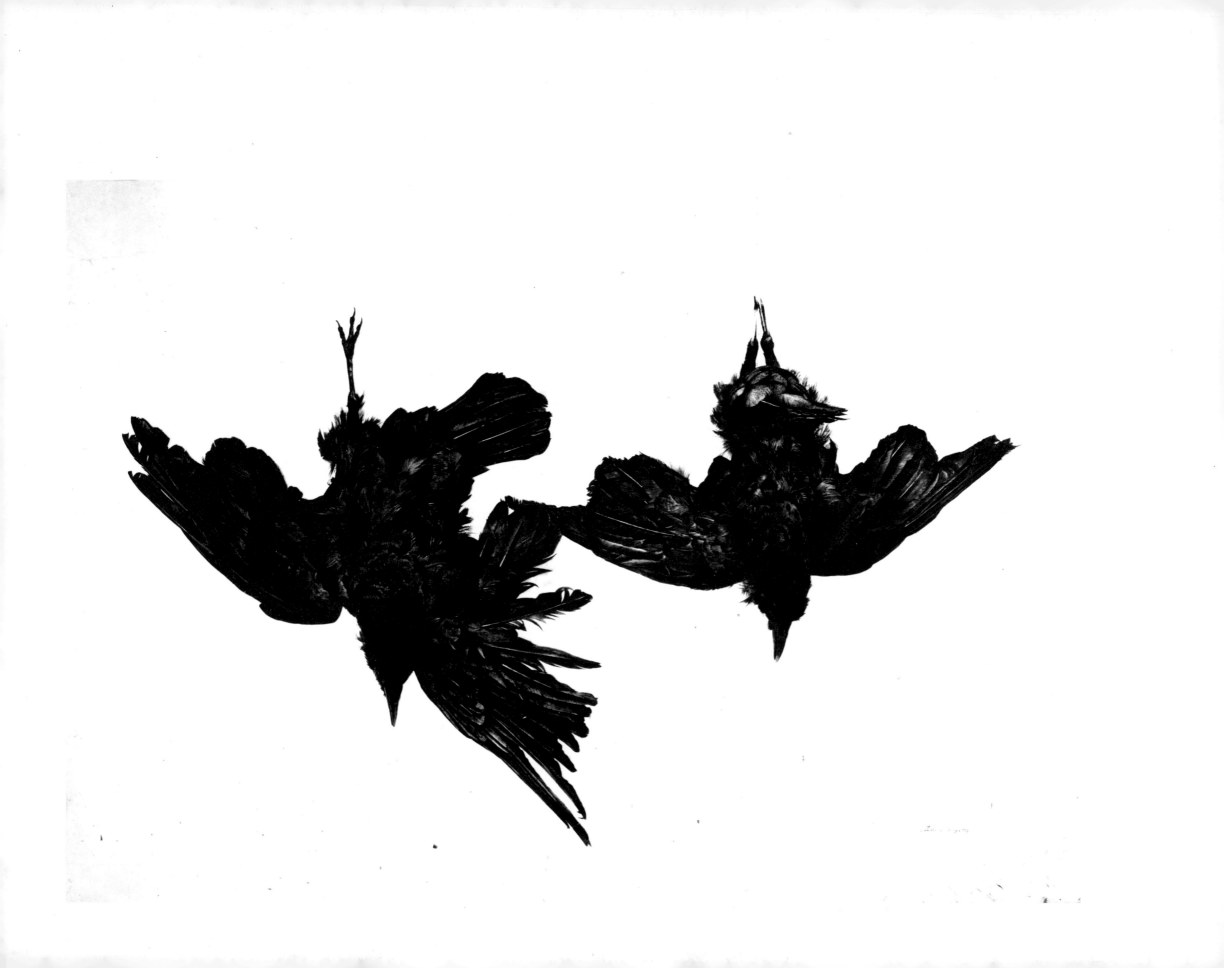

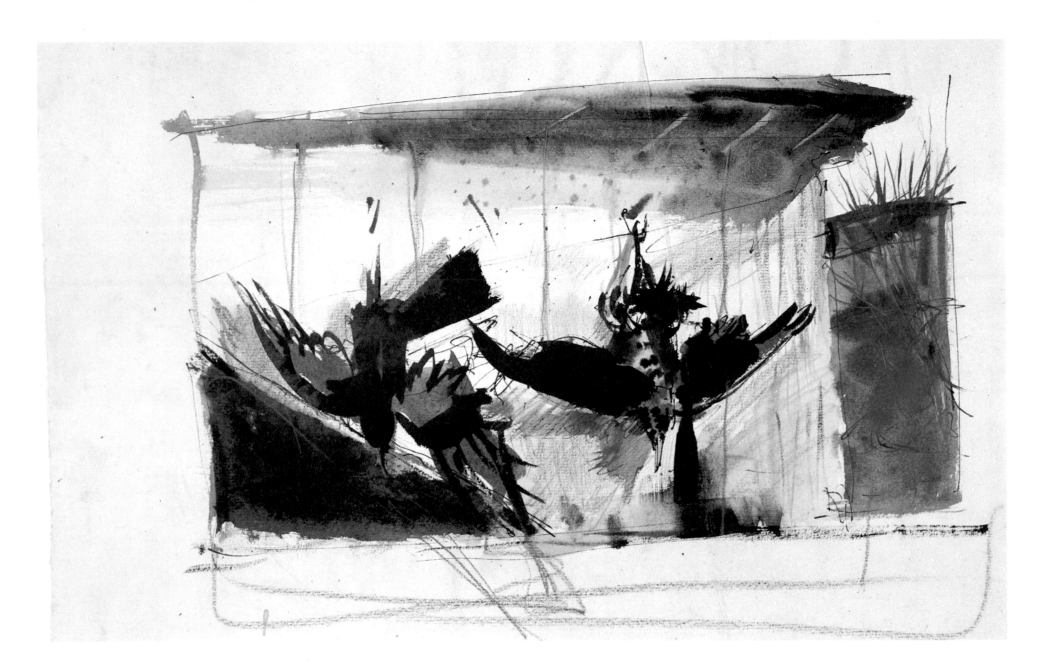

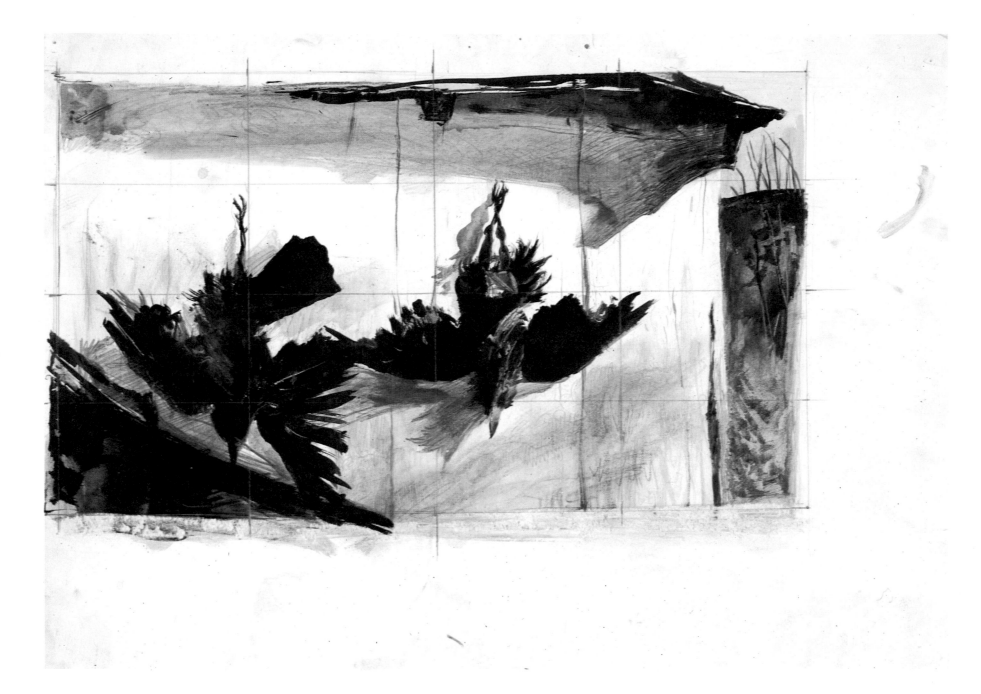

The composition, after being scored off, is ready for transfer to a tempera panel.

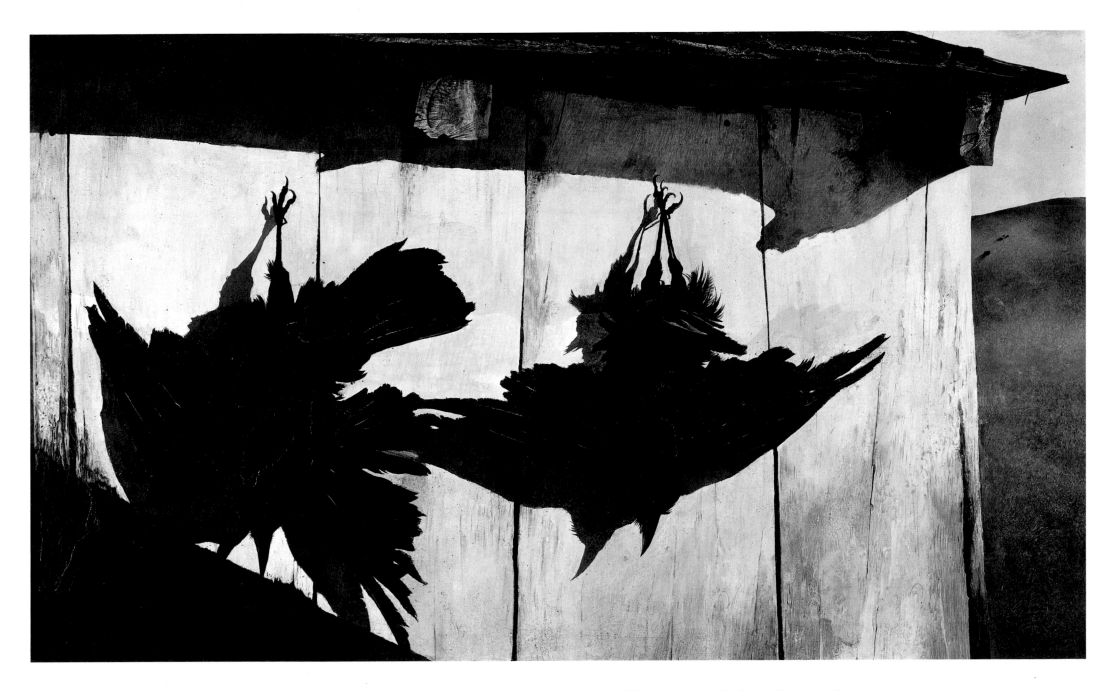

Woodshed, completed in late winter of 1944, was the first tempera Andrew Wyeth painted of the Kuerner farm.

A metal oil drum covered with a canvas tarpaulin
sits on a platform below the open shed.

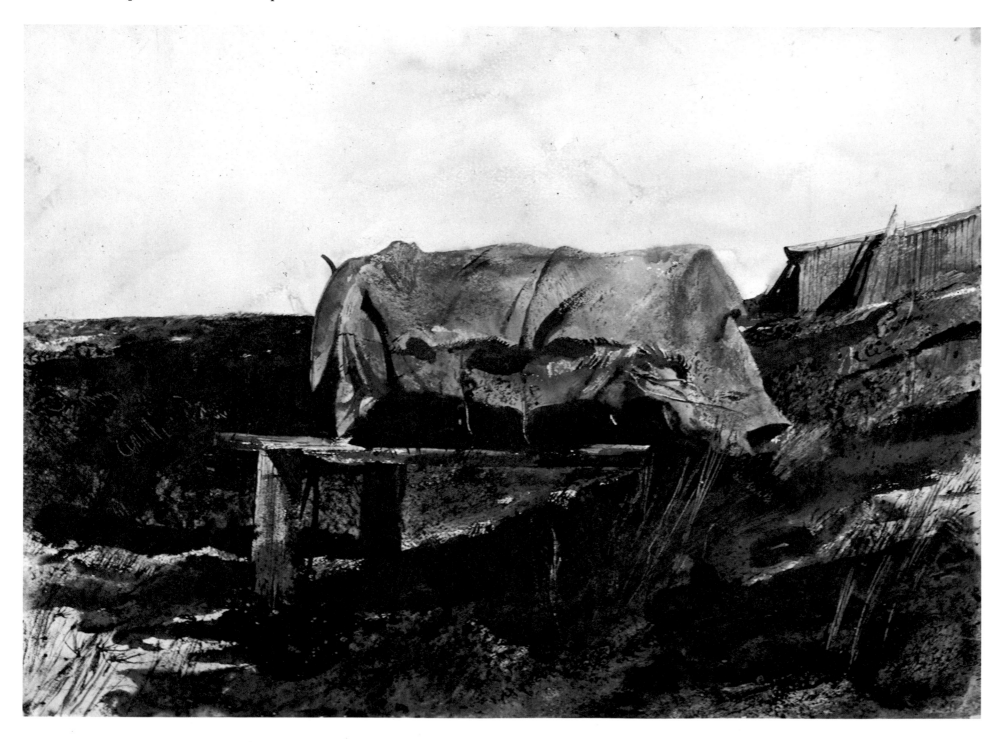

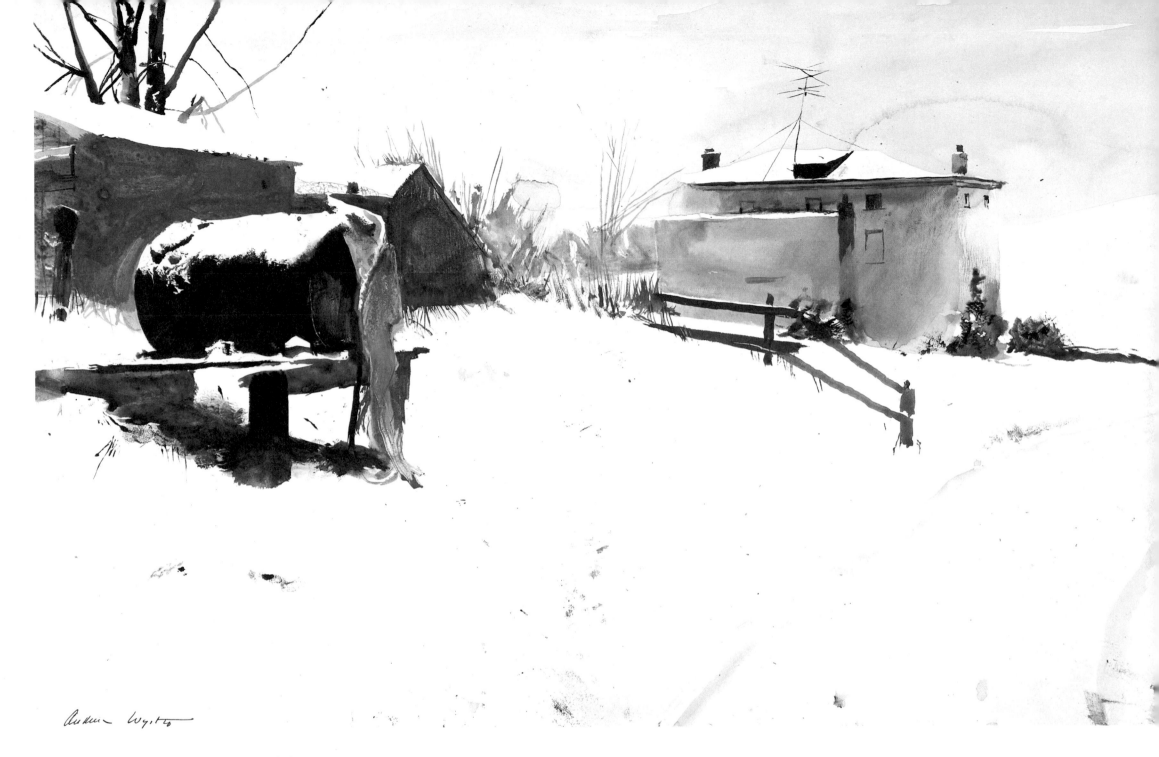

The same oil drum in winter.

To the Barn

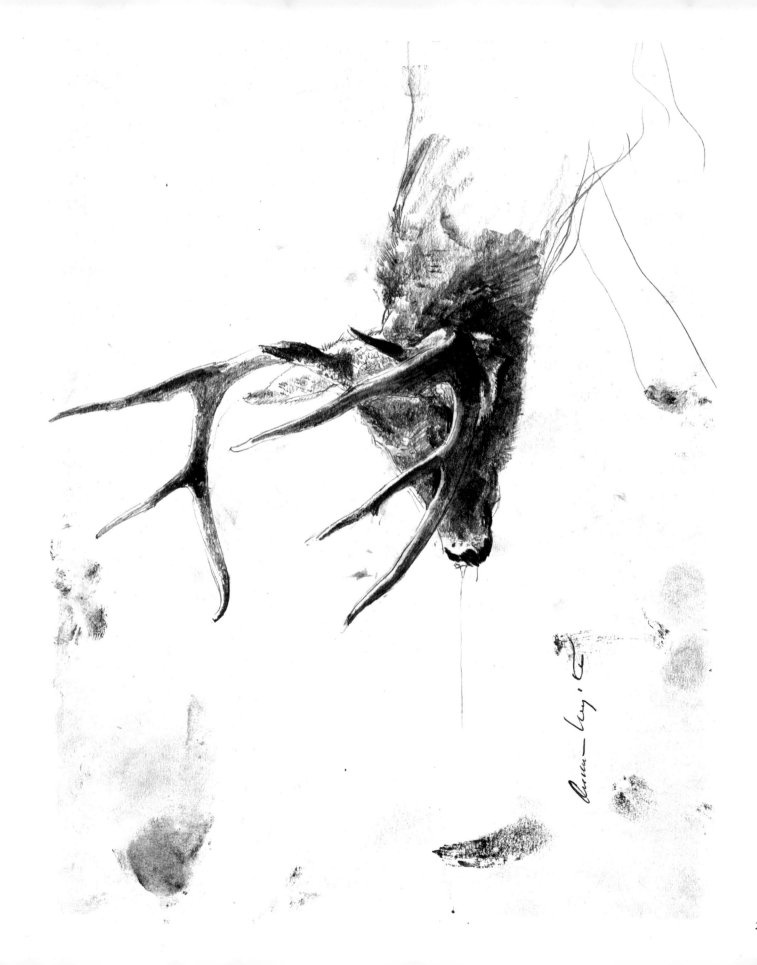

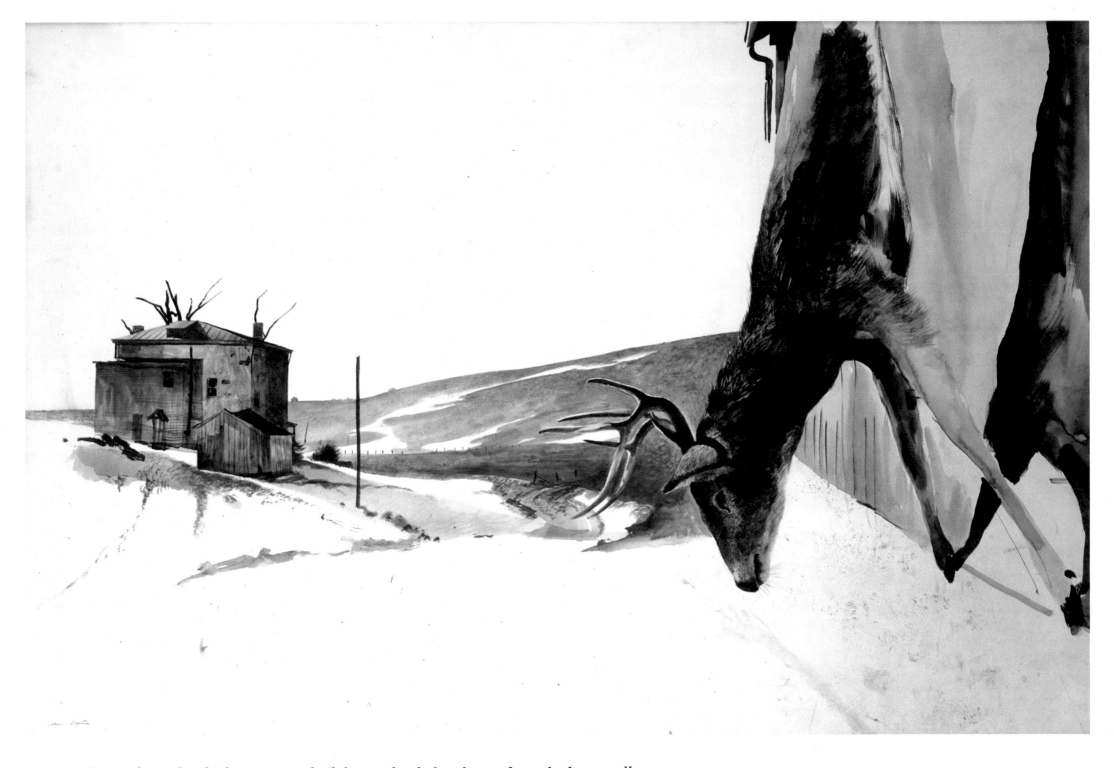

Across from the chicken coop and oil drum a buck deer hangs from the barn wall.

The small, whitewashed woodshed, close to the house, was torn down twenty years ago.

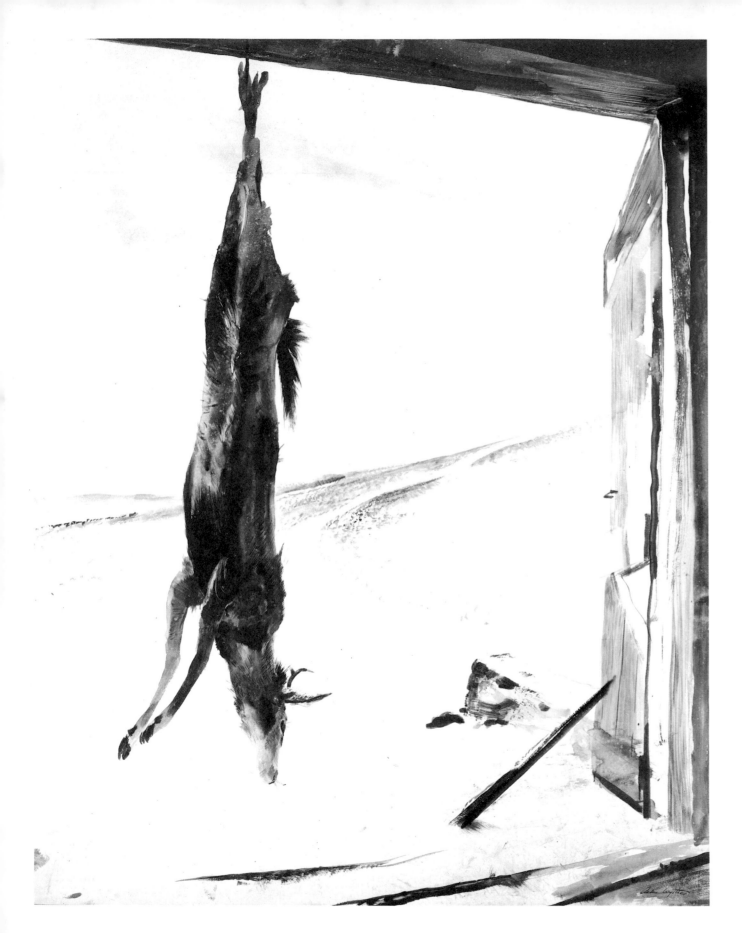

Walking back down the snowy cart road from the hills toward the farm buildings, the artist found the large back doors of the barn open and the frozen body of a young buck deer hanging from a beam.

The barn entrance that faces the house has a walled courtyard.
Cattle have left their wandering tracks in the snow on Kuerners Hill.

Inside the walled-in barnyard
a barrel full of frozen water
sits by the main door to the barn.

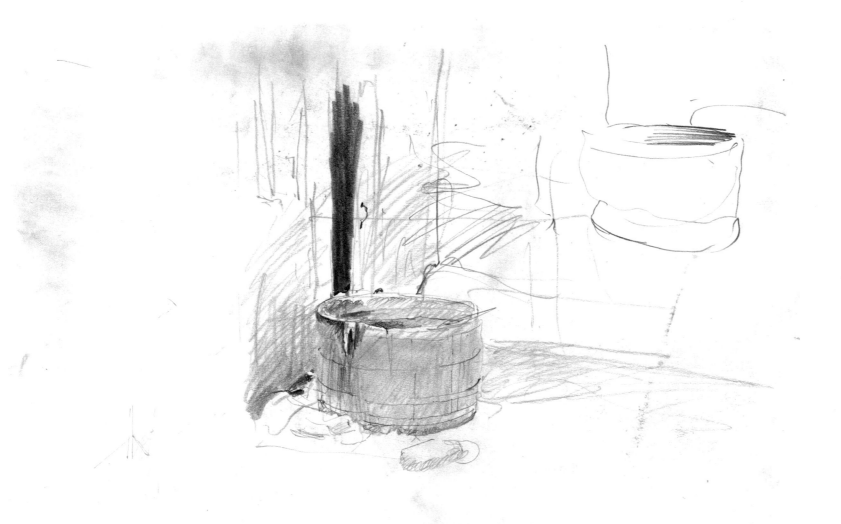

A.W.

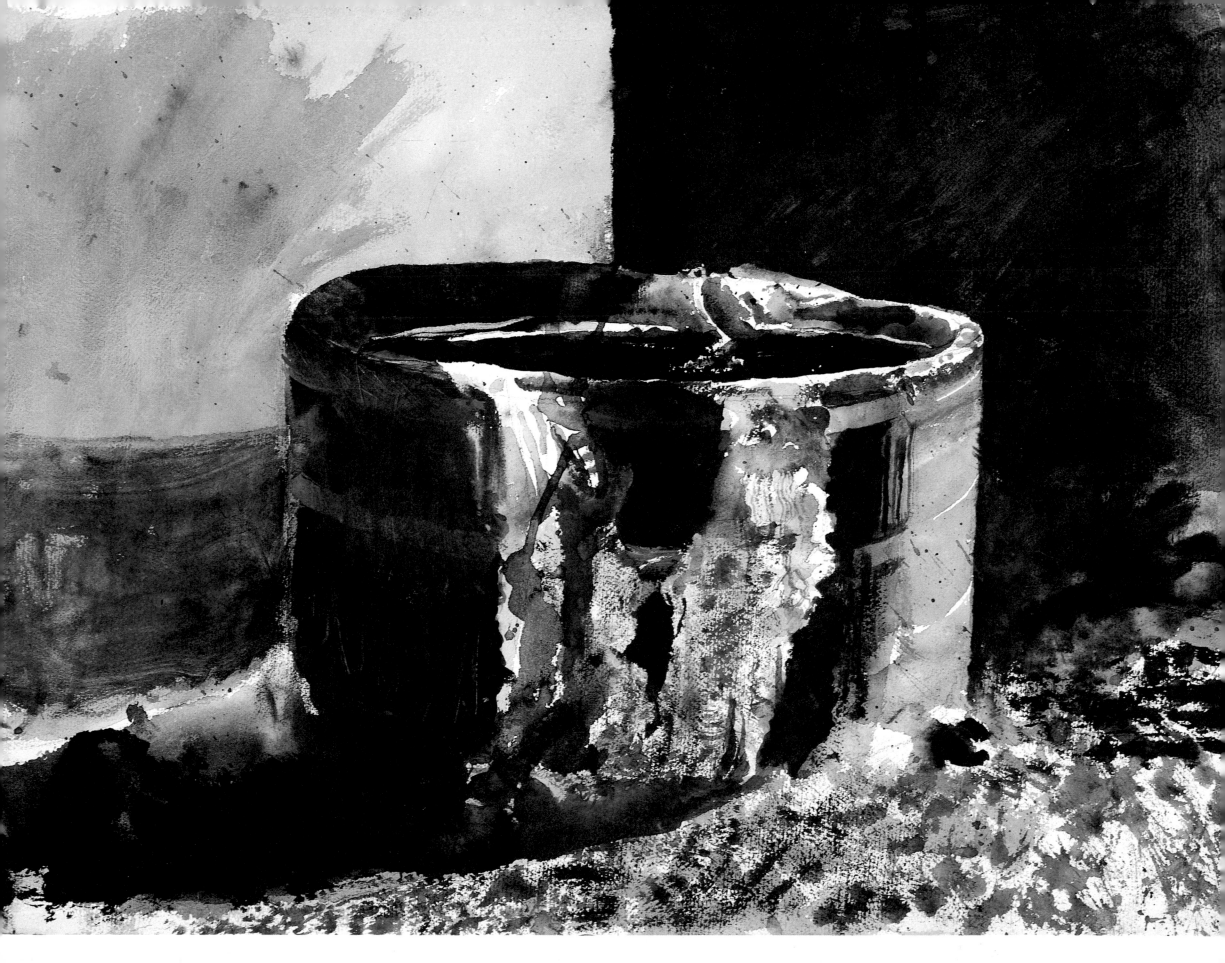

The owners of this drawing discovered it on the reverse side
of a Wyeth watercolor when they had it reframed.

Just before entering the stable,
the artist found this deer
hanging from a ceiling rafter.

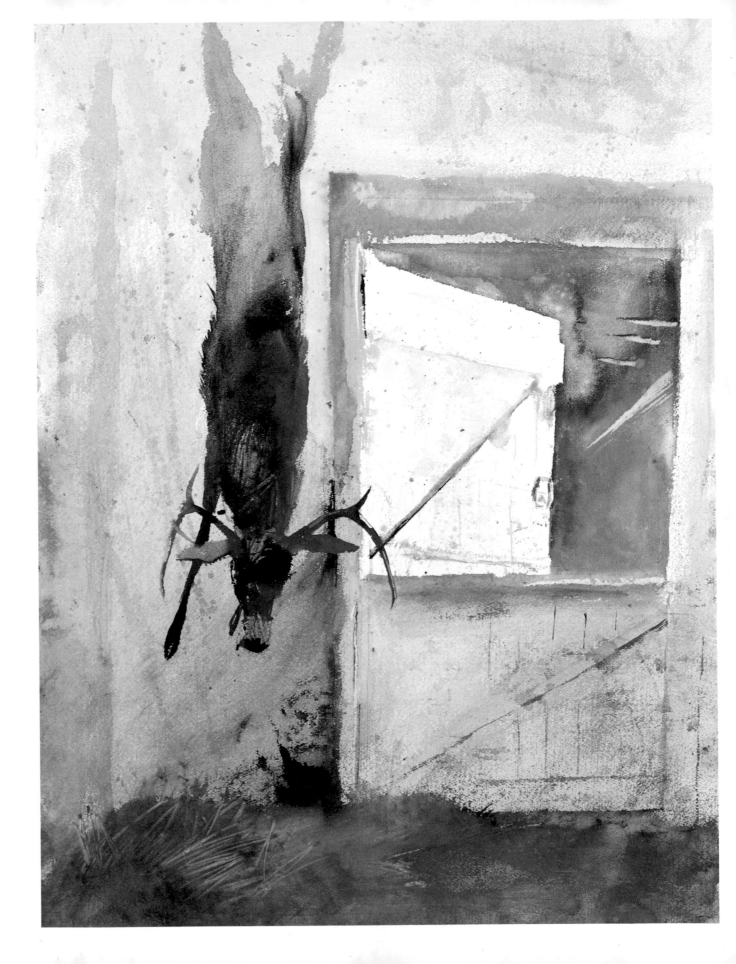

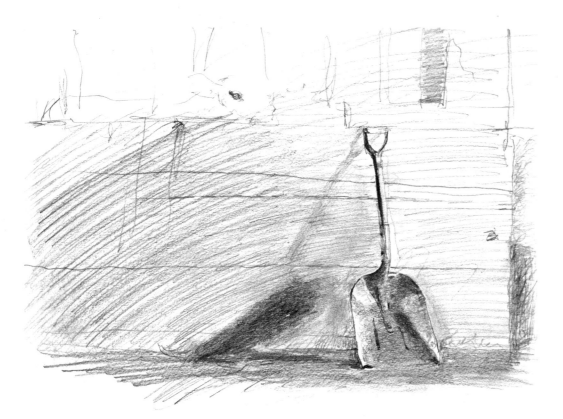

A heifer peers over a box stall. Each year Karl decides
the time has arrived to reduce his herd of Brown Swiss,
but he never does.

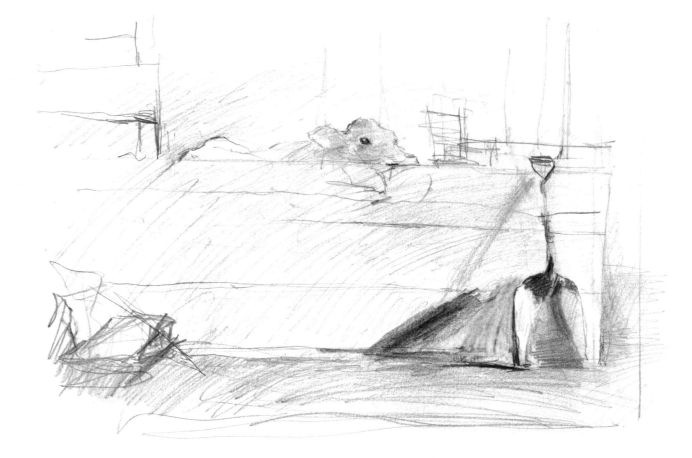

In the Milk Room

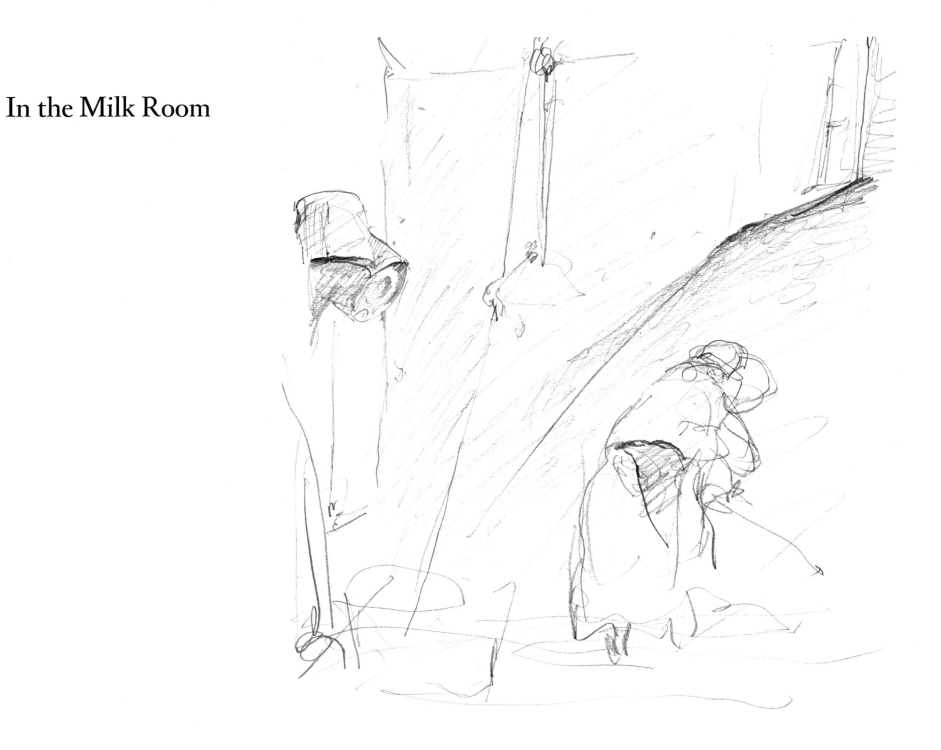

Anna, busy at work,
cleaning up the barn milk room.

Hanging on the wall are all the utensils used for butchering.

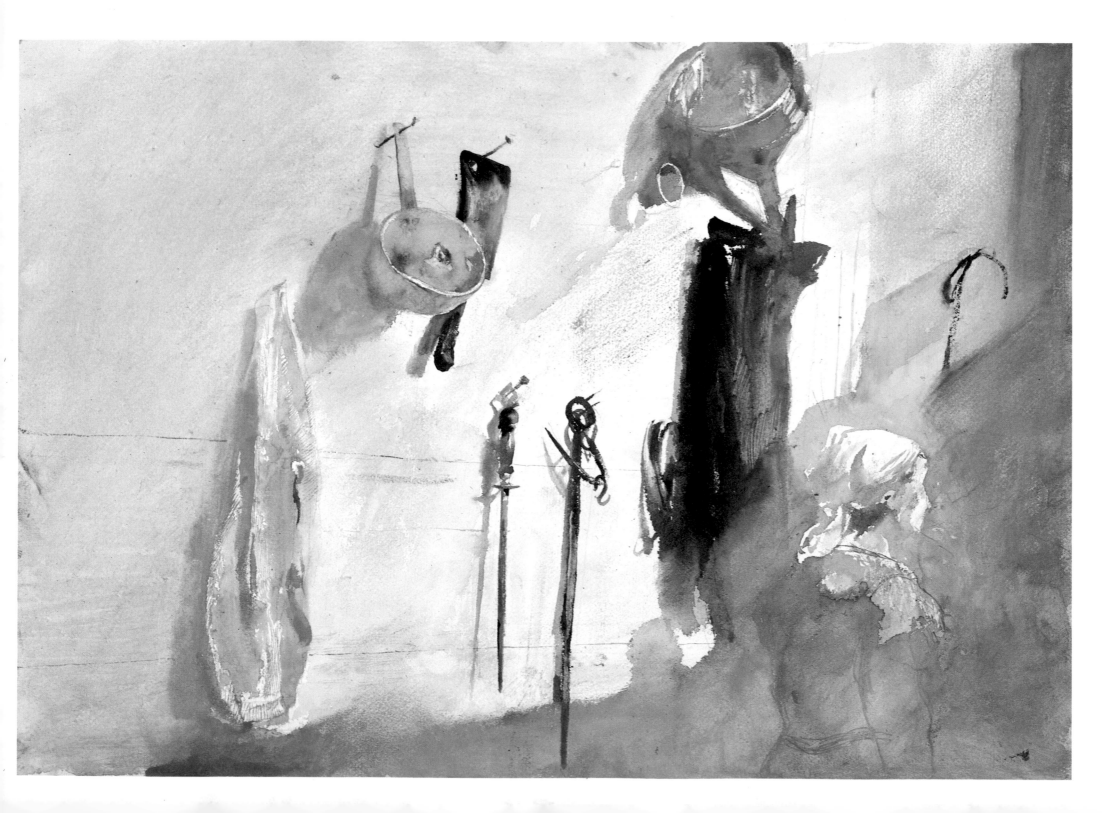

Anna begins to disappear again.

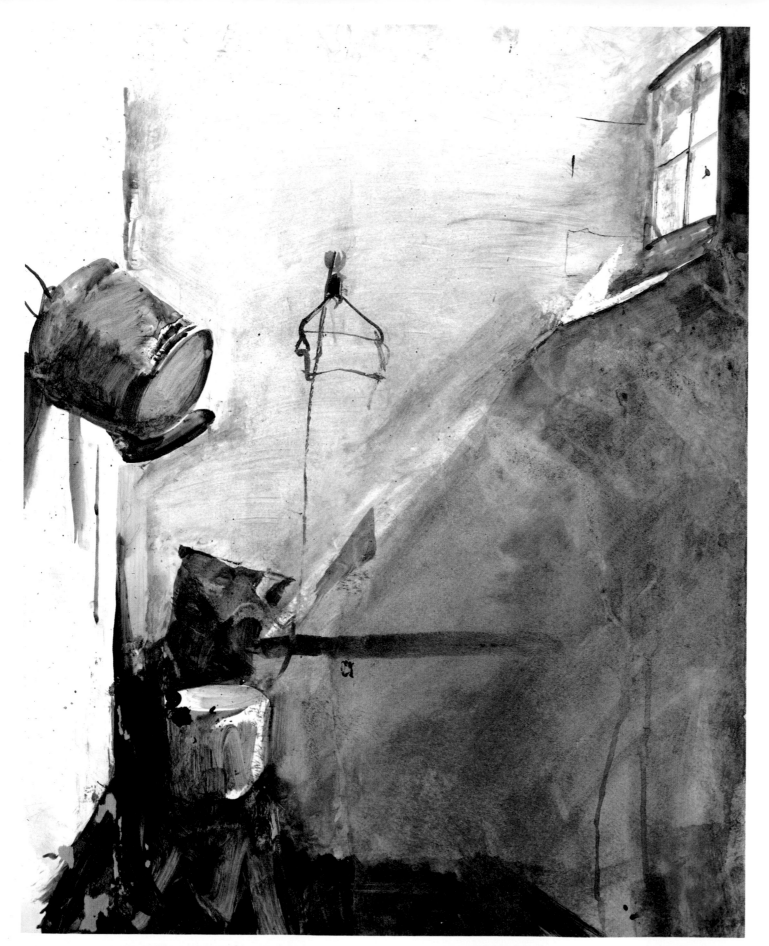

The milk room in the morning
without Anna.

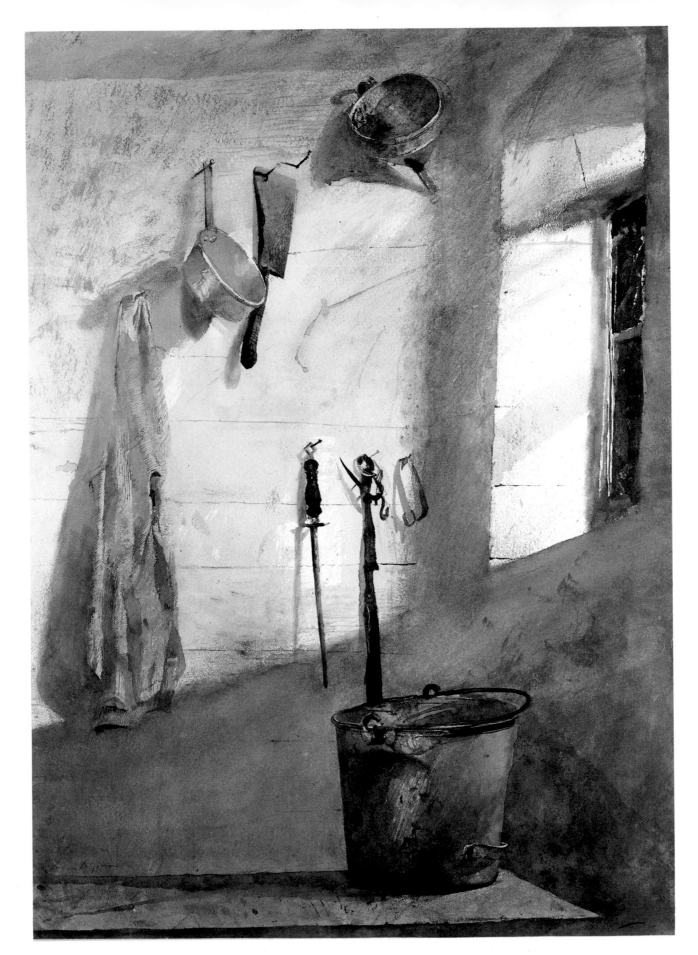

Buckets, windows and hooks
appear in picture after picture.

221

She's back again, but only briefly
as she bends over the stone trough
full of water that flows from a spring
on the side of Kuerners Hill.

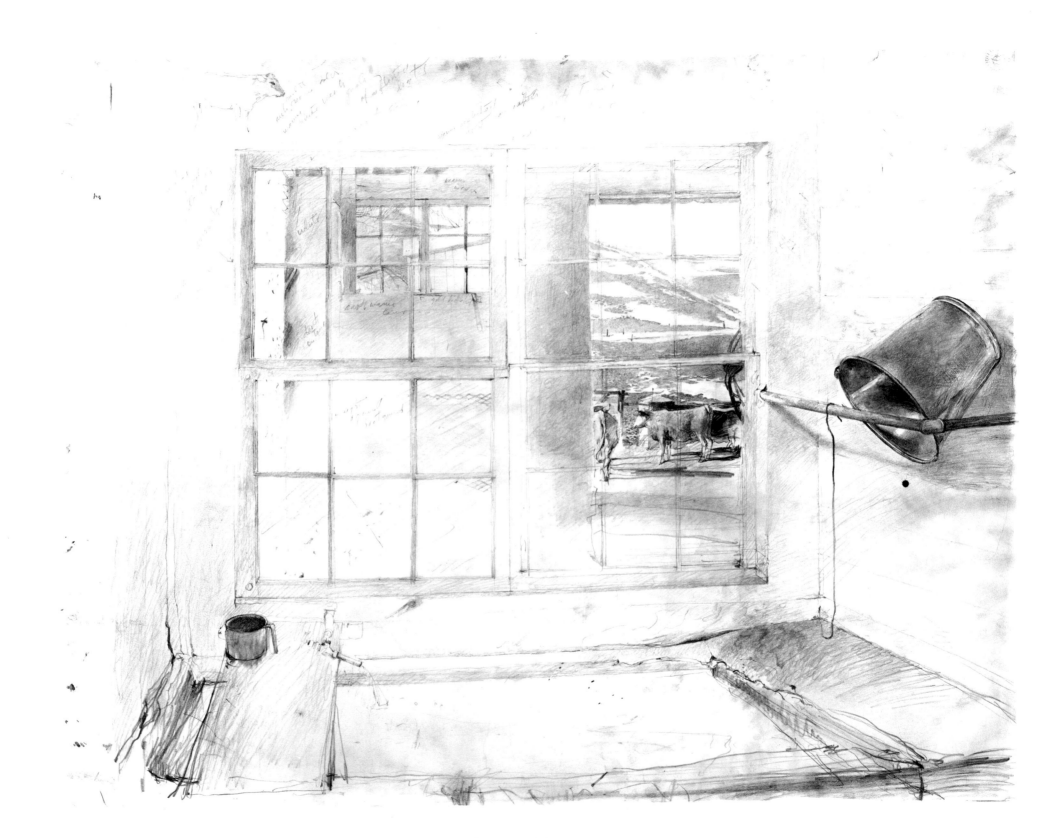

The milk room windows look onto the walled barnyard. Cattle are waiting
for the gate to be opened so they can move out to pasture.

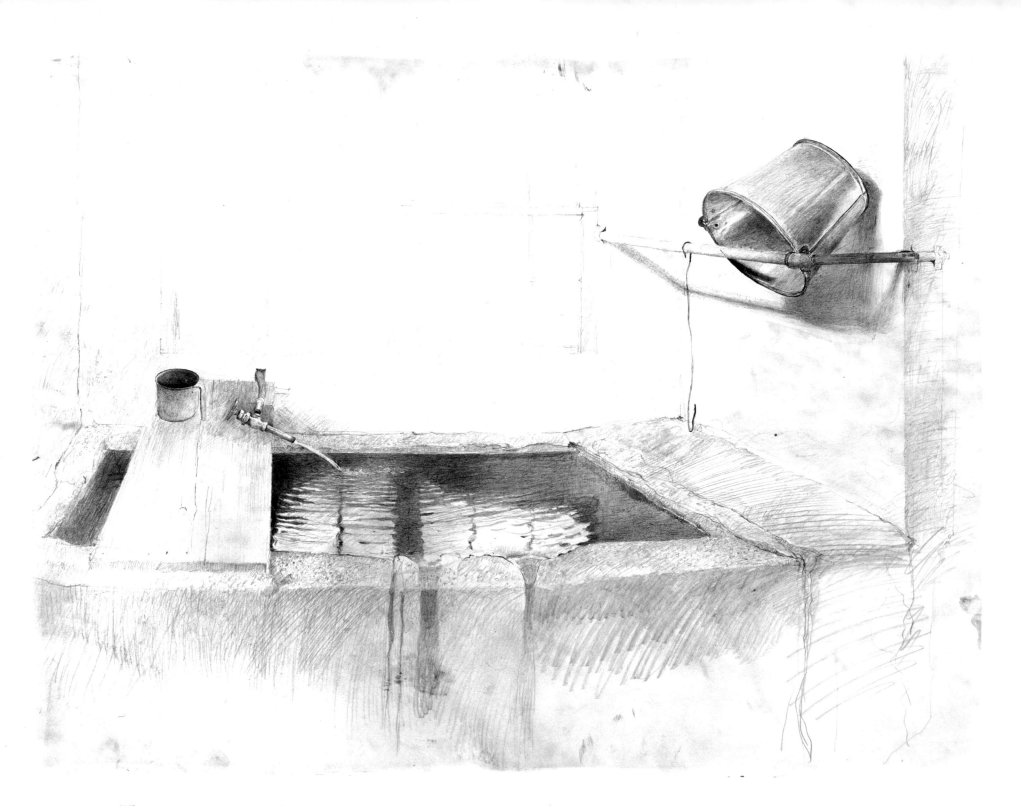

The spring water runs freely when the spigot is turned on – spilling
over the lip of the stone trough. The metal bucket glistens like a new helmet.

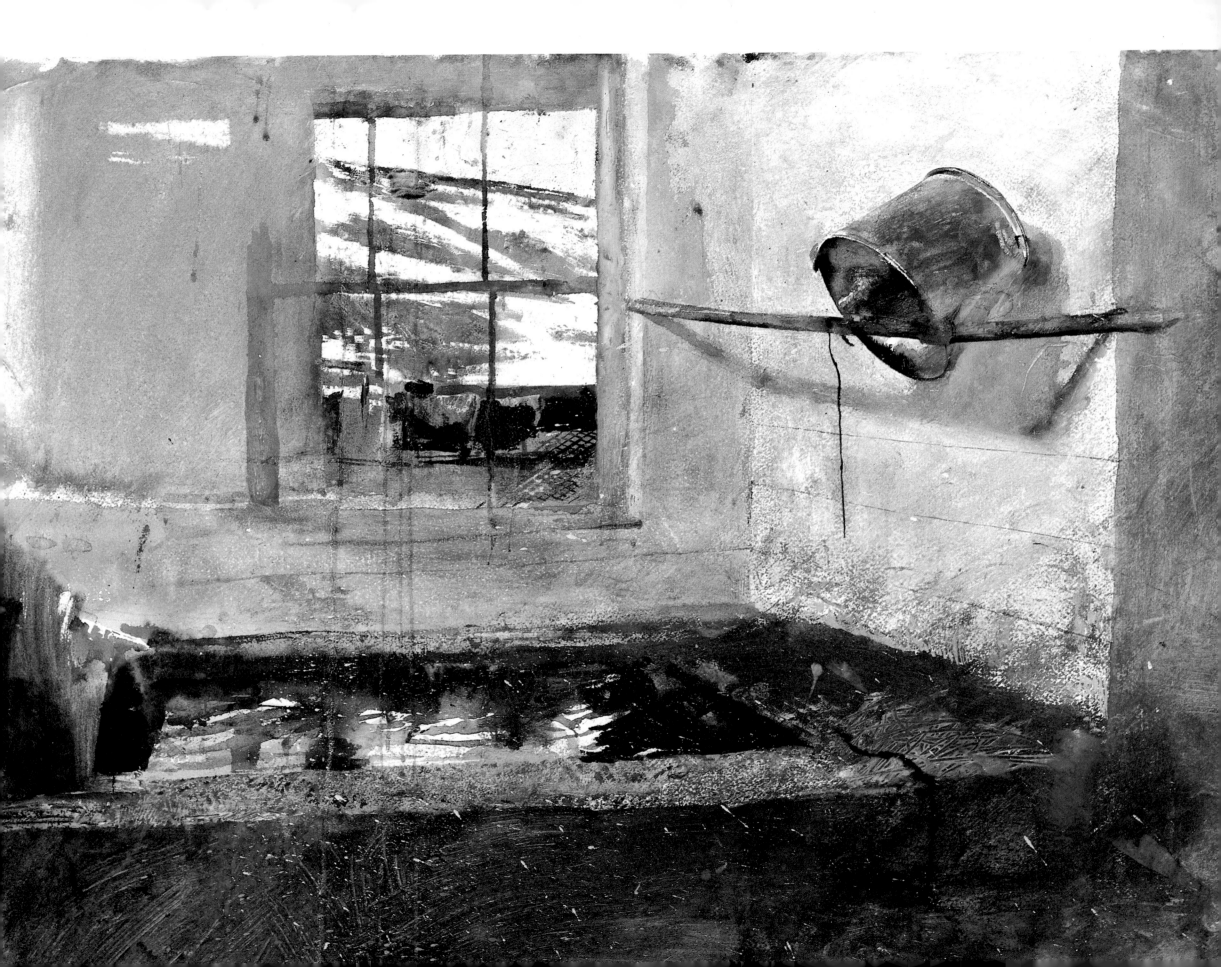

Out into
the Barnyard

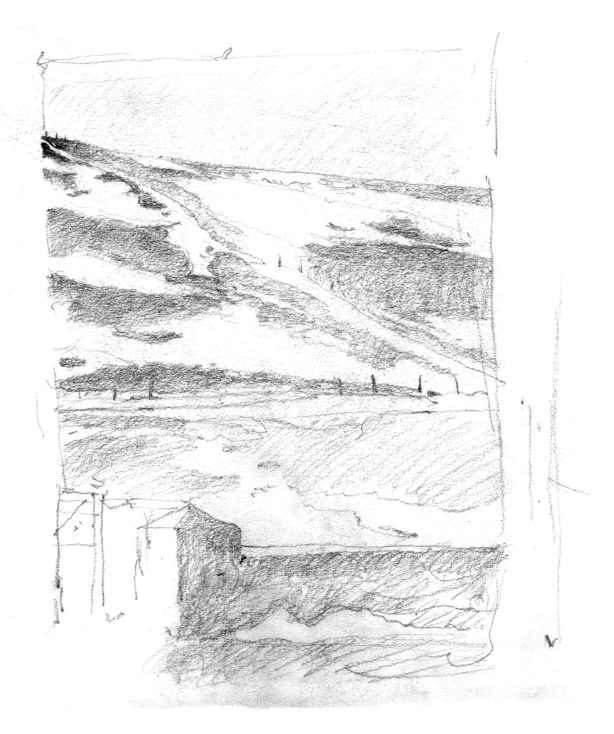

The open barn door frames the barnyard
and snow-streaked Kuerners Hill beyond.

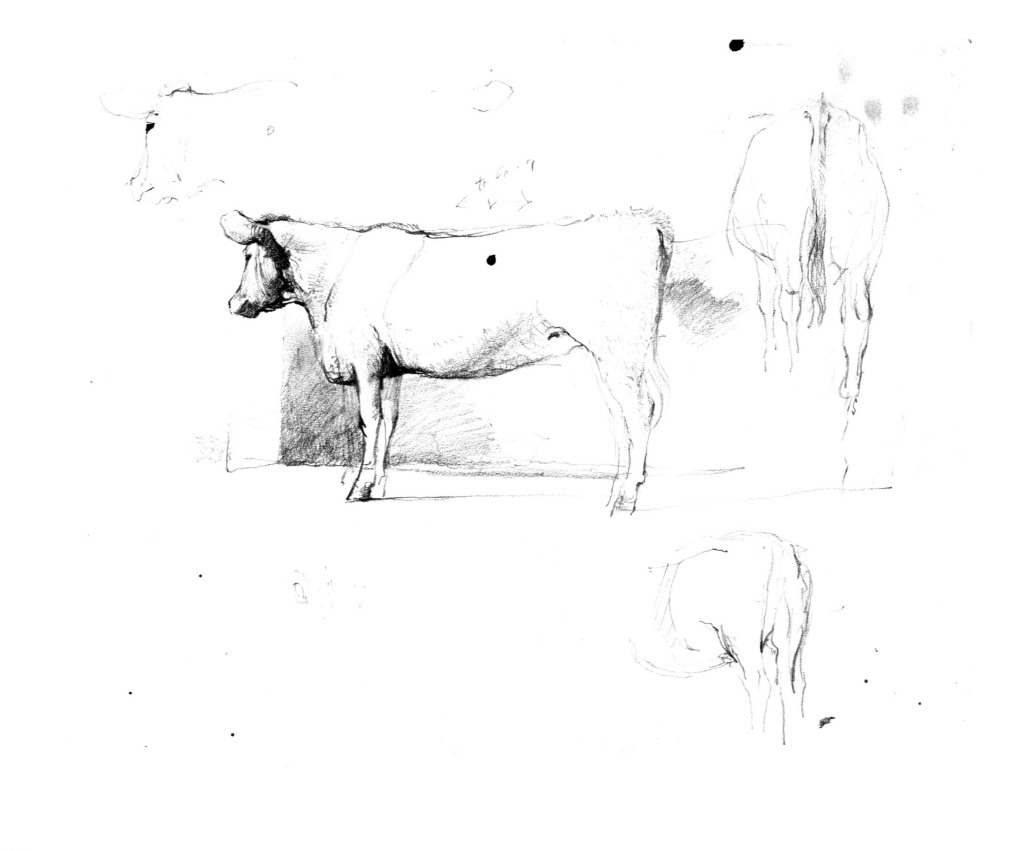

The pines on Kuerners Hill
can be seen above the barnyard wall.

Karl stands beside a bull.
When time would permit
he held this temperamental bull
by a short rope tied to a nose ring
so that his friend, the artist,
could make drawings.
One day the bull became enraged,
kicking and whirling around
with such force
that Karl and Wyeth's palette
went flying across the barnyard.

229

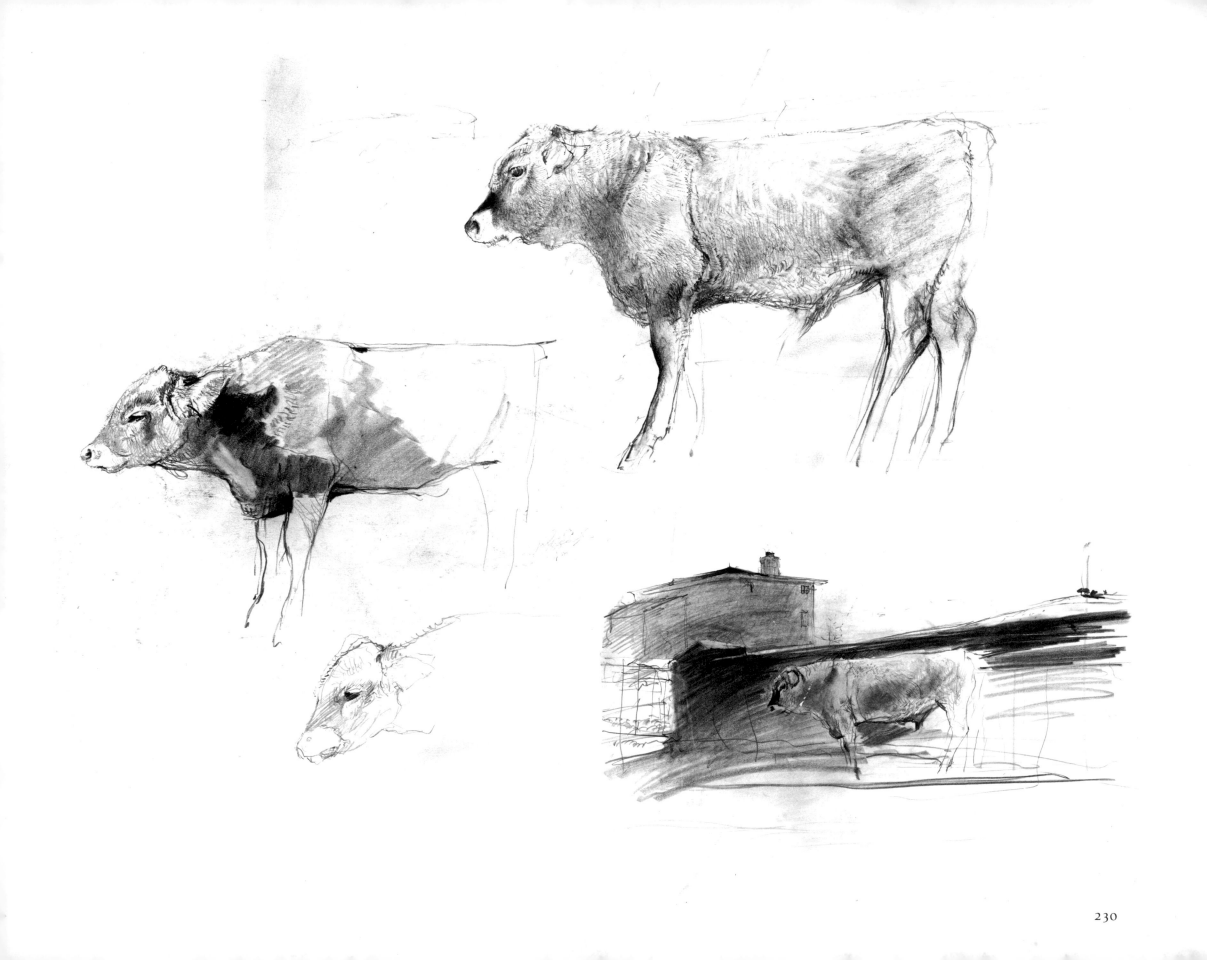

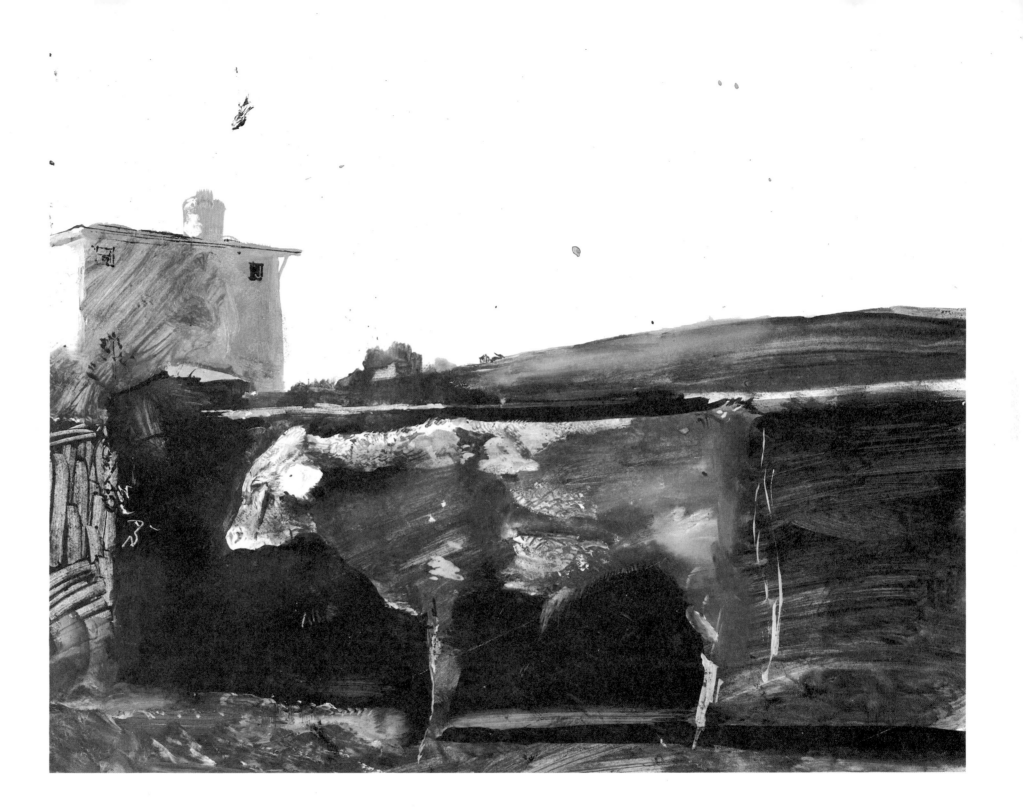

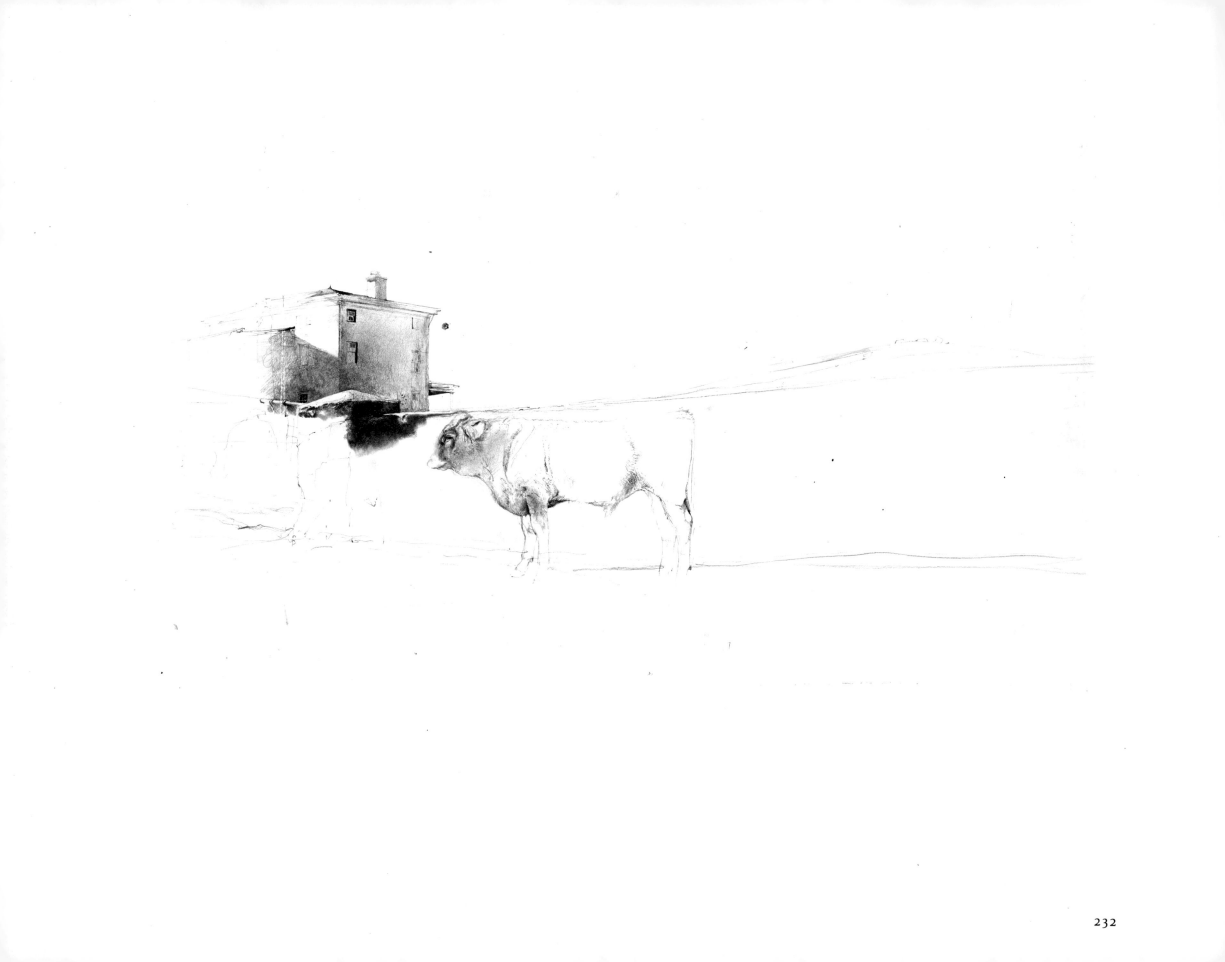

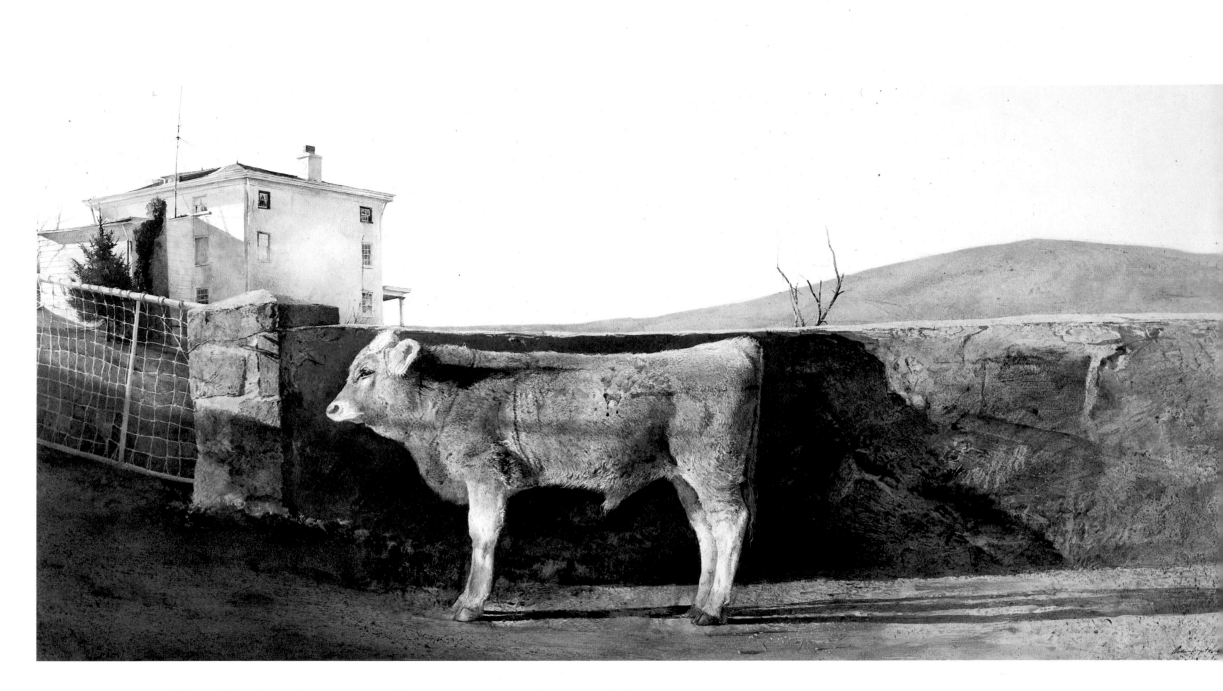

When Wyeth's palette was sent flying, paint spattered across this drybrush.

It was left, untouched, on the hindquarters of *Young Bull*.

The morning sun strikes across the green serpentine stone wall.

The German Shepherd

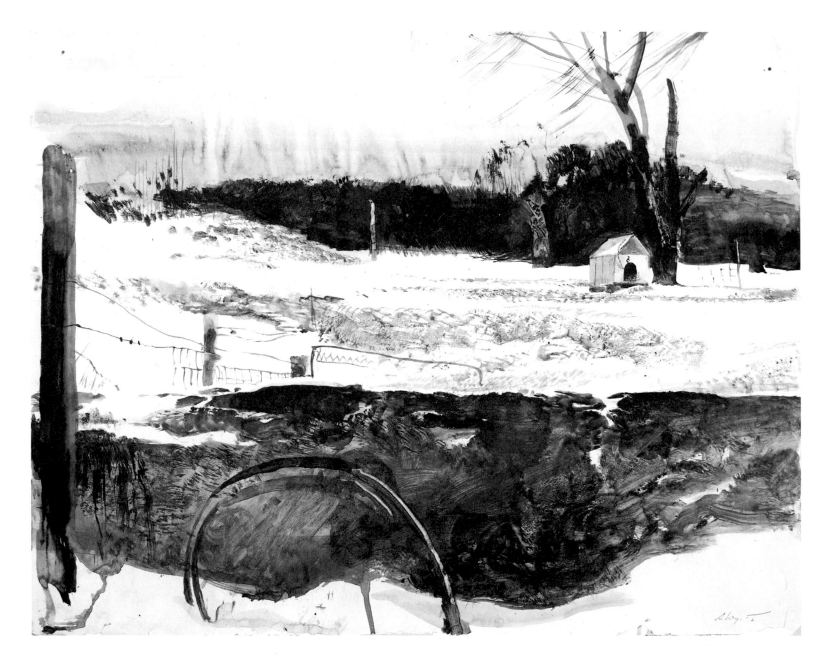

The path leading from the barn to the back door of the house passes dangerously close
to this doghouse where the German shepherd is kept chained, unless she is off on her daily run.

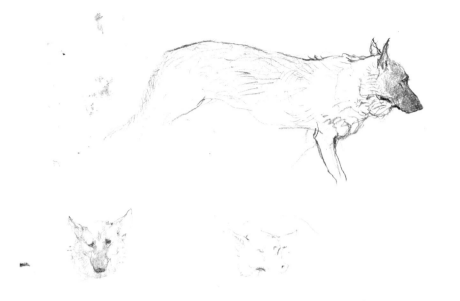

Karl has trained Nel to come back from the hills
with a shrill whistle he learned as a shepherd.

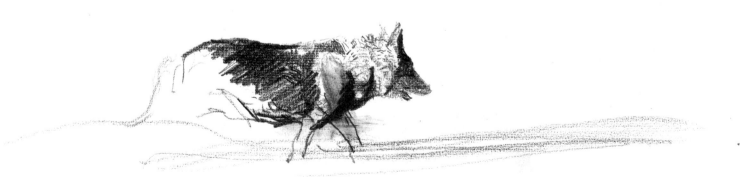

The dog returns from her patrol.
The second floor window is still open
and Karl must be smoking pork
in the big chimney.

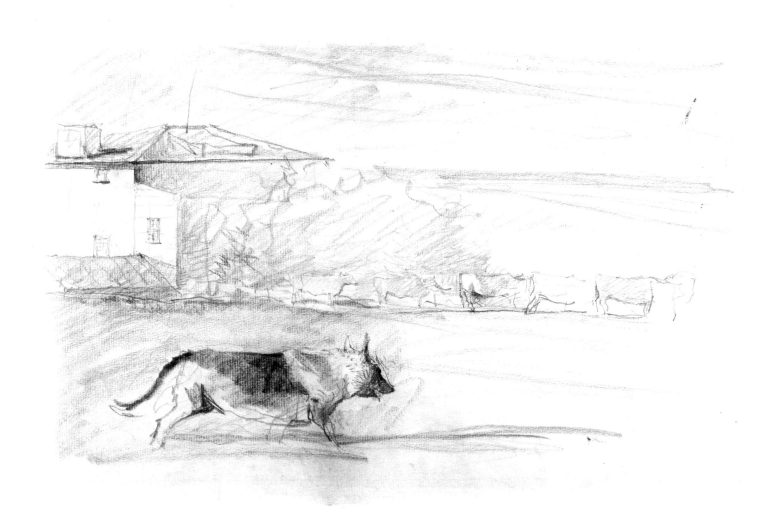

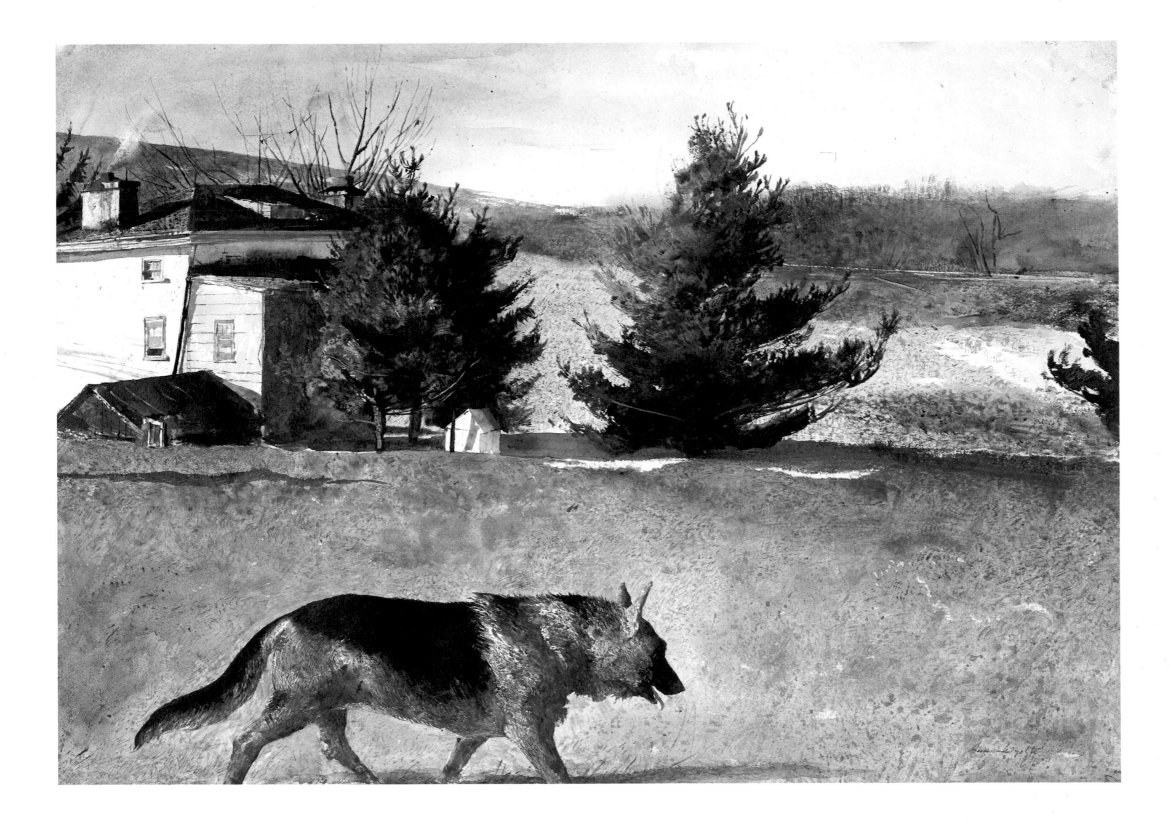

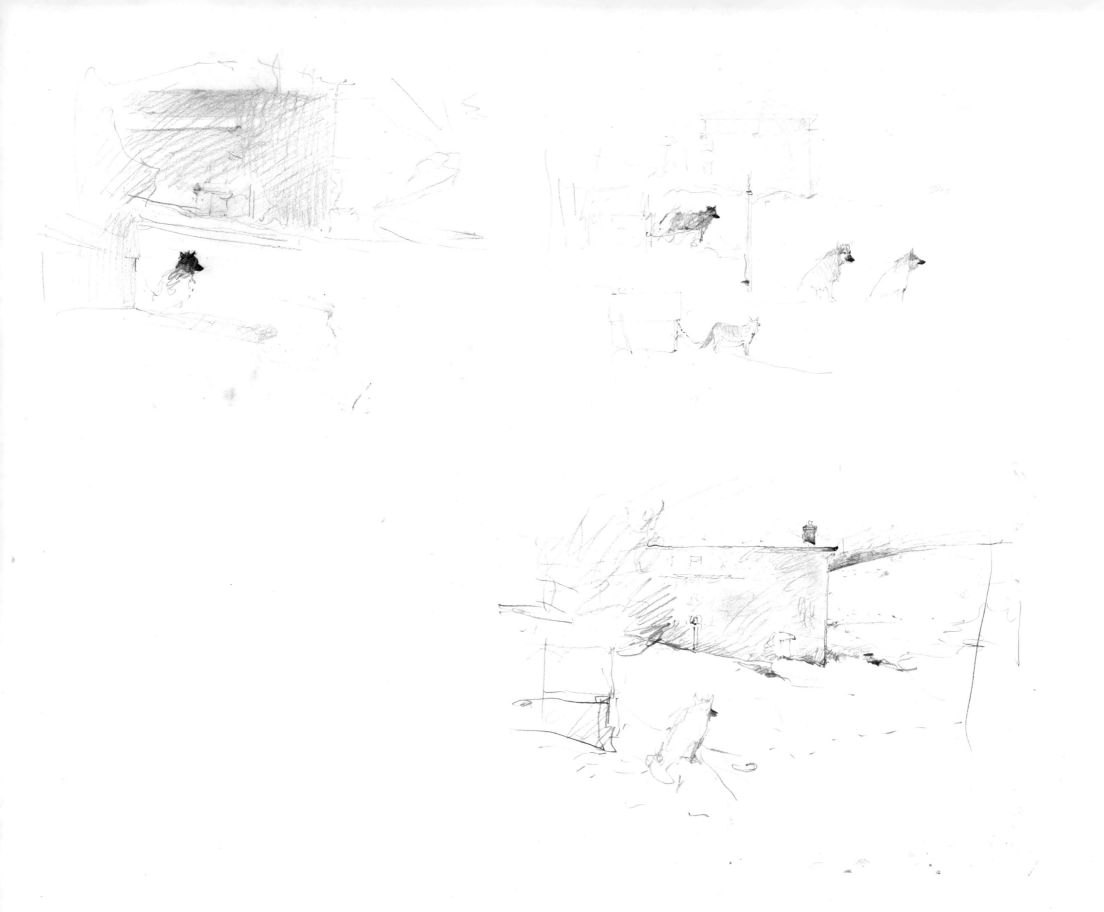

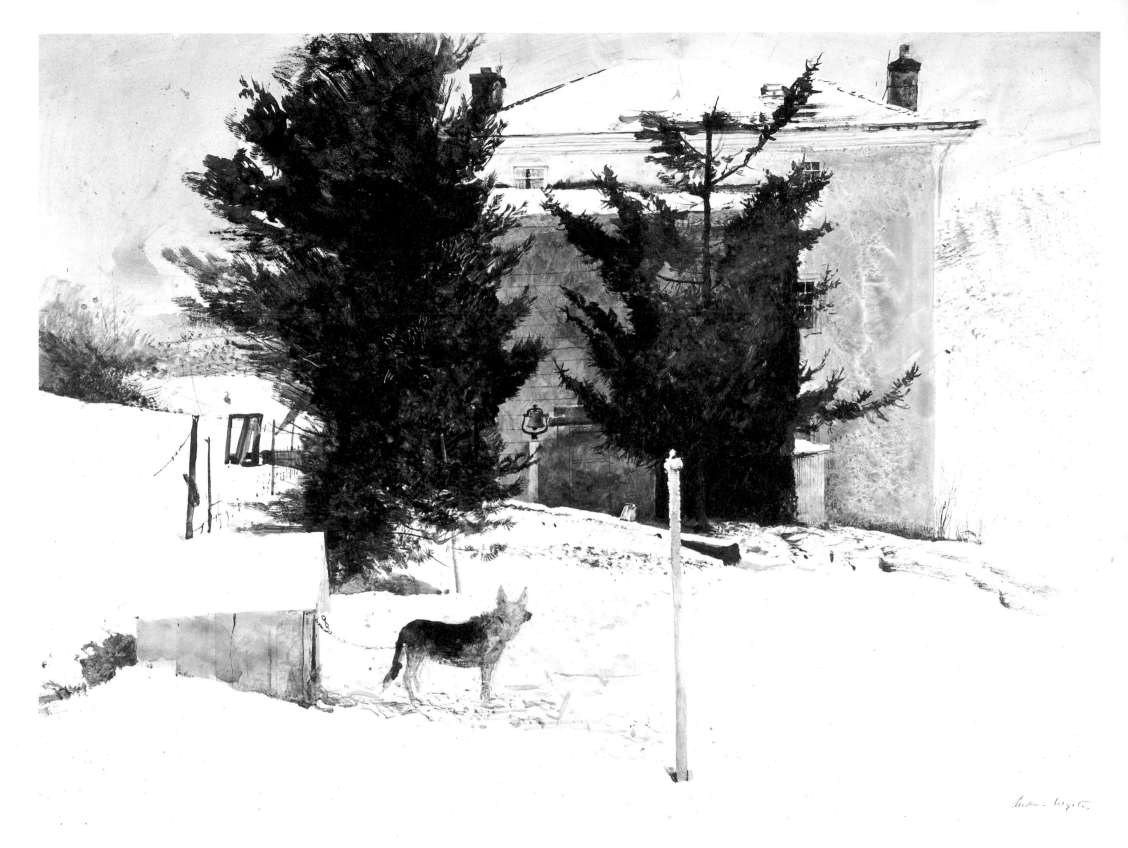

The chained German shepherd stands guard. Beside the back door are the farm bell
and an upturned bucket on the low wall built by the prisoners of war.

239

Going Inside and Upstairs

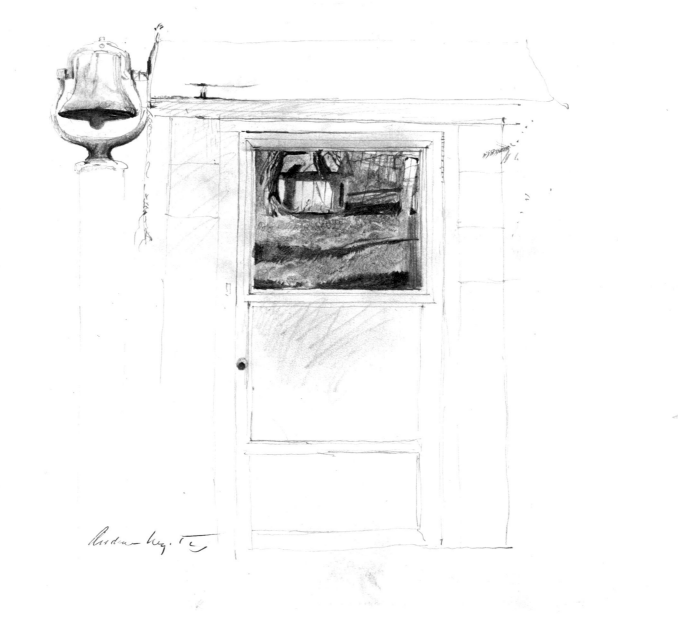

The doghouse reflected in the window glass of the storm door.

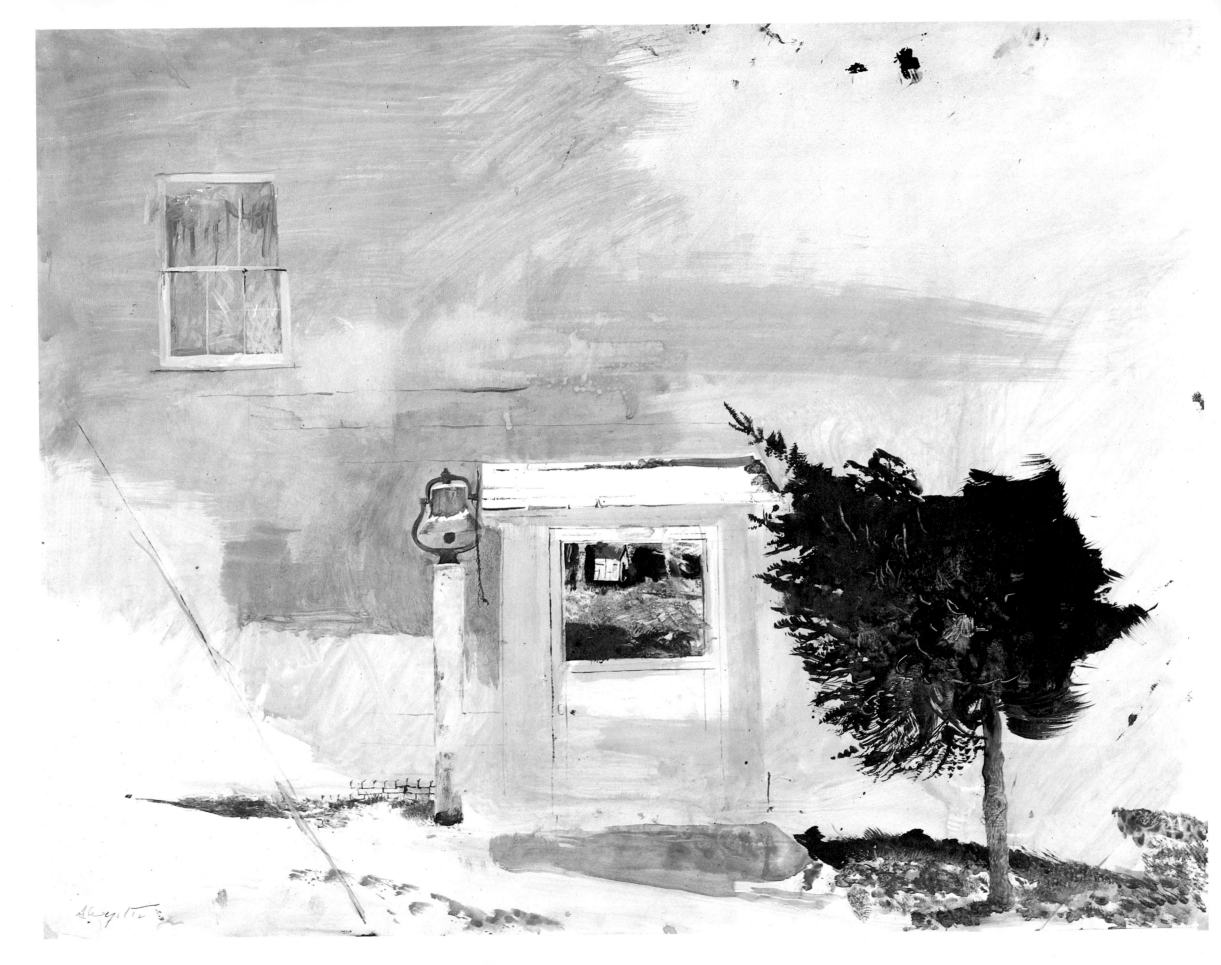

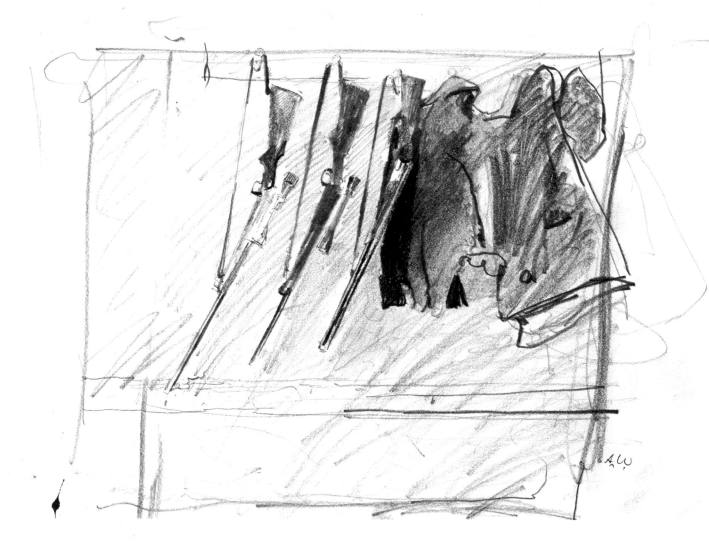

The smell of wood smoke and draft beer fills the air when you step inside. The entry room is sparsely furnished and chilly in winter. Straight ahead is a closed door that opens into the hallway where Karl's rifles, binoculars and jackets hang on wall pegs.

The artist worked so rapidly to catch
Anna's figure before she disappeared upstairs
that he drew over a drawing of Willard Snowden.

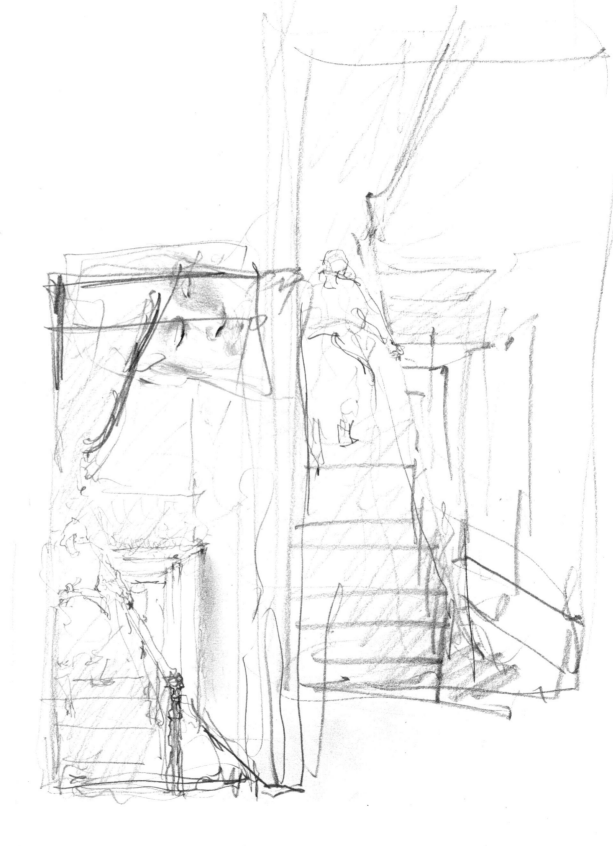

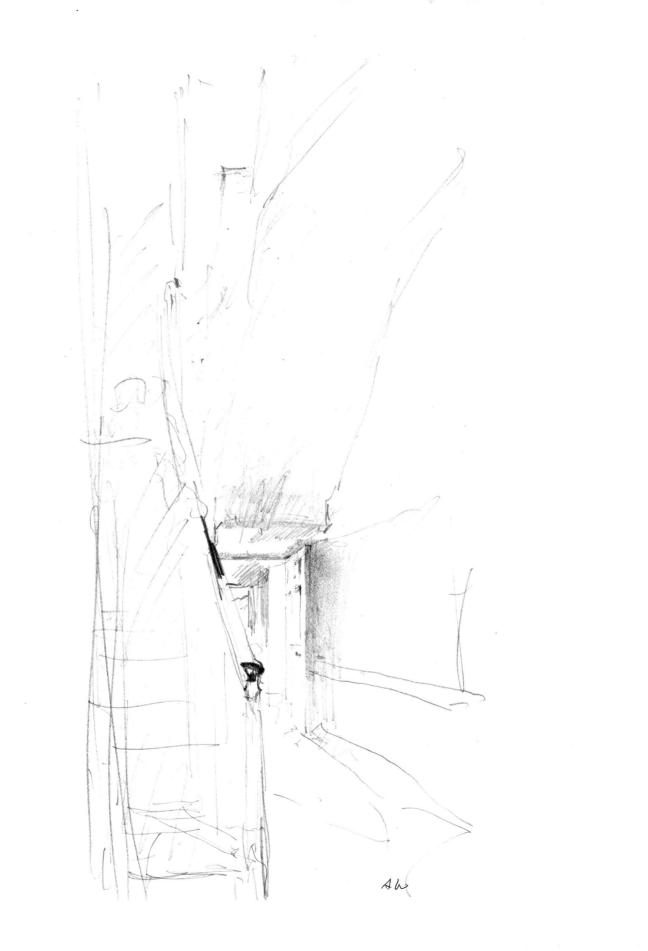

245

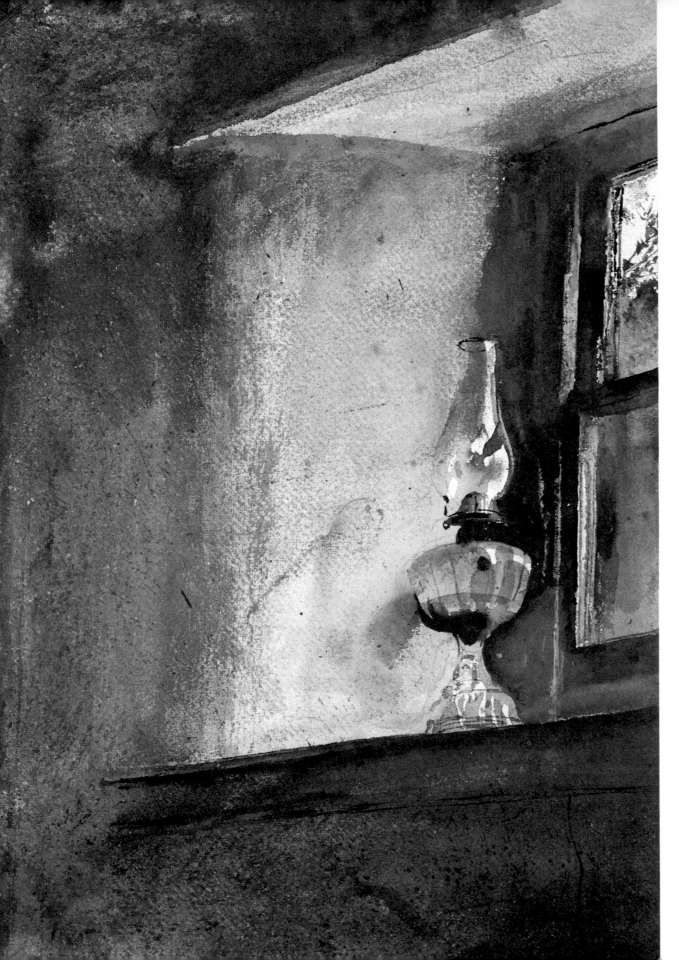

Up on the third floor
an oil lamp sits on the windowsill.

The house is built of fieldstone,
so the windows are deep-set.

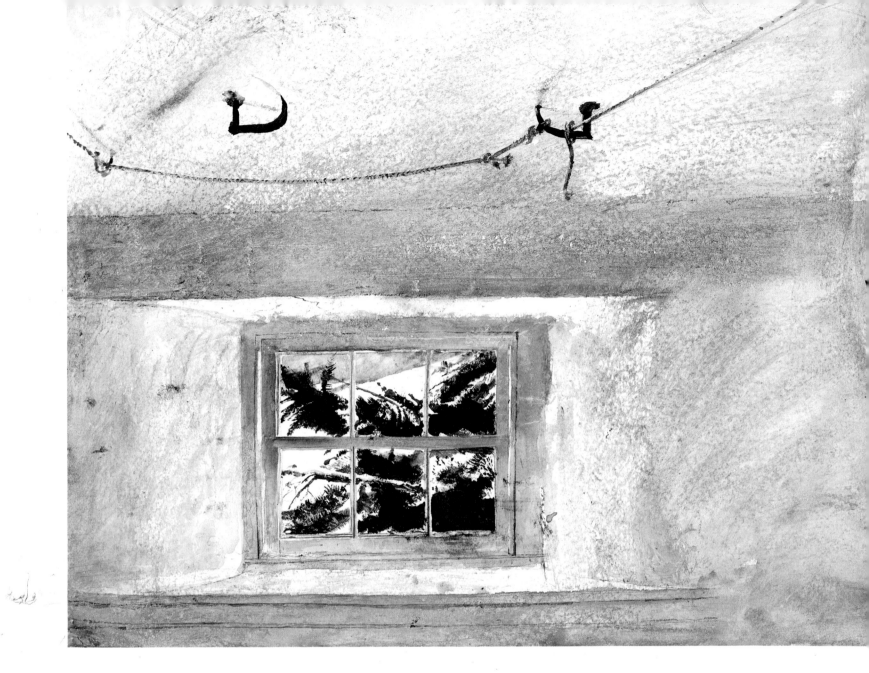

The third floor rooms with their small windows and hooks
driven into the ceilings and walls fascinate the artist.

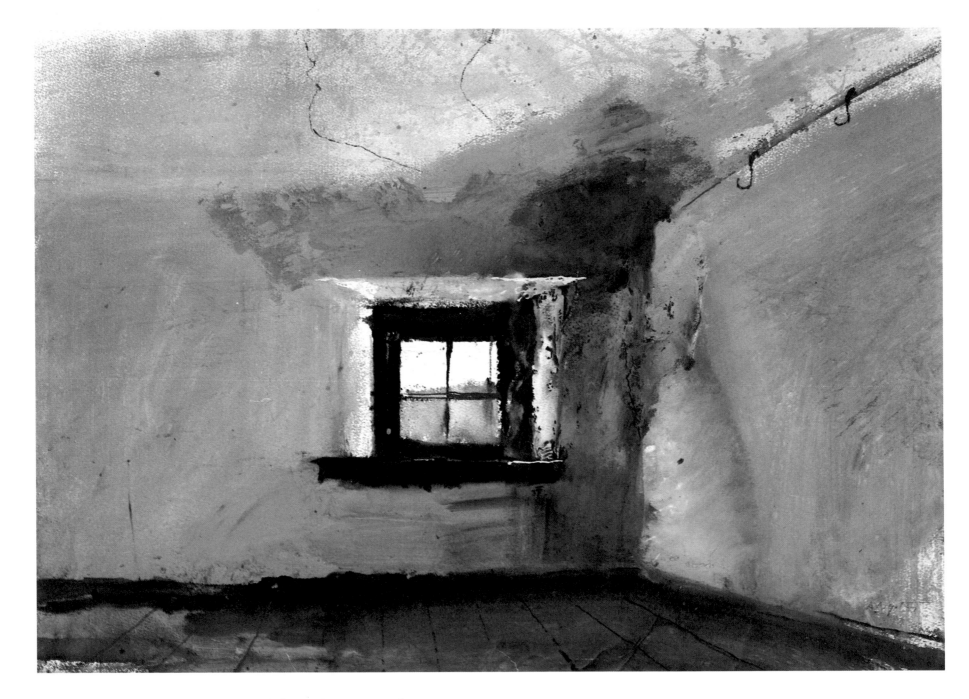

Karl

Karl's standing figure was removed from this watercolor,
leaving a phantomlike image. Andrew Wyeth has never painted a picture
or even made a drawing on the second floor of Kuerners.

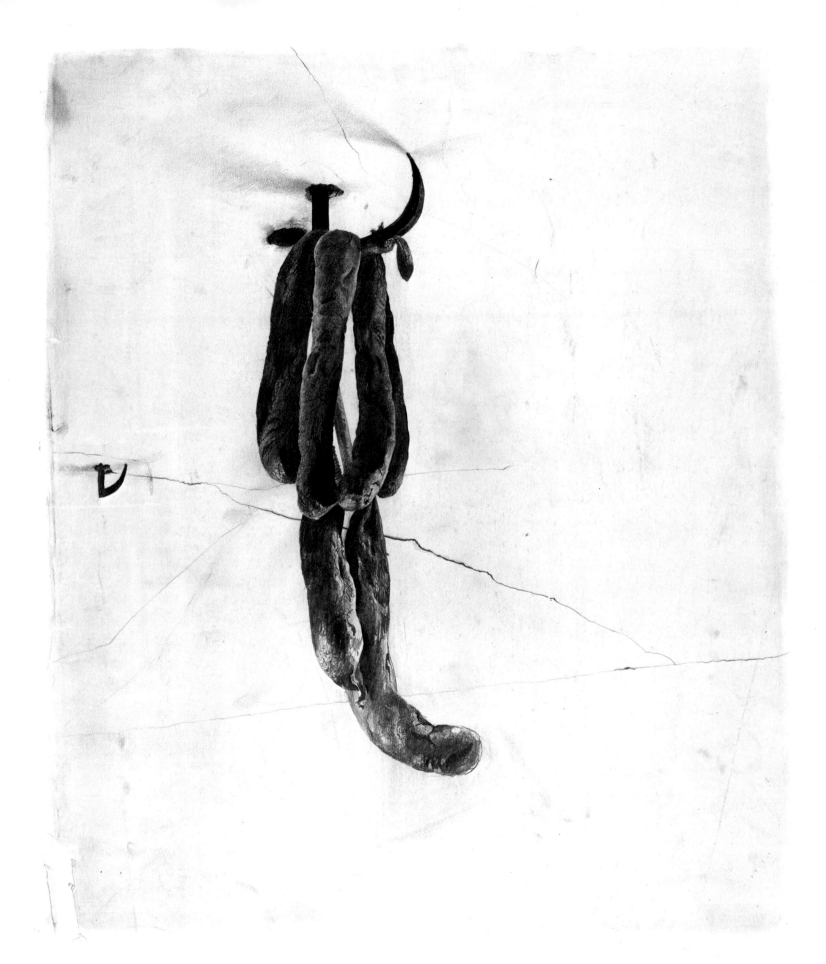

When an animal is slaughtered all blood is carefully saved and made into sausages. Every Christmas the artist's gift from Karl is a big package containing frozen venison steaks and several links of blood sausage.

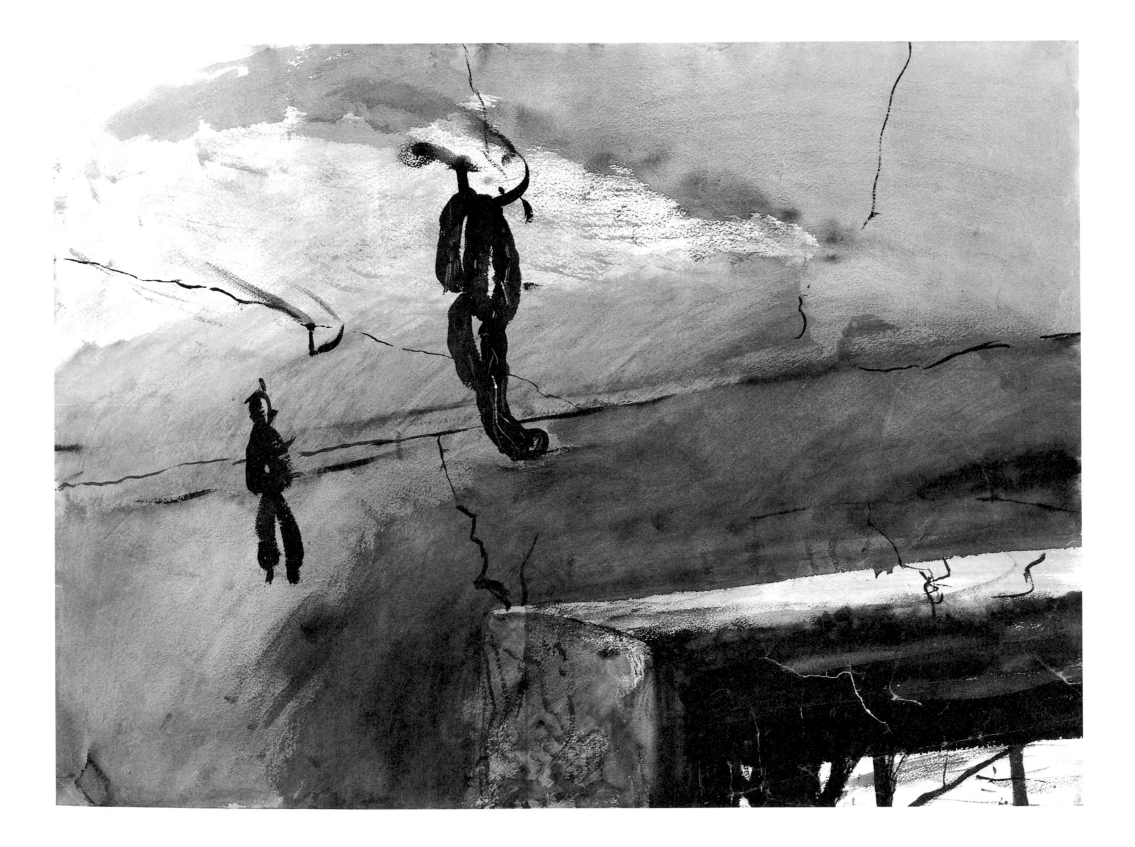

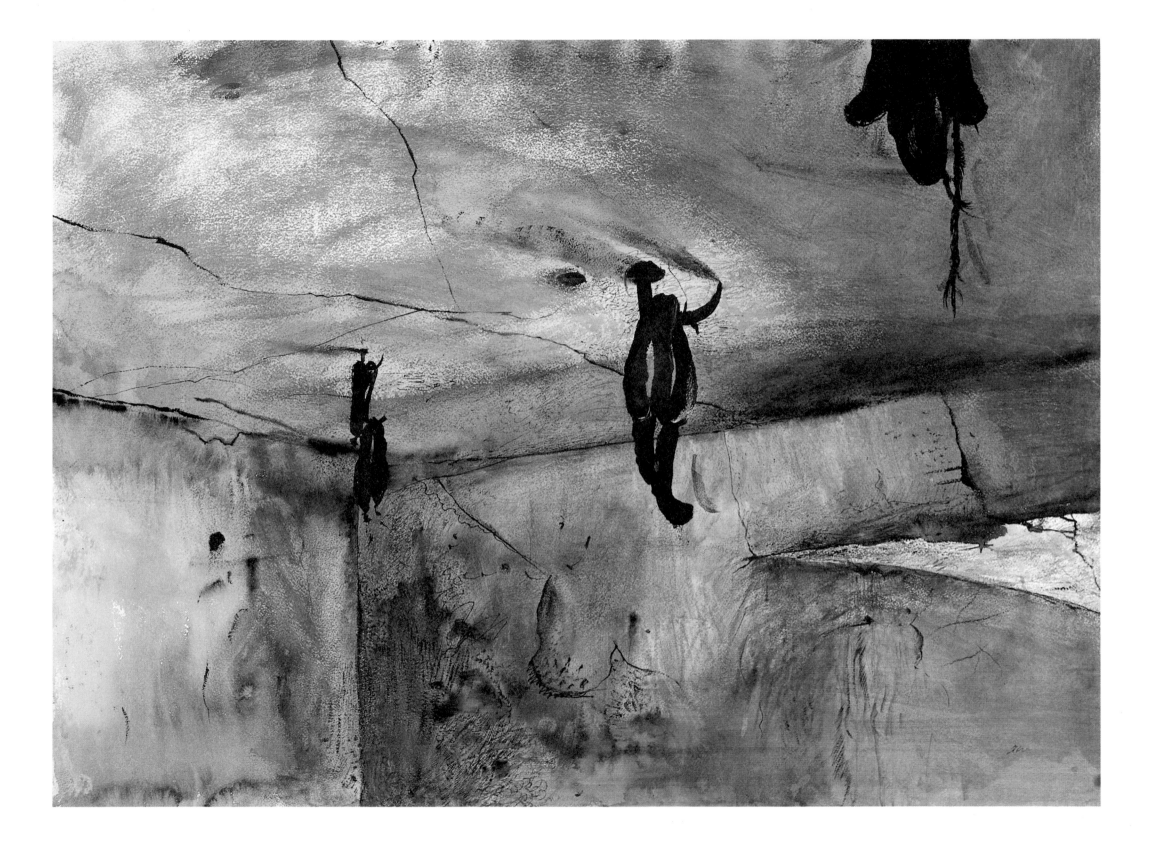

251

Karl in profile,
with sausages hanging from ceiling hooks.
The footprints of the artist's son Nicholas
are on this drawing.

The sausages are disappearing
as Karl's head takes on greater importance.

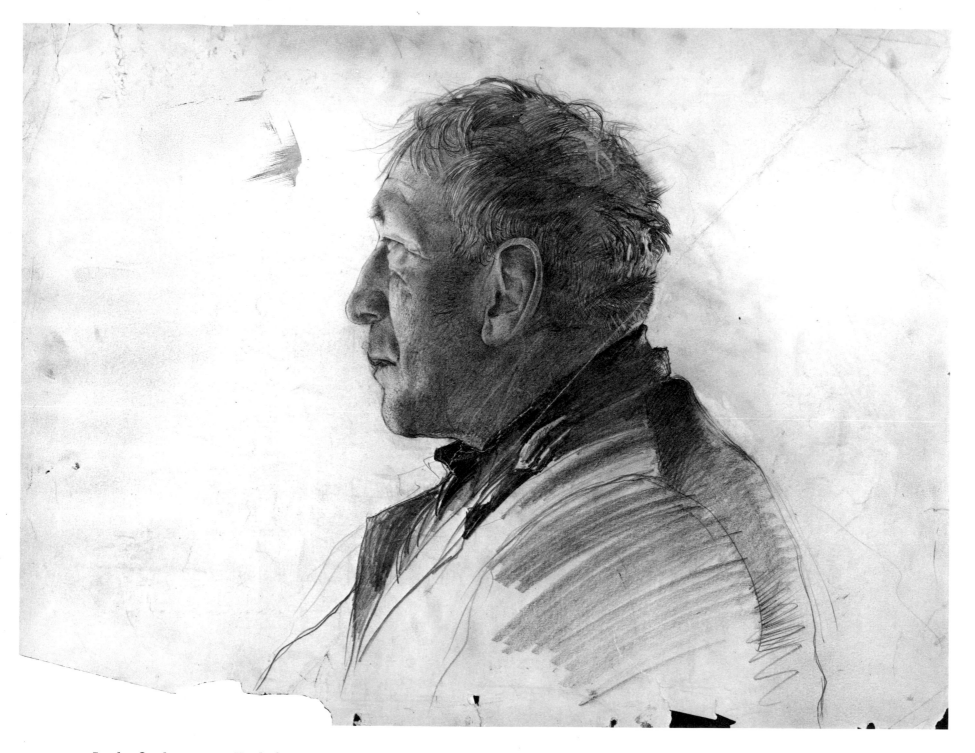

In the final tempera *Karl*, the position of the figure has been changed, the sausages and window removed, while the sinister ceiling hooks dramatize the stern, Germanic feeling in this portrait. Before it was completed, Wyeth took the tempera to Kuerners for final corrections from life, leaving the panel each night on the easel that he had set up in the third floor room. One morning he arrived to find the tempera had vanished. Anna had been going

through one of her periods of withdrawal, being completely out of touch with reality. In fact, Wyeth had passed her on the stairway, mumbling to herself. Horrified, he rushed to the barn to find Karl, who reassured him that the painting was safely hidden. Karl had been awakened during the night by the sound of footsteps overhead. He found Anna, a lamp in her hand, standing in front of this portrait talking excitedly to it, her free hand raised, ready to strike the image of her husband who would not answer her questions. Taking the lamp from her, Karl led Anna back downstairs, and took the portrait out to the barn for safe-keeping.

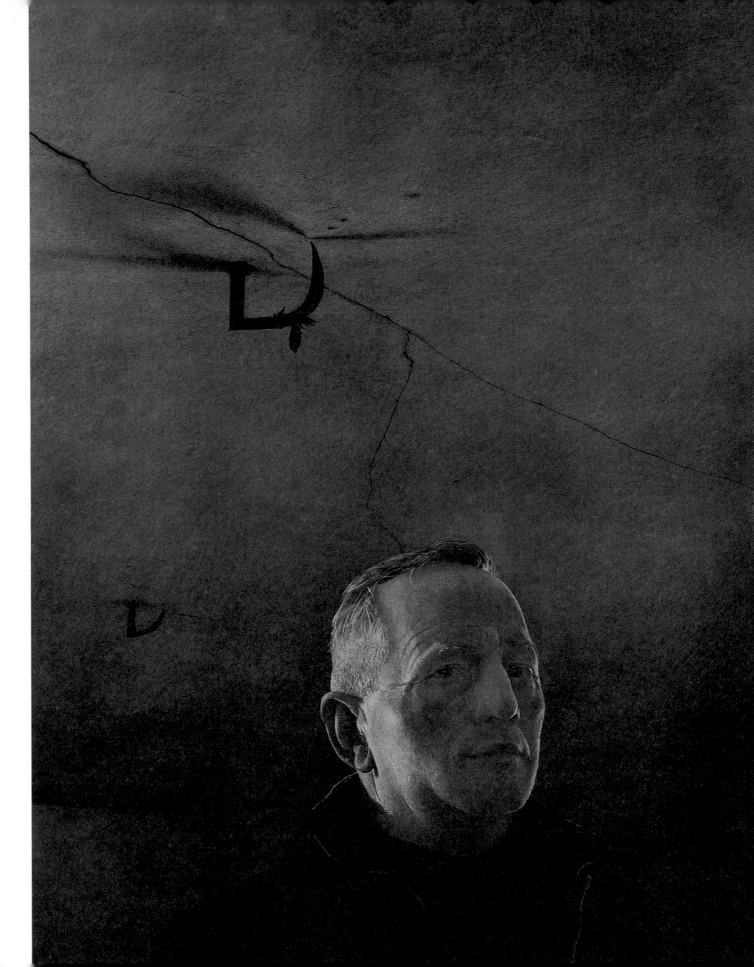

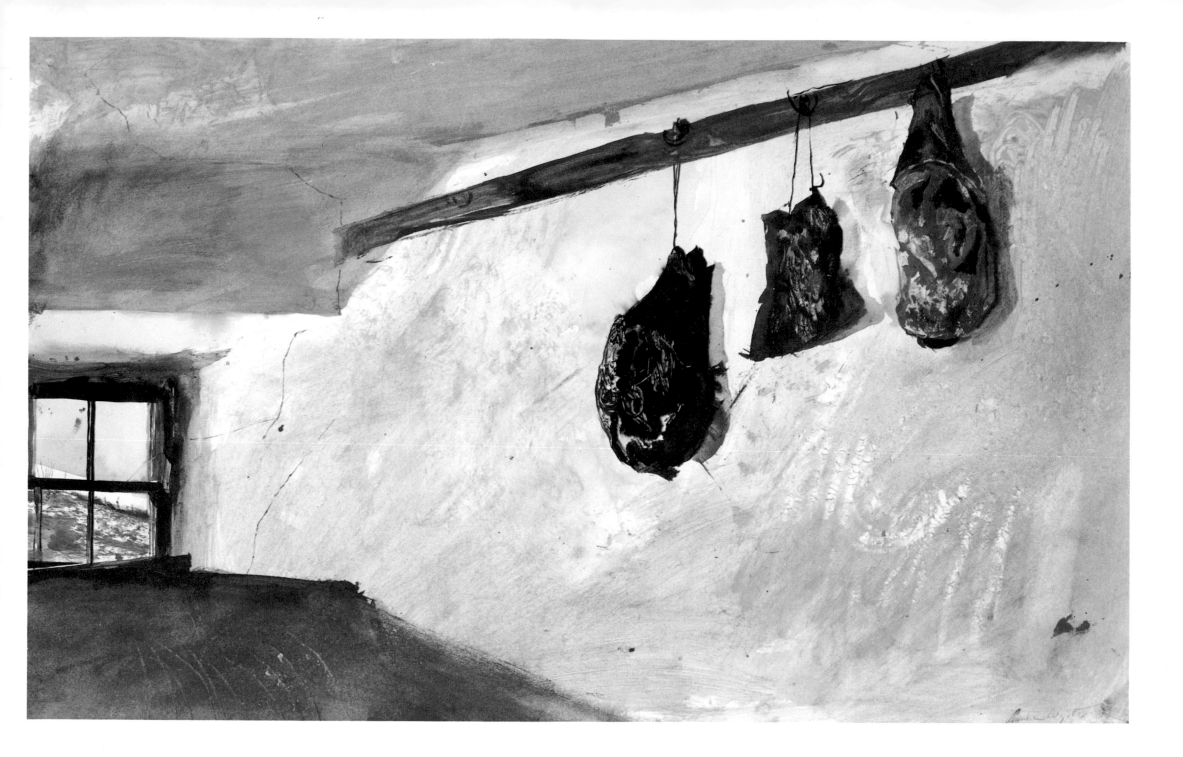

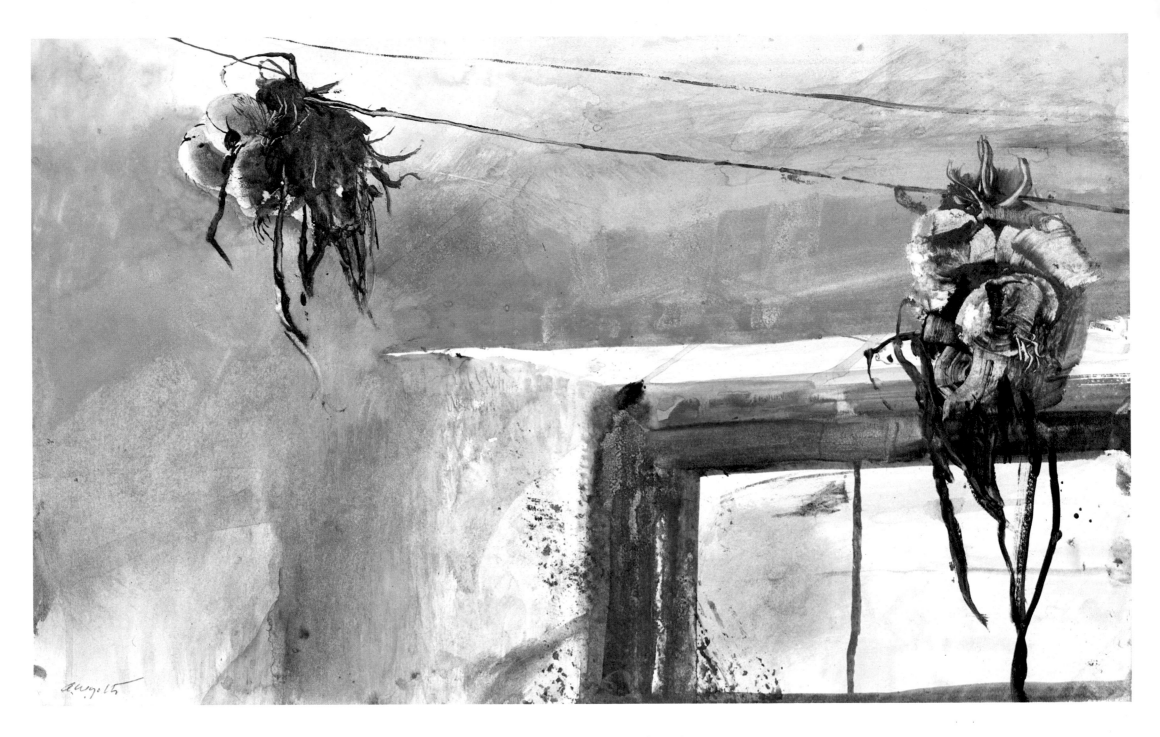

Clotheslines have been strung from the ceiling hooks with bunches of onions left to dry.
Onion pie is one of Anna Kuerner's specialties.

In the spring a blanket has been thrown over one of these lines to air out.

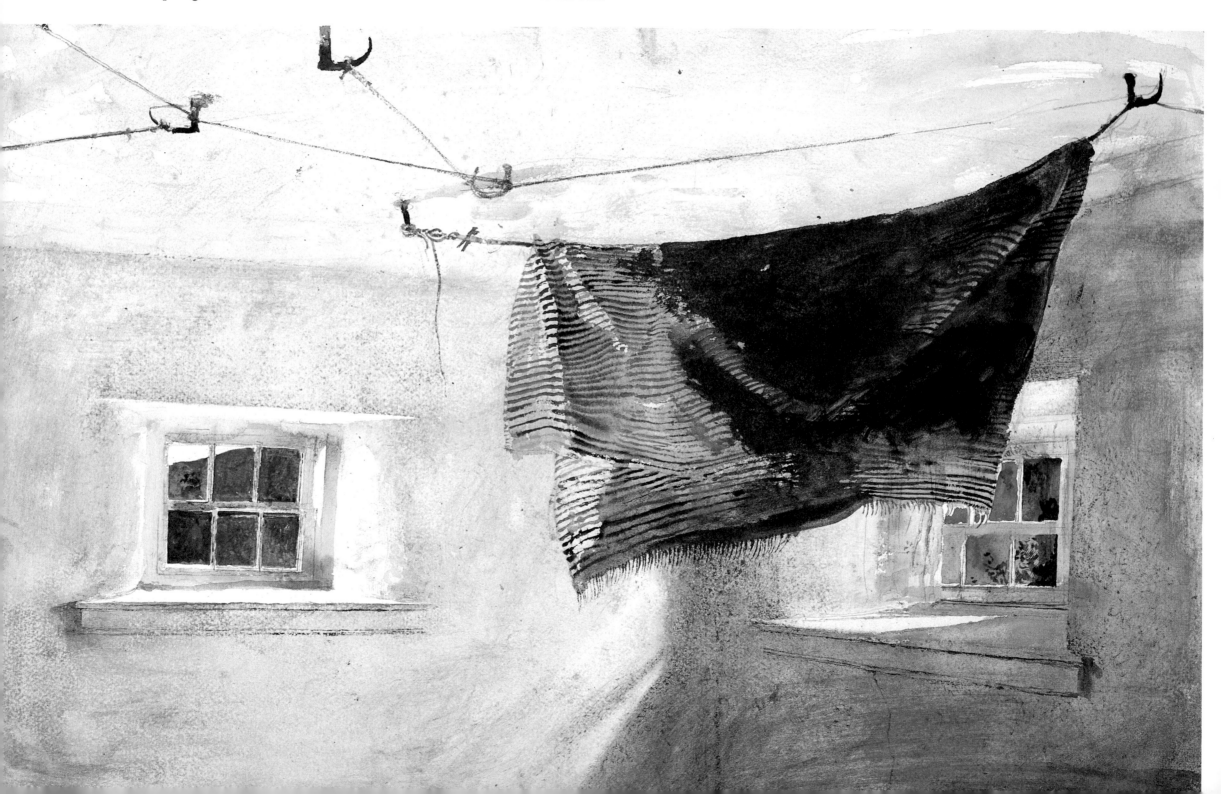

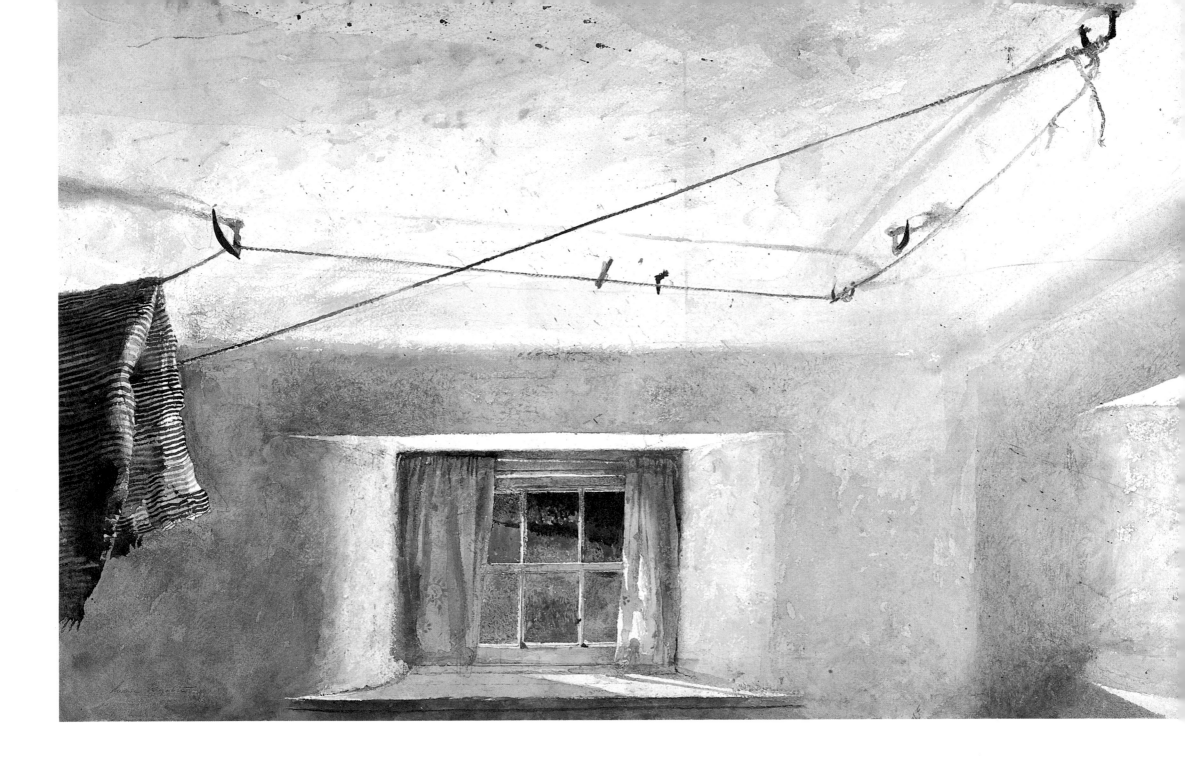

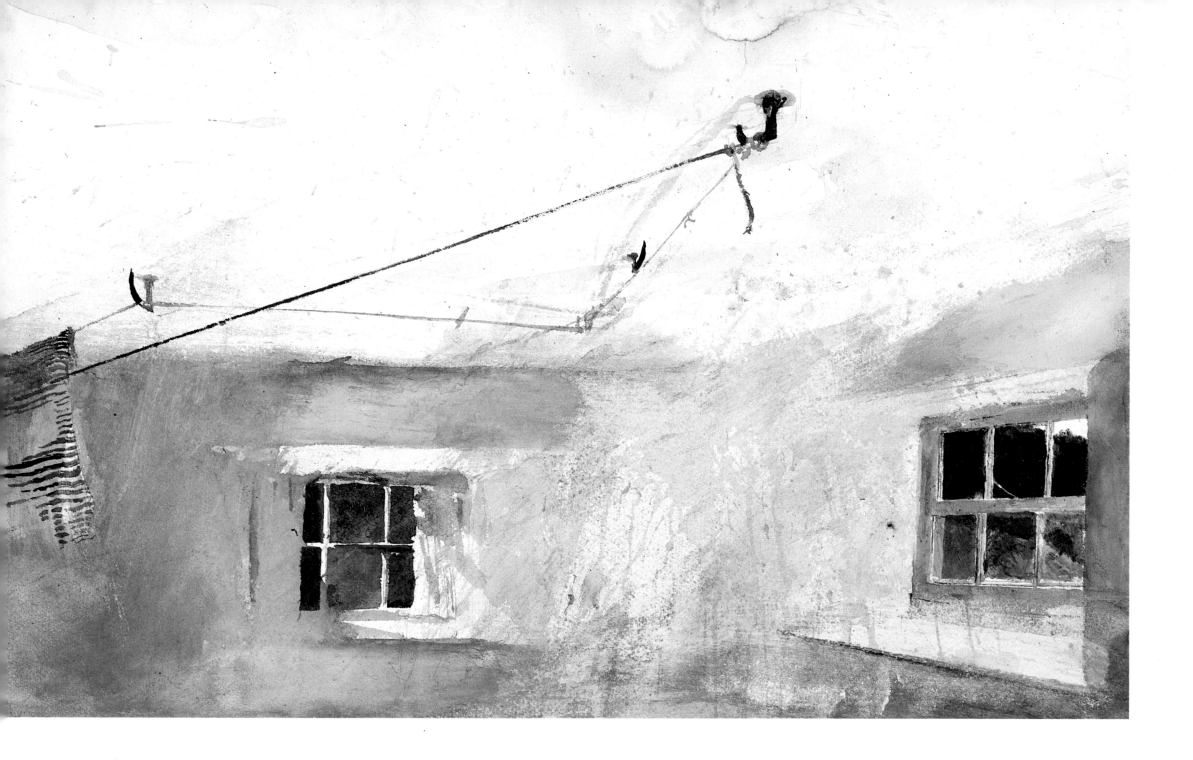

After the blanket was removed
the faintest outline of a figure
begins to appear standing in the room.

Anna

Ghostlike, the figure takes its seat
beside one of the small corner windows.

The figure is taking form
with the familiar kerchief tied around her head.

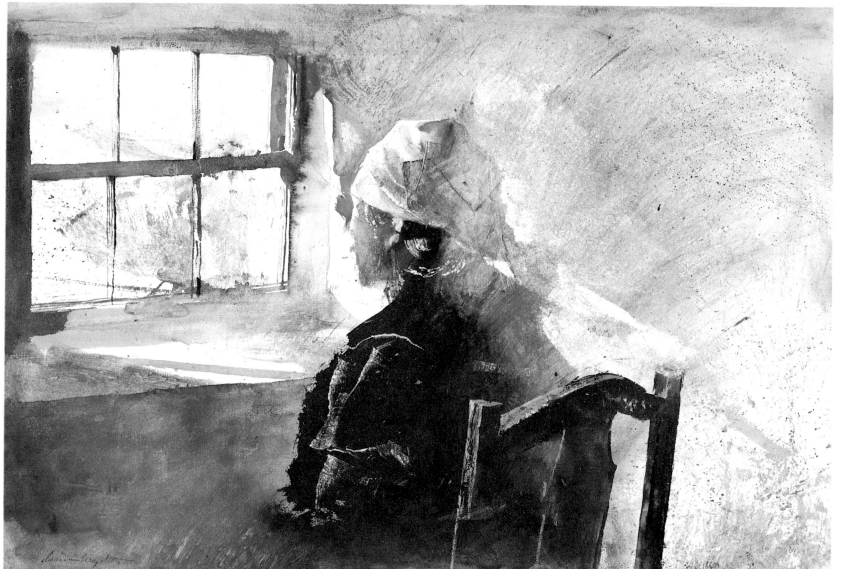

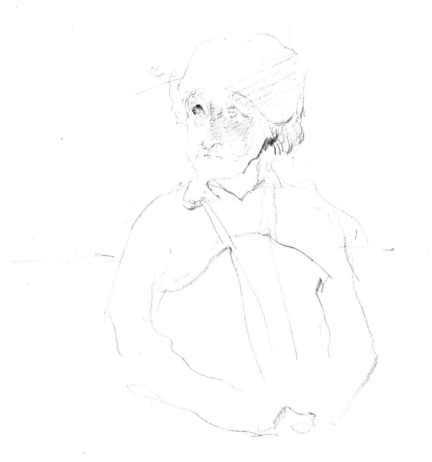

She turns around and there is Anna in a dustcap.

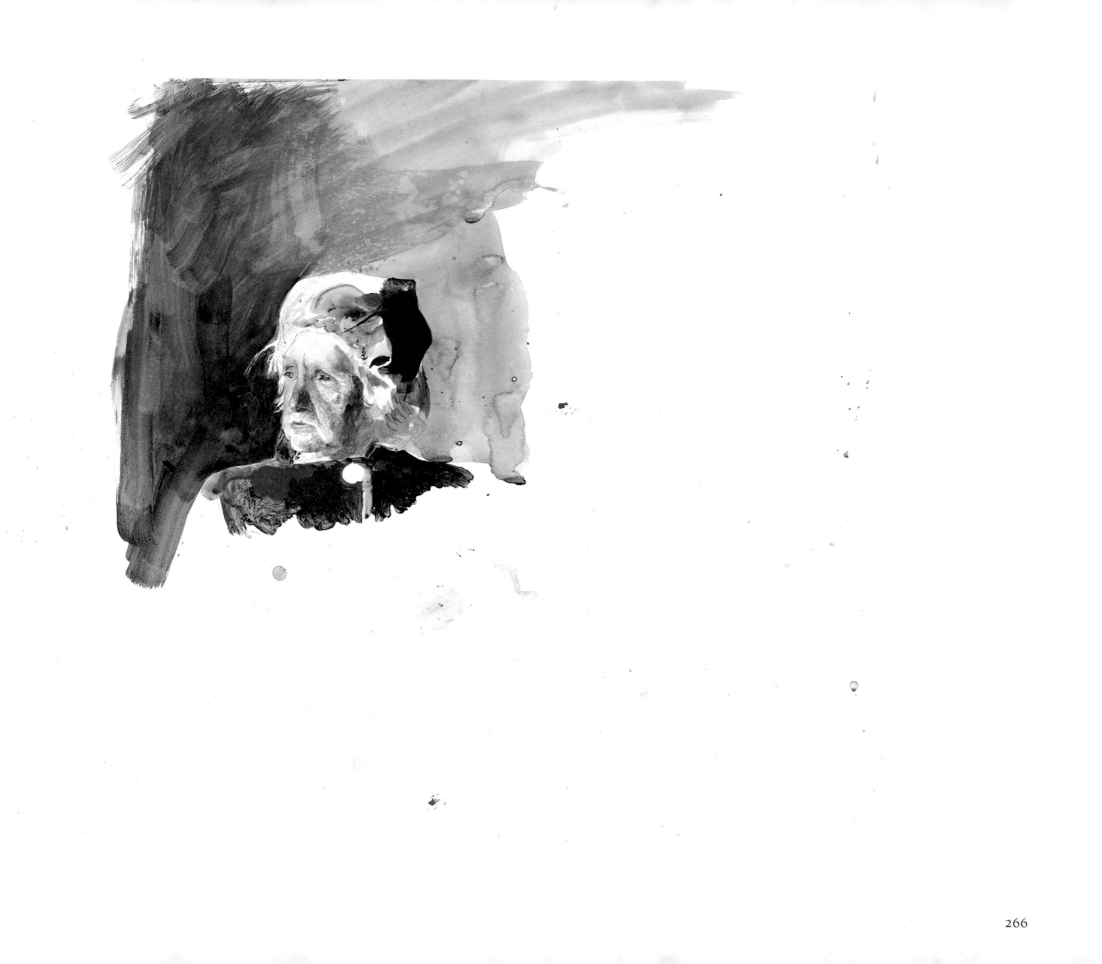

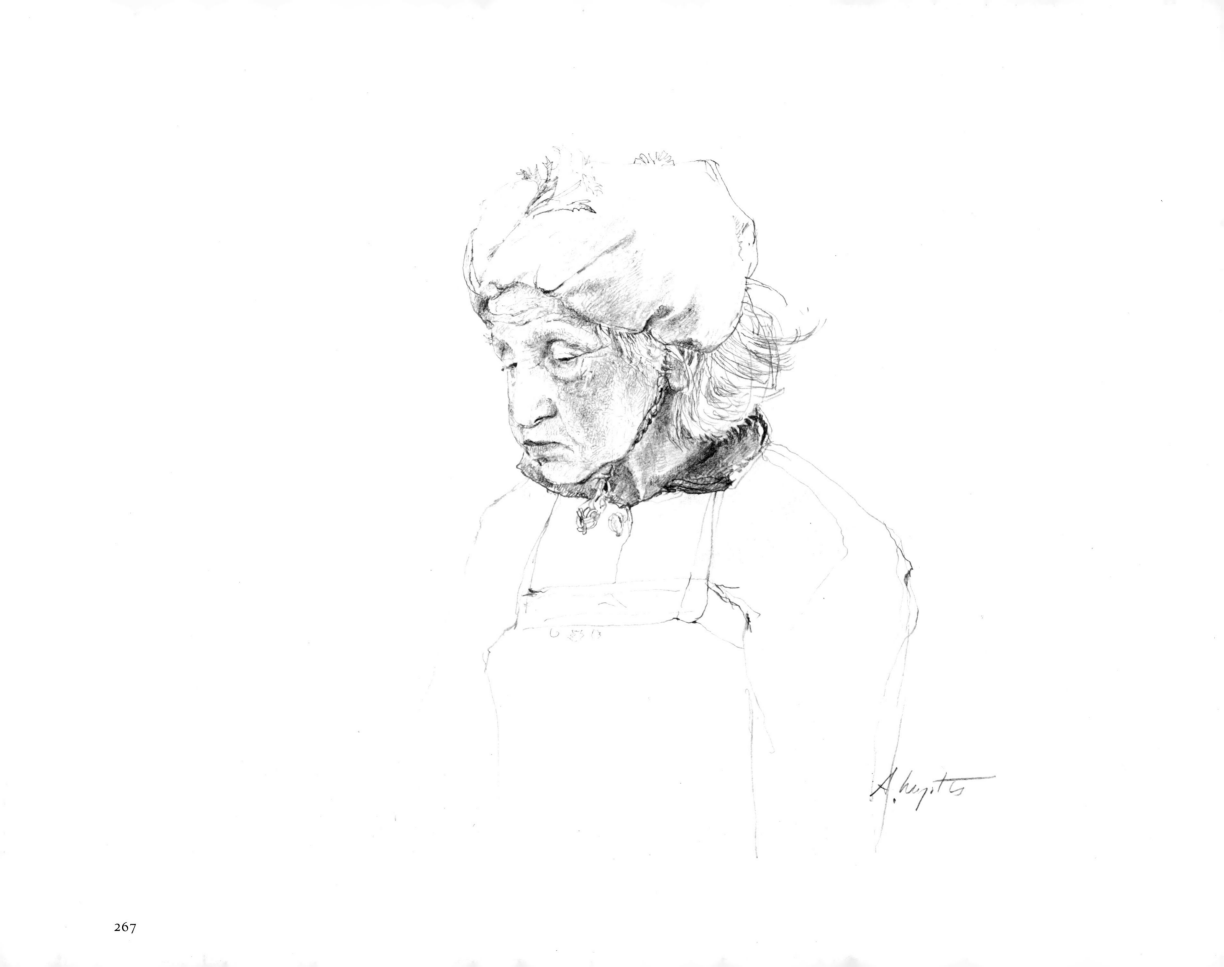

267

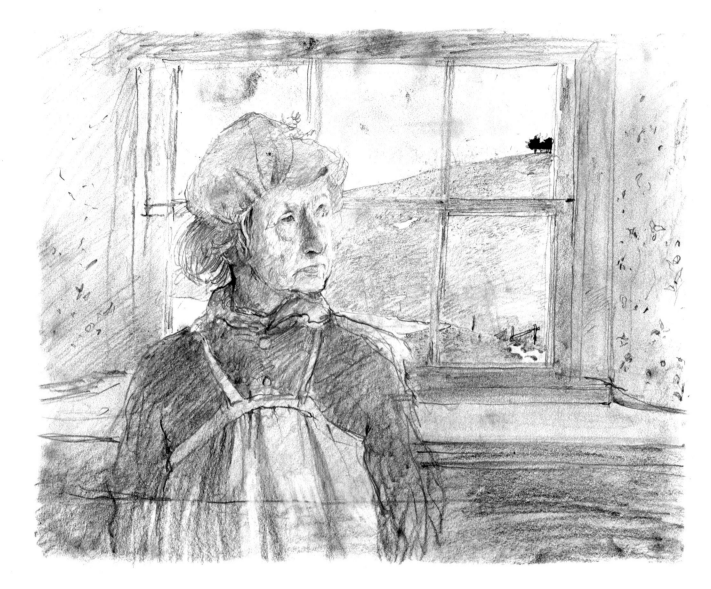

It took years for the artist to win Anna Kuerner's confidence. Despite her total disregard for her appearance, there are hints of her feminine delicacy—the blue hair ribbon and the flowered pink wallpaper. Through the window can be seen the frozen farm pond and the pines on Kuerners Hill. Wyeth tried to show his appreciation for the long hours she posed in this unheated room by bringing her gifts, but he always found them unopened on the windowsill the next day. She seldom spoke.

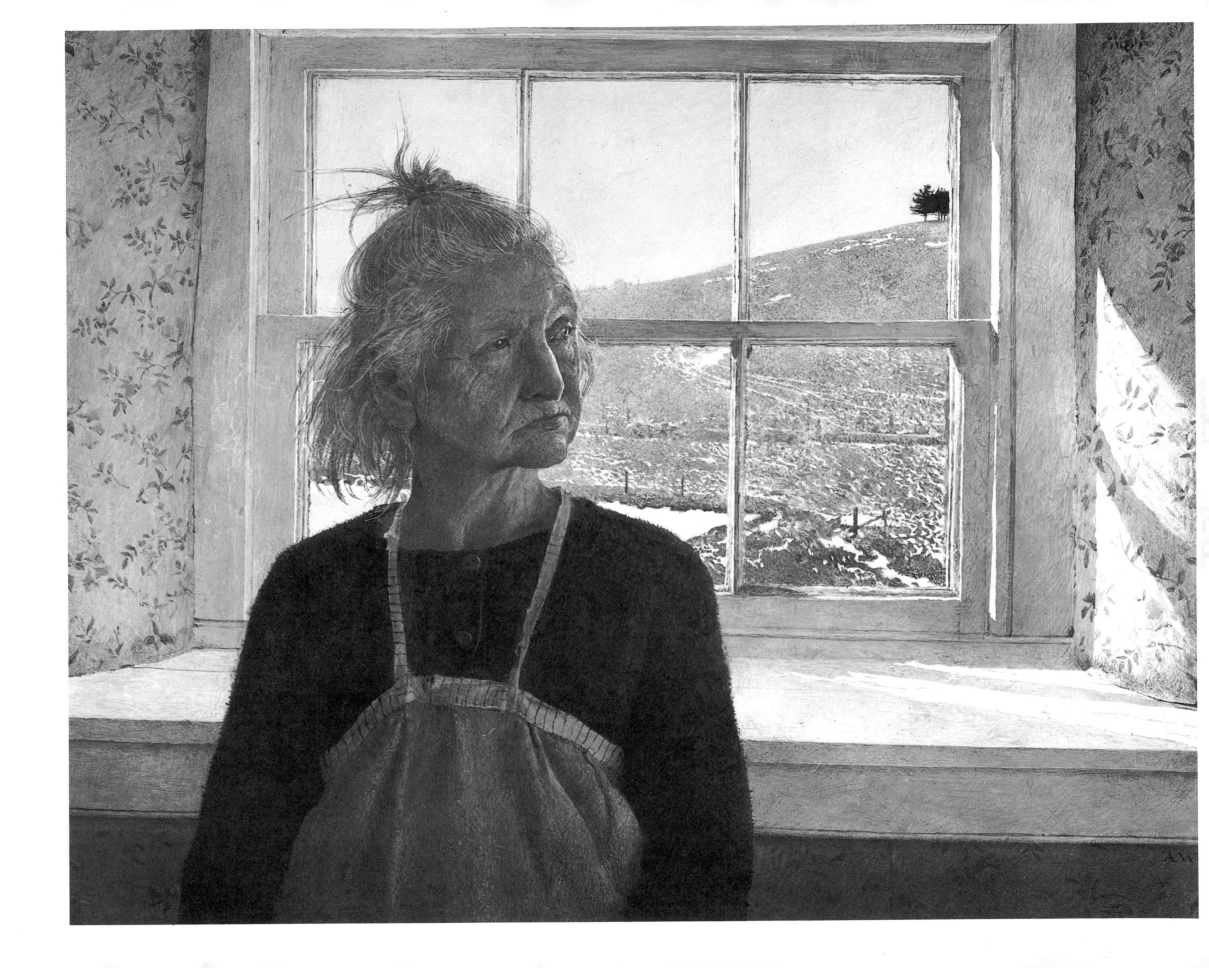

Karl and Anna

DEUTSCHES REICH

REISE-PASS

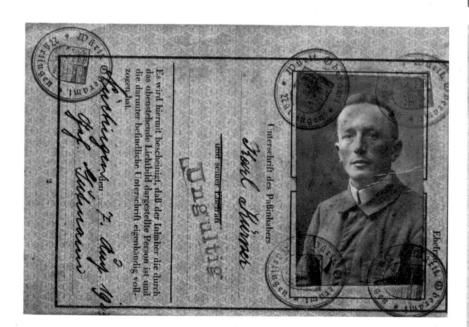

Karl's 1923 passport.

When he left Germany for America
all of his worldly possessions
came with him in this chest.

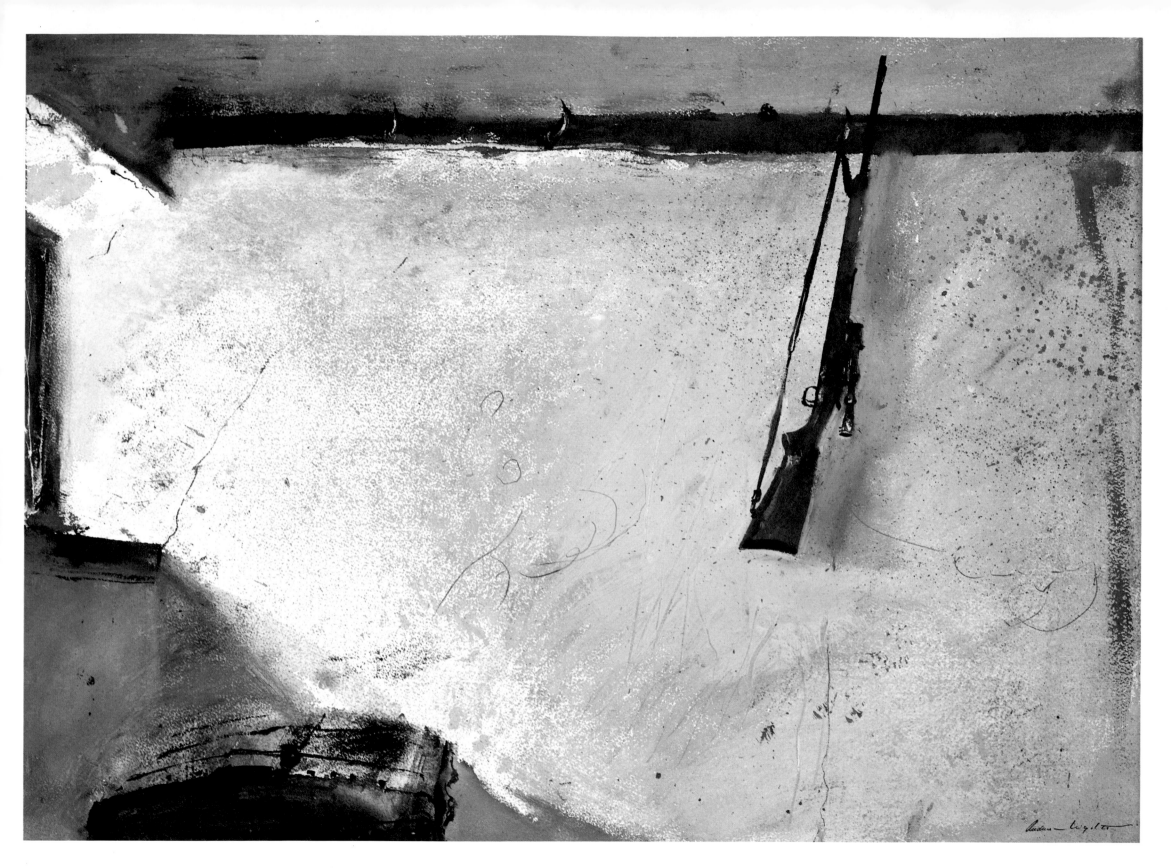

Karl's rifle hangs from a wall hook above the chest.

The marks on the wall were drawn by one of his children years ago.

Karl posed with this same rifle ten years later.

273

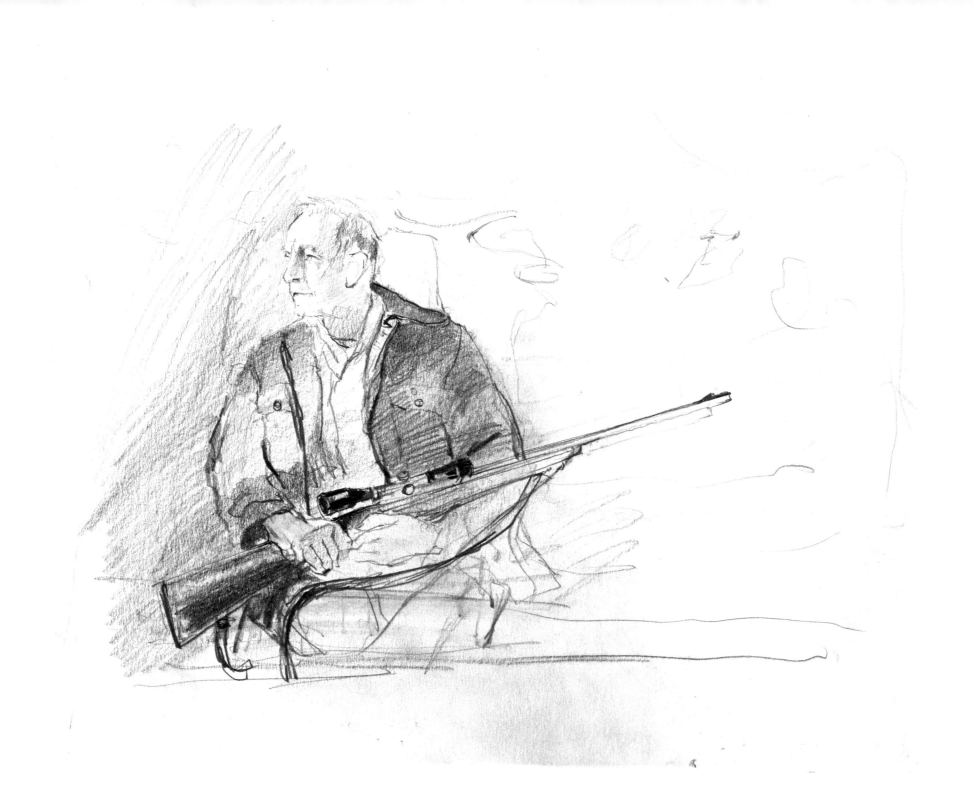

It is not unusual for Wyeth to abandon an idea
and then return to it years later. Seven years elapsed
between this drawing and the final result.

275

The vague marks on the wall that appeared in
the two previous drawings are becoming animal heads.
This third floor room is Karl's trophy room,
suggesting the hunting lodges he knew as a shepherd
in his youth back in the Black Forest of Germany.

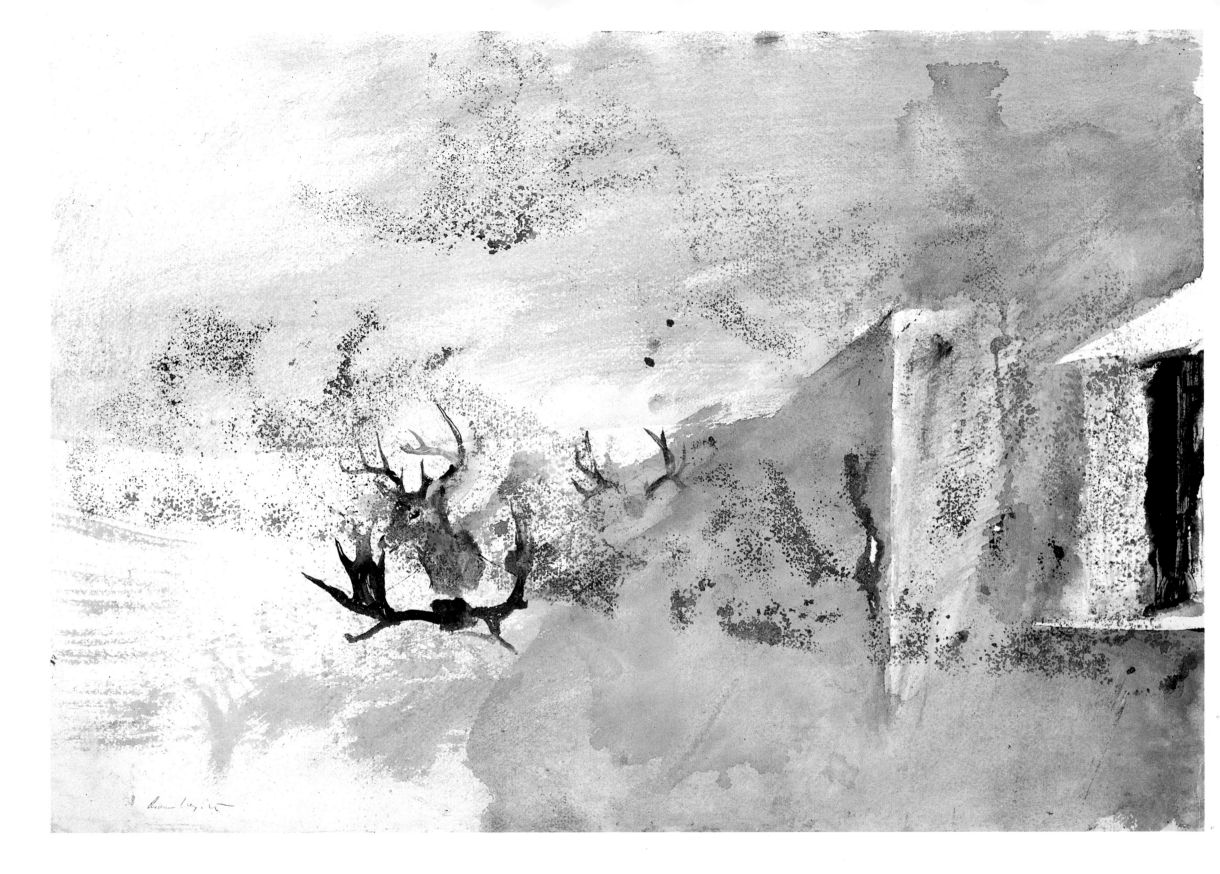

The seated figure of Karl appears surrounded
by the heads of animals he has shot.

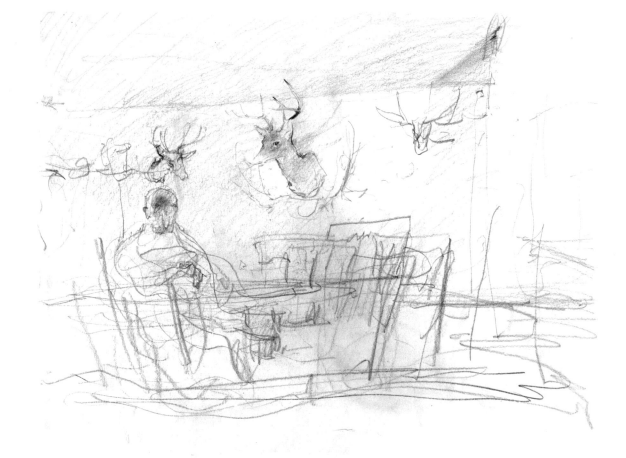

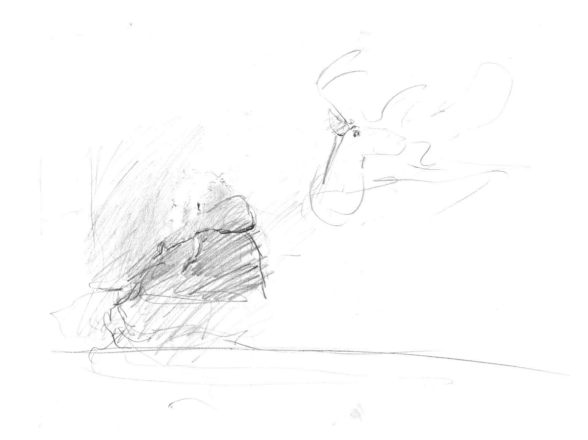

Seven years later the artist returned
to the subject of Karl in his trophy room.

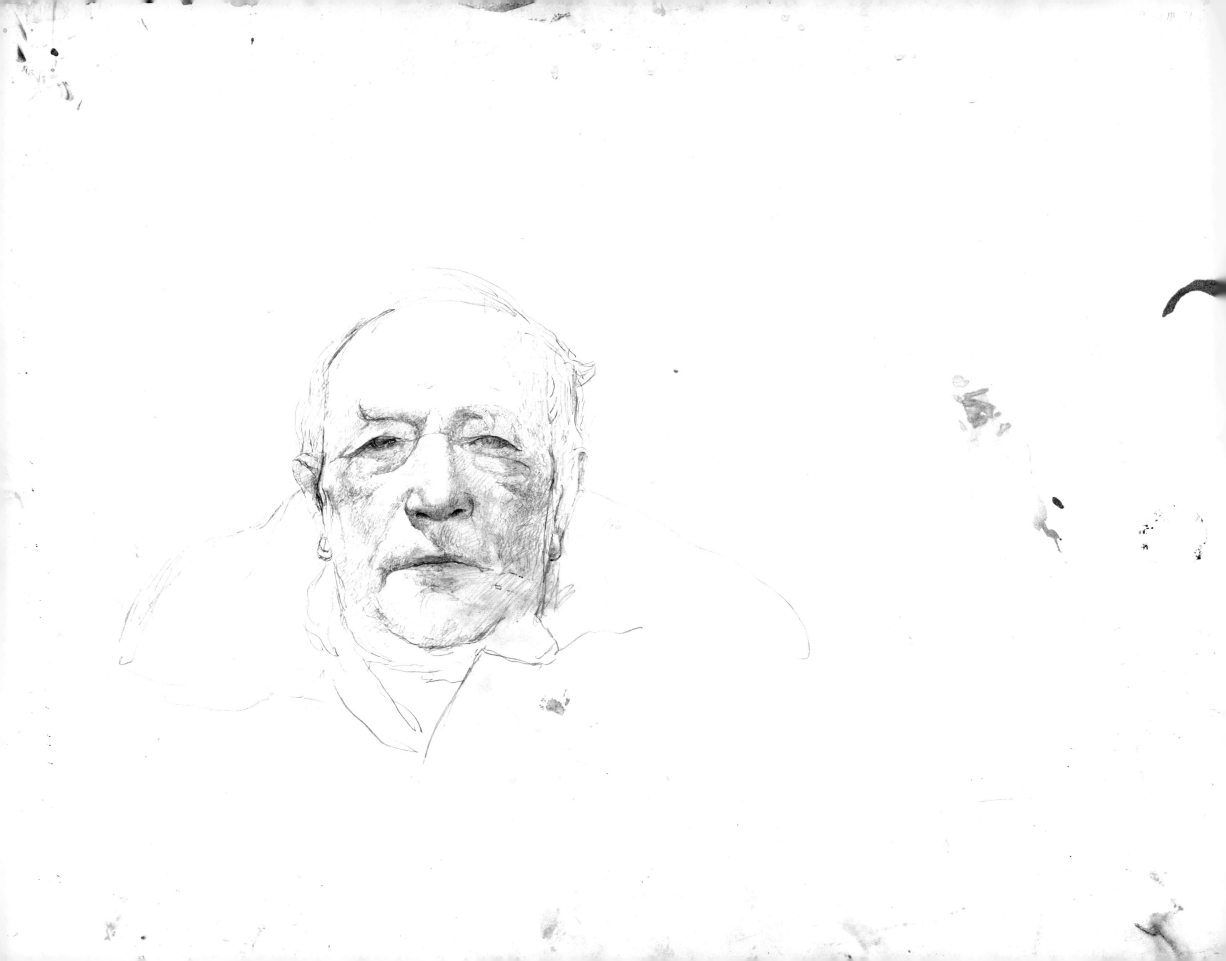

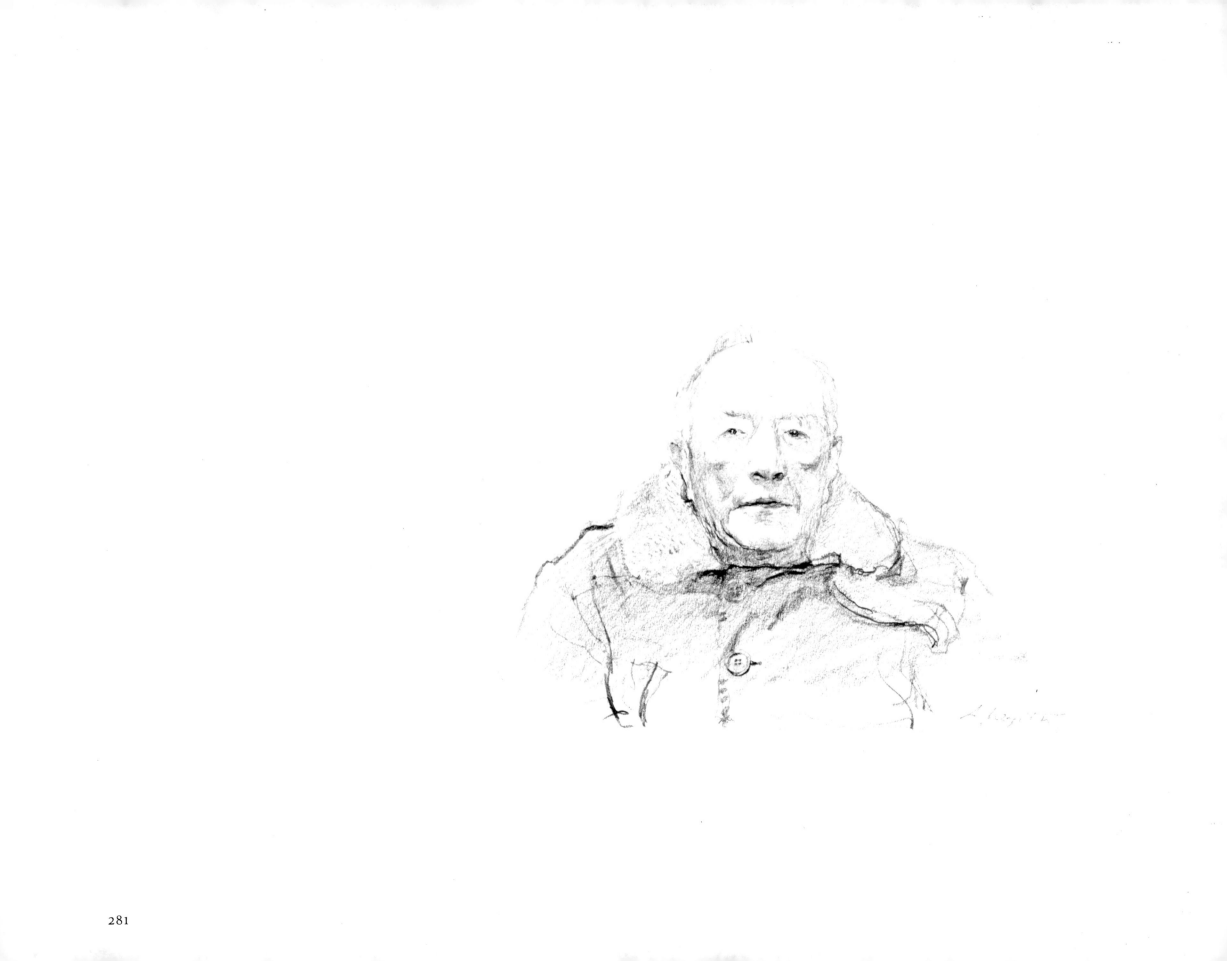

281

Anna replaces Karl in the trophy room.

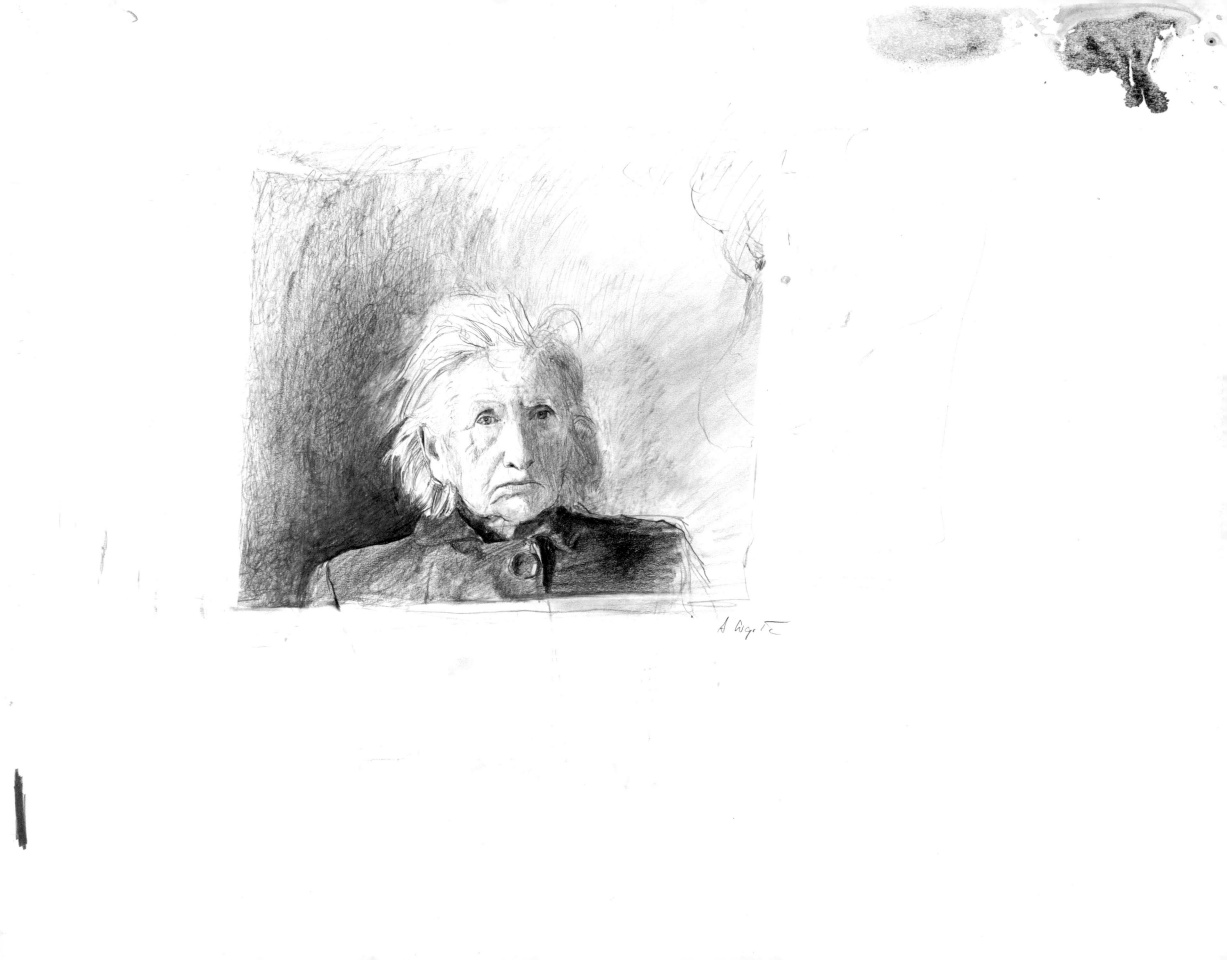

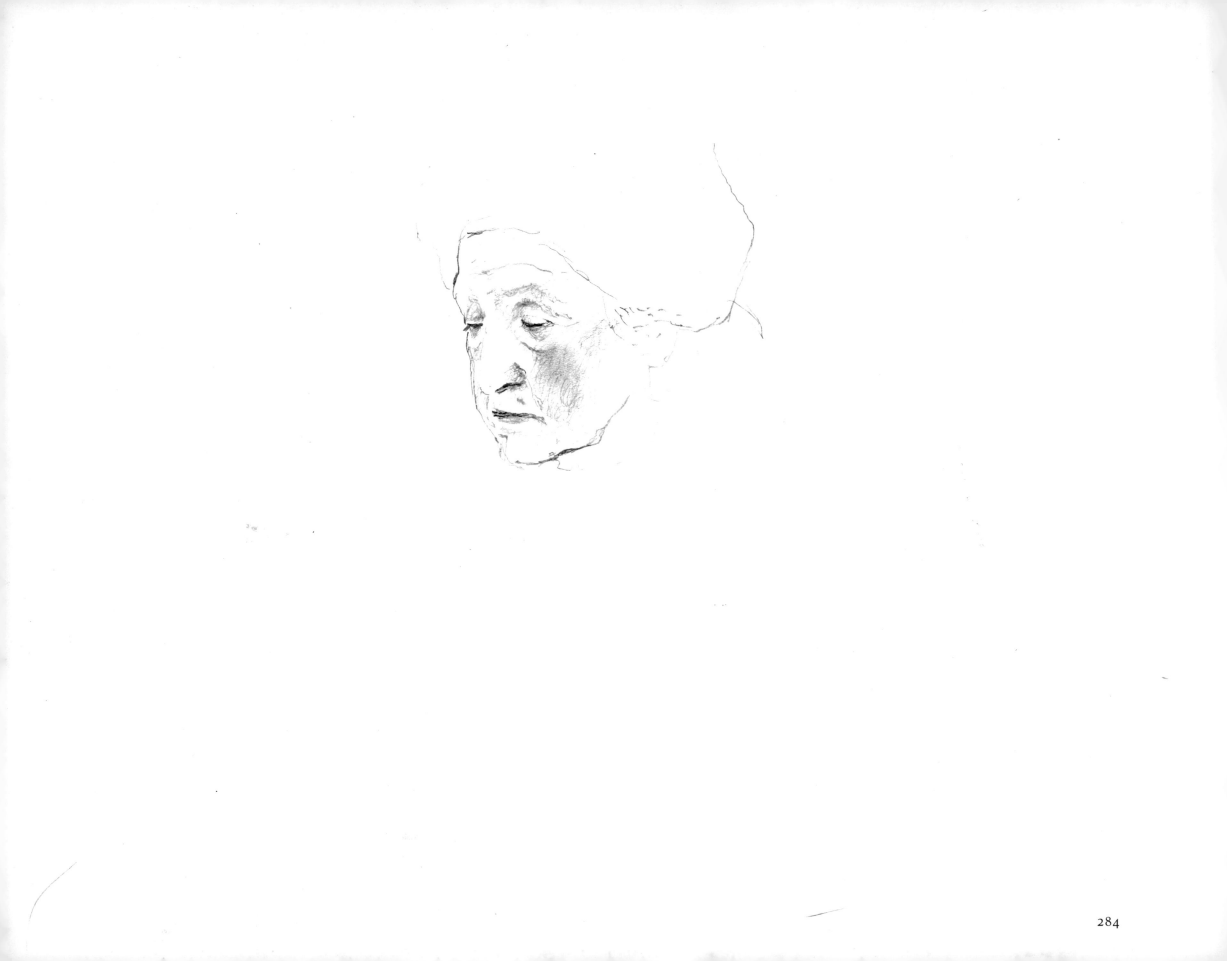

Her full name, Anna Faulhaber Kuerner, is written on this drawing.
One of her high work shoes, like the pair on the table
in the *Groundhog Day* prestudy, is carefully drawn.

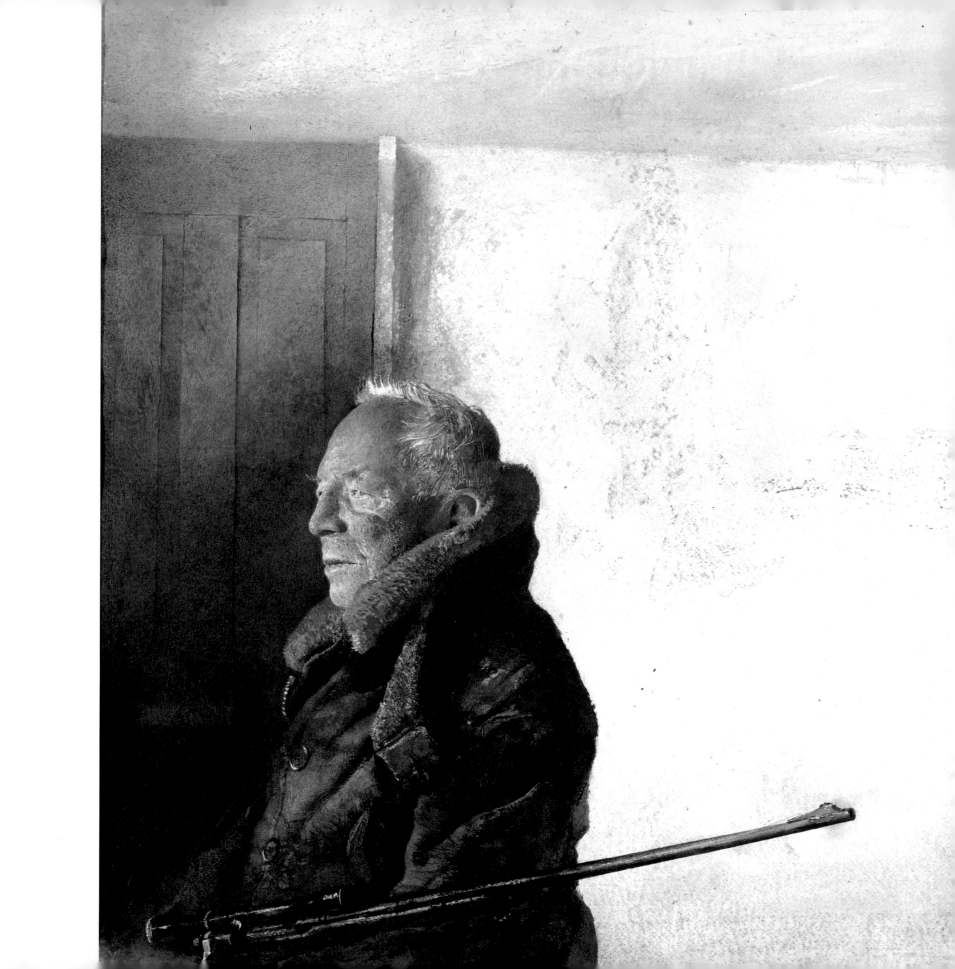

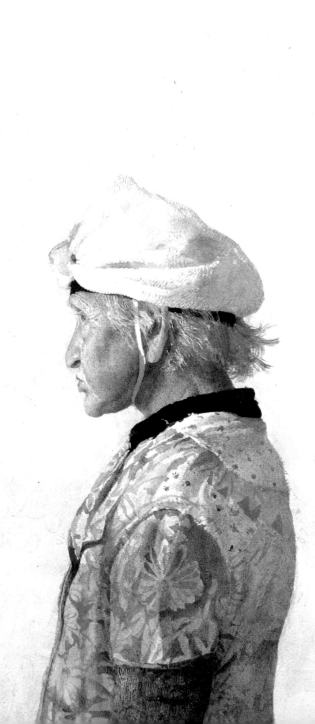

The Kuerners is completed. Between them is a faint discoloration on the wall, left by the moose horn trophy that was removed after Anna became a part of the picture. Karl wears one of the jackets that hung on a wall peg in the downstairs hall. His high powered rifle points directly at Anna, who follows him, wearing her best Sunday cap.

The Porch

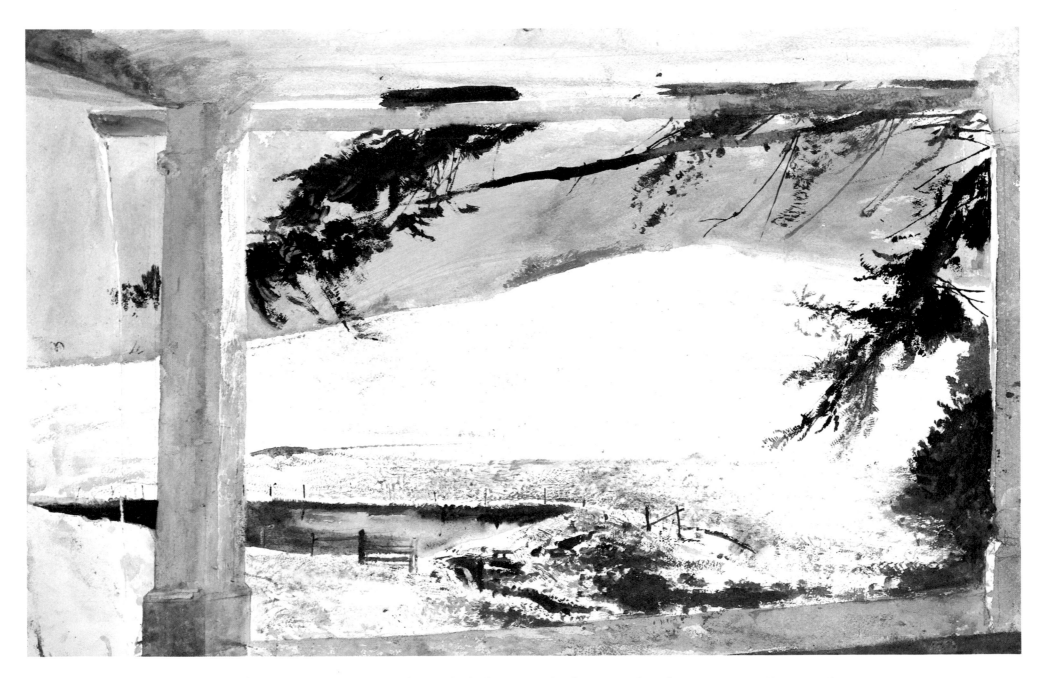

Back downstairs, we go out the front door onto the porch and look down on the farm pond with Kuerners Hill rising above.

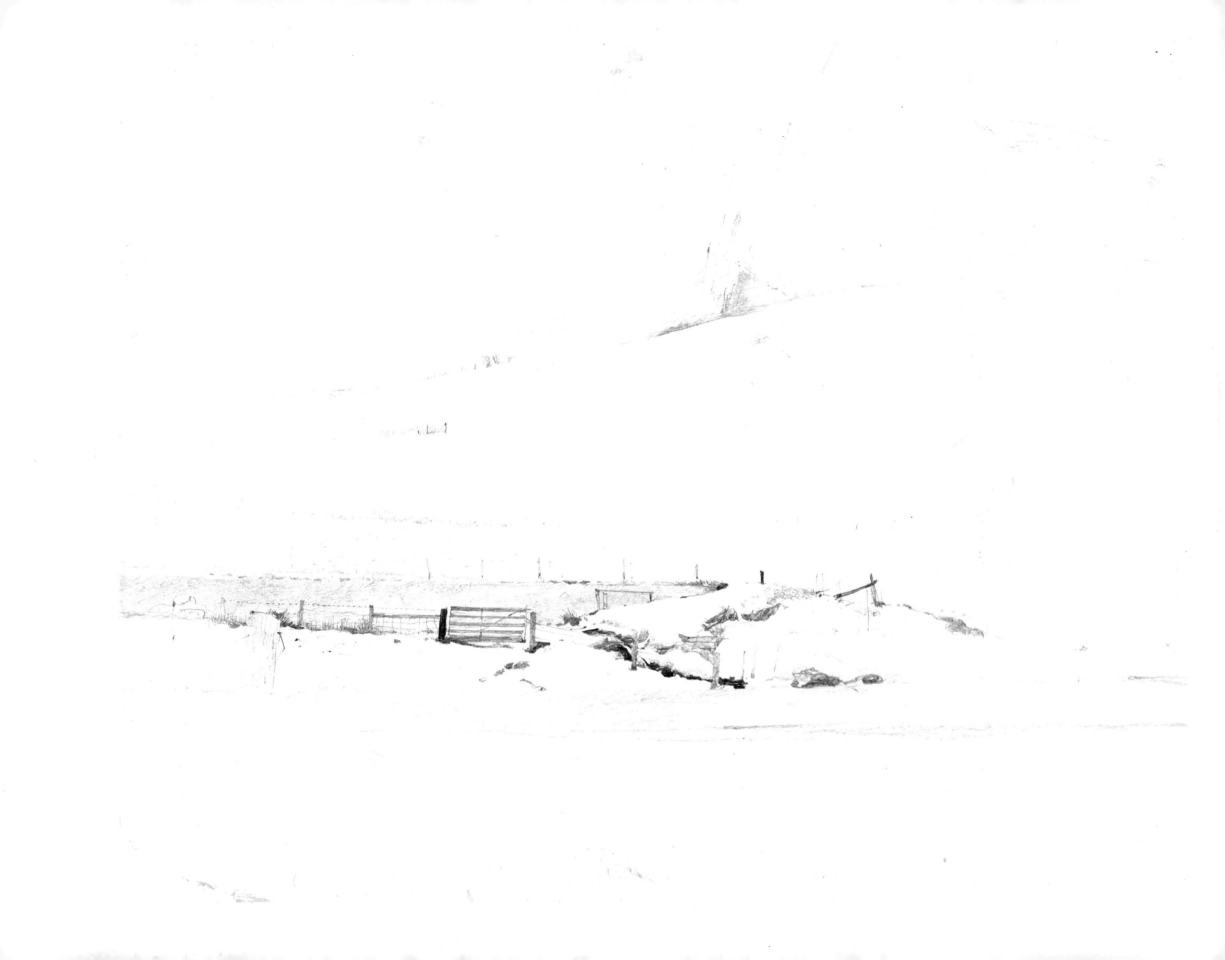

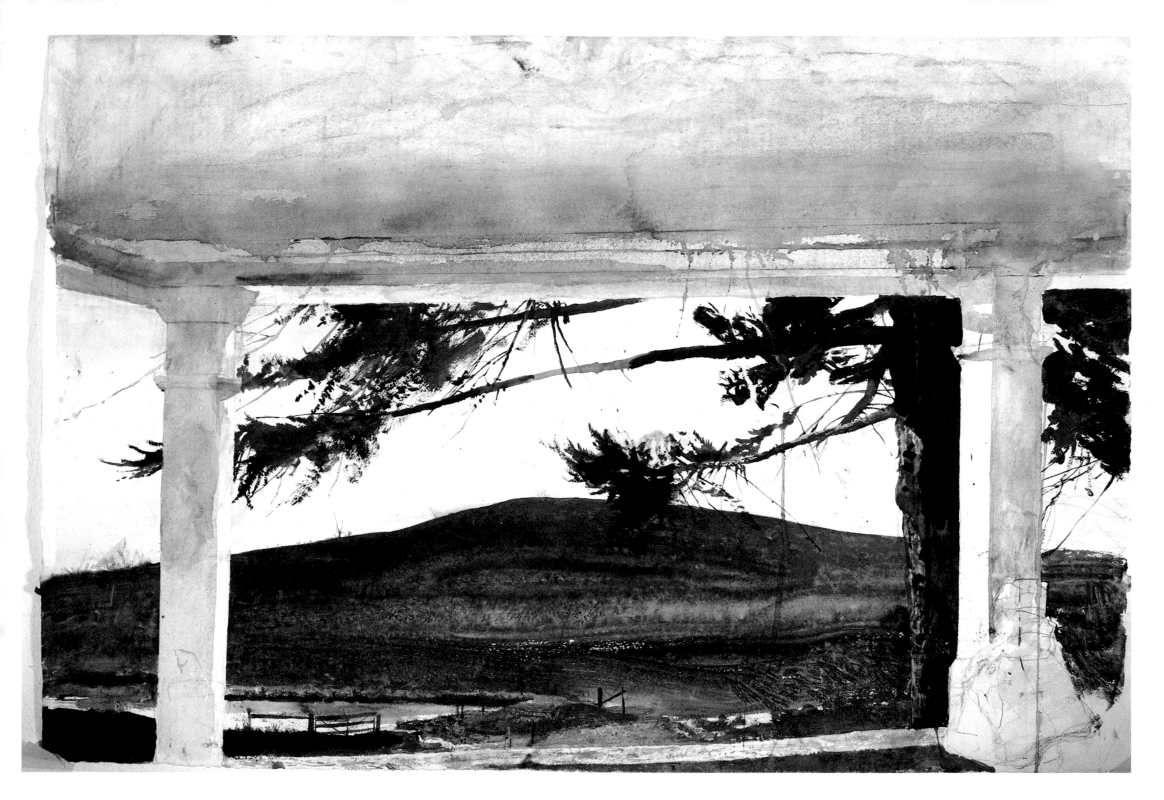

A figure is outlined behind a porch pillar

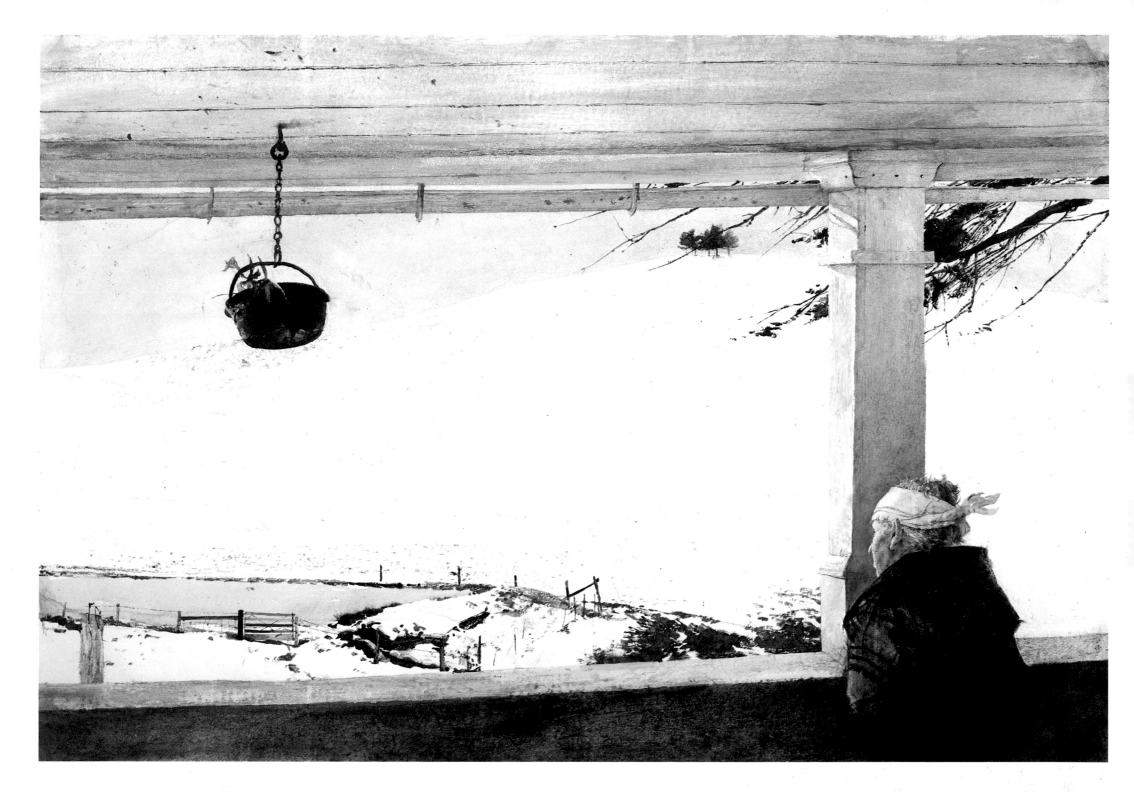

and becomes Anna. She is intent on watching something we cannot see.

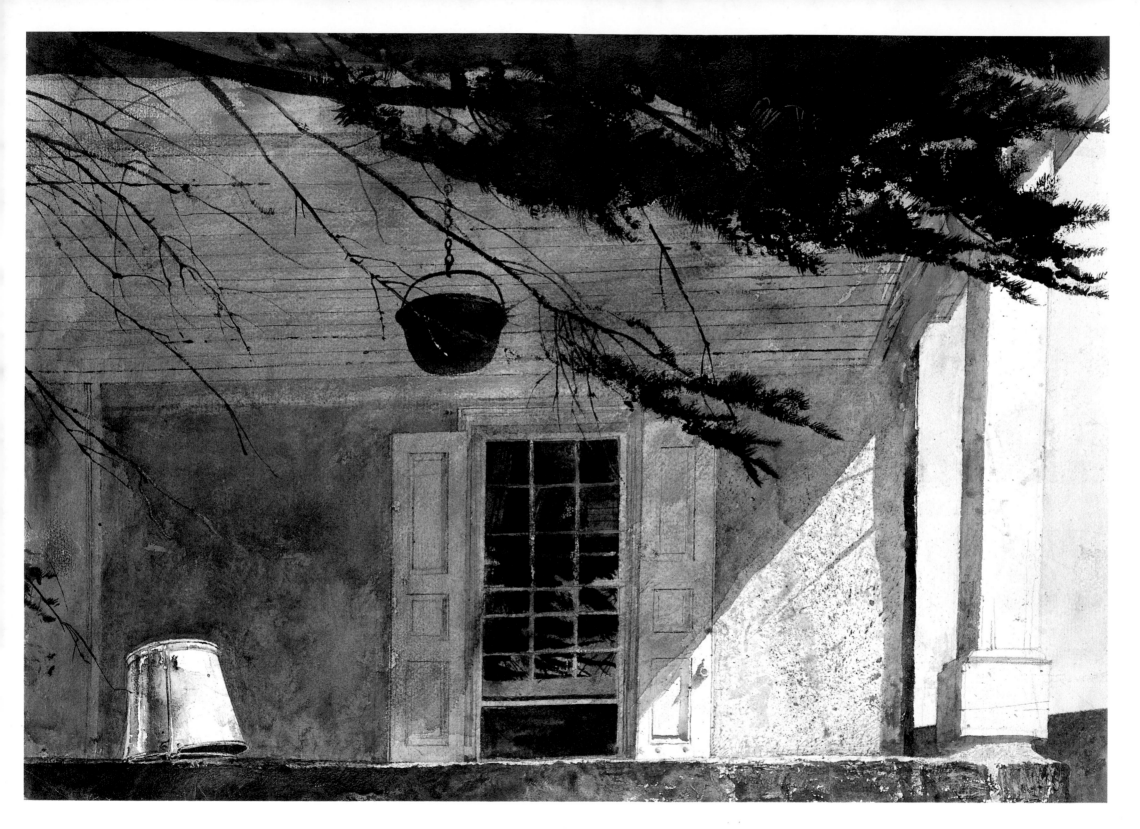

The gleaming metal bucket sits upturned on the porch wall.

The farm pond is reflected in the window. Karl's grandsons left their fishing rods on the porch table.

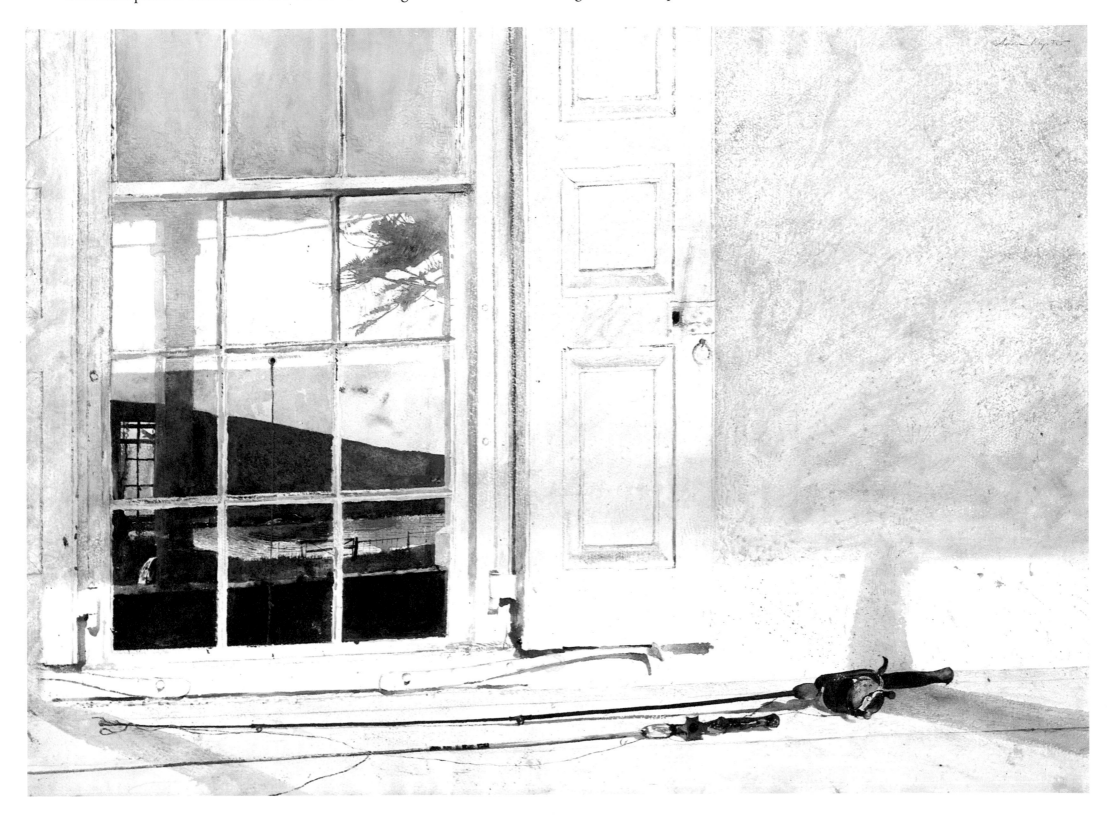

Details of the porch, the cedar tree that appeared in *Brown Swiss*

and the corner windows of the third floor room, where so many drawings and paintings were done.

We pass by the *Groundhog Day* window

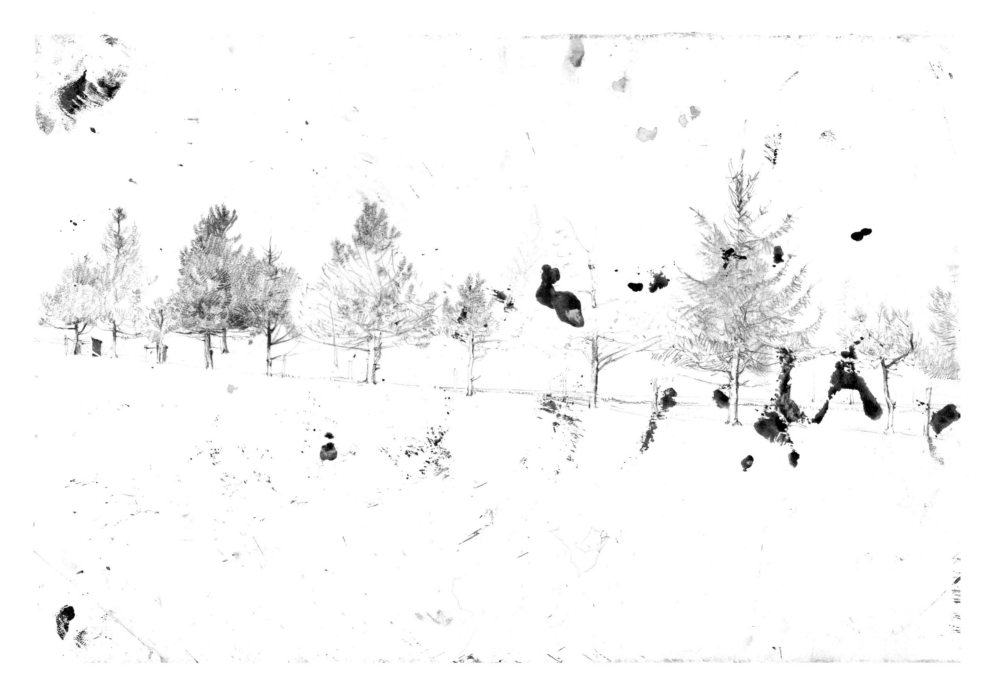

before starting out the lane lined with pines.

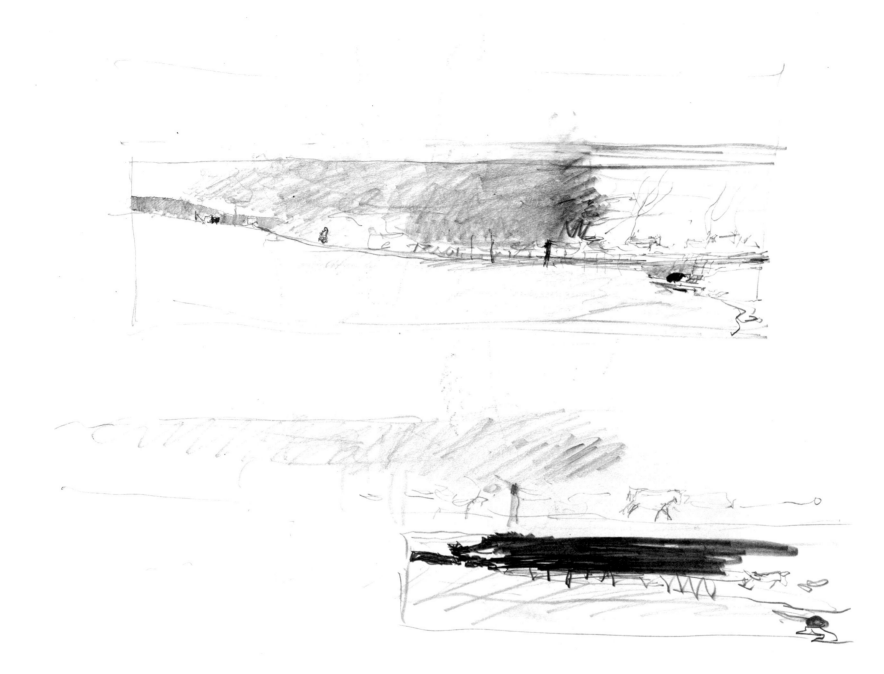

Anna's tiny figure herding cattle down the driveway
after they have spent the day pasturing on Kuerners Hill.

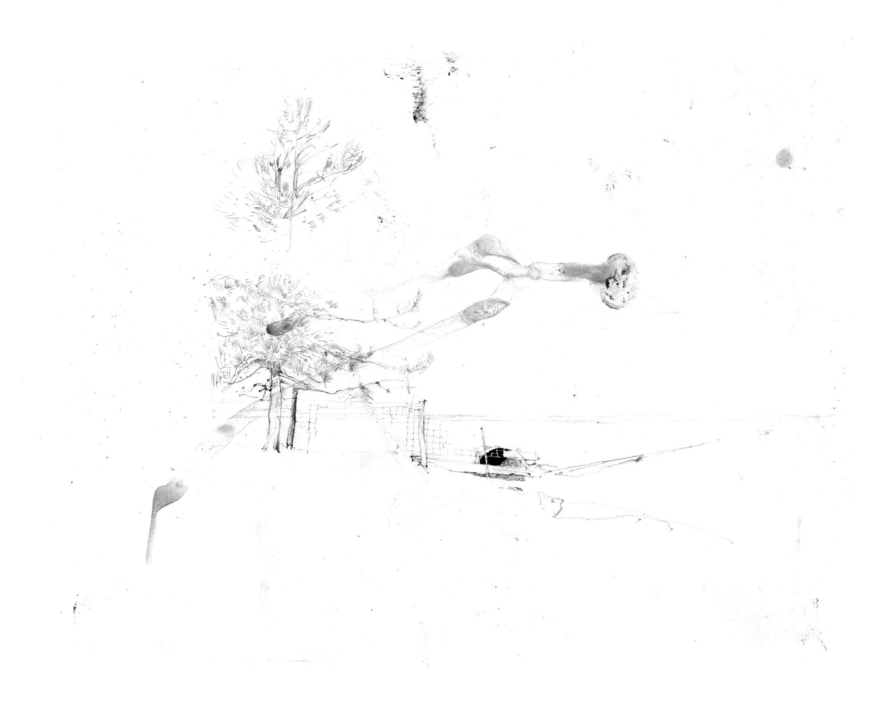

The road passes over a small stone bridge
echoing the hollow sound of their hoofs.

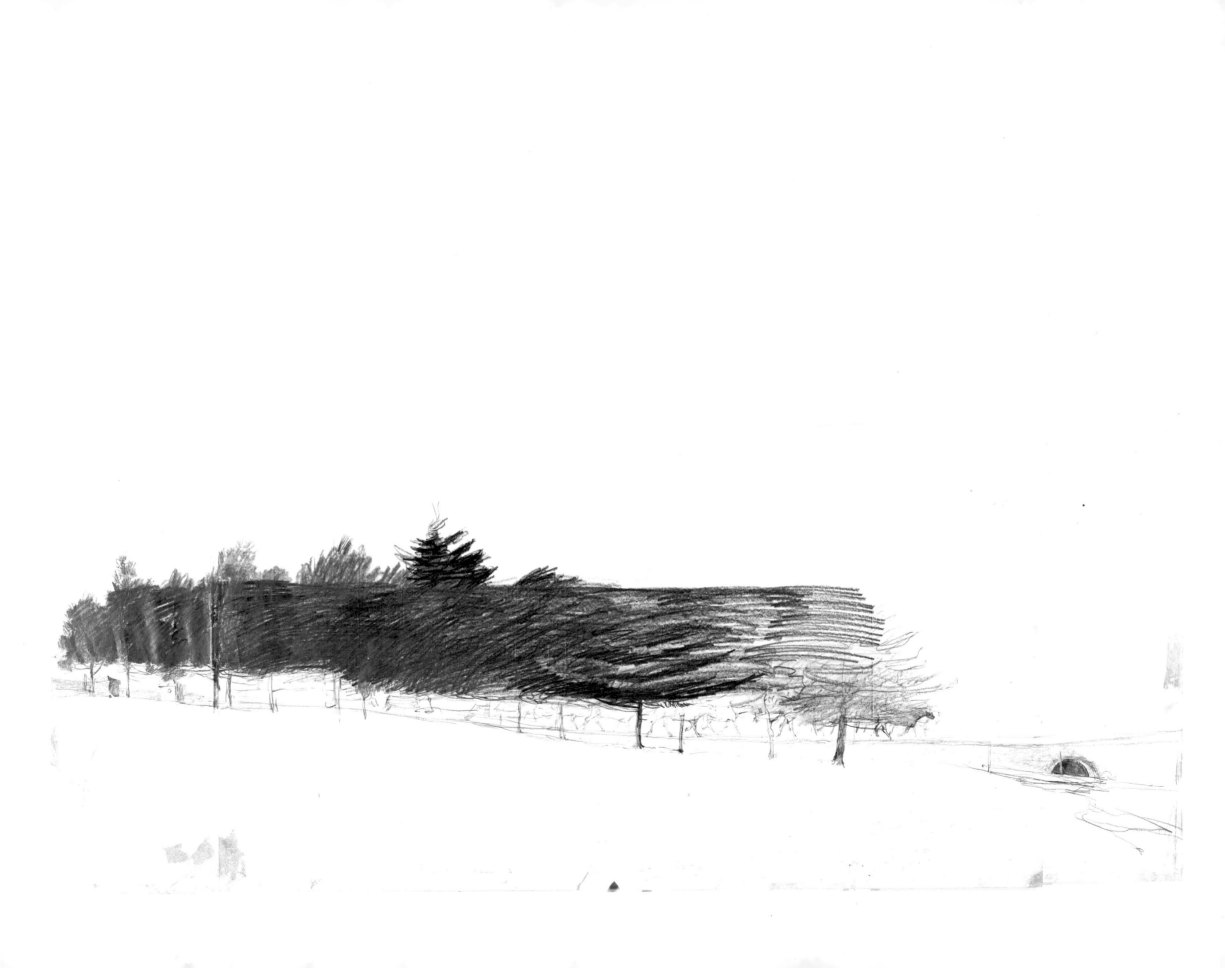

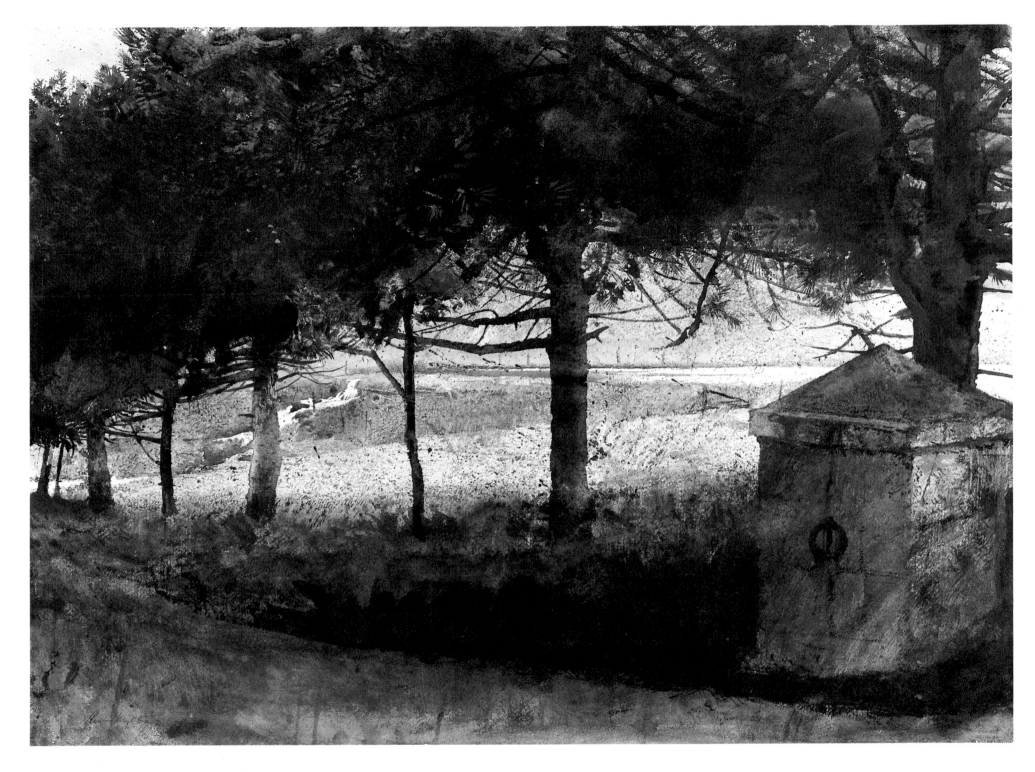

One entrance post stands like a brooding sentry under the pines.

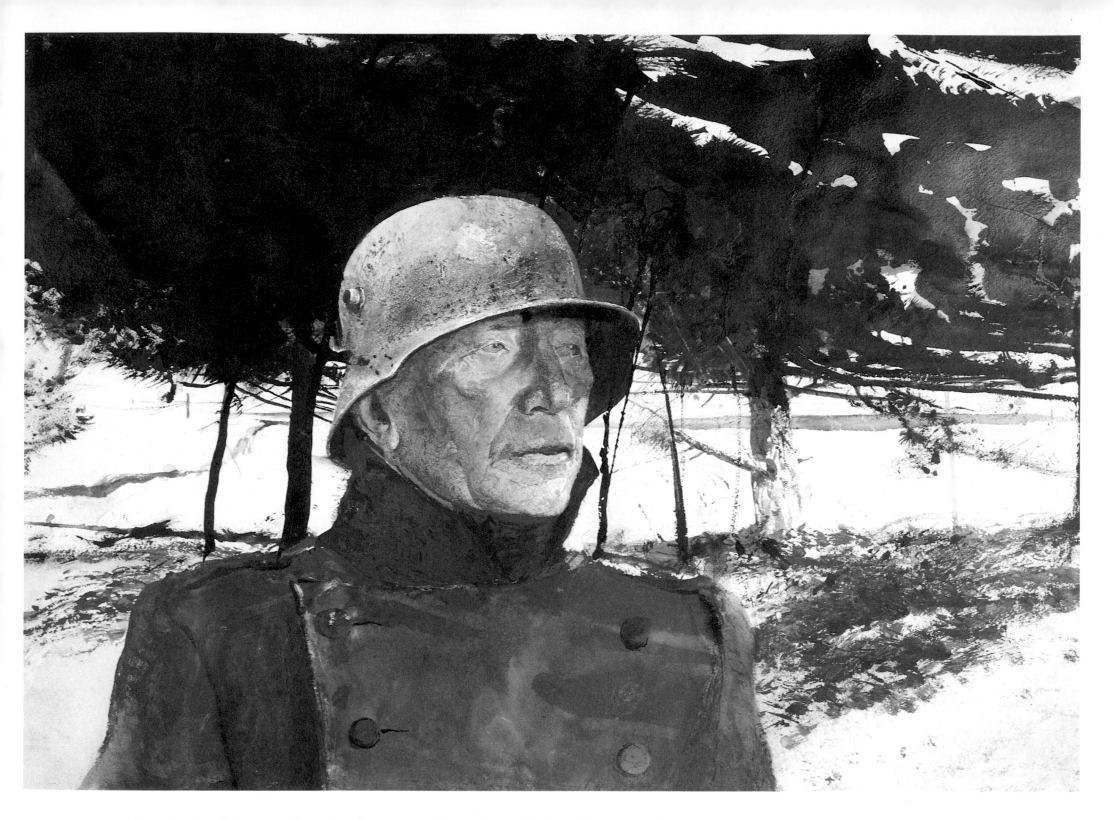

An aging Karl also stands under these same pines – dressed in his German uniform. He seems totally absorbed with something his ice blue eyes see in the far distance or the distant past.

He is not well. In other years his tractor tracks would have
left their imprint on the snow that fell during the night.

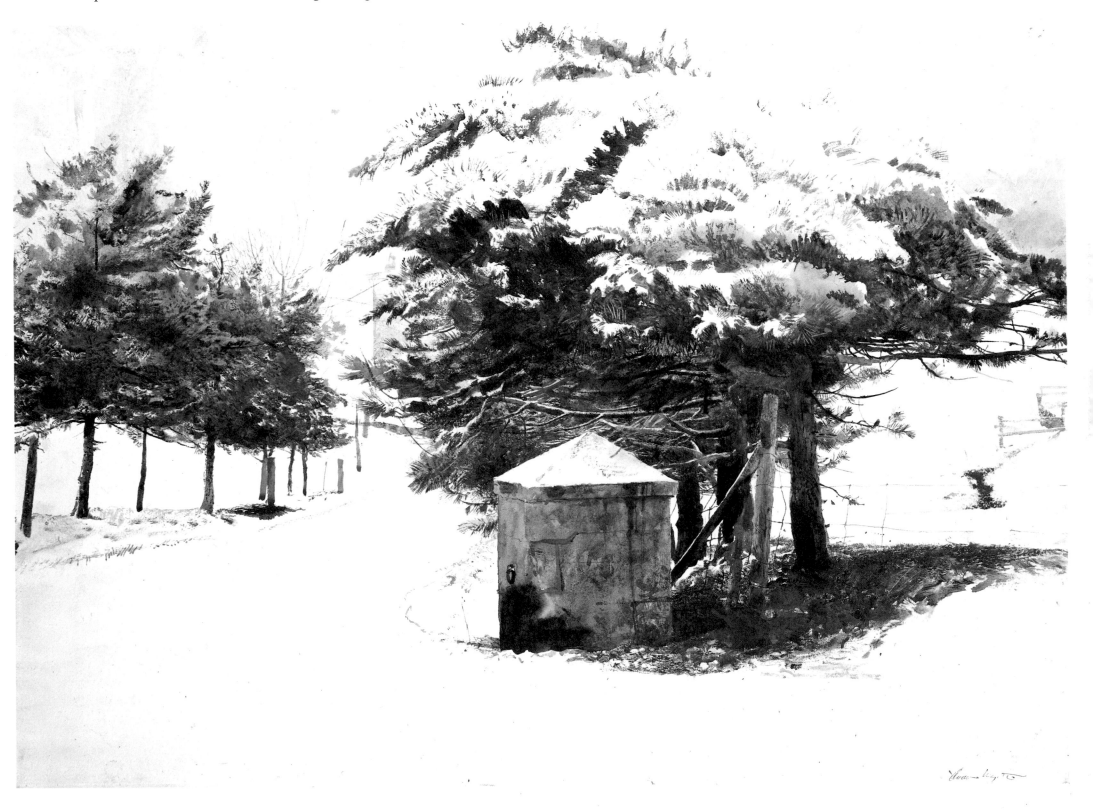

A last look at the house – it stands sharp and clear –

Leaving

then seems to become a white glow in a charred landscape before vanishing from sight.

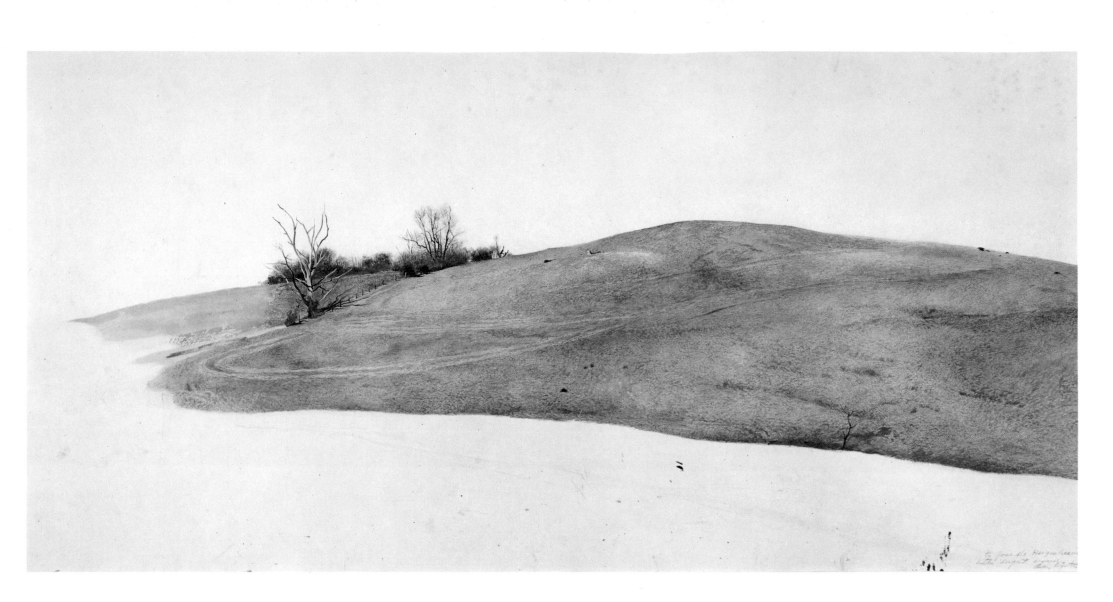

Kuerners Hill looks bare and desolate except for the tracks left by a tractor.

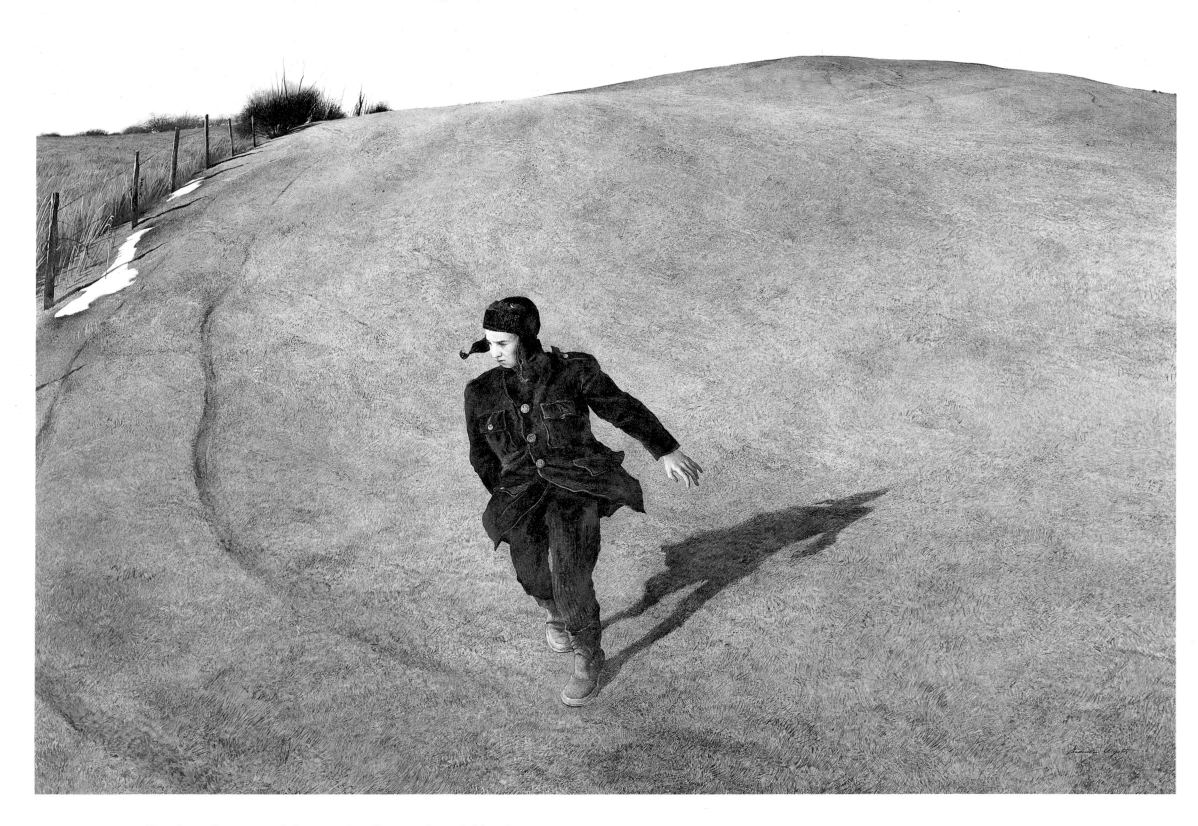

Patches of snow and the running figure of a neighbor's son
seem fleeting as life against the massive power of the Hill.

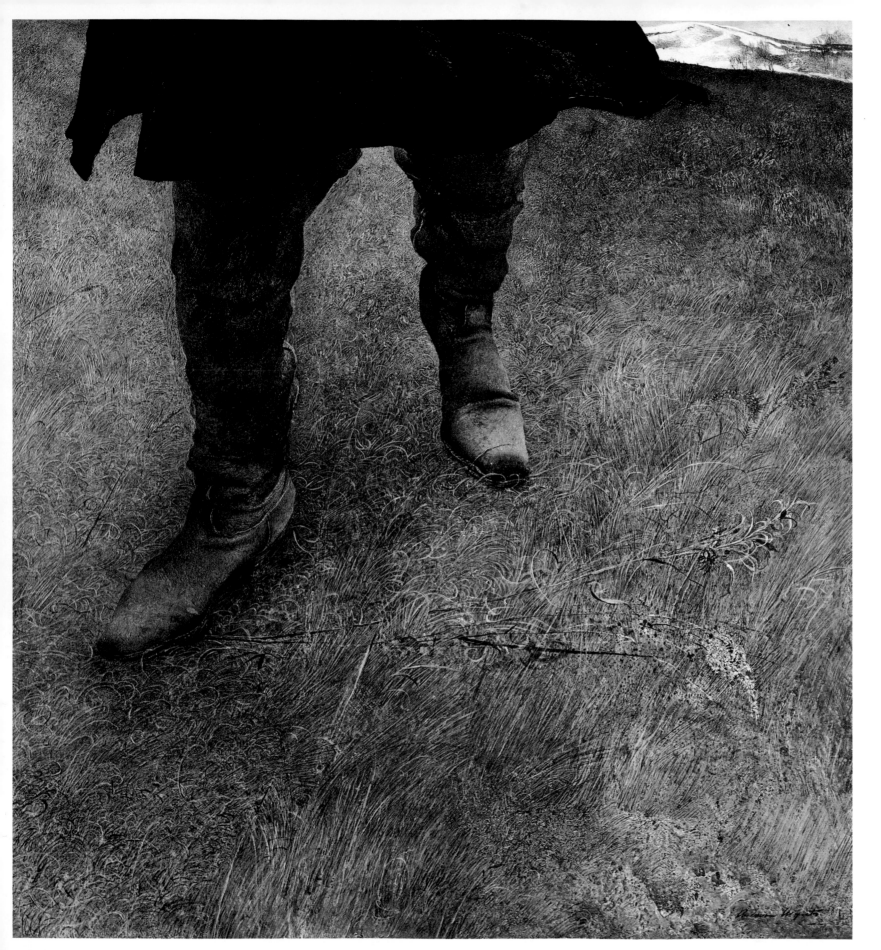

The artist continues
on his solitary way.

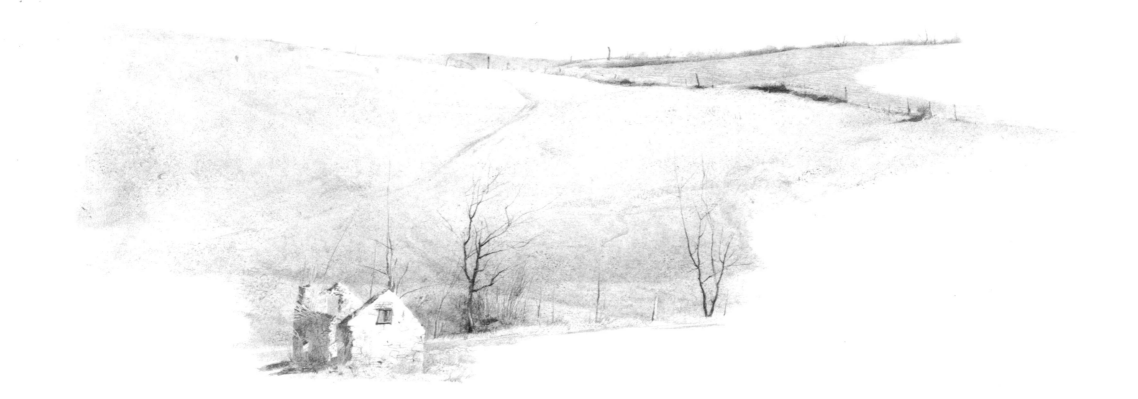

Kuerners Hill becomes a gentle slope on the far horizon beyond a gutted stone building.

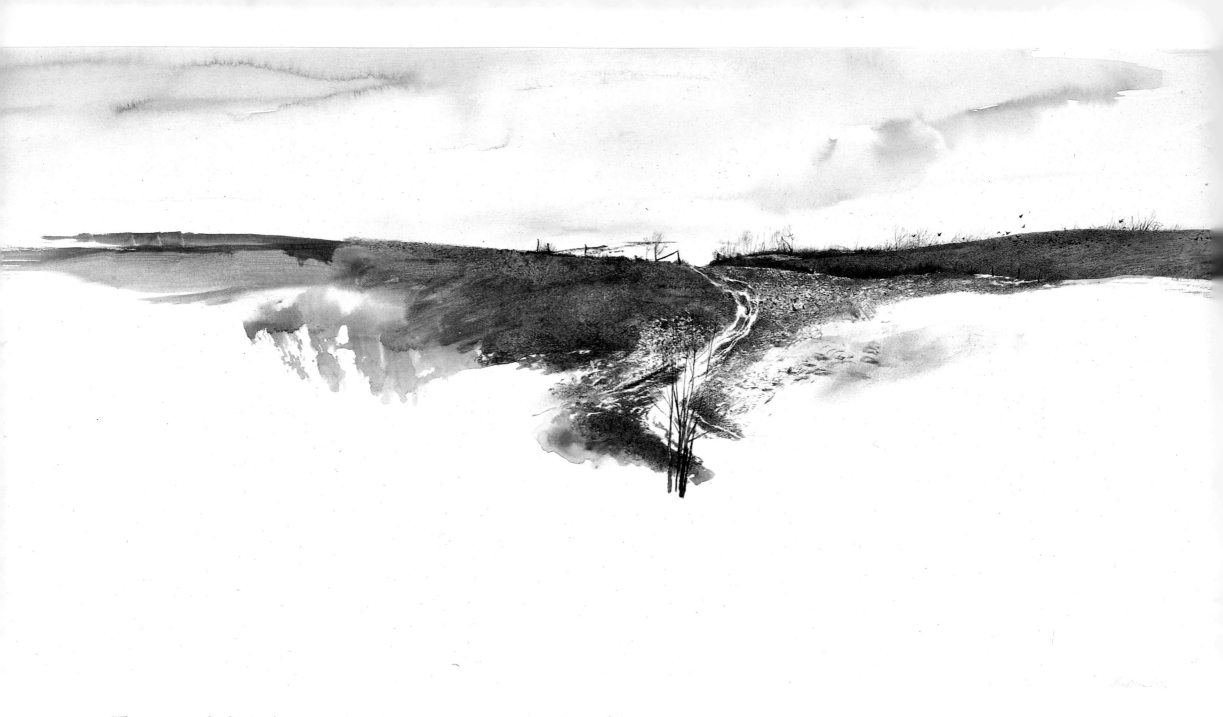

The cawing of a flock of crows is the only sound that breaks the silence of the winter landscape.

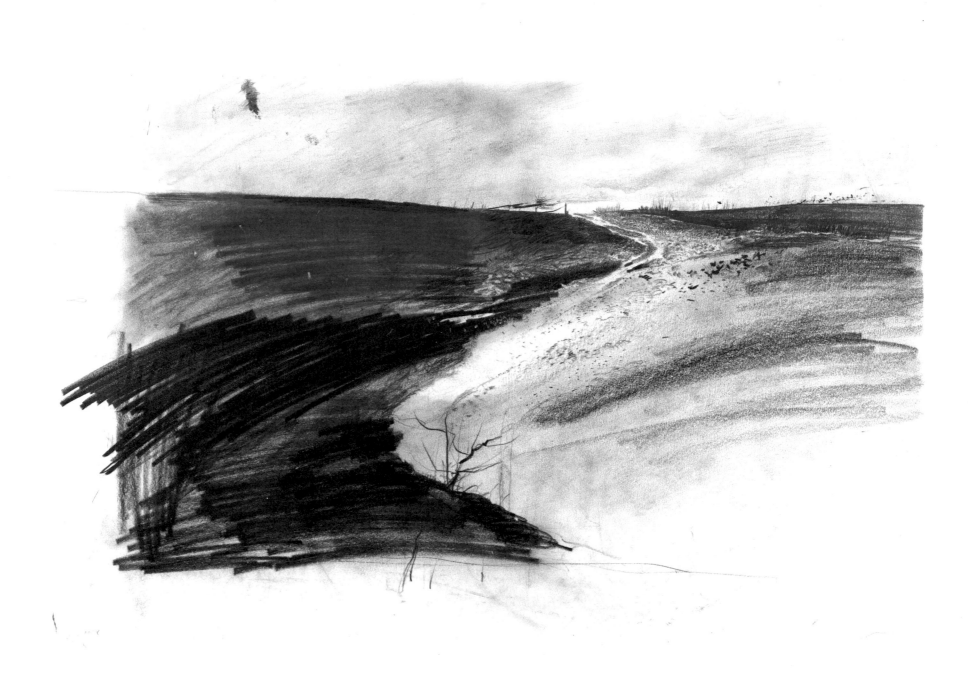

313

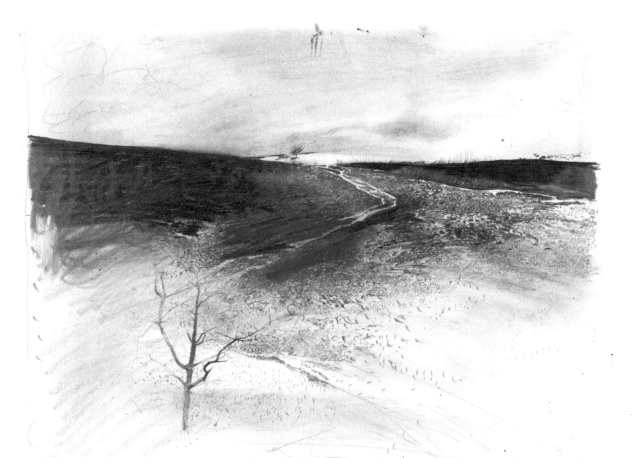

Even they fly away over the hills, until, in the end,
all that is left of Kuerners is a distant snow-capped hill.

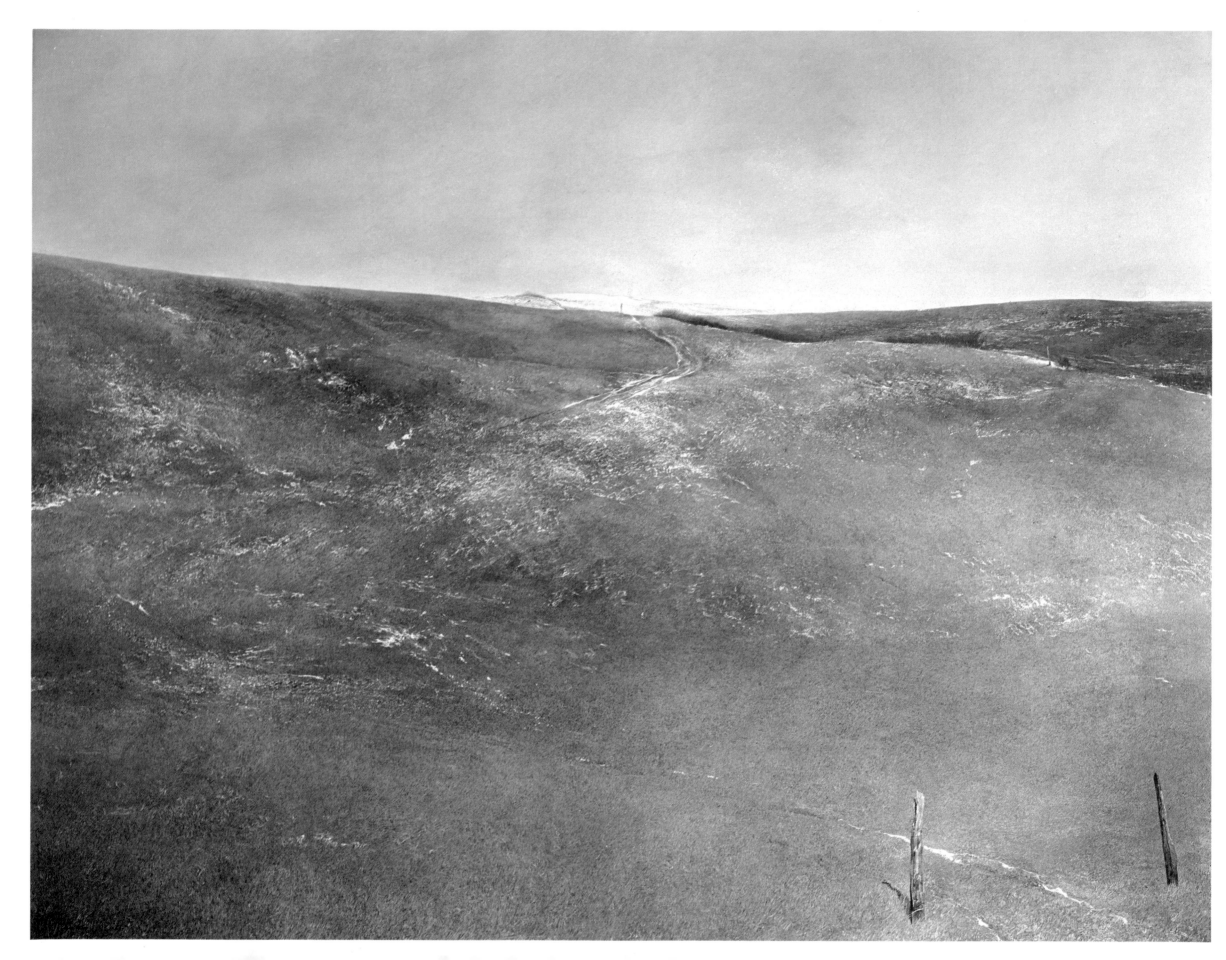

INDEX OF PAINTINGS AND DRAWINGS

38 LOWER RIGHT
Drawing 1965
Pencil 12 × 17¾

39 *Spillway* 1970
Watercolor 21¼ × 29½
Private collection

40 Untitled 1967
Watercolor 21¾ × 30

41 Study for *Brown Swiss* 1957
Pencil 13½ × 9¾

42 Drawing 1960
Pencil 10¾ × 13½

43 Untitled 1960
Watercolor 22 × 28½
Mrs. Andrew Wyeth

44 Study for *Evening at Kuerners*
1970
Watercolor 27 × 39
Katherine, Elizabeth and
James Ryan

45 *Evening at Kuerners* 1970
Drybrush 27 × 39
Mrs. Andrew Wyeth

46 Study for *Springhouse Door*
1971
Pencil 13¾ × 17

47 *Springhouse Door* 1971
Watercolor 21 × 29
Private collection

48 *Hard Cider* 1969
Watercolor 19 × 30
Mr. and Mrs. Carl A. Cantera,
Wilmington, Delaware

49 *Cider and Pork* 1956
Watercolor 21¾ × 29¼
Amanda K. Berls

50 LEFT
Letter to William E. Phelps 1957
Watercolor 2¼ × 4½
William and Mary Phelps Col-
lection, Delaware Art Museum

50 RIGHT
Study for *Brown Swiss* 1957
Pencil 17½ × 23

51 *Rope and Chain* 1957
Study for *Brown Swiss*
Pencil 16¾ × 22¾

52 Untitled 1960
Watercolor 14 × 20

53 Untitled 1960
Watercolor 14 × 20
Mrs. Andrew Wyeth

54 Study for *Brown Swiss* 1957
Pencil 8½ × 11

55 Study for *Brown Swiss* 1957
Pencil 8½ × 11

56 Drawing 1974
Pencil 18 × 23½

57 *Kuerners* 1966
Watercolor 20 × 28
Private collection

58 Study for *Kuerners* 1966
Watercolor 20 × 40

59 Untitled 1961
Watercolor 14 × 21¾
Mrs. Andrew Wyeth

60 *Down Grade* 1968
Watercolor 21¾ × 29¾
Private collection

61 Untitled 1956
Watercolor 14 × 21¾

62 Study for *The Prowler* 1975
Pencil 18 × 23½

63 Study for *The Prowler* 1975
Pencil 18 × 23½

64 Study for *The Prowler* 1975
Pencil 18 × 23½

65 Study for *The Prowler* 1975
Pencil 18 × 23½

66 TOP
Study for *Fence Line* 1967
Pencil 10¾ × 13¾

66 BOTTOM
Study for *Fence Line* 1967
Pencil 22 × 28½

67 *Fence Line* 1967
Watercolor 21 × 30
From the collection of Mr. and Mrs.
Joseph E. Levine

68 LEFT
Drawing 1970
Pencil 14 × 16½

68 RIGHT
Drawing 1970
Pencil 14 × 16½

69 LEFT
Drawing 1970
Pencil 14 × 16½

69 RIGHT
Study for *Snow Birds* 1970
Pencil 14 × 16½

70 Study for *Patrolling* 1975
Pencil 18 × 23½

71 *The Prowler* 1975
Watercolor 21¾ × 39⅝
Dr. and Mrs. Ferdinand Szabo

72 Study for *Brown Swiss* 1957
Pencil 14 × 16½

73 *Hill Pasture* 1957
Study for *Brown Swiss*
Watercolor 13½ × 19¼
Mr. and Mrs. Paul Bidwell

74 UPPER LEFT
Study for *Brown Swiss* 1957
Pencil 17½ × 22¾

74 UPPER RIGHT
Study for *Brown Swiss* 1957
Pencil 18 × 22¾

74 LOWER RIGHT
Study for *Brown Swiss* 1957
Pencil 17½ × 23

75 Untitled 1966
Watercolor 21¾ × 30

76 Study for *Brown Swiss* 1957
Pencil 12 × 23

77 Study for *Brown Swiss* 1957
Watercolor 21¾ × 29½

78 Study for *Brown Swiss* 1957
Watercolor 22½ × 29

79 *Farm Pond* 1957
Study for *Brown Swiss*
Watercolor 13¾ × 21¾
Reynolda House, Inc., Museum of
American Art

80 Study for *Brown Swiss* 1957
Pencil 18 × 28

81 Study for *Brown Swiss* 1957
Pencil and spattered watercolor
17¾ × 23½

82 Study for *Frozen Pond* 1968
Pencil 13¾ × 16¾

83 *Frozen Pond* 1968
Watercolor 31¾ × 39¾

84 Study for *Frozen Pond* 1968
Watercolor 21 × 30

85 Study for *Brown Swiss* 1957
Watercolor 21½ × 29

86 Study for *Brown Swiss* 1957
Watercolor 10½ × 13½

87 Study for *Brown Swiss* 1957
Watercolor 10½ × 13½

88 Study for *Brown Swiss* 1957
Watercolor 10½ × 13½

89 Untitled 1962
Watercolor 10¾ × 13⅝

90 Untitled 1962
Watercolor 10¾ × 13⅝

91 Untitled 1962
Watercolor 10¾ × 13⅝

92 LEFT
Study for *Brown Swiss* 1957
Pencil 8½ × 11

92 RIGHT
Study for *Brown Swiss* 1957
Pencil 8½ × 11

93 LEFT
Study for *Brown Swiss* 1957
Pencil 8½ × 11

93 RIGHT
Study for *Brown Swiss* 1957
Watercolor 14½ × 21

94– *Brown Swiss* 1957
95 Tempera 30½ × 61
From the collection of Mr. and Mrs.
 Alexander M. Laughlin

96 Study for *Brown Swiss* 1957
Pencil 8¼ × 11

97 TOP
Study for *Brown Swiss* 1957
Pencil 8½ × 11

97 BOTTOM
Study for *Brown Swiss* 1957
Pencil 15½ × 22

98 Study for *Brown Swiss* 1957
Pencil 12¼ × 21½

99 Study for *Brown Swiss* 1957
Watercolor and pencil 8½ × 11
Private collection

100 LOWER LEFT
Study for *Brown Swiss* 1957
Pencil 8½ × 11

100 UPPER RIGHT
Study for *Brown Swiss* 1957
Pencil 8½ × 11

101 Study for *Brown Swiss* 1957
Pencil 10½ × 8

102 UPPER LEFT
Drawing 1972
Pencil 22 × 28½

102 LOWER RIGHT
Drawing 1972
Pencil 11 × 13¾

103 LEFT
Study for *The Trophy* 1963
Pencil 8¼ × 10½

103 RIGHT
Study for *The Trophy* 1963
Pencil 8¼ × 10½

104 Study for *The Trophy* 1963
Pencil 8 × 10⅝

105 Study for *The Trophy* 1963
Pencil 23 × 29

106 LEFT
Study for *The Trophy* 1963
Pencil 9¼ × 13½

106 RIGHT
Study for *The Trophy* 1963
Pencil 9½ × 13½

107 Study for *The Trophy* 1963
Pencil 21¼ × 29¼

108 *Moose Horns* 1963
First version of *The Trophy*
Drybrush 15 × 23
Private collection

109 *The Trophy* 1963
Watercolor 22⅜ × 30½
Mr. and Mrs. Tate Brown

110 Study for *Brown Swiss* 1957
Watercolor 19¾ × 27¾

111 Study for *Brown Swiss* 1957
Pencil 13½ × 21½

112 Study for *Airing Out* 1969
Pencil 13¾ × 10⅞

113 *Airing Out* 1969
Watercolor 30½ × 22
From the collection of Mr. and Mrs.
 Joseph E. Levine

114 Study for *Groundhog Day* 1959
Watercolor 22 × 14
Mrs. Andrew Wyeth

115 LEFT
Study for *Groundhog Day* 1959
Pencil 10½ × 13½

115 RIGHT
Study for *Groundhog Day* 1959
Pencil 13 × 10¼

116 LEFT
Study for *Groundhog Day* 1959
Pencil 21½ × 13½

116 UPPER RIGHT
Study for *Groundhog Day* 1959
Pencil 13⅜ × 10¾

116 LOWER RIGHT
Study for *Groundhog Day* 1959
Pencil 22 × 13¾

117 LEFT
Study for *Groundhog Day* 1959
Pencil 13⅜ × 10¾

117 RIGHT
Study for *Groundhog Day* 1959
Pencil 13⅜ × 10¾

118 UPPER LEFT
Study for *Groundhog Day* 1959
Pencil 13 × 10¼

118 UPPER RIGHT
Study for *Groundhog Day* 1959
Pencil 12 × 10

118 LOWER RIGHT
Study for *Groundhog Day* 1959
Pencil 9¾ × 9¾

119 LEFT
Study for *Groundhog Day* 1959
Pencil 10¾ × 10¾

119 RIGHT
Study for *Groundhog Day* 1959
Pencil 12½ × 10¼

120 LEFT
Study for *Groundhog Day* 1959
Pencil 12½ × 10¼

120 RIGHT
Study for *Groundhog Day* 1959
Pencil 13 × 10

121 LEFT
Study for *Groundhog Day* 1959
Pencil 11 × 9½

121 UPPER RIGHT
Study for *Groundhog Day* 1959
Pencil 7 × 9

121 UPPER LEFT
Study for *Groundhog Day* 1959
Pencil 11 × 8½

122 LEFT
Study for *Groundhog Day* 1959
Watercolor 9 × 8

122 UPPER RIGHT
Study for *Groundhog Day* 1959
Pencil 4¾ × 9¾

122 LOWER RIGHT
Study for *Groundhog Day* 1959
Watercolor 4½ × 4½

123 Study for *Groundhog Day* 1959
Pencil 14½ × 19¾

124 LEFT
Study for *Groundhog Day* 1959
Pencil 12¾ × 10¼

124 RIGHT
Study for *Groundhog Day* 1959
Pencil 8 × 9

125 Study for *Groundhog Day* 1959
Watercolor 19½ × 13¼

126 Study for *Groundhog Day* 1959
Watercolor 13¼ × 20½

127 TOP
Study for *Groundhog Day* 1959
Watercolor 9¾ × 15½

127 BOTTOM
Study for *Groundhog Day* 1959
Watercolor 12¾ × 20½

128 TOP
Study for *Groundhog Day* 1959
Pencil 14½ × 23¼

128 BOTTOM
Study for *Groundhog Day* 1959
Pencil 14½ × 23¼

129 Study for *Groundhog Day* 1959
Watercolor 13¾ × 23¼

130 Study for *Groundhog Day* 1959
Watercolor 13½ × 16

131 Study for *Groundhog Day* 1959
Watercolor 13 × 10¼

132 Study for *Groundhog Day* 1959
Pencil 22¾ × 16¼

133 Study for *Groundhog Day* 1959
Watercolor 22½ × 16¾

134 Study for *Brown Swiss* 1957
Watercolor 10½ × 13½

135 *Gum Tree* 1958
Watercolor 21½ × 29⅝
Mrs. William H. Kearns

136 Study for *Brown Swiss* 1957
India ink 13¾ × 21½

137 Study for *Brown Swiss* 1957
Watercolor 13½ × 21¼

138 Study for *Groundhog Day* 1959
Pencil 10¾ × 13

139 LEFT
Study for *Groundhog Day* 1959
Pencil 13 × 10

139 RIGHT
Study for *Groundhog Day* 1959
Pencil 28½ × 22¾

140 UPPER LEFT
Study for *Groundhog Day* 1959
Pencil 11¾ × 17¾

140 LOWER RIGHT
Study for *Groundhog Day* 1959
Pencil 6 × 12

141 Study for *Groundhog Day* 1959
Pencil 13 × 10½

142 *Firewood* 1959
Study for *Groundhog Day*
Watercolor 13½ × 21½
H. H. Thyssen-Bornemisza Collec-
tion: Photograph courtesy of
Andrew Crispo Gallery, New
York

143 *First Snow* 1959
Study for *Groundhog Day*
Drybrush 13¼ × 21¼
William and Mary Phelps Col-
lection, Delaware Art Museum

144 Study for *Groundhog Day* 1959
Watercolor 21¼ × 27

145 *Wild Dog* 1959
Study for *Groundhog Day*
Watercolor 13½ × 19
James Wyeth

146 LEFT
Study for *Groundhog Day* 1959
Pencil 26¾ × 21¼

146 RIGHT
Study for *Groundhog Day* 1959
Pencil 16¾ × 23

147 Study for *Groundhog Day* 1959
Watercolor 12 × 18

148 *Log Chain* 1959
Study for *Groundhog Day*
Watercolor 14 × 20
Private collection

149 *Groundhog Day* 1959
Tempera 31 × 31¼
Philadelphia Museum of Art:
Given by Henry F. duPont and
Mrs. John Wintersteen

150 LEFT
Study for *Kitchen Garden* 1962
Pencil 13⅝ × 10¾

150 RIGHT
Study for *Kitchen Garden* 1962
Pencil 13⅝ × 10¾

151 LEFT
Study for *Kitchen Garden* 1962
Pencil 13⅝ × 10¾

151 RIGHT
Study for *Kitchen Garden* 1962
Pencil 18⅝ × 13¼

152 Study for *Kitchen Garden* 1962
Pencil 13⅝ × 21

153 Study for *Kitchen Garden* 1962
Pencil 10½ × 13⅝

154 Study for *Kitchen Garden* 1962
Pencil 10½ × 13⅝

155 UPPER LEFT
Study for *Kitchen Garden* 1962
Pencil 10¾ × 13⅝

155 LOWER LEFT
Study for *Kitchen Garden* 1962
Pencil 13⅝ × 10¾ (done
horizontally on vertical page)

156 *Kitchen Garden* 1962
Drybrush 22½ × 21¼
From the collection of Mr. and Mrs.
Joseph E. Levine

157 *Side of Kuerners* 1962
Watercolor 18 × 23¼
John Tiedtke

158 *Hickory Smoked* 1960
First version of *Below the Kitchen*
Watercolor 21½ × 29½
Private collection

159 *Below the Kitchen* 1960
Drybrush 22¾ × 18
Private collection, New York

160 *Chimney Smoke* 1957
Study for *Brown Swiss*
Watercolor 21⅝ × 29¾
Mrs. Oscar B. Huffman

161 Study for *Brown Swiss* 1957
Watercolor 13½ × 21½

162 Untitled 1971
Watercolor 19 × 30

163 Study for *Brown Swiss* 1957
Watercolor 13½ × 19½

164 *Backside* 1973
Watercolor 29 × 21
Private collection

165 *Lamplight* 1975
Watercolor 21½ × 29½
From the collection of
Anton A. Vreede, M.D.P.C.

166 *Sleet Storm* 1973
Watercolor 18¼ × 29¾
Private collection

167 Study for *Heavy Snow* 1967
Pencil 12 × 35

168 Study for *Brown Swiss* 1957
Watercolor 19½ × 27¾

169 Untitled 1963
Watercolor 14¾ × 22
Mrs. Andrew Wyeth

170 Study for *Spring Cleaning* 1964
Pencil 13¾ × 17

171 Study for *Spring Cleaning* 1964
Pencil 13¾ × 17

172 Study for *Wolf Moon* 1975
Pencil 16 × 19¾

173 *Heavy Snow* 1967
Drybrush 20 × 40
Zula H. McMillan

174 *Snow Birds* 1970
Drybrush 17 × 29½
Mr. and Mrs. William E. Mercer, Jr.

175 Study for *Brown Swiss* 1957
Pencil 13 × 10¼

176 Study for *Wolf Moon* 1975
Pencil 16 × 19¾

177 Study for *Wolf Moon* 1975
Pencil 16 × 19¾

178 Study for *Wolf Moon* 1975
Pencil 16 × 19⅝

179 *Wolf Moon* 1975
Watercolor 40 × 28½

180 Study for *Spring Cleaning* 1964
Pencil 8¾ × 13¾

181 *Spring Cleaning* 1964
Watercolor 20¼ × 29½
Private collection

182 *Gate Chain* 1967
Watercolor 22 × 14
Private collection

183 Untitled 1967
Watercolor 22 × 29

184 Study for *Brown Swiss* 1957
Watercolor 13½ × 21¼

185 Study for *Brown Swiss* 1957
Pencil 8½ × 11

186 Study for *Snow Flurries* 1953
Watercolor 13½ × 20¾

187 Untitled 1951
Watercolor 22¼ × 28½
Mrs. Andrew Wyeth

188 *Out of Season* 1953
Drybrush 13¼ × 20½
Private collection

189 Drawing 1946
Pencil 16 × 21

190 Drawing 1946
Pencil 21 × 23½

191 Untitled 1946
Watercolor 22 × 30

192 UPPER LEFT
Drawing 1967
Pencil 13⅞ × 16⅝

192 LOWER RIGHT
Study for *Cordwood* 1968
Pencil 10⅞ × 13¾

193 Untitled 1966
Watercolor 14¼ × 23

194 Study for *Cordwood* 1968
Pencil 11⅜ × 13½

195 *Toward Atwaters* 1968
Study for *Cordwood*
Watercolor 11¼ × 21½
Mr. and Mrs. Nicholas Wyeth

196 *Cordwood* 1968
Watercolor 25 × 30
Private collection

197 Untitled 1959
Watercolor 21½ × 29¾

198 *Morning at Kuerners* 1972
Watercolor 21 × 28¾

199 Untitled 1967
Watercolor 20 × 28

200 Study for *Woodshed* 1944
Watercolor 13 × 20

201 Study for *Woodshed* 1944
Watercolor 17 × 20

202 *Crows* 1944
Study for *Woodshed*
Ink 33 × 47
Lyman Allyn Museum,
New London, Connecticut

203 Study for *Woodshed* 1944
Watercolor 10¼ × 15½

204 Study for *Woodshed* 1944
Watercolor 11¼ × 17½

205 *The Woodshed* 1944
Tempera 31½ × 56¾
Private collection

206 Untitled 1958
Watercolor 21½ × 29½

207 *Oil Drum* 1957
Watercolor 13¾ × 21¾
Private collection

208 Drawing 1957
Pencil 11¼ × 8½

209 *Winter Morning* 1946
Drybrush 25 × 37½
Private collection

210 *Young Buck* 1945
Watercolor 29 × 22¾
Private collection

211 Untitled 1967
Watercolor 21¾ × 30

212 Drawing 1970
Pencil 13¾ × 16¾

213 Untitled 1970
Watercolor 21⅝ × 29⅝

214 Reverse side of *Backside* 1973
Watercolor and pencil 21 × 29
Private collection

215 Untitled 1957
Watercolor 29¾ × 21⅝

216 UPPER LEFT
Drawing 1970
Pencil 17 × 13¾

216 LOWER RIGHT
Drawing 1970
Pencil 13¾ × 17

217 Study for *Spring Fed* 1967
Pencil 17 × 13¾

218 Study for *Milkroom* 1964
Watercolor 21 × 30

219 UPPER LEFT
Study for *Milkroom* 1964
Pencil 13¾ × 17

219 LOWER RIGHT
Study for *Milkroom* 1964
Pencil 13¾ × 17

220 Study for *Milkroom* 1964
Watercolor 28⅞ × 23

221 *Milkroom* 1964
Watercolor 30 × 22
From the collection of
Thomas M. Evans

222 UPPER LEFT
Study for *Spring Fed* 1967
Pencil 8¾ × 12¼

222 UPPER RIGHT
Study for *Spring Fed* 1967
Pencil 9½ × 15½

222 LOWER RIGHT
Study for *Spring Fed* 1967
Pencil 7½ × 10½

223 Study for *Spring Fed* 1967
Pencil 22¼ × 28¼

224 Study for *Spring Fed* 1967
Pencil 21½ × 28¼

225 Study for *Spring Fed* 1967
Watercolor 21½ × 29¼

226 Study for *Spring Fed* 1967
Pencil 7¾ × 9¾

227 Study for *Spring Fed* 1967
Pencil 10¼ × 13

228 TOP
Study for *Young Bull* 1960
Pencil 14 × 16½

228 BOTTOM
Study for *Young Bull* 1960
Pencil 11 × 16¼

229 UPPER LEFT
Study for *Young Bull* 1960
Pencil and black watercolor
13¾ × 16¼

229 LOWER RIGHT
Study for *Young Bull* 1960
Pencil 11½ × 23¼

230 LEFT
Study for *Young Bull* 1960
Pencil 14 × 16½

230 UPPER RIGHT
Study for *Young Bull* 1960
Pencil 14 × 16½

230 LOWER RIGHT
Study for *Young Bull* 1960
Pencil 14 × 16½

231 Study for *Young Bull* 1960
Watercolor 13 × 16¼

232 Study for *Young Bull* 1960
Pencil 23 × 36¼

233 *Young Bull* 1960
Drybrush 19¾ × 41¼
Mrs. Andrew Wyeth

234 Untitled 1961
Watercolor 18 × 22¾

235 UPPER LEFT
Study for *Patrolling* 1975
Pencil 11 × 13¾

235 LOWER RIGHT
Study for *Patrolling* 1975
Pencil 18 × 23½

236 Study for *Patrolling* 1975
Pencil 12 × 17¾

237 *Patrolling* 1975
Watercolor 20 × 28½

238 UPPER LEFT
Drawing 1967
Pencil 13¾ × 17

238 UPPER RIGHT
Drawing 1967
Pencil 13⅞ × 17

238 LOWER RIGHT
Study for *German Shepherd* 1972
Pencil 11 × 14

239 *German Shepherd* 1972
Watercolor 21 × 28
Private collection

240 Drawing 1962
Pencil 10 × 13½

241 Untitled 1962
Watercolor 18 × 23

242 Drawing 1964
Pencil 10¾ × 14

243 Drawing 1965
Pencil 17 × 13¾

244 Drawing 1965
Pencil 19⅞ × 14⅞

245 Drawing 1965
Pencil 13¾ × 10¾

246 LEFT
Anna's Lamp 1959
Watercolor 19½ × 13½
From the collection of
Andrea Patterson Redifer

246 RIGHT
Drawing 1959
Pencil 9¾ × 13½

247 LOWER LEFT
Study for *Anna Kuerner* 1971
Pencil 10⅝ × 14

247 UPPER RIGHT
Untitled 1975
Watercolor 19 × 24

248 Untitled 1956
Watercolor 20 × 28

249 Study for *Karl* 1948
Pencil 23¼ × 18¼

250 Study for *Karl* 1948
Watercolor 21¼ × 29

251 Study for *Karl* 1948
Watercolor 21¼ × 29

252 Study for *Karl* 1948
Pencil 17 × 12½

253 Study for *Karl* 1948
Pencil 12¼ × 13¼

254 Study for *Karl* 1948
Pencil 17½ × 22¼

255 *Karl* 1948
Tempera 30⅝ × 23⅝
Private collection

256 *Smoked Meat* 1957
Watercolor 13¾ × 21¾
Private collection

257 Untitled 1958
Watercolor 13½ × 22
Mrs. Andrew Wyeth

258 First version of *Spare Room* 1973
Watercolor 19 × 30
Mrs. Andrew Wyeth

259 *Spare Room* 1973
Watercolor 19 × 30
John Lavrich,
San Francisco, California

260 Second version of *Spare Room*
1973
Watercolor 19 × 30

261 Study for *Anna Kuerner* 1971
Pencil 10½ × 13½

262 UPPER LEFT
Study for *Anna Kuerner* 1971
Pencil 10¾ × 13½

262 UPPER RIGHT
Study for *Anna Kuerner* 1971
Pencil 10½ × 13

262 BOTTOM
Study for *Anna Kuerner* 1971
Pencil 10½ × 13¼

263 Study for *Anna Kuerner* 1971
Pencil 13½ × 16½

264 LOWER LEFT
Mrs. Kuerner 1958
Watercolor 14⅞ × 21½
Hirshhorn Museum and Sculpture
Garden, Smithsonian Institution

264 UPPER RIGHT
Study for *Anna Kuerner* 1971
Pencil 13¾ × 16½

265 UPPER LEFT
Study for *Anna Kuerner* 1971
Pencil 13½ × 16½

265 UPPER RIGHT
Study for *Anna Kuerner* 1971
Pencil 13½ × 16½

265 LOWER LEFT
Study for *Anna Kuerner* 1971
Pencil 3¾ × 4½

266 Study for *Anna Kuerner* 1971
Watercolor 22½ × 27

267 Study for *Anna Kuerner* 1971
Pencil 10 × 13
Private collection

268 Study for *Anna Kuerner* 1971
Pencil 13½ × 16½

269 *Anna Kuerner* 1971
Tempera 13½ × 19½
W. S. Farish III

270 Karl's passport
(Photographs)

271 UPPER LEFT
Study for *Karl's Room* 1954
Pencil 13¼ × 20½

271 LOWER RIGHT
Study for *Karl's Room* 1954
Pencil 10¾ × 13⅜

272 *Karl's Room* 1954
Watercolor 21 × 29
Courtesy of The Museum of
Fine Arts, Houston

273 Drawing 1964
Pencil 23 × 29

274 Drawing 1964
Pencil 13½ × 17

275 Study for *The Kuerners* 1971
Pencil 20 × 40

276 UPPER LEFT
Drawing 1964
Pencil 13½ × 17

276 BOTTOM
Drawing 1964
Pencil 10½ × 20

277 Untitled 1964
Watercolor 21 × 30

278 UPPER LEFT
Drawing 1964
Pencil 13½ × 17

278 LOWER RIGHT
Drawing 1964
Pencil 13½ × 17

279 UPPER LEFT
Study for *The Kuerners* 1971
Pencil 18 × 23¾

279 LOWER RIGHT
Study for *The Kuerners* 1971
Pencil 14 × 16¾

280 Study for *The Kuerners* 1971
Pencil 23 × 27½

281 Study for *The Kuerners* 1971
Pencil 12¾ × 13¼
Mr. and Mrs. Frank E. Fowler,
Lookout Mountain, Tennessee

282 Study for *The Kuerners* 1971
Pencil 18 × 23¾

283 Study for *The Kuerners* 1971
Pencil 23 × 28¾

284 Study for *The Kuerners* 1971
Pencil 11 × 14

285 Study for *The Kuerners* 1971
Pencil 11 × 13½

286– *The Kuerners* 1971
287 Drybrush 25 × 39½

288 Study for *Easter Sunday* 1975
Watercolor 19 × 30

289 Study for *Easter Sunday* 1975
Pencil 16 × 17½

290 Study for *Easter Sunday* 1975
Watercolor 27 × 40

291 *Easter Sunday* 1975
Watercolor 27 × 40

292 *The Porch* 1973
Watercolor 21½ × 29⅜
Owned by David R. Edgerton,
Miami, Florida

293 *Rod and Reel* 1975
Watercolor 21½ × 29½

294 Study for *Brown Swiss* 1957
Pencil 17½ × 23

295 Study for *Brown Swiss* 1957
Pencil 17¾ × 23

296 Drawing 1964
Pencil 13½ × 9¾

297 Drawing 1971
Pencil 12 × 17¾

298 Drawing 1971
Pencil 13⅞ × 16⅝

299 Drawing 1971
Pencil 12 × 17½

300 Drawing 1971
Pencil 20 × 29

301 Drawing 1971
Pencil 18½ × 44½

302 Drawing 1974
Pencil 18 × 23¾

303 *Where the German Lives* 1973
Watercolor 21½ × 29½
Mr. and Mrs. Phil Walden,
Macon, Georgia

304 *The German* 1975
Watercolor 21 × 29

305 *Pines in the Snow* 1972
Watercolor 21⅛ × 29⅛
Private collection, London, England

306 Study for *Brown Swiss* 1957
Drybrush 13½ × 21½

307 Untitled 1961
Watercolor 11¾ × 18

308 *Kuerners Hill* 1946
Study for *Winter 1946*
Drybrush 22 × 44
From the collection of
R. L. B. Tobin

309 *Winter 1946* 1946
Tempera 38 × 56
From the collection of the North
Carolina Museum of Art, Raleigh

310 *Trodden Weed* 1951
Tempera 20 × 18¼
Mrs. Andrew Wyeth

311 *Archie's Corner* 1953
Study for *Snow Flurries*
Pencil 13¼ × 18¼
Private collection

312 *Flock of Crows* 1953
Study for *Snow Flurries*
Drybrush 9½ × 19
Mrs. Andrew Wyeth

313 Study for *Snow Flurries* 1953
Pencil 13 × 21

314 Study for *Snow Flurries* 1953
Pencil 13 × 19½

315 *Snow Flurries* 1953
Tempera 36 × 47
Private collection

The color separations in this book were prepared
from transparencies photographed by Donald Widdoes
from the original art in Andrew Wyeth's possession.
A few exceptions were photographed by representatives
of other owners.

The book was designed by Klaus Gemming,
New Haven, Connecticut.

The text was set in Monotype Emerson by the
Press of A. Colish, Inc., Mt. Vernon, New York.

The printing plates were prepared by the Case-Hoyt Corporation,
Rochester, New York, using direct photography from the
original drawings and four-color separations from
transparencies for the watercolor, dry brush, and
tempera paintings, with the proof being compared to the
originals in Andrew Wyeth's possession. The book was
printed by the Case-Hoyt Corporation, using four-color
process sheet-fed lithography.

The text paper is Patina Coated Matte, manufactured by the
S. D. Warren Company, a division of the Scott Paper Company.
The cover fabric is Bolton Natural Finish Buckram, produced
by the Columbia Mills, Inc.

The book was bound by A. Horowitz & Sons, Bookbinders,
Fairfield, New Jersey.

Tout bien ou rien

First Printing